Beardsley

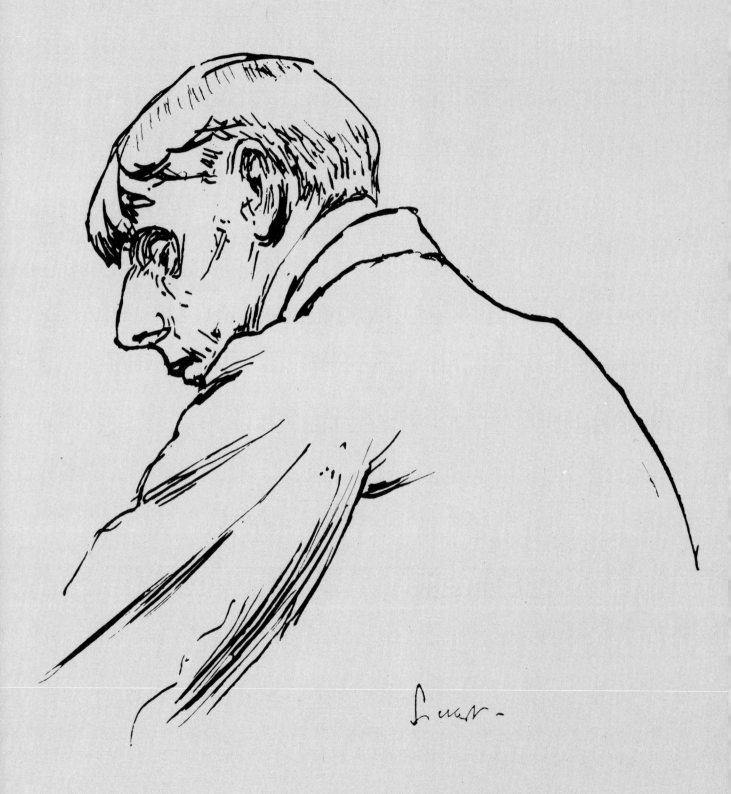

Portrait of Beardsley by Sickert

BEARDSLEY

Brian Reade

Introduction by John Rothenstein

Studio Vista

To my wife Margaret

FRONTISPIECE
Portrait of Aubrey Beardsley, quarter-length, profile to left,
c. 1894, by Walter Richard Sickert, R.A. (1860-1942). Signed
in sepia ink 'Sickert'.
Indian ink on buff paper, $9\frac{3}{4} \times 9$ inches
National Portrait Gallery, Londen

© Brian Reade 1967
Designed by Gillian Greenwood
Published in Great Britain in 1967 by Studio Vista Limited
Blue Star House, Highgate Hill, London N19
SBN 289 27890 2
Distributed in Canada by General Publishing Co. Limited
30 Lesmill Road, Don Mills, Toronto, Ontario
Set in 12pt Garamond, $1\frac{1}{2}$pt leaded
Printed in Holland by NV Drukkerij Koch en Knuttel, Gouda
Bound in Holland by NV Jansen, Leiden

Contents

Acknowledgments

Private and institutional owners of drawings have been recorded in all cases, except when photographs of certain drawings have been available with no identification of present ownership. The owners of rare books, posters etc., have been recorded also, otherwise where no acknowledgment has been given the reproductions have been made from works out of copyright.

To all who have permitted the reproduction of the drawings, books and posters in their possession I wish to give special thanks, particularly as not one of my requests was received without courtesy and co-operation.

In regard to the texts of the book, I am honoured to have Sir John Rothenstein's Introduction, and not only because of Beardsley's friendship with his father, the late Sir William Rothenstein. In compiling the introduction and the notes I have been conscious of my indebtedness to Mr R. A. Harari, who owns the largest private collection of Beardsley's drawings, and to his stimulating conversation on Beardsley subjects; also to Mr Sacheverell Sitwell for correspondence from him on various aspects of Beardsley and his art; to Mr W. G. Good for bibliographical expertise and to Mr Vyvyan Holland for valuable discussions.

In a different field I am glad to record my thanks to Mr David Carr of Starston, who undertook journeys and correspondence to trace certain Beardsley associations; and to Mr Anthony d'Offay and Mr Timothy d'Arch Smith for help in various ways. My indebtedness to others at the time of the Beardsley Exhibition of 1966, which made this book possible, is recorded in the catalogue of that exhibition published by the Victoria and Albert Museum, and is not forgotten. Finally I am happy to record thanks for the aid I have received at different times from Mr Raymond Rohauer, film curator and programme director of various museums in New York, and from Mr David Herbert and Miss Gillian Greenwood of Studio Vista Limited.

BRIAN READE
MARCH 1967

Introduction

Aubrey Beardsley was a prodigy and his career a phenomenon. Born in 1872; diagnosed only seven years later as tubercular; virtually untrained; famous by his early twenties, and dead at twenty-five, leaving an immense volume of work and exercising a wider influence abroad than any English illustrator since Hogarth; almost a world figure, in fact, if a miniature one. Of his work so formidable a critic as Meier-Graefe wrote: 'Our utilitarianism was never rebuked in stronger or haughtier terms.' Figures as remote from one another as Picasso and the pioneer Scottish architect Charles Rennie Mackintosh were in his debt. The history of art has no stranger episode than the violent impact upon an entire generation of the impeccable art of this young dandy who knew that he was dying, and whose working hours were interrupted by choking and haemorrhage.

After his death, although his influence continued to show itself in the work of countless imitators, as well as in that of a number of the masters, interest in Beardsley waned. It was not that he was forgotten—one could not forget Beardsley—but critical opinion inclined to dismiss him as a modish, over-estimated portrayer of 'the refinements of boudoir life, rococo toilet tables, powder puffs and hand mirrors'.

The waning of Beardsley's reputation was due in part to bored reaction to his earlier vast notoriety but to a greater degree to his intimate identification with a tradition that ended before its full potentialities were realized. The English Aesthetic Movement was virtually extinguished by the early deaths of Dowson and Conder as well as of Beardsley himself, but most of all by the trial and imprisonment of Wilde. So impassioned was the hostility to 'the Decadents', aroused by the trial, that the editorial premises of *The Yellow Book* (to which, incidentally, Wilde had never contributed) was attacked by a mob and its windows broken. Beardsley, its art editor, was dismissed; he lived for another three years, working with the same unremitting urgency, and at the end producing essays in a new style, 'suggesting a mind', as Robin Ironside has written, 'that has pondered the vanities of the flesh and holds them in awe'.

But he was a dying man, painfully aware of the hostility that Wilde had brought upon the entire Aesthetic Movement—a man bereft of the intellectual and social environment in which his genius had reached its sudden flowering.

At the end he devoutly embraced the Catholicism by which he was earlier diverted in its most superficial aspects.

My father has described a meeting with him very shortly before his death. 'All artifice had gone,' he wrote, 'he had found peace . . . and he spoke wistfully of what he would do if more time were allowed him . . . Perhaps some would say the old Beardsley was the true Beardsley. True as he had been to his former self, the new Aubrey would have been true to a finer self.'*

For decades after his death, Beardsley was discounted: he was a 'period' taste, a leader of an abortive movement, and an affected exquisite of negligible stature, and his sense of evil was dismissed as adolescent. Recently, however, his reputation has revived with the same suddenness with which it was originally established. Kenneth Clark, in a lecture twice

*William Rothenstein, *Men and Memories* I, p. 317

delivered in 1965, showed that, far from being an isolated exquisite, Beardsley was an artist who had contributed to the development of a number of the pioneers of modern art, among others Kandinsky and Klee. (In Clark's illuminating lecture he echoes, incidentally, a tradition that nobody saw Beardsley at work, but that he locked himself in his room, pulled the curtains and did his drawings by candlelight. But at a time when my father was living in Oxford and had no London studio he made frequent use of Beardsley's, he sitting on one side of a large table and Beardsley—engaged on his *Salome* drawings—on the other.)

The following year, the Victoria and Albert Museum brought together a comprehensive exhibition of his work. Had this exhibition been held ten years ago I suspect that the visitors would have been elderly and few. As it was, it was so packed with visitors predominantly young that few of them can have examined the exhibits with any degree of comfort.

The revival of interest in Beardsley was at first explained by the fashion for *art nouveau*. This was indeed in some measure responsible for establishing a propitious climate, but the interest was surely due to the realization that Beardsley was a far more considerable artist than had long been supposed—an artist of an entirely different character from, for instance, Alphonse Mucha, who was also accorded the honour of an exhibition at the Victoria and Albert Museum. Both these admirable exhibitions were organized by the author of the present volume.

Beardsley, it was seen, was able to create an imaginary world, but one which was credible in spite of the most audacious simplifications, and the no less audacious exclusion of everything that did not contribute to the beauty of his design and to the lucid expression of his theme. In his power of the concise delineation of the unexpected and the strange—as memorable at its best as something lit by a flash of lightning in the dark—he was unique in his generation.

No artist was ever less concerned with the everyday world viewed as 'slices of life'. Beardsley's eyes were fixed upon his own cold, nocturnal world, and his vision of it was refined and enriched by intensive study of the old masters. Even in the course of carrying out his first major commission, undertaken at the age of twenty under the inspiration of Burne-Jones, to illustrate the *Morte Darthur,* it is easy to detect the progressive enrichment of his initially Neo-Pre-Raphaelite style, as a result of his study in the National Gallery of the work of such painters as Mantegna and Pollaiuolo, as well as of many others. Later on he studied Japanese prints, Greek vase paintings, as well as certain masters, mostly French, of the seventeenth and eighteenth centuries. His art drew nourishment also from literature, more especially that of seventeenth and eighteenth-century England and France. A friend of his, by no means ill-read himself, told me that he had never mentioned a book to Beardsley that he found he had not read. Music, too—he was an impassioned Wagnerite and as a boy had given concerts in the Brighton Pavilion—made its contribution to his art.

Early in his short life Beardsley developed an almost mesmeric power of making this world of his entirely credible—even though the laws of gravity, anatomy, perspective and the like are so frequently disregarded. The ailing youth and his creation imposed itself on

his contemporaries: 'I belong', said Max Beerbohm, 'to the Beardsley period', and following the appearance of *The Yellow Book*, 'London turned Yellow in a night.' Arthur Symons wrote of Beardsley's 'desire to fill his few working years with the immediate echo of a great notoriety'. This notoriety he achieved—though at the cost of much suffering.

Asked by a friend whether he saw visions, he replied, 'No; I do not allow myself to see them except on Paper.' The visions that he saw on his paper—scarred and even pierced by repeated scratchings and rubbings, for he was a laborious craftsman—are as persuasive in our own day as they were in his own—though now as then they provoke repulsion as well as admiration.

Beardsley is even today difficult precisely to place in the hierarchy of modern artists. Compared for instance with a Rodin or a Degas he is a very minor figure, yet in many of his drawings of all periods, whether 'The Mysterious Rose-Garden', 'Enter Herodias', 'Messalina', his own bookplate, and most conspicuously in the frontispiece for *Volpone* and its four initial letters—these last made within a few weeks of his death—there is something formidable, an apprehension of good and evil—particularly of evil—appropriate to a more magisterial figure.

JOHN ROTHENSTEIN

Aubrey Beardsley

After hearing and watching the reactions of people who visited the two exhibitions devoted to Beardsley in London in 1966 and in New York in 1967, it could be said, I believe, that those who first see any quantity of drawings by this artist feel a strong impact, beginning with a sense of his power to draw attention to his art. This power is not given to all artists: it was not given in comparable measure to Blake, or to Charles Keene, for example, though Keene had another power, a more extroverted power of observation, which Beardsley lacked. A pause at the moment of discovering Beardsley, at that initial and hypnotic stage when he claims our attention, is usually followed by curiosity, by wonder, by admiration, in fairly quick succession—or it may be by distaste, by detachment or incomprehension. Incomprehension may involve some rejection of opportunities to note certain regions of the mind, while detachment may lead one to cold shoulder a whole stretch of human nature and to walk, as it were, away from the shadow of oneself.

For those who are willing to accept the fact that in Beardsley's art there is something that waits to be understood, one way of pursuing the subject is by the use of a metaphor. In a sense all words are metaphorical, and the easiest thing therefore is to choose one—not necessarily the right word because no particular word would be 'right' for Beardsley— but the first word that suggests itself in the context of graphic art, or of any art, and which we can use, as in long division, to discover how many times it goes into our subject, and what is left over.

Without apology therefore I suggest the quite ordinary word Ideal. This word is useful because it is linked to the notion of effort, to the means by which any ideal is sought; and since theory should not be confused with practice, be it understood that ideals are never reached and that nobody identifies, or can identify himself, with his End.

A study of the drawings and designs reproduced in the present book may be undertaken to find out if the sense of an ideal goes into them at all. Quite soon I think it will be seen that it does. In the first place nobody would dispute surely that Beardsley's craftsmanship reflects a presence in him of the urge to define, and of what arises from this urge, coherence: or that the means of achieving his coherence was mostly by drawing lines which give the impression at normal focal length that they are 'perfect'—for of course they can be magnified in such a way that any detail may seem like a smudge of ink. At the point of convention which links the artist and the onlooker, these drawings were made, and we become aware of them, as tokens for ideal definitions by line and by area of the forms conceived. This is true of Beardsley's craftsmanship at its best, and also at its worst, because the same approach to craftsmanship was always there, the standard of performance on occasions varying short of his potential. Thus, it was an ideal elegance of form that was made to embrace both the sweet and the macabre in 'The Coiffing'. Sometimes hideously grotesque conceptions stand alone, as in the *Bon-Mots* series, and the ideal has to be seen as a minus quantity. In *Le Morte Darthur* what is left over often is an element of journalism, linked with the medium of the line-block for which so much of his work was contrived, a medium which lent itself too easily, because of its cheapness, to ephemeral illustration. At other times Beardsley crosses

the grotesque with the handsome, as in *Salome,* and what we find left over is sensationalism. In *The Rape of the Lock* the comeliness of the figures is weakly supported by the technique, while the ornate, sarcastic and realistic qualities of the drawings are increased by it. What we have left over here is escapism, to accord with Beardsley's unfitness to travel a life-span in the Victorian age.

That any artist should go to such lengths to convince both himself and the spectator that his conceptions exist and that they could be put down in black and white with such clarity, is evidence of the discipline that goes before skill, of the disposition which lies behind the strength of character that in turn maintains the discipline. But this skill and its discipline were themselves means to ends; and what, we may ask, was Beardsley coherent about? What does this impressive work of the hand reveal, or describe or convey? And when we turn the pages of the present book once more we may note that there seem to be often some signs of a conflict between the inventions of the artist and his ideals as a craftsman: that the lines and black masses and meaningful reserves of white paper are clear enough usually, but that something corresponding to the ideal of this sort of craftsmanship, which disdains suggestion, does not always go into the reading of the drawing, and we are left at the mercy of all kinds of suggestions, some of them pathetic, some burlesque. Our attention then is held no longer by the initial impact of the drawing upon us (assuming we have not turned away), but by a curiosity which obliges us to wait and to watch, as though someone were climbing a precipice and might fall. And after a time we may agree that this balancing act is the act of balancing factors into which perfection does *not* go, against other factors into which it goes with ease. So we find languid looking arabesques which seem to have been drawn with energy in order to hold them precisely in that quality. We find arabesques again which seem to have graceful assumptions but which hold linear descriptions of monsters and abortions. We find a craft of great delicacy, which also implies great steadiness of mind and hand, employed to insinuate a meaning that if left to itself would escape from our thoughts like a gas.

We look further and suspect the artist of a pleasure in these balancing acts like the pleasure of a humorist in his own wit, but also like the mischievous pleasure of a comedian in some tragic part. Finally, as this curiosity develops and we look over all the pages before us, we become alarmed perhaps that a suspense produced in us by the sight of certain drawings by Beardsley is a suspense we cannot avoid because we ourselves have helped to produce it: the drawing itself being a convention which is so coherent that it is, as an object, conclusive. The balancing feat is now seen to be often the feat of the ironist, including the self-ironist, and his art the art of horror-comedy in terms of this word ideal, that is in terms of the comparatively simple graces within the range of a black-and-white draughtsman, all mounted and executed with marvellous precision.

To such generalizations there are numerous exceptions. For instance, the striving towards an ideal content—a content which required little or no balancing feat to present—is obvious in a drawing like 'Ave Atque Vale' (Plate 441), which illustrates with a sort of holographic sadness, in spite of imperfections of observation, a poem of Catullus translated by Beardsley and itself an epitaph ready-made for the end of his life. Or we can note the feelings of pleasure in feminine forms and clothes which he recorded in drawings like the one of Miss Emery (Plate 370), where there is only the merest glimpse of sub-irony in the slightness of line.

As I have mentioned one very well-known illustration by Beardsley, 'Ave Atque Vale', it is convenient to emphasize that his careful but inexperienced representation of the young man's hand is the kind of defect that can lead us to consider what species of artist he was not. He was not an academic, not an impressionist in any sense, not a realist. He had not been trained, as in those days French artists were trained, in a long gruelling process of observation, comparison and rationalization of what he saw before him—models dead or

alive, nudes, draperies and chairs. He lacked therefore the benefit of a great luxury trade in picture-making with its satellite arts of designing and illustrating, or of the long tradition which Paris preserved of technical exercise in manual and mental dexterity. Rather, in England, the tradition was one of adventure, of adventure of the spirit, of exploiting academic opportunities of lesser range and breaking free—like Hogarth or Blake or Constable, to quote the names of widely differing artists and men, whose one common factor was their obstinate courage. To Beardsley likewise this courage was given, dying as he was from his youth up, undermined by tuberculosis and yet fevered by that very destructive force to the pitch of schizophrenic obsession. There came a time in his short life of twenty-five years when he was too ill to do much, when he was either dying or drawing or reclining and thinking; when the old days of concerts and parties and popular infamy were gone and when his friends had become mere letters in the post to be answered; when the small sums he earned from Leonard Smithers to illustrate or decorate limited editions were inadequate to keep him in comfort and he became a pensioner of his admirer, Raffalovich. With his mother his oedipal relationship was classically strong—Ellen Beardsley who expected to be present at the last minute, as she was present throughout most of his life, but had left the room. In the space when she was gone too, the ideal, this time the ideal of a super-ego, drove him to exert himself and to begin drawing, but was divided by Death: while the special gold pen he used for this purpose fell or was thrown to the floor, to remain there like an arrow, fixed until she returned*.

He had been provocative rather than aggressive. He had indulged erotic curiosity and the fantasies of youth, and he had the nerve to externalize those fantasies for publication in Victorian England. He had been astute, sarcastic, bold, shy, amusing and, on occasions, charming. From perversity he had professed to admire the French without reservation, as if 'French' were another word for Freedom, and as a boy might admire his uncle in order to spite his own father. Up to a point all this was sincere. And yet he was essentially un-French. That curious humour, that mischievous irony, the innuendos, the spleen, the stoicism—these were quite basic English, and of all English artists of the nineteenth century he most distilled that spirit of negligent grace admired in the Dandies by Baudelaire.

He was plunged into life on 21 August 1872, nearly twelve months after his sister Mabel was born on 24 August previously. And their birthplace was Brighton, on the south coast of England, where the atmosphere is brilliant, the trees few and the Neo-Classic buildings of the Regency stand terrace by terrace like so many regiments—or at least they stood then. Beardsley's father was a ne'er-do-well descended from London jewellers, and his mother forced by poverty after her marriage to become a governess in London, was the daughter of a retired surgeon-major living in Brighton. His parents never had any home there, but he and his sister were brought up in the house of his father-in-law, the surgeon-major. From earliest times brother and sister were much in each other's pockets, as used to be said, and this accounts in some degree no doubt for Beardsley's curious erotic life. It was Mabel who took the lead: her brother was closer perhaps to her than to their mother, upon whom he was also dependent; indeed, he seems to have resented his mother, sometimes, as a force in the way of his own development.

During those early years Mabel and Aubrey would sing and recite at the houses of their mother's patrons, and Aubrey would even play little pieces on the piano in his role as an infant prodigy. For his mother's friends too he would design dinner cards and make small pictures in the style of Kate Greenaway. Both children were keen on acting, and by the time they reached late adolescence their amateur performances at home were quite remarkable.

Aubrey went first to a preparatory school in Brighton, then to a boarding school at Hurstpierpoint in the same county, and finally—his last academic submission—to Brighton

*From an unpublished account by Mrs Ellen Beardsley in the possession of Mr Donald Weeks, London.

Grammar School, where at first the little boy's breeches that showed his knock knees made him feel vaguely inferior, and he soon took to trousers and an air of self-mastery. Beginning as a day-boy lodging with his maternal great-aunt, who also lived in Brighton, he became a boarder at the school at the beginning of 1885. He brought with him accomplishments learnt from his mother, a little French, a taste for music and a will of iron, and moreover a strange arrogance as of far-off patrician ancestors. It was an arrogance which manifested itself in facetiousness rather than downright conceit, and in self-consciousness rather than self-knowledge. From the first he gave an impression of being orientated hetero-sexually. His relations with his father deteriorated, his mother became the staff of his life, and he turned, it appears, to his playmate of a sister in the holidays for early sexual experience. Nevertheless, an attachment with a Brighton girl sprang up while he was at the Grammar School, although the letters that remain as evidence of this affair* suggest that he may have been too deficient in physique and too agile in mind to risk taking his correspondent very seriously. As he wrote he also drew, for he had decided he could draw. And in these letters to Miss Felton, his adolescent drawings were comic and self-conscious, while from his schoolmates he earned popularity in a short while by the countless numbers of caricatures he made for their amusement. His form-master at one stage, H. A. Payne, and his house-master, A. W. King, both encouraged the young eccentric, who was not strong enough to play games like the other boys. They encouraged him to read grown-up books, to compose literary effusions, to exercise his French in little French plays organized partly for his benefit—and for the benefit of his best friend among the boys, Charles Cochran, who later became the well-known impresario; and they encouraged him to draw when inclined, though they criticized him for not rising above that style of caricature in which he redeemed himself, so he thought, for not being as other boys were. He made caricatures of everybody, including the head-master; and instead of studying Virgil's texts he would shed his school hours in illustrating Virgil's stories in the burlesque manner of Gilbert à Beckett's *History of England*. His Brighton days ended in a sort of triumph, with Beardsley designing the costumes, and illustrating the libretto of the school Entertainment, 'The Pay of the Pied Piper', and acting too in this comic opera—although it was performed in the Christmas season after he had left, and he appeared in it strictly as an Old Boy (one who had left the school).

Having left the school, Beardsley had no alternative but to accept a job as clerk, first in a surveyor's office in London, and shortly afterwards in the offices of the Guardian Life Insurance Company. The struggle between his image of himself and his restricted view of life became so acute he relieved it by aping the assumptions of Aesthetic cliques of the period, by a snobbery derived from Whistler's *Gentle Art of Making Enemies*. Beardsley himself was so different from Whistler that his behaviour during this period must be counted affectation; whereas Whistler's affectations were psychologically functional. While still a clerk, Beardsley was able to spend lunch hours in the bookshop of Jones and Evans in Queen Street near the Guardian Life Insurance offices, and evening hours as often as possible at concerts. It was during his early London period that a passion for the operas of Wagner was sown in his mind, to be cultivated in its first growth by Alfred Gurney, a High Church parson from Brighton, who had obtained by that time a living at St Barnabas, Pimlico, not far from where the Beardsley family, now united, had come to live.

Meanwhile Beardsley went on drawing. His premonitions of a short life at this date, 1891, were expressed in a circumscribed use of his energy. Tuberculosis, inherited from the paternal side of his forebears, had been diagnosed in 1879: and it was not long after he had been working in London as a clerk that he began to experience the shocks and the ex-haustion of consumptive attacks. Interested though he was at first in all the visual arts, he had insufficient strength to experiment consistently in oils or to investigate in this

*In private possession. Two letters, each on two sheets folded. From Brighton Grammar School, not dated.

medium the values of colour and three dimensional representation, though he did make attempts to imply those dimensions in his drawings. They were the dimensions explored in Venetian painting of the sixteenth century: by the nineteenth century it was the Impressionists, the masters of Touch, who had inherited something of the Venetian approach. Beardsley soon lost interest in this type of art, turned to the other North Italian Schools, to engravings by Mantegna and Blake, and was led away from any sort of current actualism to the elaborate linearism of Burne-Jones. Whistler's decorations in the Peacock Room at 49 Princes Gate, which Beardsley went to see with his sister, made a deep impression on him, but this did not prevent him from idolizing Burne-Jones, from imitating his drawings, going to visit him, and even winning from the elderly painter encouragement to aid him in deciding that he would make his own living as an artist. Accordingly he went for a year to evening classes at the Westminster School of Art, the only art training he ever had, and the old comic strain of his schooldays fell dormant. In the middle of 1892 he went to Paris, called on Puvis de Chavannes with a letter from Burne-Jones, and gave him a sample of his work. And it was then no doubt that he became aware of posters by Toulouse-Lautrec, in which the figures of Parisian night life were represented in silhouetted, or nearly silhouetted, shapes. In this year, too, Beardsley's taste reflected the current vogue for all that was Japanese in his 'Japonesque' style, in which arabesques and areas of black ink, given texture by slight abrasions, were artfully balanced, or dis-balanced, in order to dramatize the subject of the drawing without lifting it much from an almost geometrical purity of line. This was his tribute to the Japanese print-makers of the eighteenth and nineteenth centuries.

In the paintings of Botticelli, which he could see in the National Gallery, Beardsley found, too, an ideal, a second-hand ideal already evolved by the Pre-Raphaelites. In Dürer, Pollaiuolo and Mantegna he found other ideals, distressed by awareness of harsher feeling, and this awareness corresponded in him to his former sense of the burlesque. When late in 1892, on the recommendation of Frederick Evans of the bookshop he used to visit, he was suddenly commissioned by John Dent to illustrate a new edition of Sir Thomas Malory's *Le Morte Darthur*—his first professional undertaking—he gave up his post at the Guardian Life Insurance Company, getting Mabel's approval for this step, but not consulting his parents. Over 350 drawings were required for the book, to be reproduced by the line-block process, a photo-process of facsimile reproduction then coming into wider use and limiting him to a style of drawing in black and white, without intermediate tones. The work lasted him for eighteen months and to begin with he was obliged to lean heavily upon his assimilation of motifs and mannerisms, especially those of Burne-Jones and Walter Crane and William Morris and other outstanding book decorators of the day. A concurrent commission from the same publisher brought him the series of miniature *Bon-Mots* to illustrate with vignettes, and in these little books he let himself go in an opposite direction, with calligraphic fantasies in a grotesque vein that sprang from his earlier resource of the burlesque.

Shortly after this beginning with Dent, Lewis Hind, the editor presumptive of *The Studio*, which was still at the planning stage, was so impressed by some drawings by Beardsley that he arranged for Joseph Pennell to write an article around reproductions of them in the first number of the new magazine. It was then that his experimental illustration to a passage in Oscar Wilde's *Salome* appeared, 'J'ai Baisé Ta Bouche Iokanaan' (Plate 272), which led in a short time to a commission from Elkin Mathews and John Lane of The Bodley Head for Beardsley to illustrate a translation of Wilde's play from the French. This was published in the following year, 1894.

The *Salome* illustrations are so well-known we will not linger on them, except to point out that they were really the last of his early works. They were novel at the time and still have the power to amaze by their qualities, largely because as abstract patterns the composi-

tions are individual, because the short cuts and evasions defy all the law and order of descriptive drawing as understood at that time, and because the sense of drama conveyed by the designs is so intense. It was as though he were an actor manqué—his sister became a professional actress and he might well have become one also—who had learnt the manner in which actions and gestures could be translated on paper, not in three-dimensional realism, but in the two values of black and white in flat areas, linked by lines that varied in strength to suggest something of the arrested quality in the outlines of a bas-relief. Beardsley's art was enhanced at this date by his study of the paintings on Greek vases at the British Museum.

Then, after numerous commissions for posters, title-pages and frontispieces, came *The Yellow Book,* founded by Beardsley and the American writer, Henry Harland, in London on the first day of 1894. As art editor of this periodical the young artist's financial situation was so much improved that his sister and he were able to continue the lease of the house they had taken, 114 Cambridge Terrace, in Pimlico. A phase began of being sociable, in the Victorian sense, when tea-parties held by the Beardsleys attracted the young writers and artists of *The Yellow Book* circle, not to speak of Oscar Wilde (who never contributed to the Bodley Head periodical) and some of his friends. And Mabel's charm and her physical beauty served to bring other visitors, who for Aubrey himself would never have gone out of their way. Aubrey himself was still apt to give an impression that he followed Whistler, and for that matter Gautier and Baudelaire, in despising the middle classes from which he had sprung and in justifying almost any activity from strange sins to Black Magic, provided such activities had Style. Beardsley's style at this time was that of a dandy, an epigrammatist, a close critic, a polite listener and to some extent a nostalgist of the mire—like George Moore before him, whose *Flowers of Passion* was published as far back as 1878, containing the translation of a poem 'Le Succube' by Catulle Mendès with verbal images anticipating the lilies in the 'Iokanaan' drawing, and who showed the way that emancipated young men were to arrive, after reading Gautier and Swinburne, glancing at the 'Nocturnes', or better still at the Impressionists, going to Paris and concluding that to shock their elders and each other was better fun than to Succeed. Only Beardsley began to succeed—a success of disesteem —for his illustrations in *The Yellow Book* made it notorious, while his name was plugged in the journals of 1894 as a Decadent, a disciple of Evil, as if he were the fulfilment of some strange dream by Joris Karl Huysmans, something the empirical English thought better left in French yellow wrappers than permitted to blazon itself in a magazine sold on the bookstalls of W. H. Smith.

Happy in defiance, Beardsley noticed the world around him, and his art during 1894 and 1895 reflects his excitement at London life, its Lady Golds, its Wagnerites, its Night Pieces and its Éducation Sentimentale (such as that was). The end of this phase came with the trial of Oscar Wilde in 1895, beginning with the failure of Wilde's case against Lord Queensberry in April, and the mistaken belief among the public that Wilde and Beardsley were brothers under the skin, a belief which inspired William Watson, Alice Meynell and Francis Thompson, egged on by Mrs Humphry Ward, the novelist, to blackmail John Lane to get rid of this youthful art editor of *The Yellow Book* and to remove the plates after his drawings for the current number—otherwise their names would be withdrawn from the Bodley Head publishing list. Lane gave in: Beardsley went. For months afterwards he suffered a reaction against the kind of life he had lived, took care to be seen about with women, and in due course his art took a fresh turn, this time away from the world he saw around him and towards an imagined world of the eighteenth century, based on the ideal art of that century from Watteau to the *petit maîtres* of the *ancien régime.* Fortune in the shape of Leonard Smithers came to his aid, and this enterprising publisher of erotic books started yet another magazine, *The Savoy,* with Arthur Symons as literary editor and Beardsley as the regular source of drawings for reproduction, mostly in line-blocks again, and as adviser

on the graphic art contributed to it. The magazine began in the first, and ended in the last, month of 1896. In the same year Smithers published *The Rape of the Lock* with Beardsley's 'embroiderings', and, in a very limited edition, *The Lysistrata* of Aristophanes translated by Samuel Smith, again with illustrations by Beardsley.

The Rape of the Lock was praised universally by critics at the turn of the century, after Beardsley was dead. In the illustrations his ironic disposition was safely contained within the meaning of Pope's urbane, antiquarian verses. Moreover a new technical device occurred to the illustrator: he began to use dotted lines in quantity to give stippled effects. Because of the emphasis laid by him on ornate embroideries and those flounces of lace that he mistakenly associated with the epoch of the poem, a notion took hold of these critics and their readers that Beardsley was a supreme decorator, and nothing much more. In fact it is hard to see how these illustrations stop at being decorations. In most of them the scenes are treated as pictorial dramas with great restraint: space is understood and implied by the artist's completely personal craft, and in this respect the drawings are richer than those for *Salome;* but the extraordinary black fields and arabesque lines of the *Salome* period are absent and with them has gone all trace of those curvilinear forms which he bequeathed to the practitioners of *art nouveau.*

The Lysistrata is another matter. In these eight drawings there was a return to something like the manner of decorations on Greek pottery, so far as Beardsley with his deliberated lines and dots and modest areas of black could approximate the spontaneous execution of the ancient Greeks, which arose from constant practice in doing the same thing in the same way. None the less, the *Lysistrata* series, and the illustrations to Juvenal's Sixth Satire, never completed and never published in book form, contain among them the only successful examples of true satire in all Beardsley's output. The old burlesque spirit of his schooldays was revived in the roughest of them and mixed with a controlled aggression, delivered against both sexes, and unlike anything to be found in the satirical works of other artists, since or before.

What unites Beardsley's drawings of 1896 and of the second half of 1895 is the renewed and open assertion of Neo-Classical values—the profile character of the bas-relief—emerging despite the rococo exaggerations of *The Rape* and the bawdy exaggerations of *The Lysistrata.* If space is implied, it is implied by way of the whole design; there is no aerial perspective, the outlines are all closed, and the forms are rationalized so that they expound very clearly ideas in the artist's mind. There is no chance for anyone contemplating these drawings to stage a romance of his own, except by non-visual means, for visual suggestion is reduced to a minimum; and this may have been a factor that influenced critics in the twentieth century, tiring of imitators in particular, to dismiss the whole ethos of Beardsley as literary. That it is literary because the subjects had literary sources is of course fallacious.

In his next major works in a new style, the *Illustrations to Mademoiselle de Maupin,* also published by Smithers, Beardsley dropped his severely black-and-white technique for a technique of line and wash, and the intermediate tones thus introduced had to be reproduced by photogravure. It was an attempt to go beyond the limitations of most of his previous drawings and to imitate aquatint. But it showed him pretty clearly as a master of tone-grading as well as of tone contrasts. The same neatness, precision and uncompromisingly definitive exposition of ideas is to be seen in these drawings in terms of the new technique. His growing sense of three dimensions, which formerly he had implied, he now wished to exploit, as in 'The Lady at the Dressing Table' (Plate 490) where his constant preoccupation with toilet scenes—an indication of narcissistic and transvestite moods—is expressed all the more vividly by his play on vanishing points, a primitive feat on similar lines to the jagged exploits of Cubists in 1910.

In the *Volpone* illustrations, Beardsley's last undertaking, there appears a strong effort to

achieve two kinds of perfection: the perfection of a certain kind of seventeenth-century line-engraving, which was the reference for the frontispiece reproduced in line-block; and the Baroque dramatization of light, in order to vivify and make quasi-tangible, more real if you wish, his sense of the form of an idea, which he introduced in the designs for initials reproduced in half-tone and photogravure. Whether his intellectual approach could ever have been enriched by the sensuousness needed to mature such a technique as this last, must remain one of those queries that has anybody's answer. Beardsley died on 16 March, 1898, before the *Volpone* illustrations were completed.

From the time of the Wilde trials in 1895 and the termination of his association with the *Yellow Book* staff, Beardsley was a dying man. His condition was undoubtedly aggravated by these events: in a sense it might be said that he never recovered from them. His life became literally dislocated. The Cambridge Terrace house had to be given up. There were visits to Dieppe in the late summer of 1895, when he occupied his time either planning *The Savoy* with Arthur Symons who was there too, or watching the gamblers in the Casino, intermittently writing passages down in a portfolio as he progressed, laboriously enough, with his never-to-be-finished *Story of Venus and Tannhäuser,* parts of which, expurgated, came out as 'Under the Hill' in *The Savoy.* After a winter in London in chambers at St James's Place, he paid a short visit to Paris early in 1896, going on later to Brussels where he collapsed. When he returned to London in the early summer he consulted a specialist, Dr Symes Thompson, and learnt that he was seriously ill. 'I am beginning to be really depressed and frightened about myself', he wrote in a letter at this time. In July he spent a short period at The Spread Eagle Hotel, Epsom, where he finished *The Lysistrata* drawings, and at the end of that month he was in Boscombe, Bournemouth, reduced to a state of great weakness. He recovered sufficiently to make a brief visit to London in August, but this exertion set him back more than ever, and he was not to leave Bournemouth again until April 1897, having been converted meanwhile to Roman Catholicism. He left there finally on his doctor's advice for the South of France, but a stay in Paris which he enjoyed did him little good, and he had to be taken out to St Germain-en-Laye. In July he was once more in Dieppe, and in the autumn he was back in Paris. But although he cheered up in Paris, medical advice was not in favour of him risking a winter in that city, and in November 1897 he and his mother, who had been with him most of the time since Bournemouth, set off for Menton in the south of France, where in the Hôtel Cosmopolitain, bed-ridden at last, but still working whenever possible on the *Volpone* drawings, he died some four months later. Indeed he had seldom given up working unless incapacitated by the chills and the haemorrhages that ravaged him; and his feverish productivity, when he was active, was linked indirectly with the fever produced in him by illness. His life became transposed into work: it became concentrated by the restrictive force of tuberculosis into mental adventures. Running parallel with the development of his tubercular disease ran the development of his sexual imagination, again intensified by the disease itself, but otherwise not inappro-priate to the age he had reached. Since he was so much attracted to sexual themes, some consideration must be given to the nature of the mind that pursued them.

Beardsley has often been referred to as homosexual.* His aggressive-looking Messalinas are said to represent a morbid interest in dominating women. What was felt to be his degra-dation of feminine attractions; his obsession with phalluses and their sizes; his many delineations of hermaphrodite creatures and a pederastic episode in his unfinished *Story of Venus and Tannhäuser* are supposed to be evidence of homosexual inclination. To these symptoms can be added his graphic references to transvestism, flagellation, lesbianism and sexual symbolism of all kinds, revealing a mental erethism, to which one key might be the supposed homosexual strain. All this is doubtless orthodox, but it is also unsatisfactory.

Given the mental erethism, and this is sufficiently pronounced, we might look for the

*The most recent exponent of this view is Armand Bitoun, in his interesting article 'Aubrey Beardsley et l'esthétisme homosexuel' in *Les Lettres Nouvelles,* Mars–Avril, 1967.

origins of this in Beardsley's upbringing and to his first knowledge, suggested by his early story published in *Tit-Bits* in 1889, where the subject of breach-of-promise occurs, that his father had a misadventure which ended in the selling of all the inherited Beardsley property to buy off a breach-of-promise threat soon after his marriage with Mrs Beardsley in 1870. This seems to have been something the family, remarkably permissive as it was, made little attempt to conceal, and something also perhaps that started in Beardsley a lifelong curiosity about what sexual relationships were, or what they could be.

A point to emphasise is that just when homosexual developments might have been expected in his life, in the school years for instance, there is no evidence of them; in fact it was during those years that an autobiographical incident recorded in the manuscript of *Venus and Tannhäuser,* but scored out, shows the author as a heterosexual voyeur; while such a passive attitude agrees with the legend, and with his own boasts to the same effect,* that his chief erotic experiences were incestuous and that his sister Mabel led the way in this, as in much else. It was she, as we have already noted, who took up acting as a profession, her sick brother, equally keen though he was on the stage, having to fall back on the sedentary art of drawing. Both Mabel and Aubrey liked on occasions to dress in the clothes of the opposite sex, but transvestism is usually its own reward, and not by any means a necessary phase of homosexuality. This tendency in Aubrey ran alongside his resignation to an art, as it were, of the voyeur, and with obscure attempts to identify himself perhaps with the sex of the only two beings he might be said to have loved.

Passive and non-aggressive heterosexual males are vulnerable to advances from either sex, which condition may explain not only the narcissism of Tannhäuser in the story, but the whole tone of this composition, not to mention a passage in which the hero invites seduction from Venus: it suggests also how Beardsley could attract Oscar Wilde's friend, Ada Leverson, to make an attempt at seducing him;* and on the other hand, it sheds light on the emotional approach to him sought by André Raffalovich, an overt homosexual, converted in 1896 to chastity and to the Roman Church, who influenced Beardsley to become another convert to the same faith, paying him £100 a quarter to keep him in reasonable comfort—far more indeed than the poor young man ever earned from the drawings he sold to Leonard Smithers.

While Beardsley had prominent painters among his friends, including William Rothenstein and Richard Sickert, and from 1895, Charles Conder, his work as an illustrator ranged up against his own literary tastes, and it was in the literary and aesthetic circles of the Nineties that he began to be noticed soon after he came to live with his family in London. The emotional pressures exerted by an interlinked minority in this very mixed group were either pro-matriarchal or candidly homosexual, pressures increased by the relay of forerunners going back through Wilde to Pater, Simeon Solomon, Oscar Browning, William Cory, Swinburne and Mulready to Beckford; and to the works, sayings and behaviour of Englishmen who had adapted an ideal of masculine beauty to women. It will have to be admitted sooner or later that a large part of English culture in the nineteenth century was underwritten not overtly, not even consciously perhaps, but none the less distinctly, by homosexual men; and the decay of this culture can be seen in the world of High Camp in the 1920s and later. Through the veils that darkened his private life and made him aloof and mysterious, Beardsley was anxious to give signs that he too was willing to please: hence the outcrop of homosexual images in *Le Morte Darthur* early in 1893, when he had adopted something of the mores of his new friends, Robert Ross and Count Eric Stenbock. When in 1896 and 1897 it was expedient to please Smithers, who was avid for women, and when it was expedient to express a revulsion of feeling towards the set which had launched him, now discredited for a year or two after the trial of Wilde, Beardsley had no qualms at all in writing to Smithers in the style of some fully-fledged mulierast. If there was an overt

*Information from Mr David Carr, recorded in correspondence between him and Mrs Olive Scanlan, formerly a friend of Ellen and Mabel Beardsley and their circle (1966).
**Information from a friend of the late Robert Ross.

homosexual strain in Beardsley, fomented by cultural values, it may have revealed itself in his drawings of youths and boys with their hair piled high on their heads: many examples of these appear in *Le Morte Darthur,* and there is a later example in the tall young Lacedaemonian ambassador in the last drawing for *The Lysistrata* (Plate 466). Nor should we forget the pierrots who stood for some sort of ideal rejected by the Philistine world; that they were sex-objectives is possible; they also represent, I should think, projections of his own body-image. The idea of himself as a spavin-legged dandy that was given a form in 'The Abbé' (Plate 423), was at first the Abbé Aubrey, and then on second thoughts the hero of his unfinished novel, the Abbé Fanfreluche, later changed to Tannhäuser. In the story Tannhäuser enjoys a light-hearted pederastic diversion (borrowed from Suetonius' life of the Emperor Tiberius) and is mentally stimulated by various deviations; but his objective is Venus herself, while he is the personification of the feminine anima in a masculine (not very masculine) body, so that his 'reactions' to Venus are almost like those of some type of lesbian. Beardsley's preoccupation with lesbians was marked; but this again was linked with a knowledge of his sister, whose form appears often in his drawings of women—in the frontispiece to Davidson's *Plays* for example (Plate 321)—and there seems indication enough to believe that she, like her brother in an inverse sense, was an aggressive heterosexual woman with transvestite leanings, capable moreover of lesbian emotions. If anything of a homosexual ideal goes into Beardsley's life therefore, it seems probable it was cancelled by irony, and again irony—the very tension of his art.

The fact is left that many of his drawings embody both conscious and unconscious heterosexual symbolism. In this one respect he was the most powerful, because the most recondite and productive, symbolist of the nineteenth century. Look for instance at the design for the front cover of *The Rape of the Lock* (Plate 404): a near-abstract design with miniature prophecies in certain details of the visual experiences we now associate with Mondrian's paintings of thirty years later. But the whole design also breaks up into symbols, with Belinda's lock of hair in a significant position surrounded by the shadows of breasts and buttocks. Beardsley's emblem itself is an emblem of coitus, despite indignant protests to the contrary from his Edwardian-minded biographer Macfall; and a phallic interpretation must be given to the adaptation of a bentwood chair on which Salome, in the published version of 1894, sits at her toilet (Plate 281). It is the constant occurrence of forms like these, disguised as linear descriptions of plausible objects, that both repels and attracts the observer according to breed. And to have achieved suggestion by a deliberately non-suggestive craft, for it would be absurd to suppose that Beardsley never knew what he was doing, was to have achieved a compromise by distortion of the Neo-Classical ideals on which his technique was based—and this may be the measure of his 'decadence'. But to reject, to dismiss, to pretend to ignore the results of an intuitive reading of his drawings is what I mean in the first paragraph of this essay by walking away from the shadow of oneself. That is what anyone does who puts Beardsley aside as a decorator; and that is what anyone does also who says with indifference 'Beardsley has nothing to do with me'.

The shadows which Beardsley never walked away from, but even tried, as it were, to embrace, became the shadows of his own inadequacy, frail as he was from the start and sensitive to all that divided him from the sheep of this world. It is from conflicts like this that arrogance emerges, and Beardsley's own arrogance was discarded finally when, as Rothenstein noticed in 1897, he accepted the fact of imminent death, and perhaps a little the consolations of his adopted faith. But years before that, in 1892 and 1893, a curious passion for the hideous declared itself, in the *Bon-Mots* grotesques most of all, but again in several drawings of those years in which a foetus or an abortion, or some other diminutive monster, appears. Just why the foetus especially meant so much to Beardsley has never been explained, or rather explained away. Macfall supposed, without going into detail,

that Beardsley was influenced by the perusal of medical books, presumably belonging to the old surgeon-major or to the surgeon-major's father who had been a doctor in Brighton. But it was not until 1892 at the earliest that foetuses came to be drawn by Beardsley, and this was long after the period when he could have pored over medical books as a child. What was the occasion, or the trauma, that suggested these foetus shapes? Had he seen them preserved in bottles at country fairs? Such experiences would seem too casual to inspire what amounted to a minor obsession. Had he witnessed a miscarriage of his sister's and one for which he himself had been responsible? She is certainly known to have had an illegitimate birth.* Whatever happened and whatever the explanation may be, Beardsley took pains to render his diminutive monsters with humour, so that their original hideousness was redeemed and they became amusing and endearing even. As with introverted humorists, and in a limited sense he was a comic artist, Beardsley's fantasies evolved from within a doubting, disturbed unconscious, and had to be justified as parts of himself. We find a similar process of humorization in Edward Lear. And just as Beardsley belongs in a way to each one of his inventions, so the foetus shapes belonged to him, and were symbols perhaps of his own despair in face of the future. How otherwise can we find any meaning in the drawing of a mother and foetus modelled remotely on an Italian Renaissance picture of the Virgin and Child and entitled 'Incipit Vita Nova' (Plate 275)? Here anyway is the expression of a cancelled ideal in a simple form.

Let us return to our word ideal. As was agreed, Beardsley, the eclectic, solitary magpie, needs no comparison with erudite academics, nor with artists of the nineteenth century who complemented the scientific programme of that age as aesthetic observers. The art of the materialist, of the impressionist, is the art of finding concepts and harmonies in the varied material he observes: the art of Beardsley, like Blake's art, was that of clothing his concepts in minimal and adequate observations and forcing these into pseudo-mathematical harmonies. It is odd how many of his figures were seen in profile: he was evidently content to remain from the academic viewpoint an amateur, not much concerned with discovering how he might have drawn his figures in more complex positions. At the same time he had little of that Platonism fashionable in the 1880s, he enjoyed but he mocked the confusion of attributes favoured by homosexuals and never imposed a hieratic symbolism on what was provisionally an illustrative art. Only in the *Volpone* drawings there appeared at last signs of a retreat, or an advance, from those limits that helped him to fuse his almost auto-biographical fantasies with the act of drawing, signs that he was beginning to panic away from those flippant shades which kept him cool amidst the bustle of nineteenth-century beliefs, including the prominent superstition that there is one kind of knowledge proved by the test of function, the trend of expediency. Such is the masculine-favoured trend, making men scientific, sensible even, and incorrigible. But as Maier-Graefe has said, our utilitarianism was never rebuked in stronger or haughtier terms than in Beardsley's art, the art of a schizoid, epigraphic mind which only death could heal.

The tools of his craft were not unusual: a pencil, a pen, indian ink, water to make ink washes (which he used occasionally), a brush of 'camel' or of sable hair, and cartridge paper of an ordinary grade. It was customary at that date to recommend Bristol board and other smooth cards for black-and-white drawings reproduced by the line-block process; but these were never in use by Beardsley, and drawings on that type of support which bear his emblem or his name or his initials are, without question, forgeries. There are visible in some of the *Morte Darthur* drawings certain lines made by comparatively broad nibs: in the *Bon-Mots* vignettes, the lines are so fine that a Gillot crowquill, or the Gillot nib No. 1000 which came on the market before 1894, would seem to have been necessary. When he gave up the hair-line manner it is probable he gave up the use of fine nibs, and the variety of line-drawing in his later work was evidently attained by the flexible use of

*The source of this information cannot be disclosed.

drawing nibs of average breadth. As was mentioned above, he died with a favourite gold pen falling or flung from his hand. The same dandified taste was apparent in his method of work. He never, so far as we know, made preliminary studies, or took tracings from sketches, for any of his compositions, though drawings survive which are unfinished or went wrong and were abandoned. His usual practice was to begin his drawing by scribbling with a pencil, making a host of flourishes and loops and scratchy lines. Over these somewhat vague schemata he drew with pen and brush, and with a firmness of hand that led without considerable erasion to the finished result. He had the reputation of working at night by the flames of the candles in his two favourite candlesticks, and although the notion of nocturnal labours lends itself to satanic pictures of Beardsley, as if he were a lamp that shed darkness by day, it is true that frequently he worked very late, having been conditioned to do so when still a clerk, drudging from nine-thirty to five-thirty in the Guardian Life Insurance. In his last years he often drew at any hour that suited him, as he found sleeping difficult.

Beardsley's end was tragic, if mainly because he was not convinced that his achievement was sufficient. 'Destroy all copies of Lysistrata & bad drawings', he wrote pathetically to Smithers, as death approached. But Smithers knew better. And for the unprejudiced commentator his achievement was more than sufficient; it was concrete, and charged with the new meanings which independent works of art accumulate, as round them everything changes. That achievement of his varied in quality: like anyone else, Beardsley was capable of vulgarisms; also he was capable of 'daintiness', to use Whistler's irritating word. These were rare slips in the polarization of a most unusual mentality, less divisible obviously by any ideal than his so-called decadence or his bias in sexual fantasy. None the less, his mastery of dramatic and disintegrative pattern, to emphasize this apart from his mastery of line, was unique in the history of European art, and none combined as he did the matching of such gifts with an ability to fix and enlarge certain shades of dawning consciousness in works as calculated as those of a line-engraver. By comparison the relative stability, or on the other hand the fugitive dash, in the drawings of other artists, then and since, can seem almost oppressive. If he had worked on a larger scale, or in colour, he might have compromised the standards he set himself. For it could be said that he brought, without intending or heeding it, the craft of the jeweller, the craft, that is, of his paternal ancestors, and the craft of the silhouettist, which was that of his maternal grandmother, to the intellectual art of draughtsmanship. Indeed his best drawings have a material excellence which paintings can rarely have, like the sheer excellence of a flawless stone; and Beardsley himself can be seen united with Pater at length in his search for the condition of a hard, gem-like flame. It was impossible of course. But our metaphor seems to go often into the life and works of this exceptional youth; while the historians cannot deliver what is left to the fullness of Time.

Guide to the plates and the notes

The chief aim in making this survey of Beardsley's work has been to reproduce as many drawings by him as became available after the Beardsley Exhibition of 1966, and this has permitted the inclusion of a number of illustrations for *Le Morte Darthur* and for the *Bon-Mots* series which have never been published since the dates of their appearance in the original books. These early professional works of the artist have been much underrated, and the present time seems favourable to a better appreciation of them. Another advantage in making reproductions whenever possible from the actual drawings and not from existing reproductions, is that Beardsley's skill as a draughtsman is brought closer to the eye, and in some instances where there are abrasions or erasions or traces of pencil sketcking, these have been reproduced by using half-tone methods for the plates, although the drawings may have been made for line-blocks in which such details would never have appeared.

A comprehensive selection from Beardsley's works could scarcely be arranged however without adding to the reproductions of surviving drawings many other plates, either, for example, of books to show stamped covers after his designs, or from existing reproductions when the drawings for these are not to be found. In such cases the plates have been made from the earliest line-blocks or half-tones after the drawings, as for *The Yellow Book, The Savoy,* and other publications during Beardsley's lifetime.

The dimensions of the present volume have not enabled me to keep the plates in the second class always separate from those in the first class, but each plate is annotated, and in these notes will be found measurements in inches for almost all of the drawings; and when media other than indian ink have been employed, this is stated: when, as in the majority of the notes no medium is stated, indian ink is all that is readily visible in the drawing described.

Reproductions of Beardsley's posters have been included, and of his two paintings in oil. The quantity of juvenile drawings published by John Lane in *The Uncollected Work of Aubrey Beardsley* in 1925 records so much similar material of limited interest that only a small but relevant proportion of it has been thought suitable for representation in this book. Otherwise the selection covers all the most important of Beardsley's designs and illustrations, including many not reproduced in the standard books on the subject, and several drawings never before published in any form.

References to the authors Vallance and Gallatin indicate the following works of reference: Robert Ross, *Aubrey Beardsley,* with revised iconography by Aymer Vallance, London, 1909.

A. E. Gallatin, *Aubrey Beardsley,* Catalogue of Drawings and Bibliography, New York, The Grolier Club, 1945.

There are also references to the following, sometimes abbreviated:

The Early Work of Aubrey Beardsley, with prefatory note by H.C. Marillier, John Lane, London and New York, 1899.

The Later Work of Aubrey Beardsley, John Lane, London and New York, 1901.

These last two books have been frequently republished and the plates were re-arranged in the later editions. Unless otherwise stated, the letters from Beardsley referred to will be found in J. Gray (Ed.), *Last Letters of Aubrey Beardsley,* 1904, and R. A. Walker (Ed.), *Letters from Aubrey Beardsley to Leonard Smithers,* 1937. Other works connected with the subject have been referred to fully, when occasion has arisen. B.R.

The notes following the illustration plates are arranged chronologically or in groups to maintain a logical sequence through Beardsley's work. The illustrations, because of problems caused by the layout, do not exactly follow this sequence. They are cross-referenced to the notes by bracketed figures after the captions.

1 Drawing done at the age of eleven (1)

Drawing done at the age of eleven (2)

3 La discourse (3)

4 La lecture (4)

5 La chymist (5)

6 Flavouring the apple tart (6)

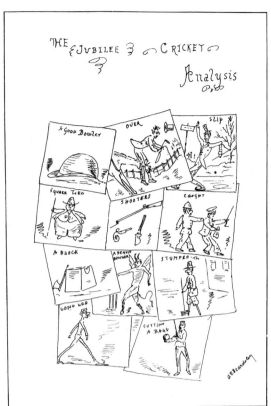

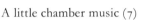
A little chamber music (7)

8 The Jubilee Cricket Analysis (8)

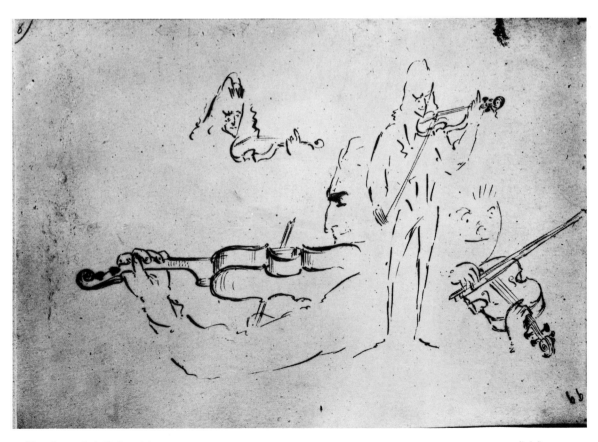

9 Sketches of violinists (9)

10 Illustrations to *The Pay of the Pied Piper* (10)

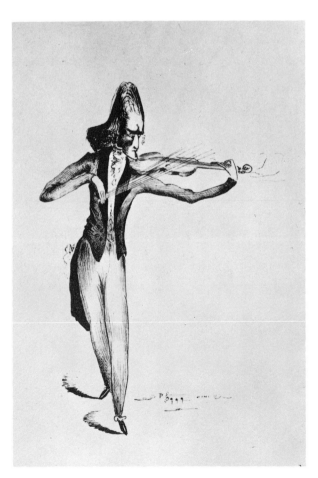

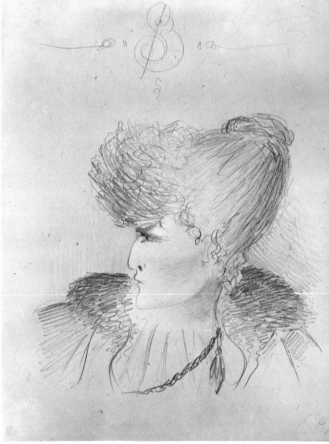

11 Paganini (11)

12 Sarah Bernhardt (12)

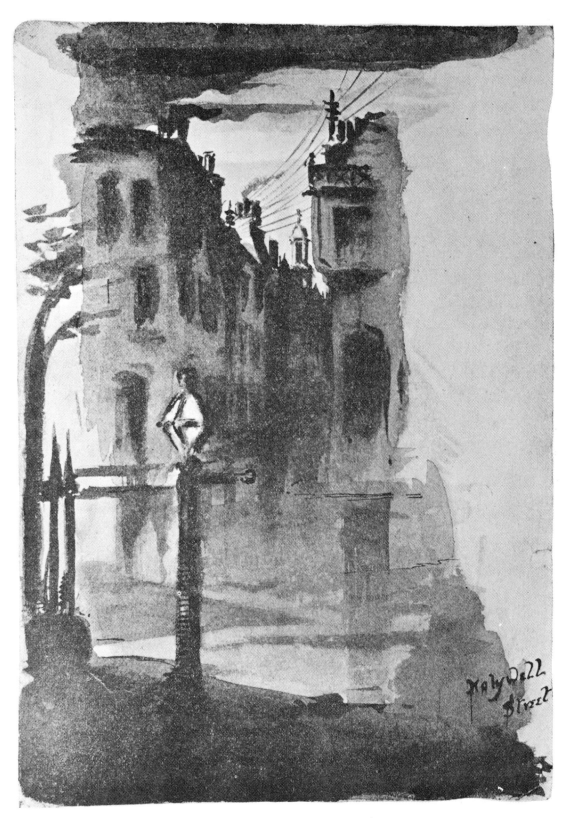

13 Holywell Street, London (13)

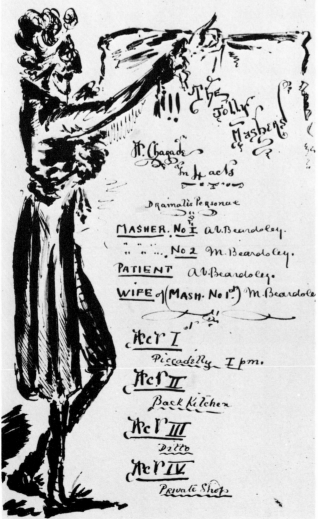

15 The Jolly Mashers (15)

16 Songs (16)

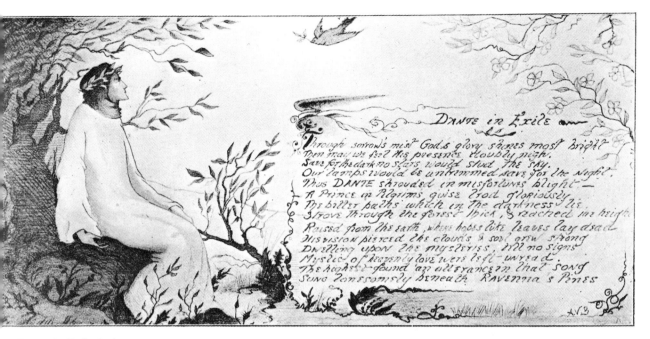

Through sorrow's mist God's glory shines most bright
Then may we feel His presence doubly nigh.
Save for the dark no stars would stud the sky,
Our lamps would be untrimmed save for the Night.
Thus DANTE shrouded in misfortunes blight—
A Prince in Pilgrim's guise trod gloriously
The bitter paths which in the darkness lie,
Strove through the forest thick, & reached the height.
Raised from the earth, where hopes like leaves lay dead,
His vision pierced the clouds & soul grew strong
Dwelling upon the mysteries, till no signs
Mystic of heavenly love were left unread.
The highest found an utterance in that song
Sung lonesomely beneath RAVENNA's PINES

17 Dante in Exile (17)

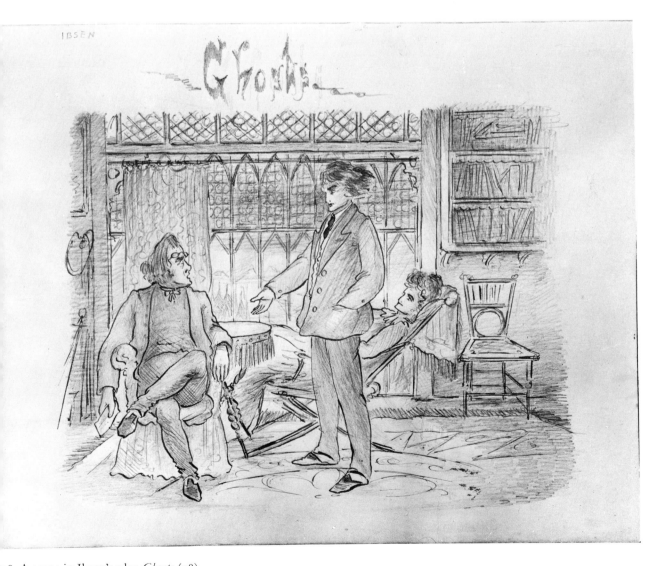

18 A scene in Ibsen's play *Ghosts* (18)

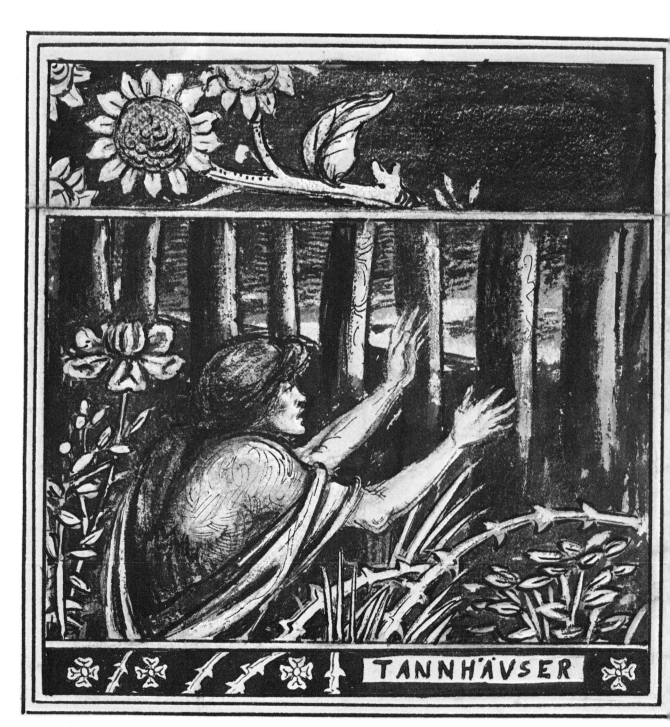

19 Tannhäuser (19)

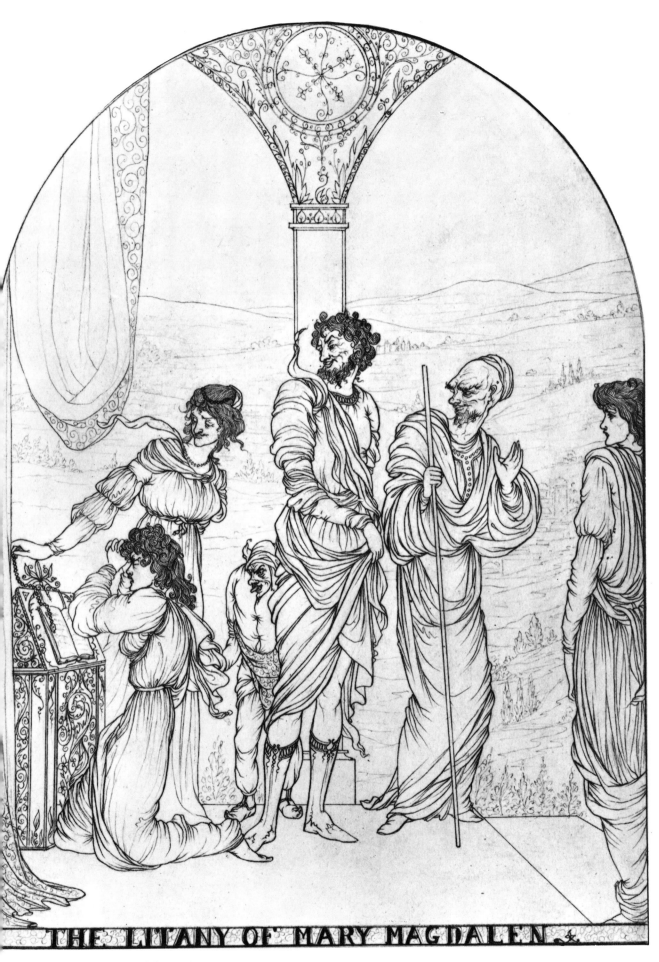

The Litany of Mary Magdalen (20)

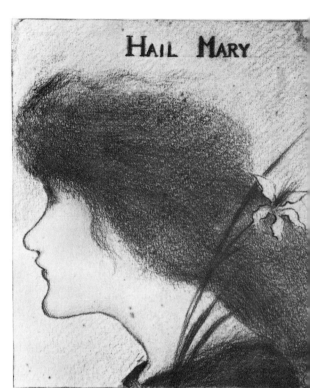

22 Hail Mary (21)

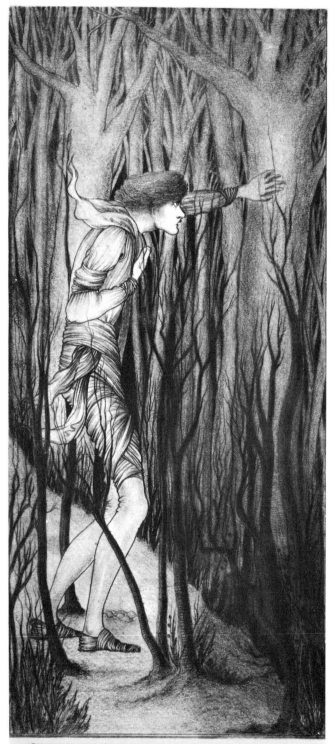

HAMLET PATRIS MANEM SEQVITVR.

21 Hamlet Patris Manem Sequitur (22)

Self-Portrait (23)

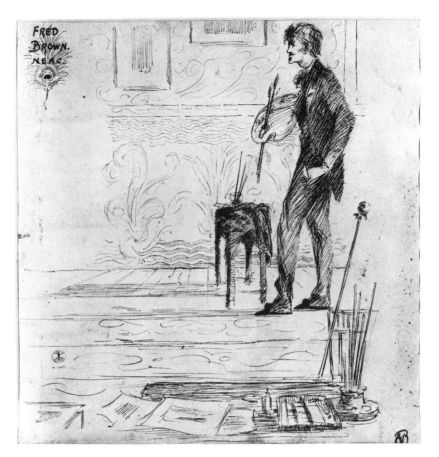

24 Professor Fred Brown (24)

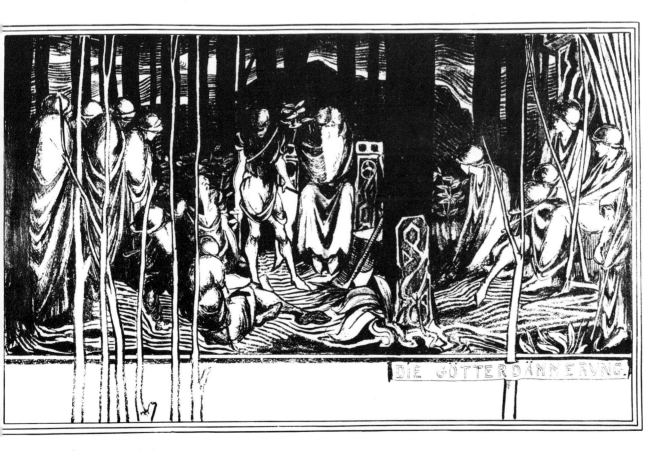

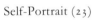 Die Götterdämmerung (25)

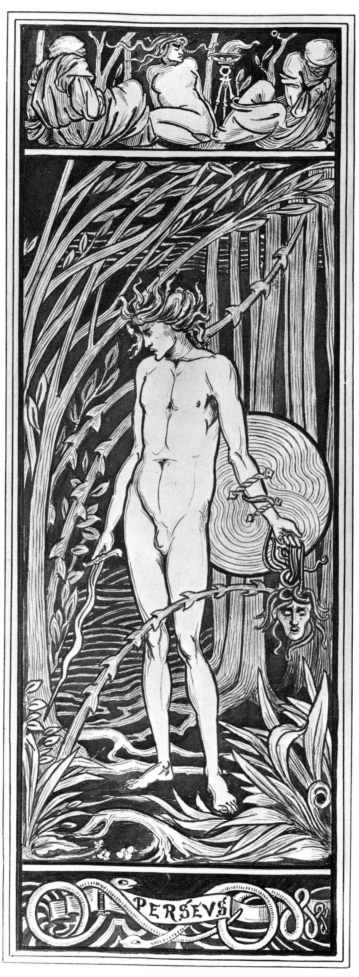

26 Perseus (26)

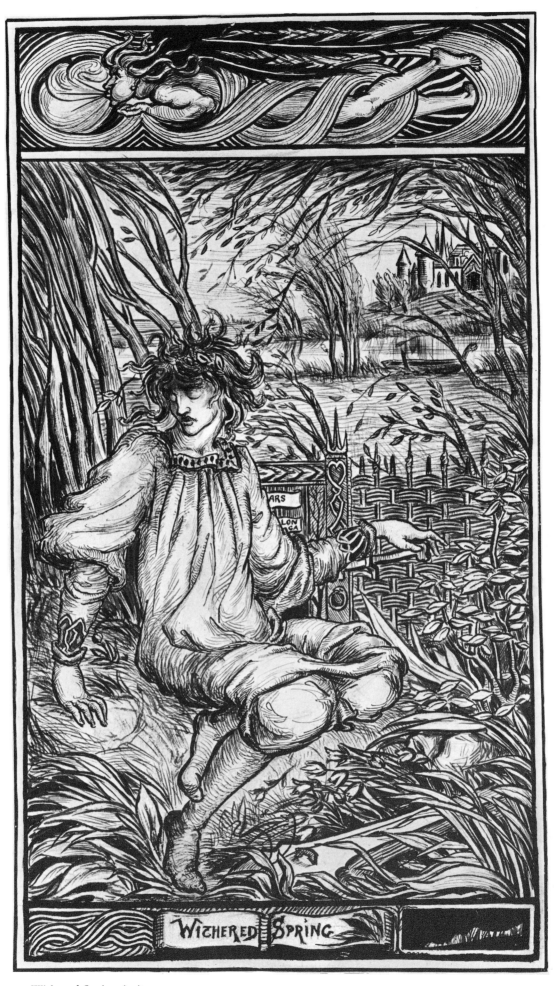

27 Withered Spring (27)

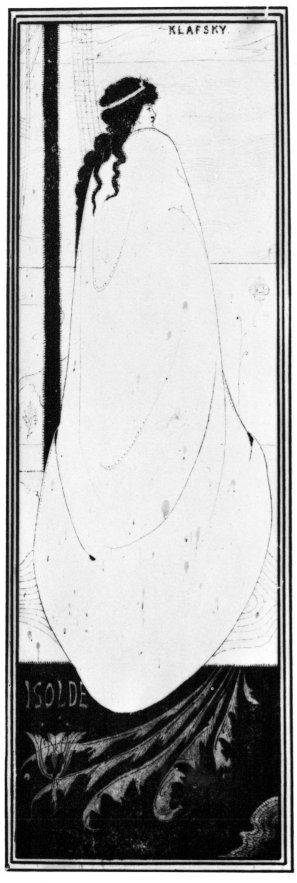

28 Katharina Klavsky (28)

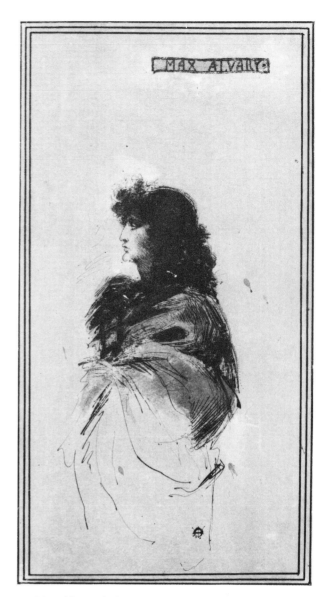

29 Max Alvary (32)

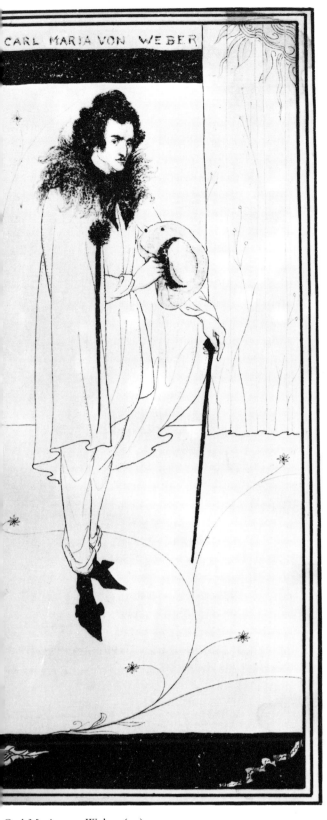

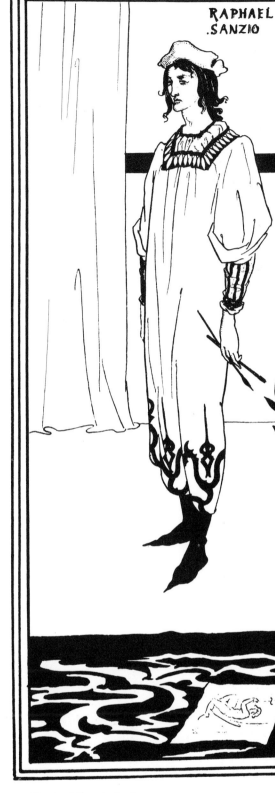

Carl Maria von Weber (29) 31 Raphael Sanzio (30)

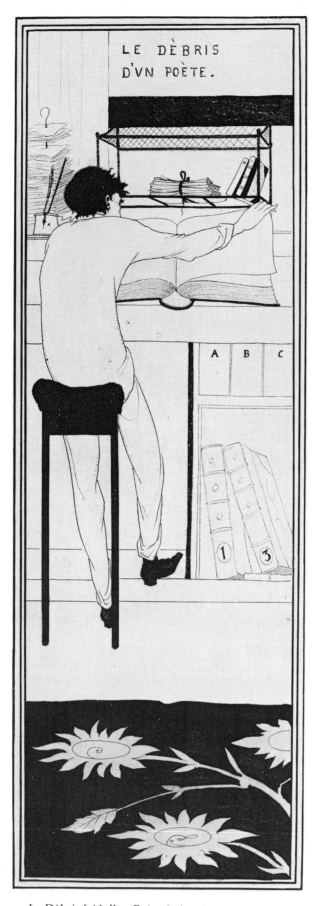

32 Le Dèbris [*sic*] d'un Poète (31)

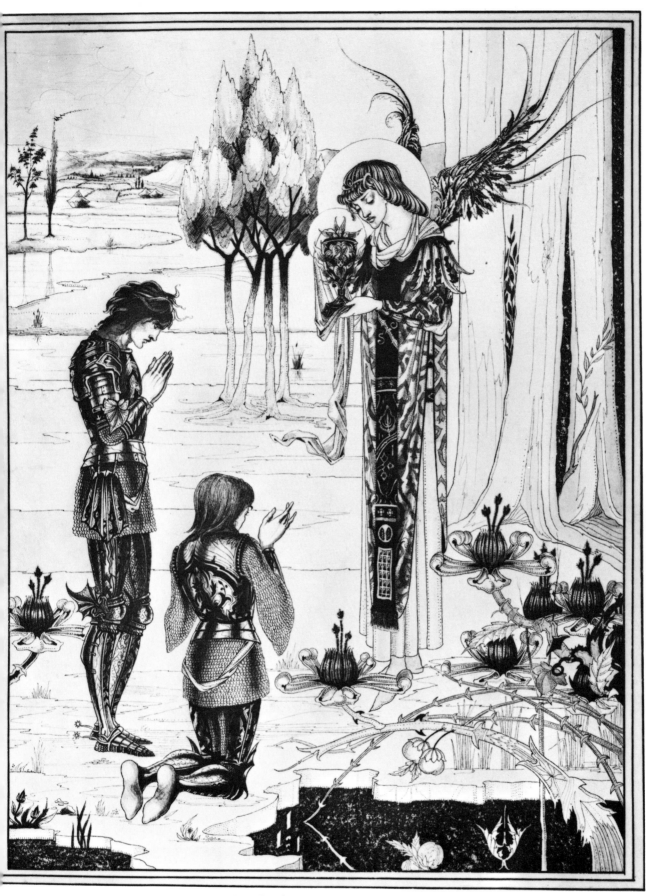

The Achieving of the Sangreal, from *Le Morte Darthur* (33)

34 Front cover of *Evelina* (34)

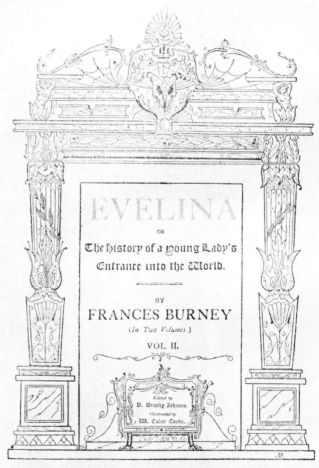

EVELINA

OR

The history of a young Lady's
Entrance into the World.

BY

FRANCES BURNEY

(In Two Volumes.)

VOL. II.

Edited by
R. Brimley Johnson.
Illustrated by
W. Cubitt Cooke.

LONDON: Published by J.M.DENT and COMPANY
at ALDINE HOUSE in Great Eastern Street, E.C.

MDCCCXCIII

35 Title-page of *Evelina* (35)

37 Title-page design (37)

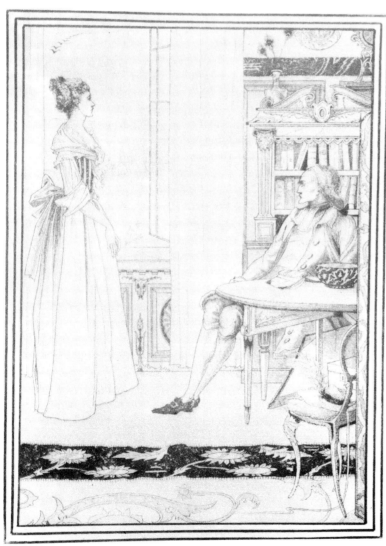

36 Evelina and her Guardian (36)

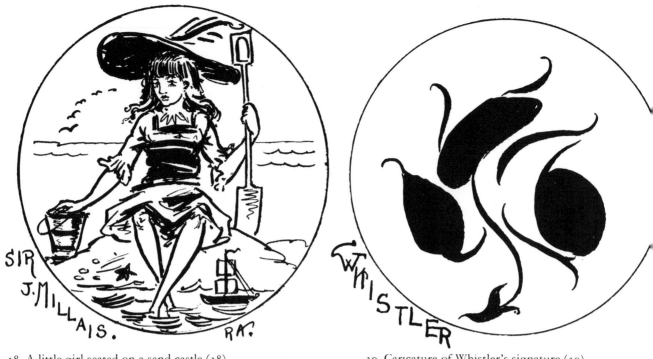

38 A little girl seated on a sand castle (38)

39 Caricature of Whistler's signature (39)

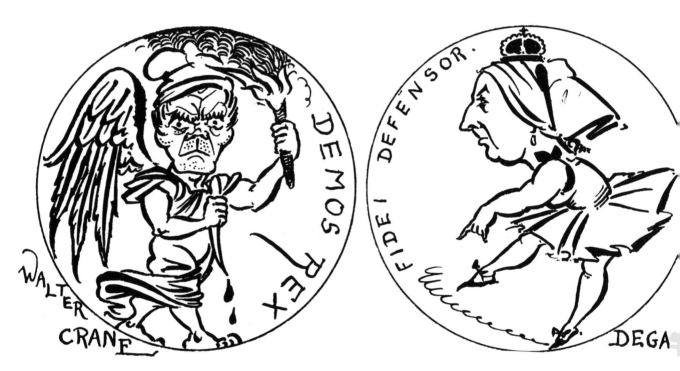

40 Caricature of Walter Crane's socialist opinions (40)

41 Caricature of Queen Victoria as a ballet dancer (41)

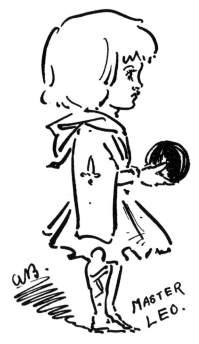

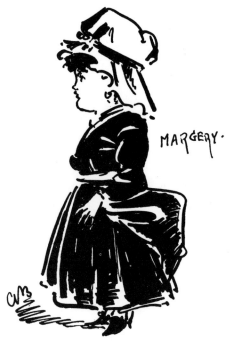

42 Master Leo (Master Leo Byrne as Godfrey) (43) 43 Margery (Kate Phillips) (44)

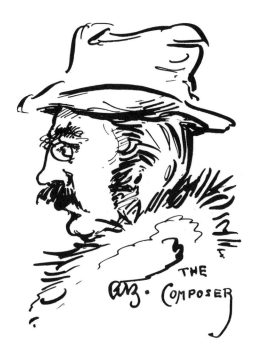

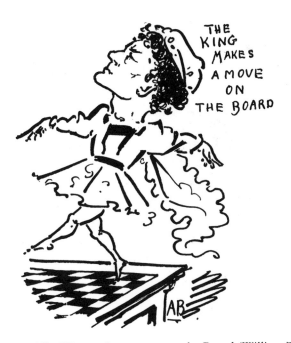

44 The Composer (Sir Charles Villiers Stanford) (45) 45 The King makes a move on the Board (William Terriss) (46)

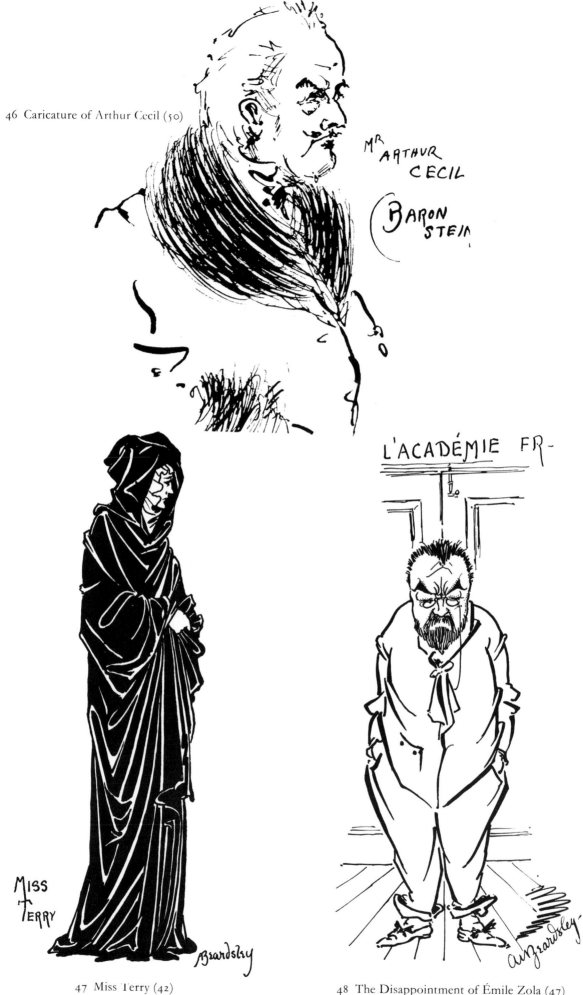

46 Caricature of Arthur Cecil (50)

MR ARTHUR CECIL

BARON STEIN

L'ACADÉMIE FR-

MISS TERRY

Beardsley

47 Miss Terry (42)

48 The Disappointment of Émile Zola (47)

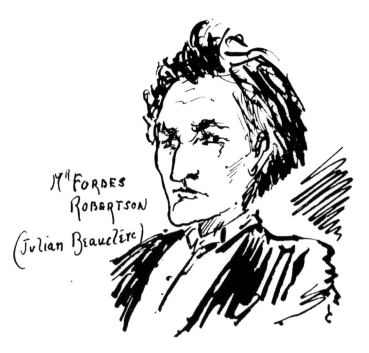

49 Caricature of Forbes Robertson (49)

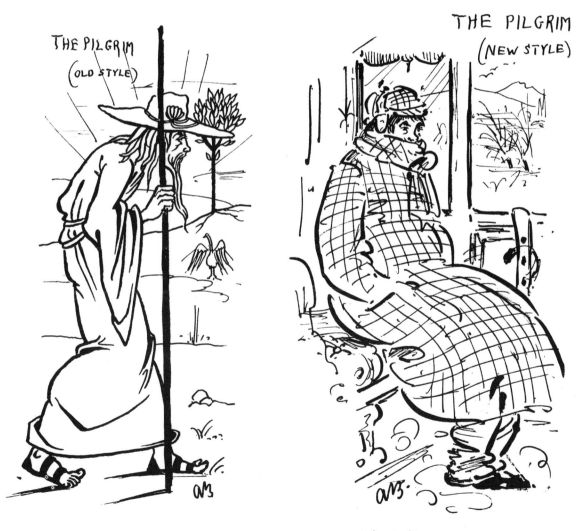

50 Pope Leo XIII's Jubilee (48)

51 'The Bullet-Proof Uniform: Tommy Atkins thinks it rather fun' (51)

52 Becket (52)

53 Caricatures of Norman O'Neill (53)

54 Caricature of Norman O'Neill (54)

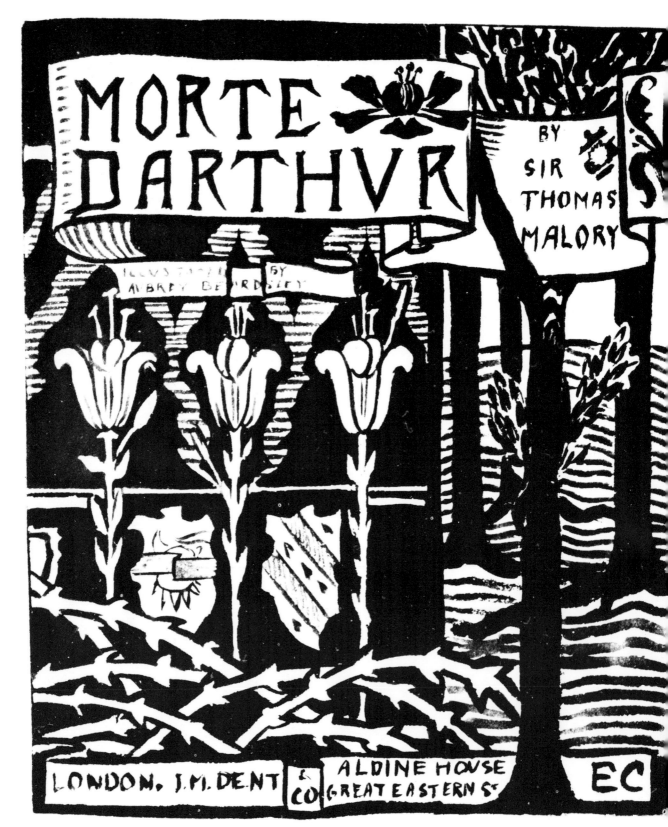

55 Projected design for covers of the parts of *Le Morte Darthur* (55)

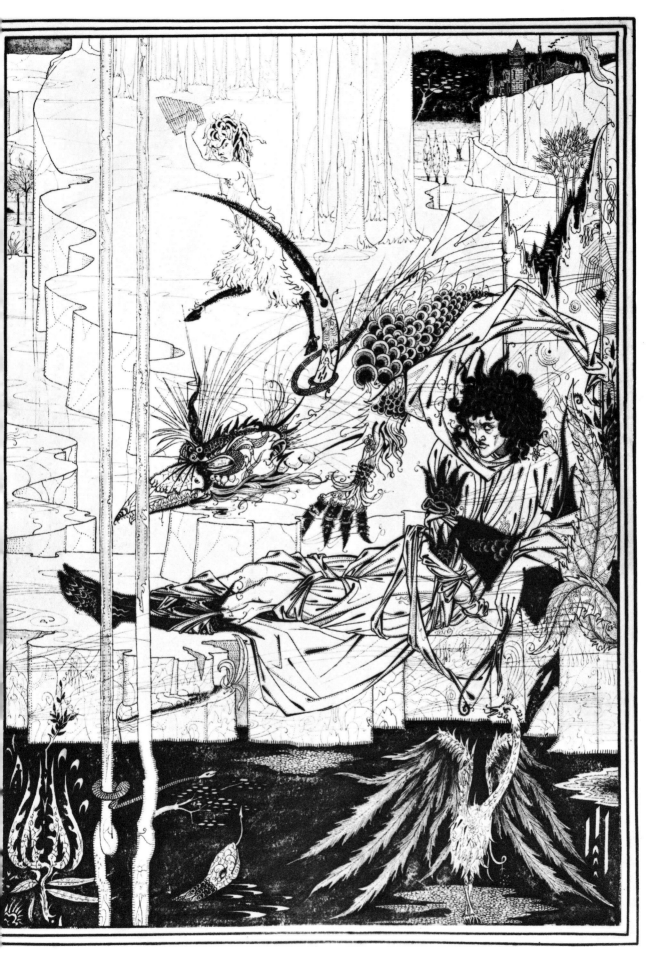

How King Arthur saw the Questing Beast, for *Le Morte Darthur* (56)

57 For the title-page of *Le Morte Darthur* (57)

58 For the preface of *Le Morte Darthur* (58)

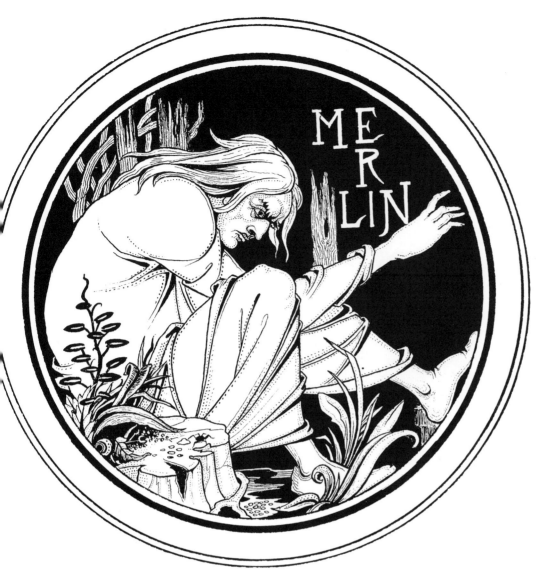

Merlin in *Le Morte Darthur* (59)

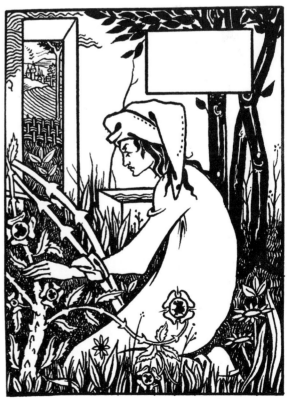

60 Chapter-heading for *Le Morte Darthur* (60)

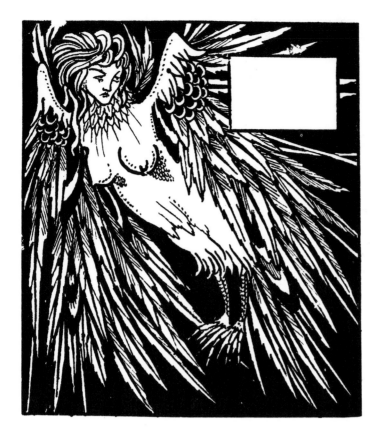

61 Chapter-heading for *Le Morte Darthur* (63)

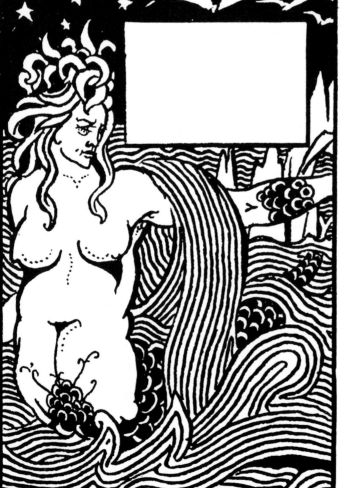

62 Chapter-heading for *Le Morte Darthur* (64)

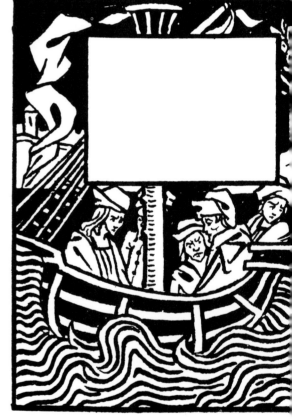

63 Chapter-heading for *Le Morte Darthur* (61)

64 Chapter-heading for
Le Morte Darthur (62)

65 Chapter-heading for
Le Morte Darthur (65)

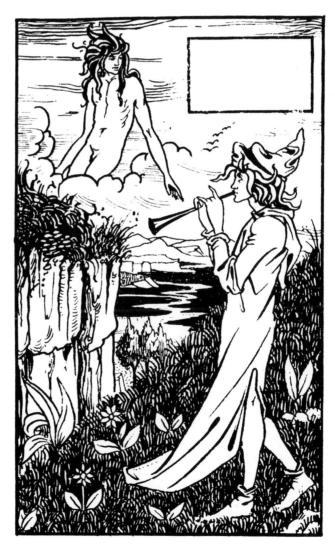

66 Chapter-heading for *Le Morte Darthur* (66)

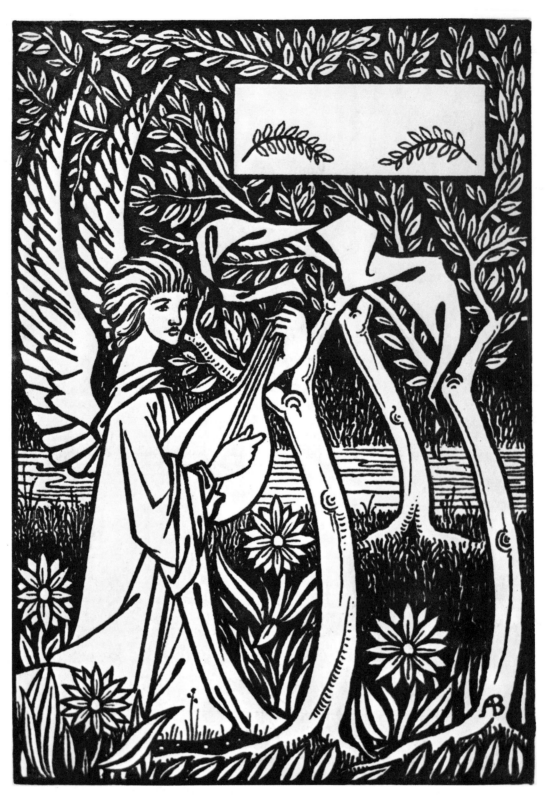

67 Chapter-heading for *Le Morte Darthur* (67)

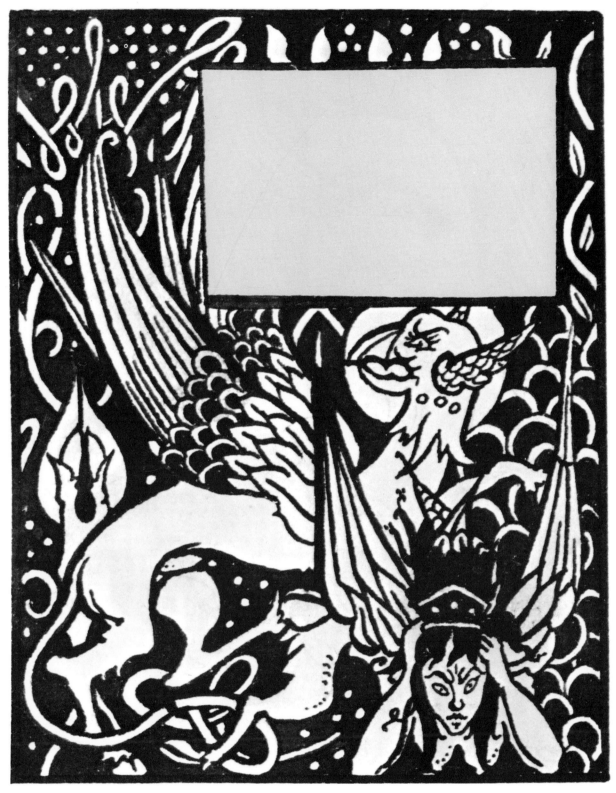

68 Chapter-heading for *Le Morte Darthur* (68)

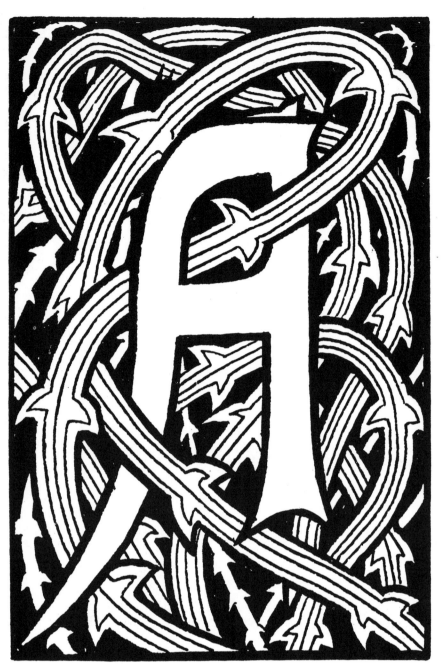

69 Initial A for *Le Morte Darthur* (69)

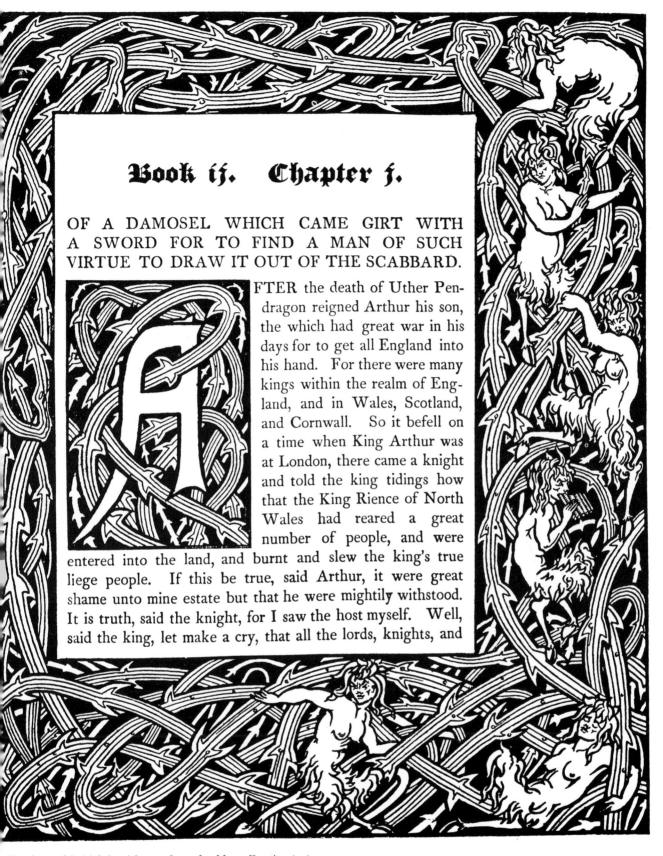

Book ij. Chapter j.

OF A DAMOSEL WHICH CAME GIRT WITH A SWORD FOR TO FIND A MAN OF SUCH VIRTUE TO DRAW IT OUT OF THE SCABBARD.

AFTER the death of Uther Pendragon reigned Arthur his son, the which had great war in his days for to get all England into his hand. For there were many kings within the realm of England, and in Wales, Scotland, and Cornwall. So it befell on a time when King Arthur was at London, there came a knight and told the king tidings how that the King Rience of North Wales had reared a great number of people, and were entered into the land, and burnt and slew the king's true liege people. If this be true, said Arthur, it were great shame unto mine estate but that he were mightily withstood. It is truth, said the knight, for I saw the host myself. Well, said the king, let make a cry, that all the lords, knights, and

Border and Initial A with text from *Le Morte Darthur* (70)

71 Full page border for *Le Morte Darthur* (72)

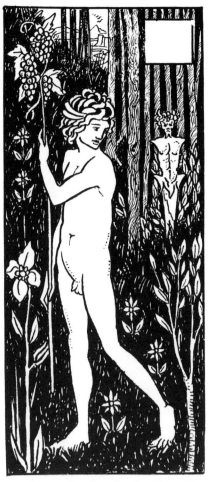

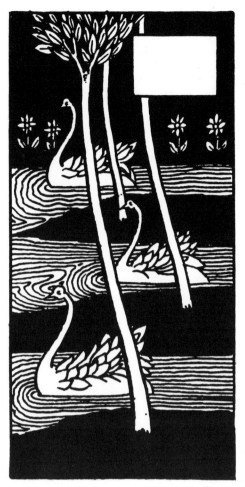

72 Chapter-heading for *Le Morte Darthur* (75)

73 Chapter-heading for *Le Morte Darthur* (73)

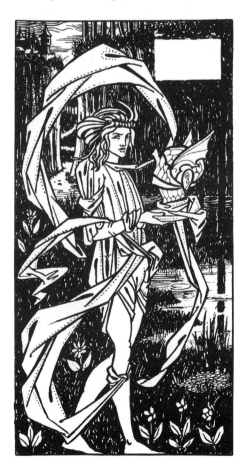

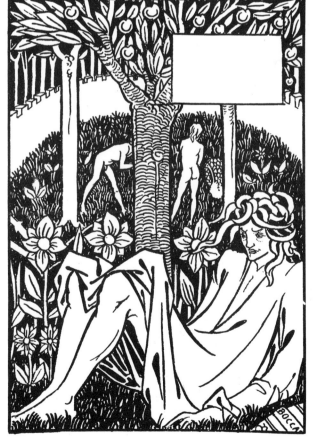

74 Chapter-heading for
Le Morte Darthur (74)

75 Chapter-heading for *Le Morte Darthur* (71)

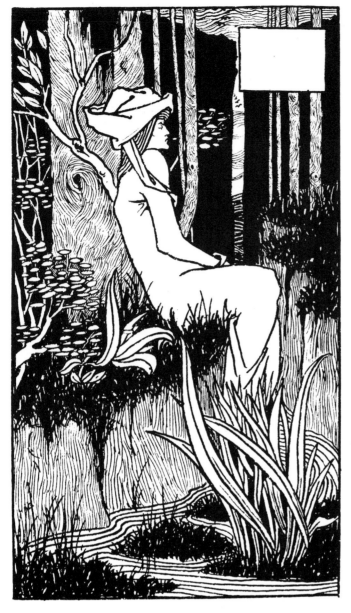

76 Chapter-heading for *Le Morte Darthur* (77)

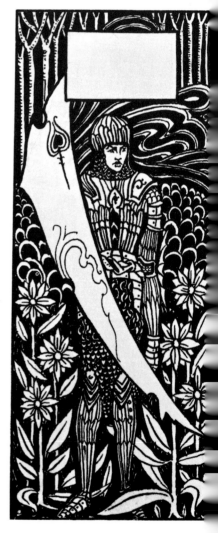

77 Chapter-heading for
Le Morte Darthur (78)

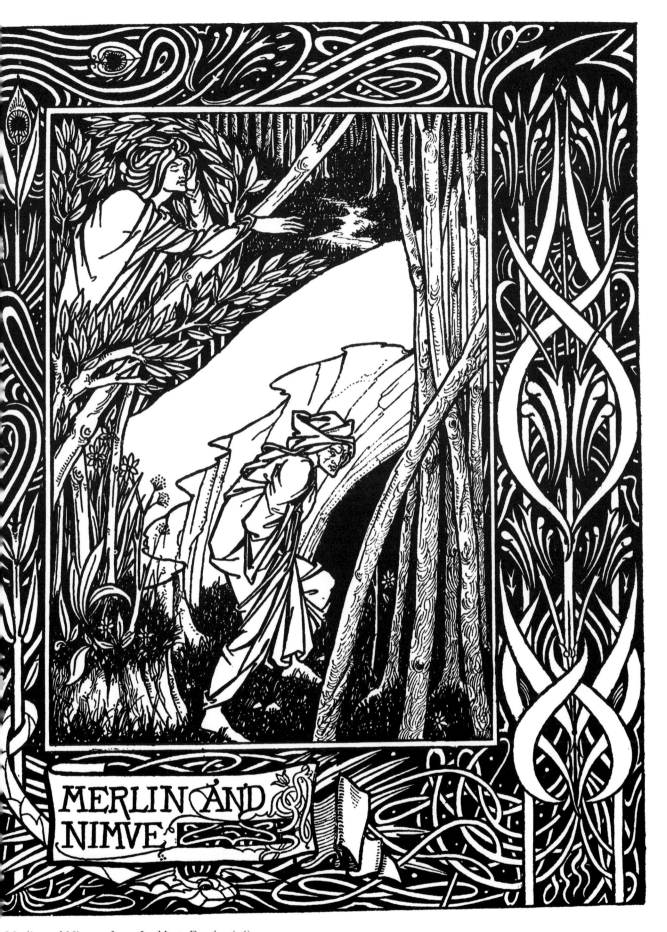

Merlin and Nimue, from *Le Morte Darthur* (76)

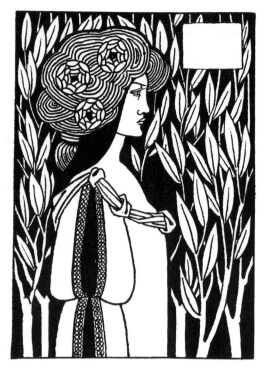

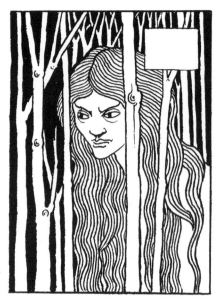

79 Chapter-heading for *Le Morte Darthur* (83)

80 Chapter-heading for *Le Morte Darthur* (81)

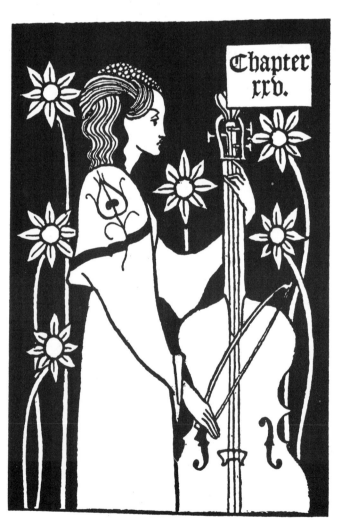

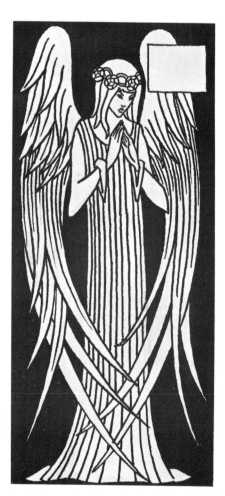

81 Chapter-heading from *Le Morte Darthur* (80)

82 Chapter-heading for *Le Morte Darthur* (82)

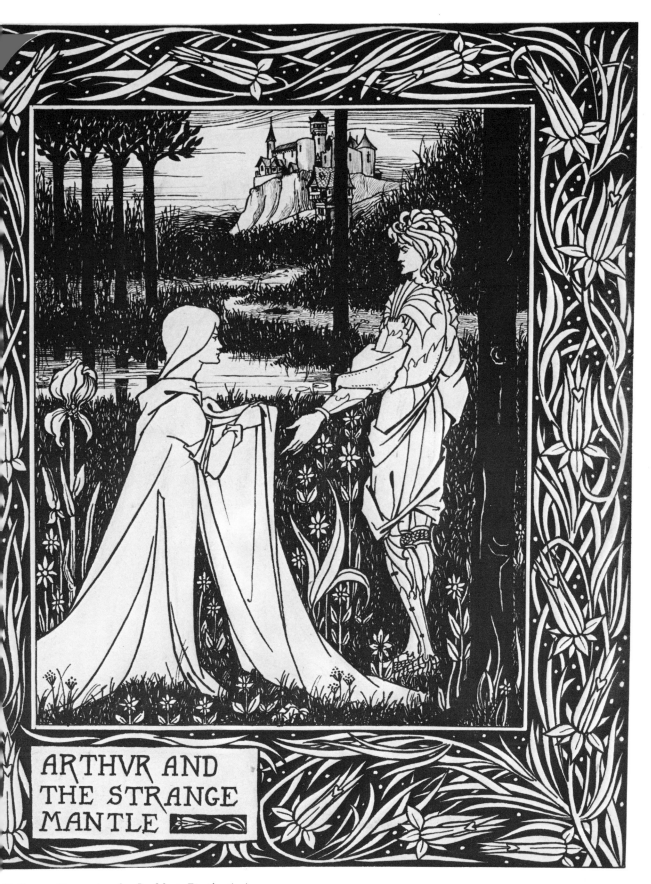

ARTHVR AND
THE STRANGE
MANTLE

Full-page illustration for *Le Morte Darthur* (79)

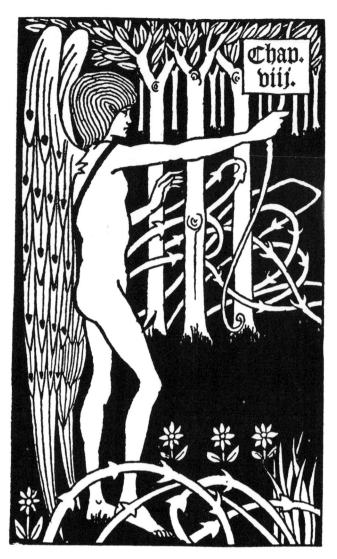

84 Chapter-heading from *Le Morte Darthur* (85)

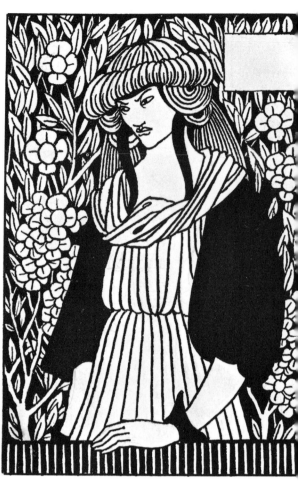

85 Chapter-heading for *Le Morte Darthur* (84)

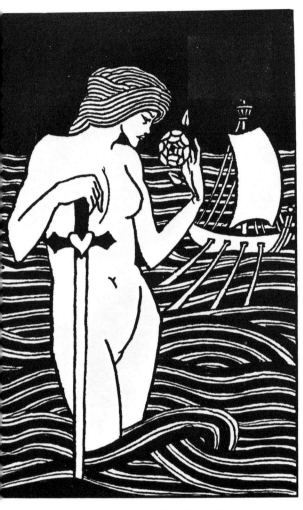

Chapter-heading for *Le Morte Darthur* (86)

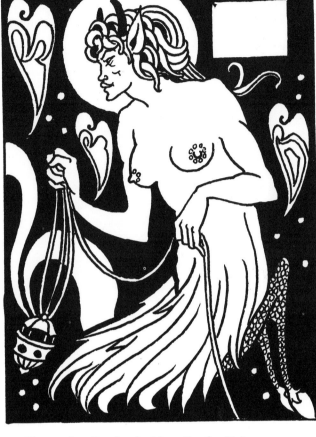

87 Chapter-heading for *Le Morte Darthur* (87)

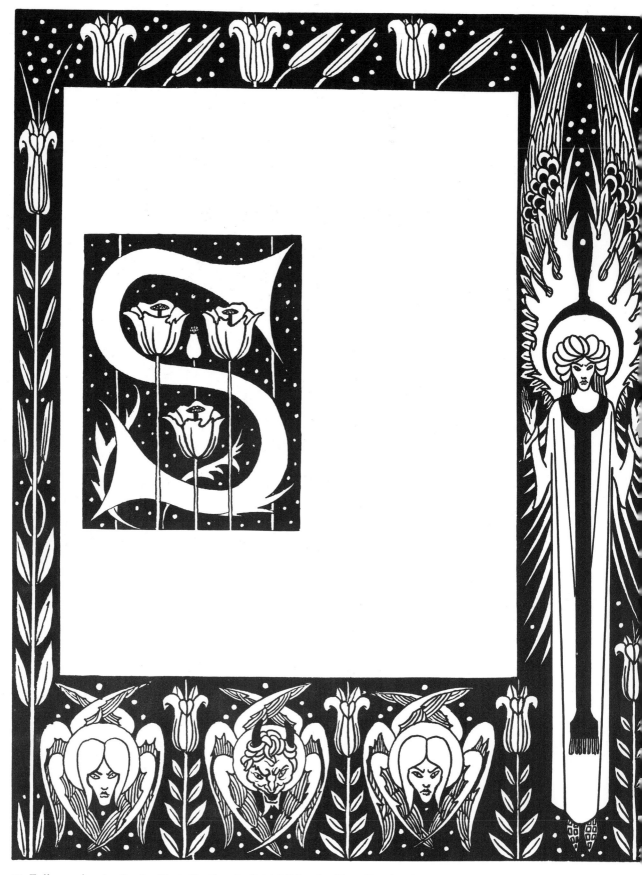

88 Full-page border for *Le Morte Darthur*, 89 Initial S for *Le Morte Darthur* (88, 89)

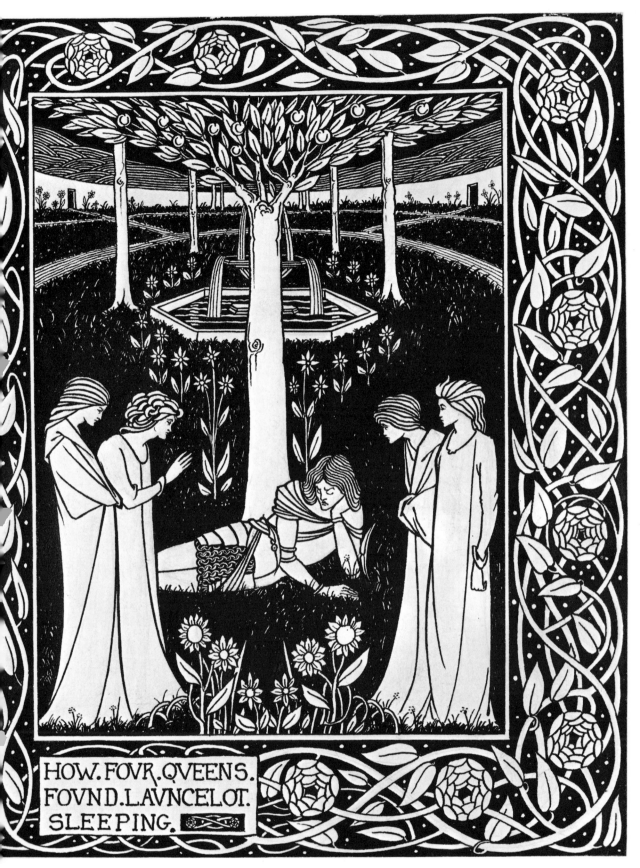

How Four Queens Found Launcelot Sleeping, for *Le Morte Darthur* (90)

91 Chapter-heading from *Le Morte Darthur* (91)

92 Chapter-heading for *Le Morte Darthur* (92)

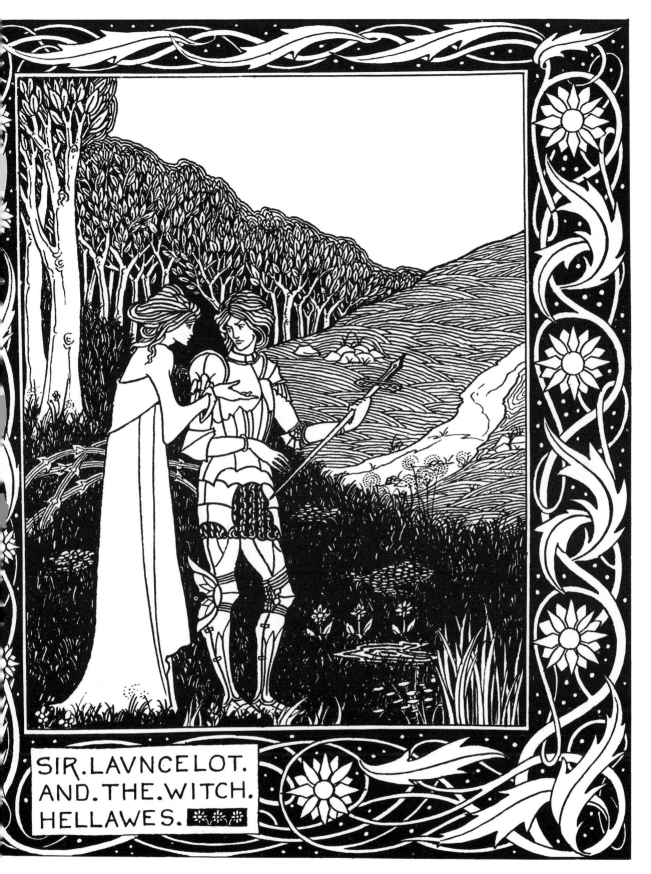

Sir Launcelot and the Witch Hellawes, for *Le Morte Darthur* (93)

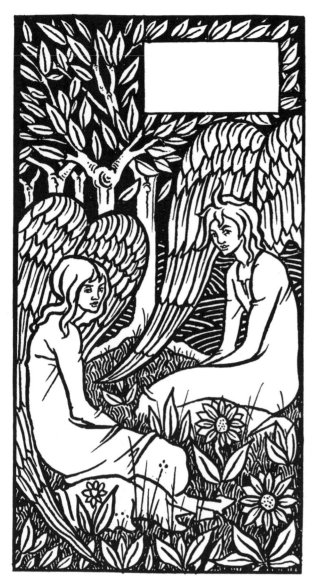

94 Chapter-heading for *Le Morte Darthur* (97)

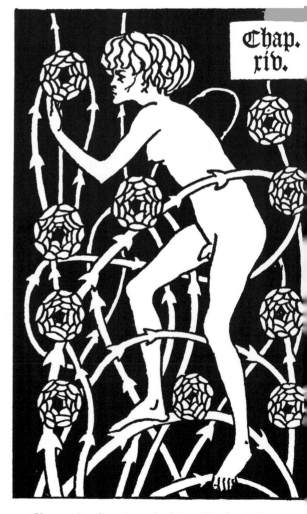

95 Chapter-heading from *Le Morte Darthur* (96)

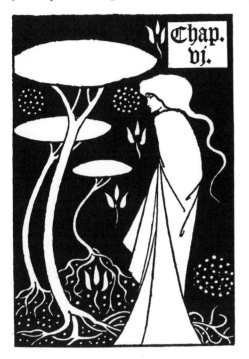

96 Chapter-heading from *Le Morte Darthur* (94)

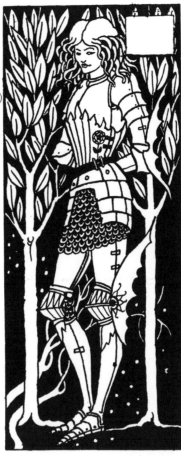

97 Chapter-heading for
Le Morte Darthur (98)

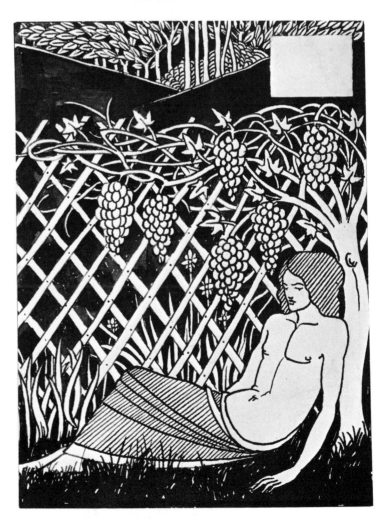

98 Chapter-heading for *Le Morte Darthur* (95)

Book viij. Chapter j.

HOW SIR TRISTRAM DE LIONES WAS BORN, AND HOW HIS MOTHER DIED AT HIS BIRTH, WHEREFORE SHE NAMED HIM TRISTRAM.

IT was a king that hight Meliodas, and he was lord and king of the country of Liones, and this Meliodas was a likely knight as any was that time living. And by fortune he wedded King Mark's sister of Cornwall; and she was called Elizabeth, that was called both good and fair. And at that time King Arthur reigned, and he was whole king of England, Wales, and Scotland, and of many other realms: howbeit there were many kings that were lords of many countries, but all they held their lands of King Arthur; for in Wales were two kings, and in the north were many kings; and in Cornwall and in the west were two kings; also in Ireland were two or three kings, and all were under the obeissance of King Arthur. So was the King of France, and the King of Brittany, and all the lordships unto Rome. So when this King Meliodas had been with his wife, within a while she waxed great with child, and she was a full meek lady, and well she loved her lord, and he her again, so there was great joy betwixt them. Then there was a lady in that country that had loved King Meliodas long, and by no mean she never could get his love;

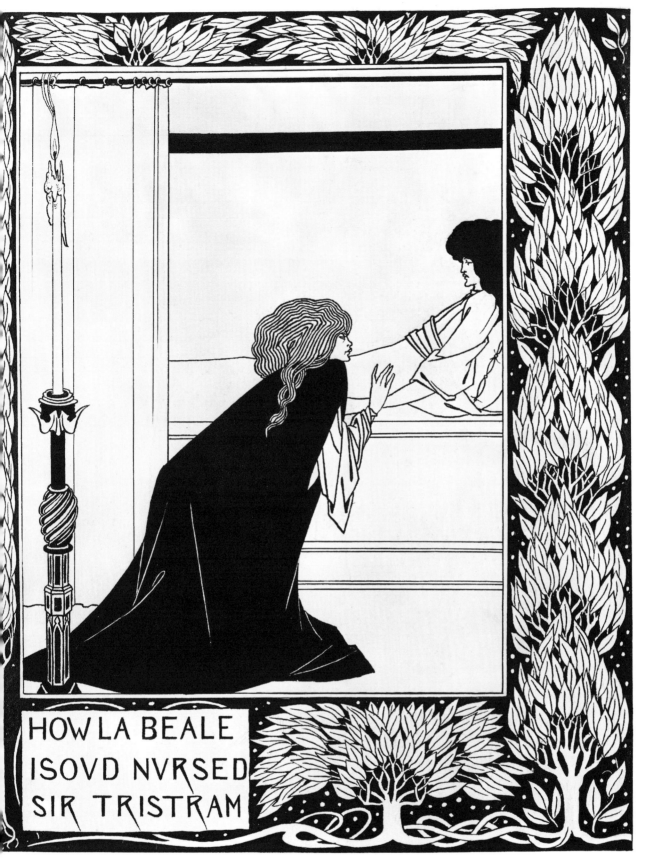

HOW LA BEALE ISOVD NVRSED SIR TRISTRAM

How La Beale Ysoud Nursed Sir Tristram, for *Le Morte Darthur* (100)

101 Chapter-heading for *Le Morte Darthur* (101)

102 Chapter-heading for *Le Morte Darthur* (102)

103 Chapter-heading for *Le Morte Darthur* (103)

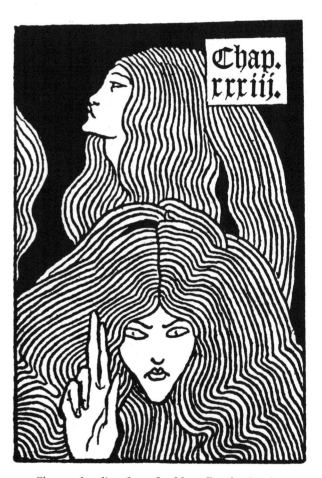

104 Chapter-heading from *Le Morte Darthur* (105)

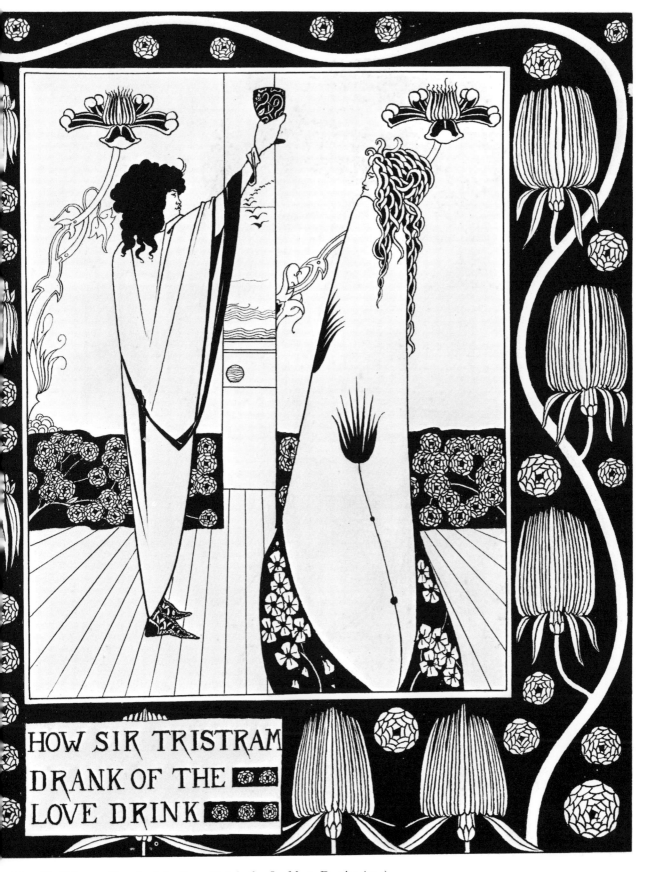

HOW SIR TRISTRAM
DRANK OF THE
LOVE DRINK

How Sir Tristram Drank of the Love Drink, for *Le Morte Darthur* (104)

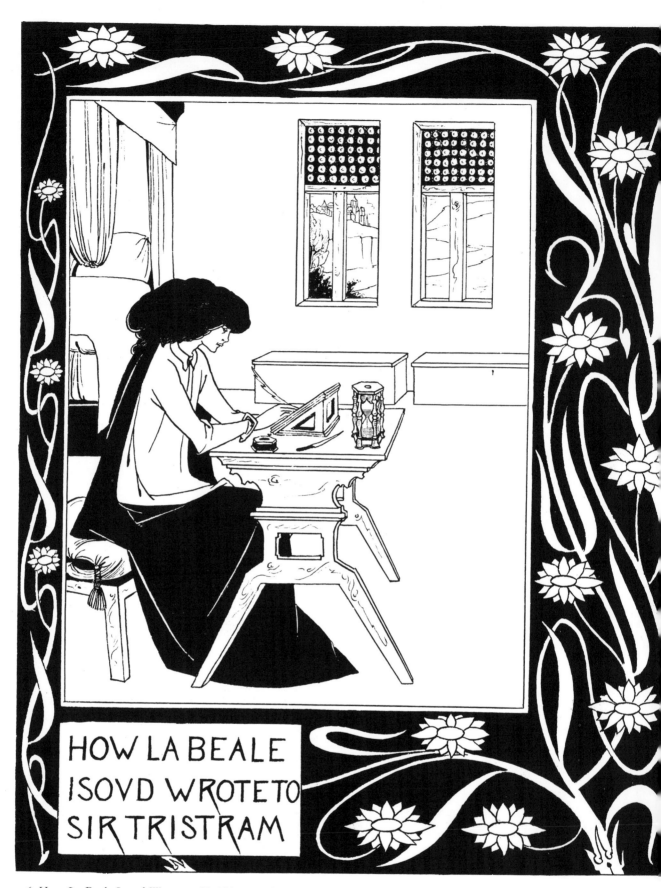

HOW LA BEALE
ISOVD WROTE TO
SIR TRISTRAM

106 How La Beale Isoud Wrote to Sir Tristram, for *Le Morte Darthur* (108)

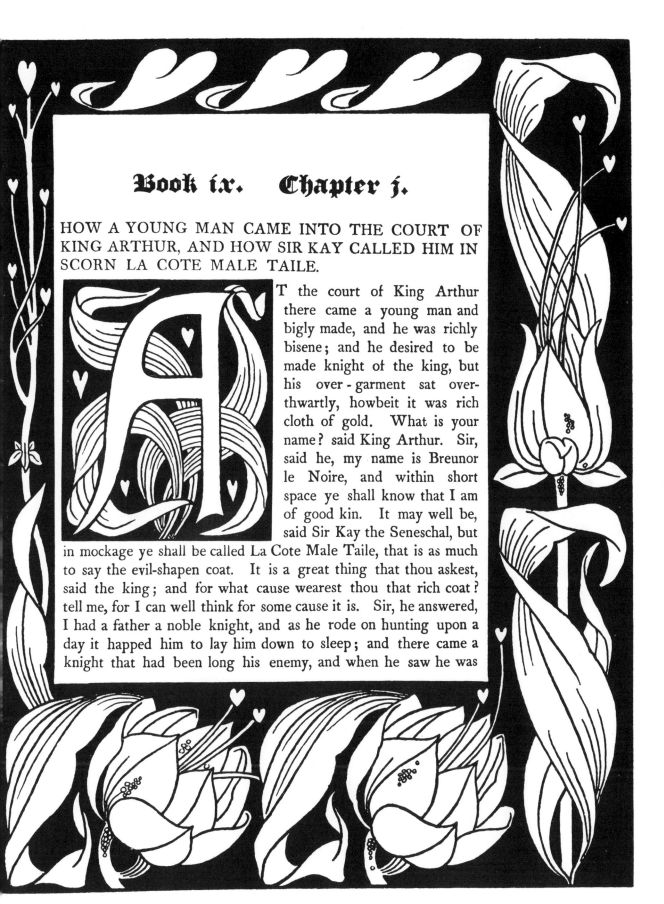

Book ix. Chapter j.

HOW A YOUNG MAN CAME INTO THE COURT OF KING ARTHUR, AND HOW SIR KAY CALLED HIM IN SCORN LA COTE MALE TAILE.

AT the court of King Arthur there came a young man and bigly made, and he was richly bisene; and he desired to be made knight of the king, but his over-garment sat overthwartly, howbeit it was rich cloth of gold. What is your name? said King Arthur. Sir, said he, my name is Breunor le Noire, and within short space ye shall know that I am of good kin. It may well be, said Sir Kay the Seneschal, but in mockage ye shall be called La Cote Male Taile, that is as much to say the evil-shapen coat. It is a great thing that thou askest, said the king; and for what cause wearest thou that rich coat? tell me, for I can well think for some cause it is. Sir, he answered, I had a father a noble knight, and as he rode on hunting upon a day it happed him to lay him down to sleep; and there came a knight that had been long his enemy, and when he saw he was

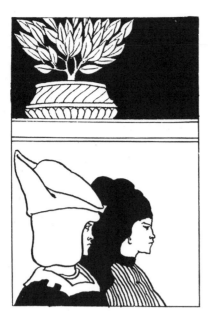

108 Chapter-heading for *Le Morte Darthur* (109)

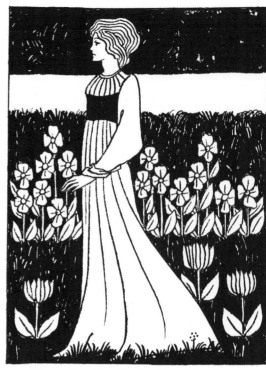

109 Chapter-heading for *Le Morte Darthur* (106)

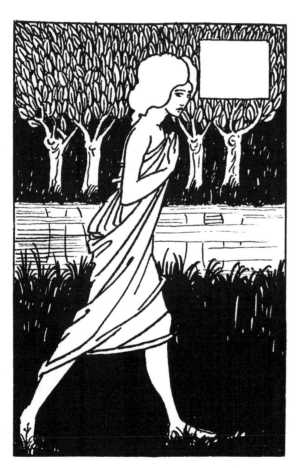

110 Chapter-heading for *Le Morte Darthur* (112)

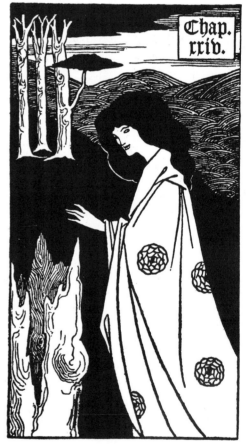

111 Chapter-heading from *Le Morte Darthur* (111)

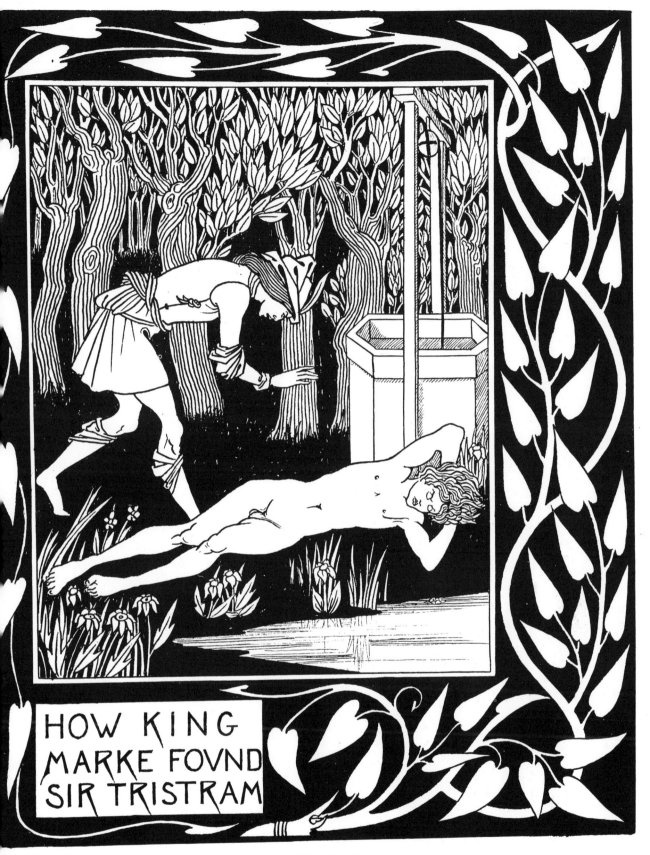

2 How King Mark found Sir Tristram sleeping, for *Le Morte Darthur* (110)

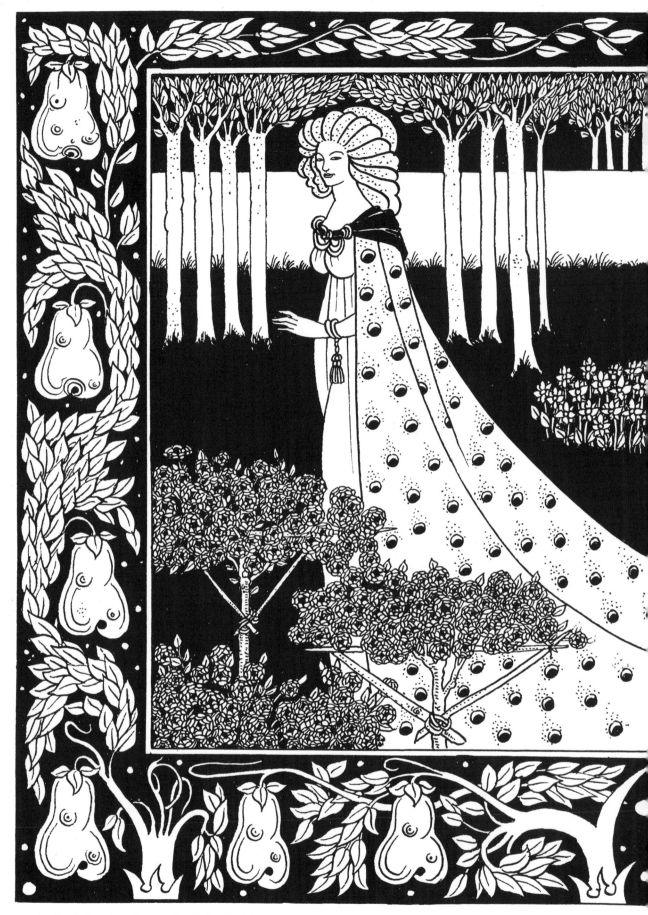

113 La Beale Isoud at Joyous Gard, for *Le Mort Darthur* (114)

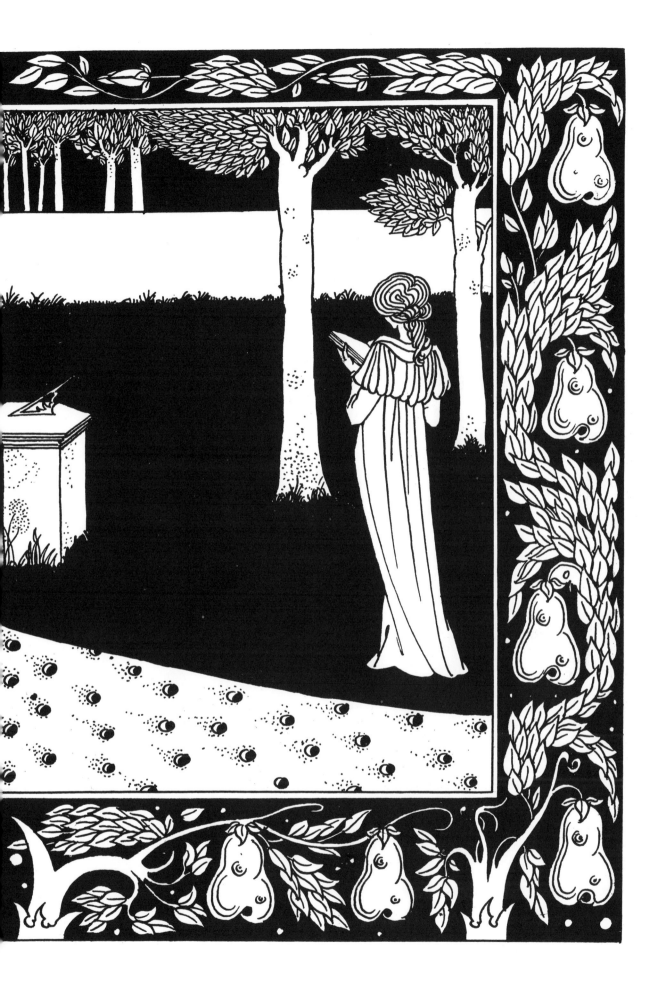

114 Chapter-heading for *Le Morte Darthur* (116)

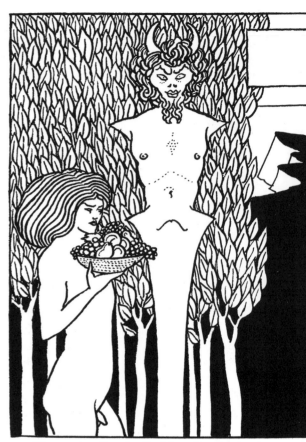

115 Chapter-heading for *Le Morte Darthur* (115)

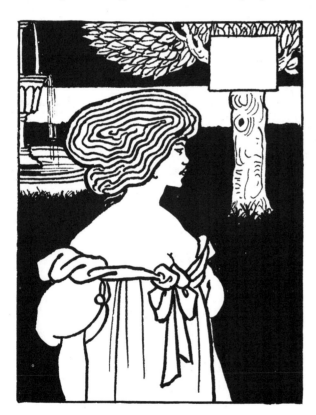

116 Chapter-heading for *Le Morte Darthur* (120)

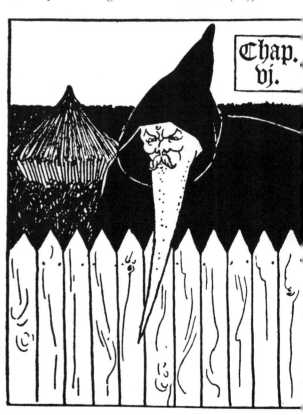

117 Chapter-heading from *Le Morte Darthur* (118)

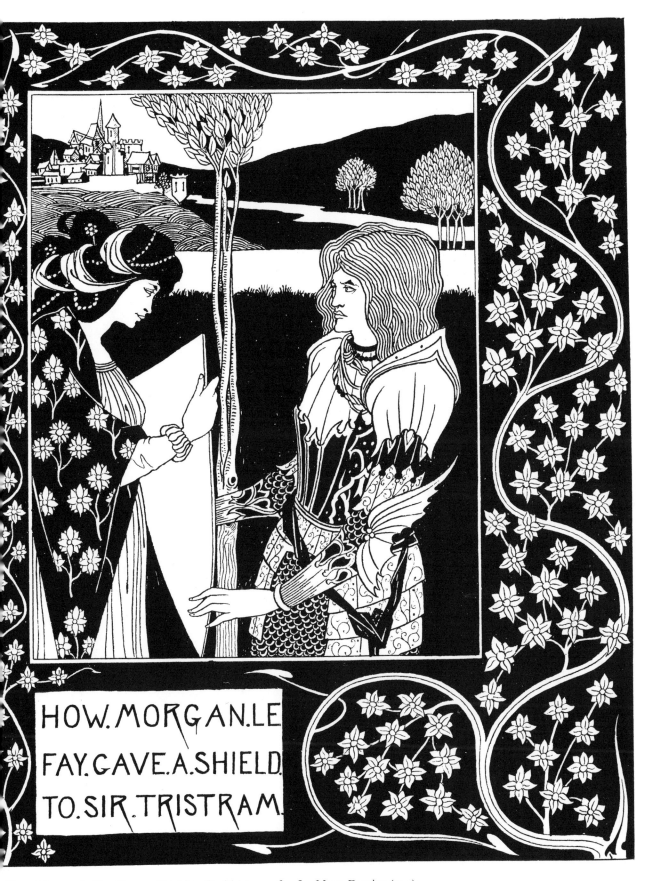

HOW. MORGAN. LE FAY. GAVE. A. SHIELD. TO. SIR. TRISTRAM.

How Morgan le Fay Gave a Shield to Sir Tristram, for *Le Morte Darthur* (113)

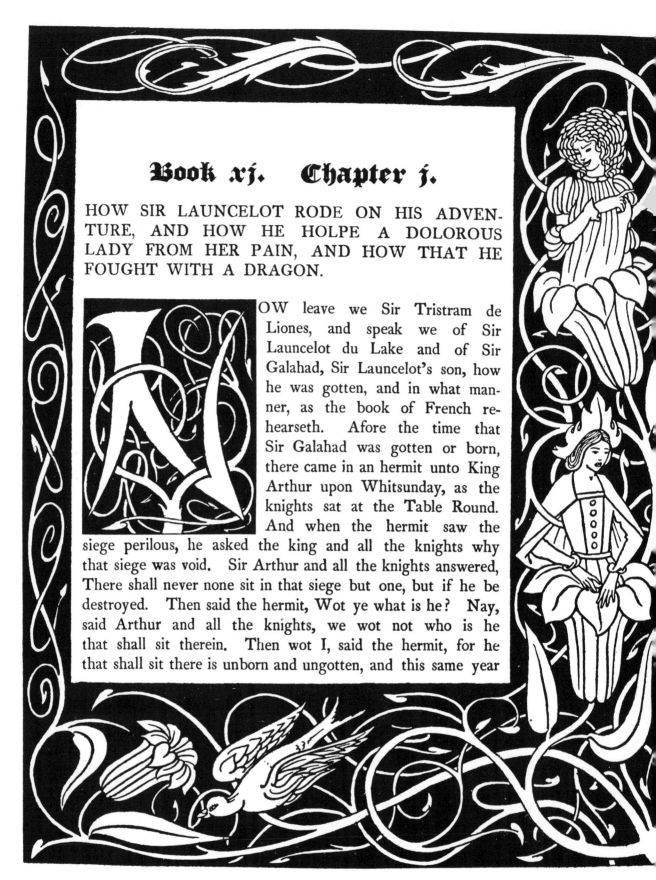

Book xj. Chapter j.

HOW SIR LAUNCELOT RODE ON HIS ADVEN-
TURE, AND HOW HE HOLPE A DOLOROUS
LADY FROM HER PAIN, AND HOW THAT HE
FOUGHT WITH A DRAGON.

NOW leave we Sir Tristram de Liones, and speak we of Sir Launcelot du Lake and of Sir Galahad, Sir Launcelot's son, how he was gotten, and in what manner, as the book of French rehearseth. Afore the time that Sir Galahad was gotten or born, there came in an hermit unto King Arthur upon Whitsunday, as the knights sat at the Table Round. And when the hermit saw the siege perilous, he asked the king and all the knights why that siege was void. Sir Arthur and all the knights answered, There shall never none sit in that siege but one, but if he be destroyed. Then said the hermit, Wot ye what is he? Nay, said Arthur and all the knights, we wot not who is he that shall sit therein. Then wot I, said the hermit, for he that shall sit there is unborn and ungotten, and this same year

120 Full-page border with the initial A, for *Le Morte Darthur* (119)

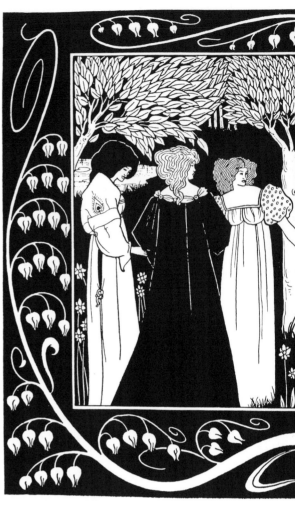

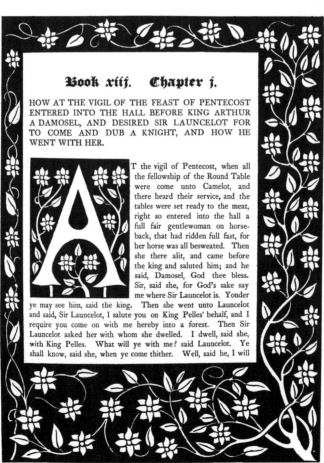

Book xiij. Chapter j.

HOW AT THE VIGIL OF THE FEAST OF PENTECOST ENTERED INTO THE HALL BEFORE KING ARTHUR A DAMOSEL, AND DESIRED SIR LAUNCELOT FOR TO COME AND DUB A KNIGHT, AND HOW HE WENT WITH HER.

AT the vigil of Pentecost, when all the fellowship of the Round Table were come unto Camelot, and there heard their service, and the tables were set ready to the meat, right so entered into the hall a full fair gentlewoman on horseback, that had ridden full fast, for her horse was all besweated. Then she there alit, and came before the king and saluted him; and he said, Damosel, God thee bless. Sir, said she, for God's sake say me where Sir Launcelot is. Yonder ye may see him, said the king. Then she went unto Launcelot and said, Sir Launcelot, I salute you on King Pelles' behalf, and I require you come on with me hereby into a forest. Then Sir Launcelot asked her with whom she dwelled. I dwell, said she, with King Pelles. What will ye with me? said Launcelot. Ye shall know, said she, when ye come thither. Well, said he, I will

122 Border and initial A, with text from *Le Morte Darthur* (123)

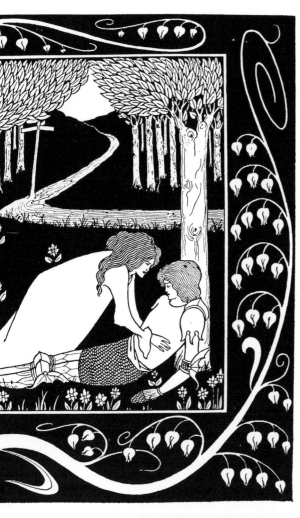

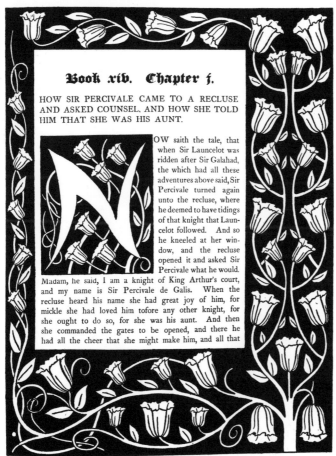

HOW SIR PERCIVALE CAME TO A RECLUSE AND ASKED COUNSEL, AND HOW SHE TOLD HIM THAT SHE WAS HIS AUNT.

OW saith the tale, that when Sir Launcelot was ridden after Sir Galahad, the which had all these adventures above said, Sir Percivale turned again unto the recluse, where he deemed to have tidings of that knight that Launcelot followed. And so he kneeled at her window, and the recluse opened it and asked Sir Percivale what he would. Madam, he said, I am a knight of King Arthur's court, and my name is Sir Percivale de Galis. When the recluse heard his name she had great joy of him, for mickle she had loved him tofore any other knight, for she ought to do so, for she was his aunt. And then she commanded the gates to be opened, and there he had all the cheer that she might make him, and all that

123 Initial N and full-page border from *Le Morte Darthur* (125)

125 Chapter-heading for *Le Morte Darthur* (126)

126 Chapter-heading for *Le Morte Darthur* (124)

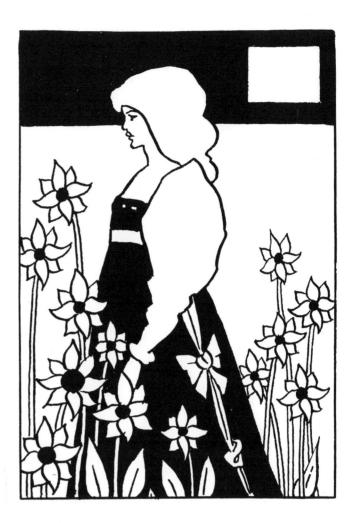

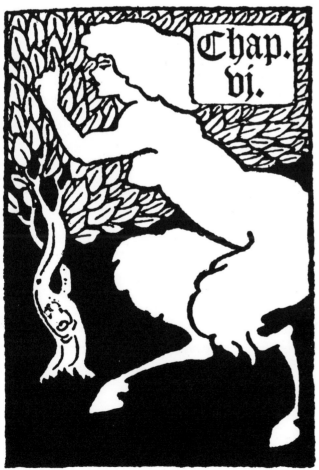

127 Chapter-heading from *Le Morte Darthur* (127)

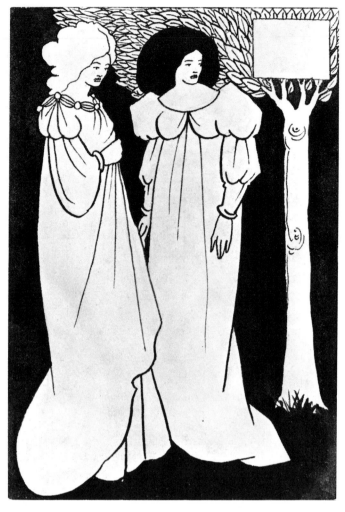

128 Chapter-heading for *Le Morte Darthur* (130)

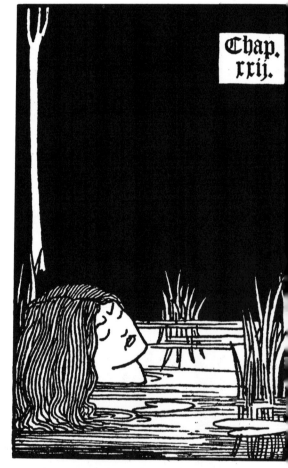

129 Chapter-heading from *Le Morte Darthur* (128)

Book xv. Chapter j.

HOW SIR LAUNCELOT CAME TO A CHAPEL, WHERE HE FOUND DEAD, IN A WHITE SHIRT, A MAN OF RELIGION, OF AN HUNDRED WINTER OLD.

HEN the hermit had kept Sir Launcelot three days, the hermit gat him an horse, an helm, and a sword. And then he departed about the hour of noon. And then he saw a little house. And when he came near he saw a chapel, and there beside he saw an old man that was clothed all in white full richly; and then Sir Launcelot said, God save you. God keep you, said the good man, and make you a good knight. Then Sir Launcelot alit and entered into the chapel, and there he saw an old man dead, in a white shirt of passing fine cloth. Sir, said the good man, this man that is dead ought not to be in such clothing as ye see him in, for in that he brake the oath of his order, for he hath been more

Border and initial W with text from *Le Morte Darthur* (129)

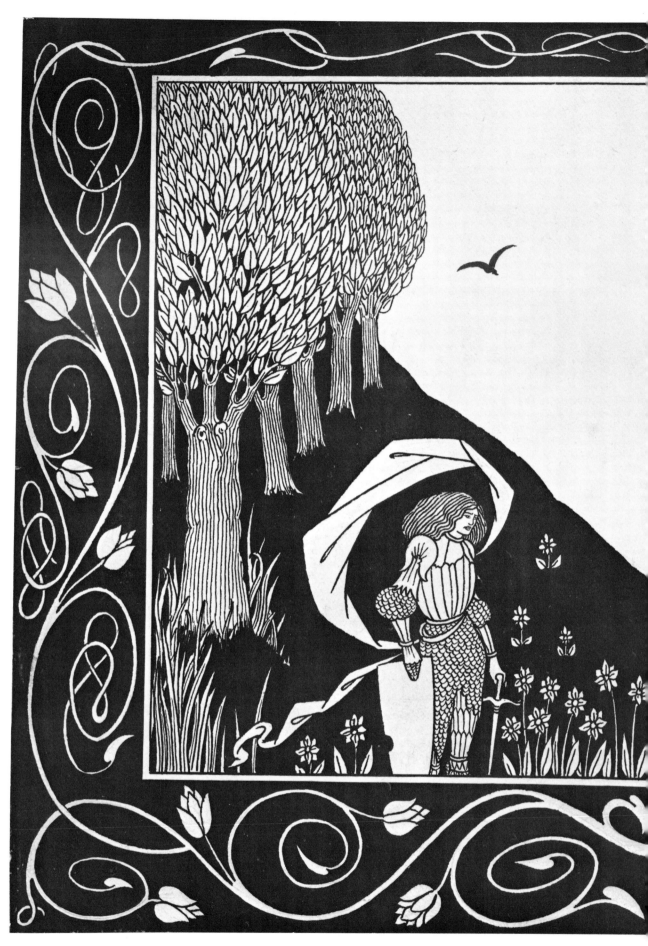

131 How a Devil in a Woman's likeness would have tempted Sir Bors, for *Le Morte Darthur* (131)

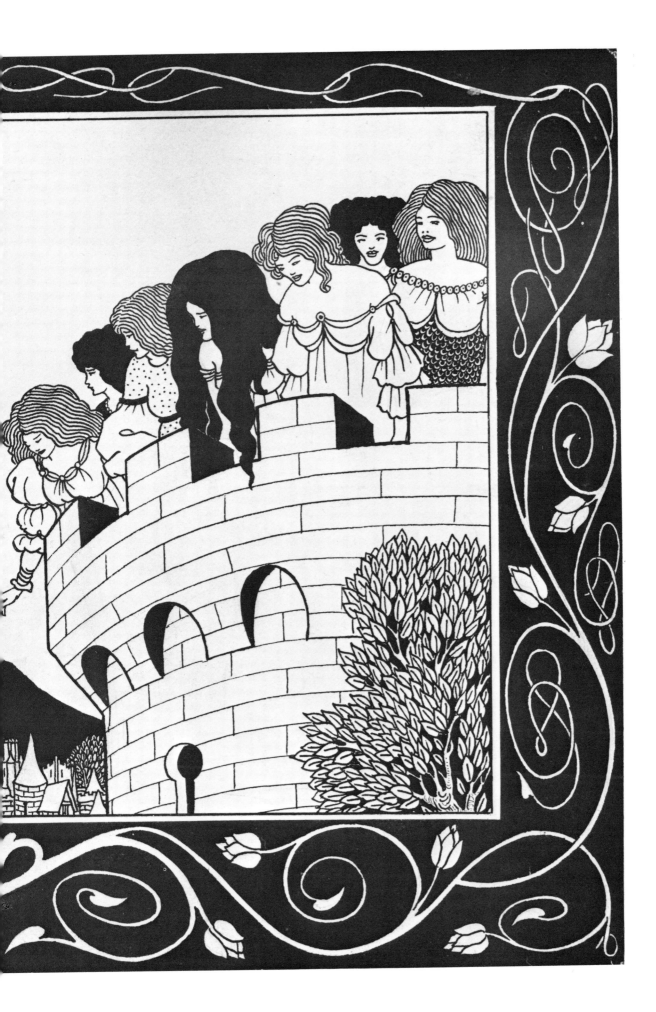

132 Chapter-heading for *Le Morte Darthur* (134)

133 Chapter-heading from *Le Morte Darthur* (133)

134 Border and initial N for *Le Morte Darthur* (132)

135 Chapter-heading for *Le Morte Darthur* (13

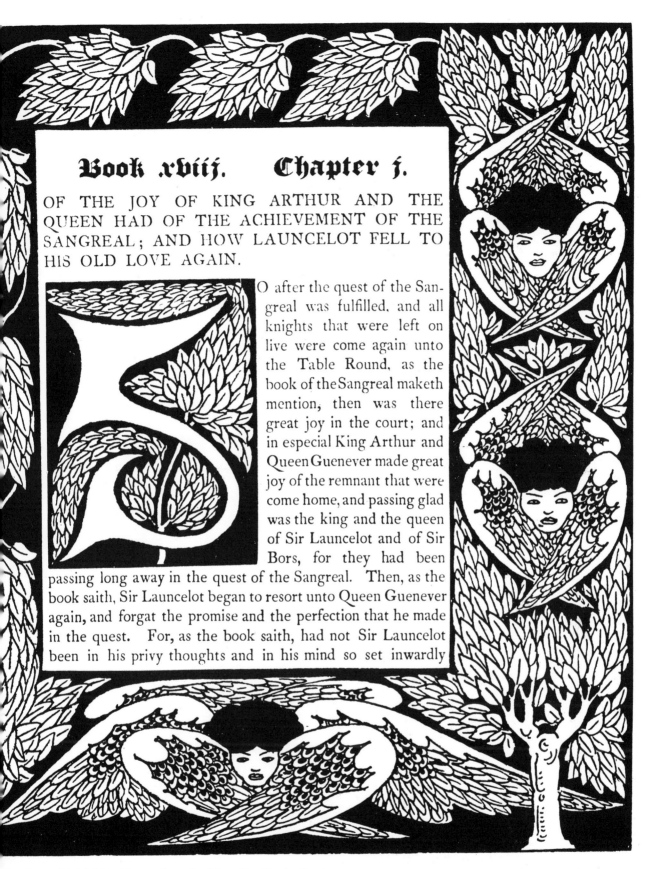

Book .xviij. Chapter .j.

OF THE JOY OF KING ARTHUR AND THE QUEEN HAD OF THE ACHIEVEMENT OF THE SANGREAL; AND HOW LAUNCELOT FELL TO HIS OLD LOVE AGAIN.

SO after the quest of the Sangreal was fulfilled, and all knights that were left on live were come again unto the Table Round, as the book of the Sangreal maketh mention, then was there great joy in the court; and in especial King Arthur and Queen Guenever made great joy of the remnant that were come home, and passing glad was the king and the queen of Sir Launcelot and of Sir Bors, for they had been passing long away in the quest of the Sangreal. Then, as the book saith, Sir Launcelot began to resort unto Queen Guenever again, and forgat the promise and the perfection that he made in the quest. For, as the book saith, had not Sir Launcelot been in his privy thoughts and in his mind so set inwardly

Border and initial S with text from *Le Morte Darthur* (136)

137 How Queen Guenever rode
on Maying, for *Le Morte Darthur* (141)

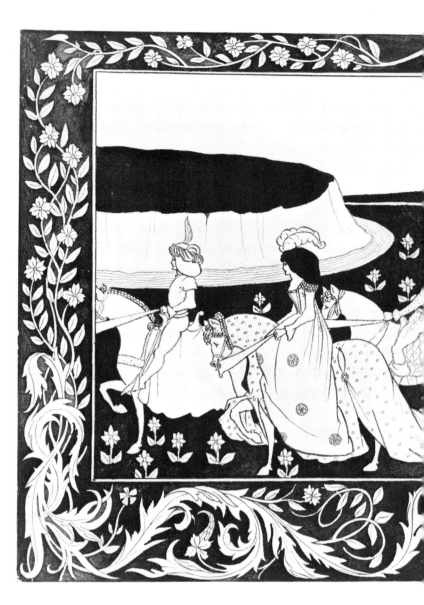

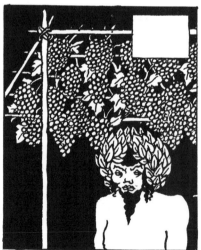

139 Chapter-heading for
Le Morte Darthur (138)

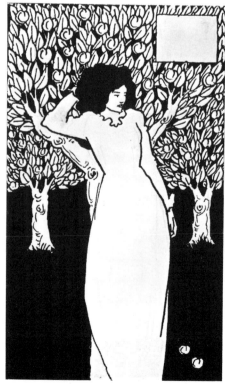

138 Chapter-heading for *Le Morte Darthur* (140)

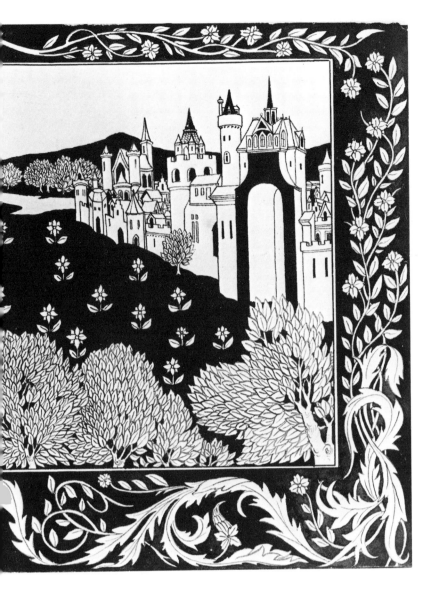

140 Chapter-heading from
Le Morte Darthur (137)

141 Chapter-heading from *Le Morte Darthur* (139)

142 Chapter-heading for *Le Morte Darthur* (145)

143 Chapter-heading from *Le Morte Darthur*

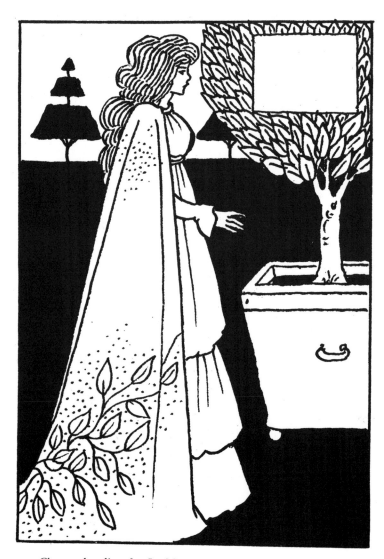

144 Chapter-heading for *Le Morte Darthur* (148)

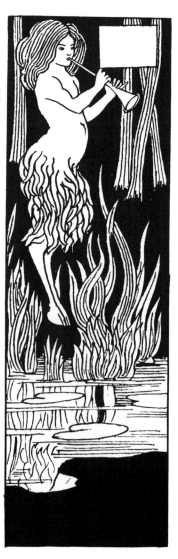

145 Chapter-heading for *Le Morte Darthur*

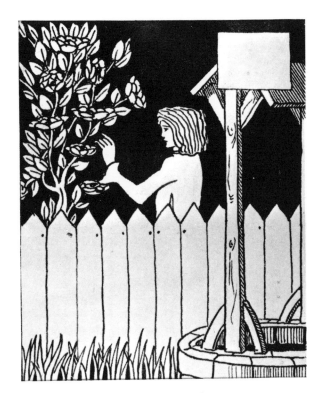

146 Chapter-heading for *Le Morte Darthur* (142)

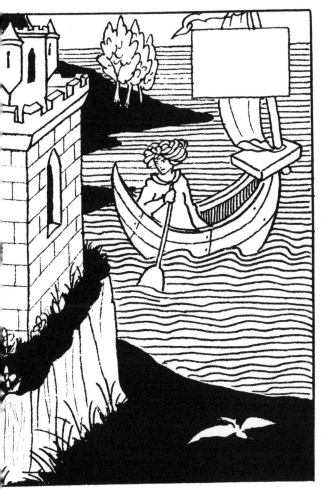

Chapter-heading for *Le Morte Darthur* (147)

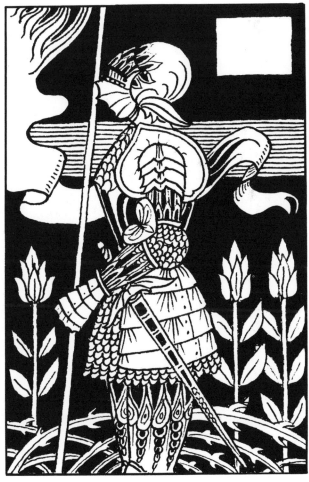

148 Chapter-heading for *Le Morte Darthur* (146)

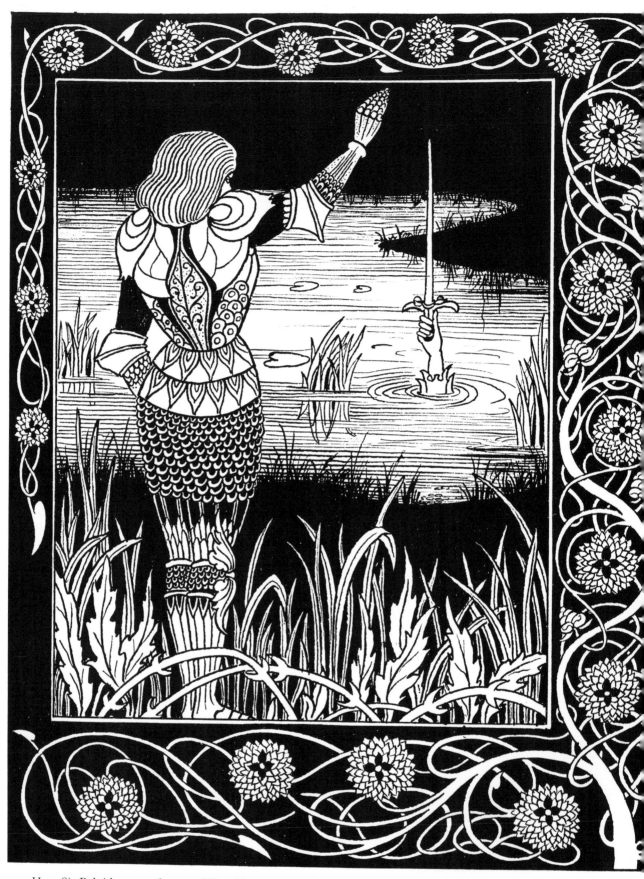

149 How Sir Belvidere cast the sword Excalibur into the water, for *Le Morte Darthur* (149)

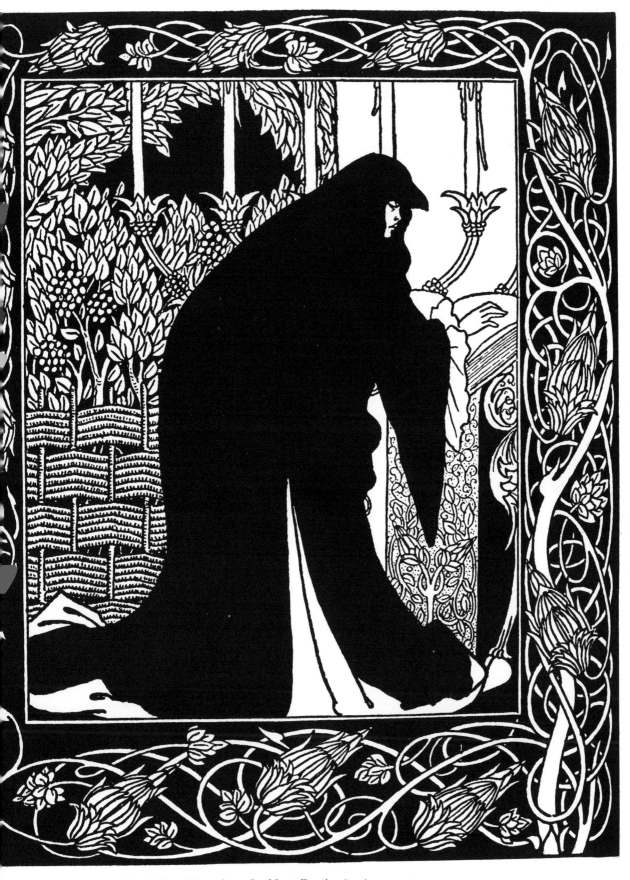

How Queen Guenever Made Her a Nun, from *Le Morte Darthur* (150)

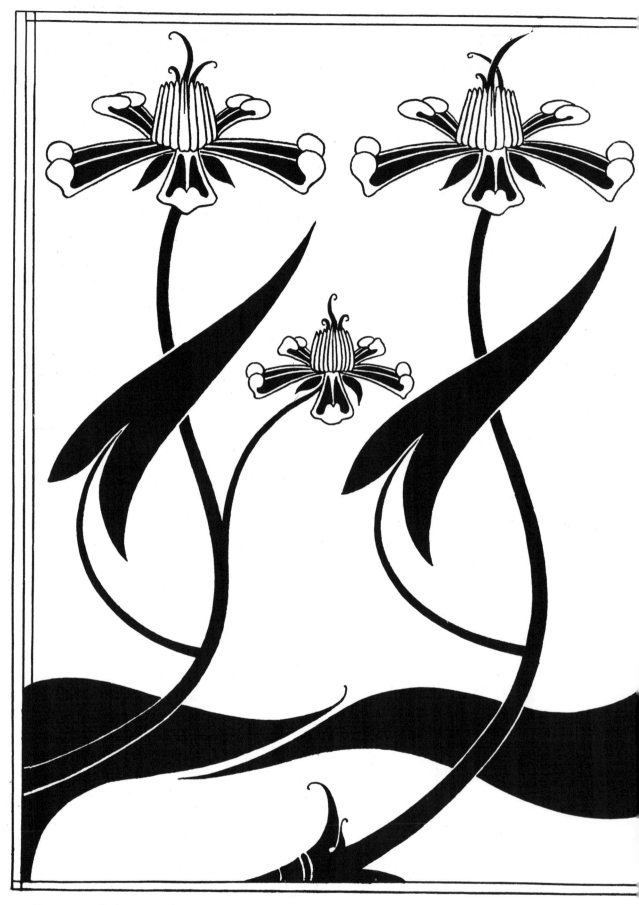

151 Front cover design on the bound volumes of *Le Morte Darthur* (151)

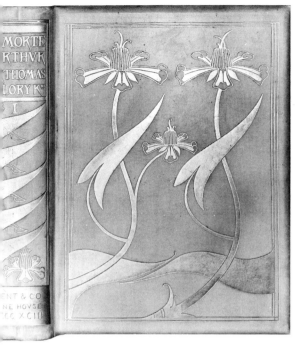

Front cover and spine of *Le Morte Darthur* (152)

153 Chapter-heading for
Le Morte Darthur (1909) (155)

Chapter-heading for *Le Morte Darthur* (1909) (154)

155 Chapter-heading for *Le Morte Darthur* (1909) (153)

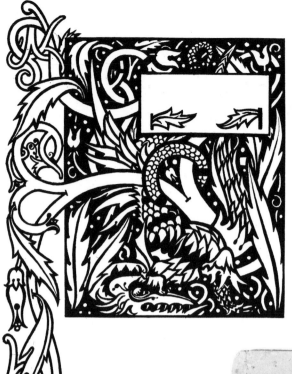

156 Chapter-heading for *Le Morte Darthur* (1927) (158)

157 Grotesque figure of a man
wearing a monocle (163)

158 Unfinished drawing for border for *Le Morte Darthur* (161)

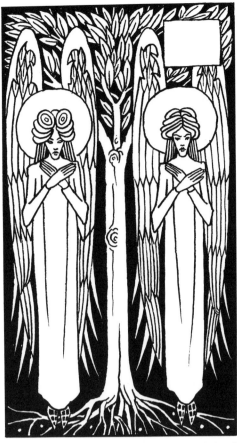

159 Chapter-heading for *Le Morte Darthur* (1909) (156)

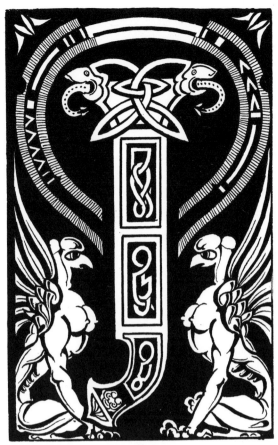

160 Initial J ascribed to Beardsley (160)

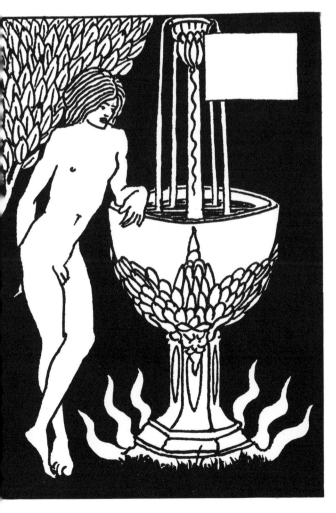

Chapter-heading (not used) for *Le Morte Darthur* (159)

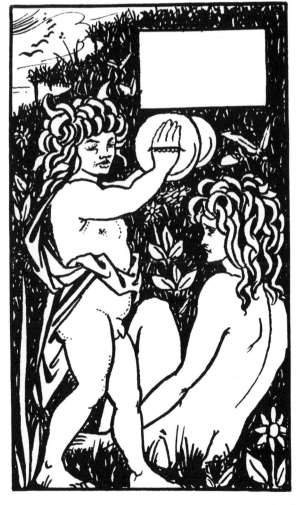

162 Chapter-heading for *Le Morte Darthur* (1909) (157)

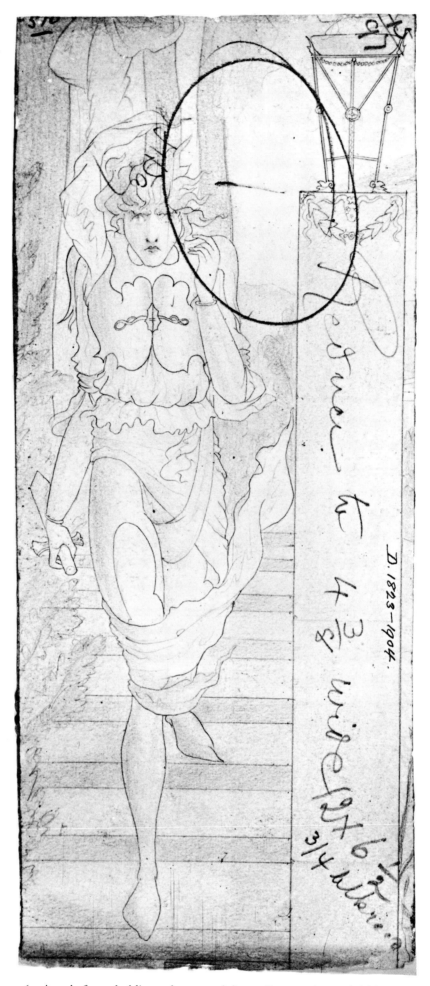

163 A male figure holding a dagger and descending a staircase (162)

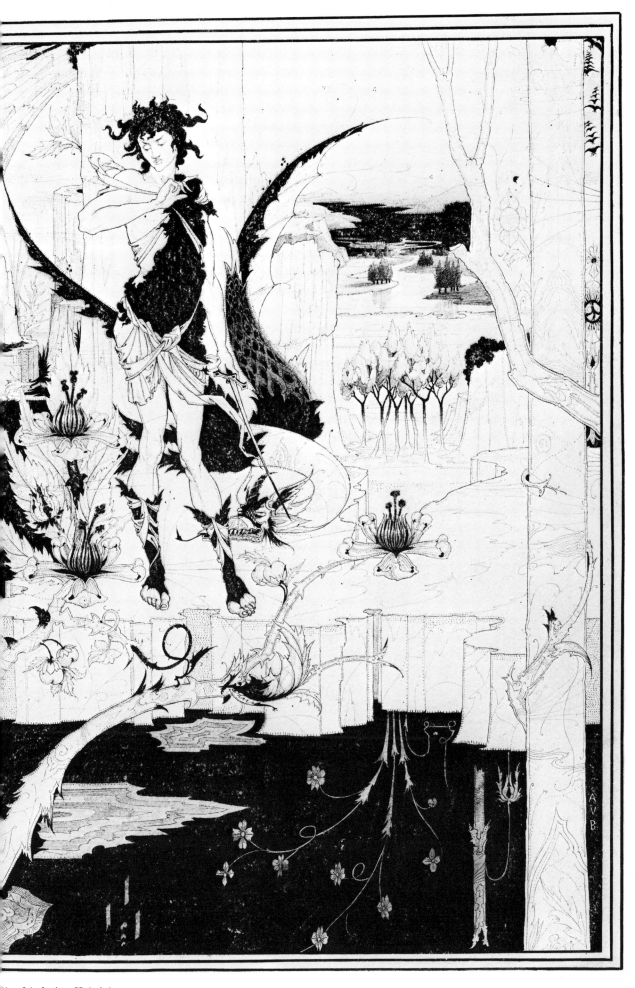

Siegfried, Act II (164)

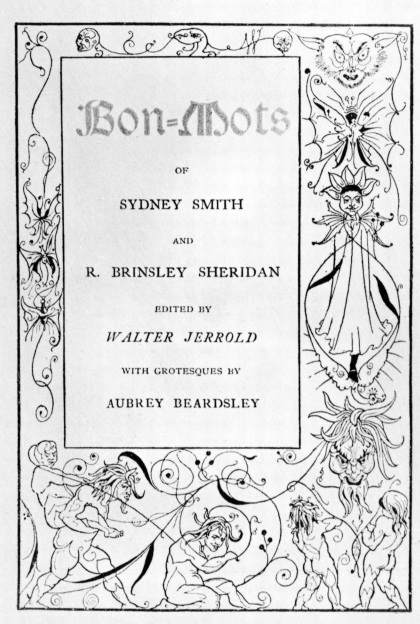

165 Title-page of *Bon-Mots* of Smith and Sheridan (165)

166 Vignette in *Bon-Mots* of Smith and Sheridan (167)

167 Vignette in *Bon-Mots* of Smith and Sheridan (166)

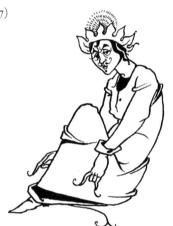

168 Vignette in *Bon-Mots* of Smith and Sheridan (168)

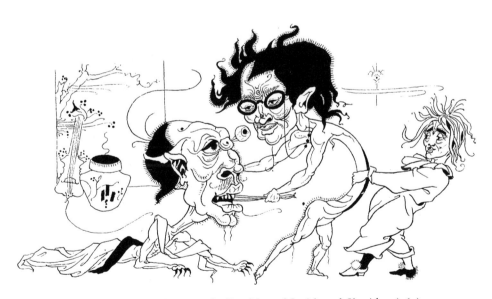

169 Vignette in *Bon-Mots* of Smith and Sheridan (169)

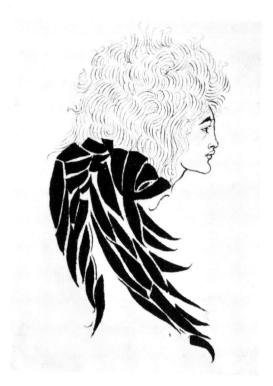

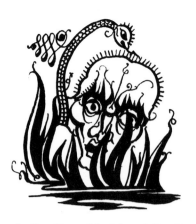

171 Vignette in *Bon-Mots* of Smith and Sheridan (173)

170 Vignette in *Bon-Mots* of Smith and Sheridan (170)

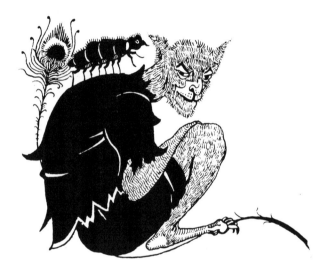

172 Vignette in *Bon-Mots* of Smith and Sheridan (171)

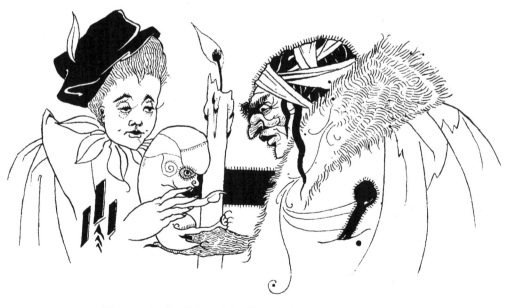

173 Vignette in *Bon-Mots* of Smith and Sheridan (172)

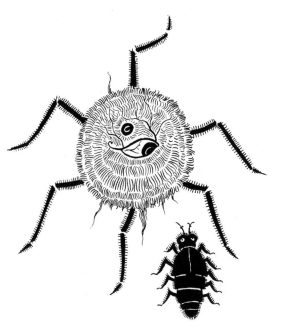

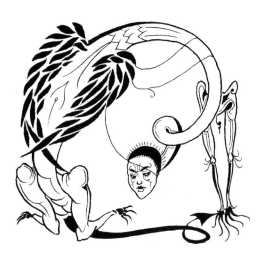

174 Vignette in *Bon-Mots* of Smith and Sheridan (176)

175 Vignette in *Bon-Mots* of Smith and Sheridan (175)

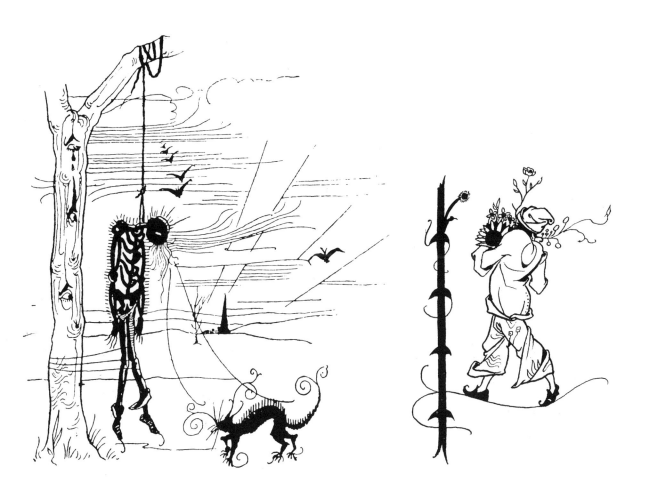

176 Vignette in *Bon-Mots* of Smith and Sheridan (174)

177 Vignette in *Bon-Mots* of Smith and Sheridan (177)

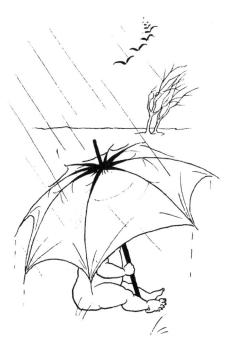

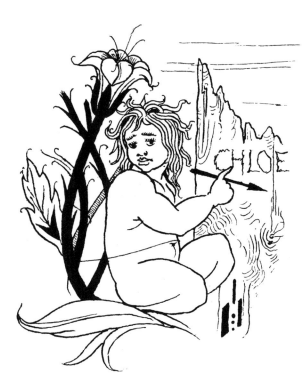

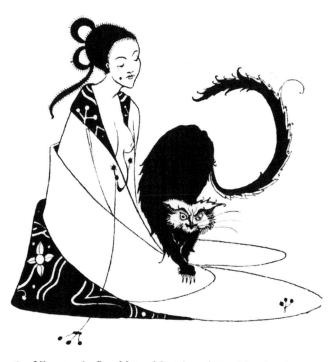

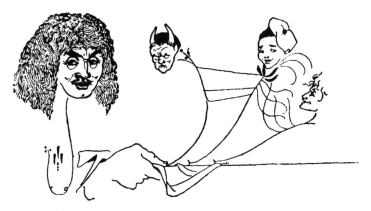

182 Vignette in *Bon-Mots* of Smith and Sheridan (183)

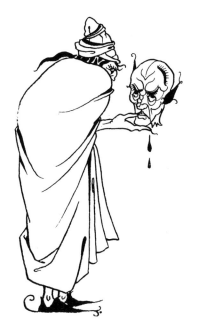

183 Vignette in *Bon-Mots* of Smith and Sheridan (181)

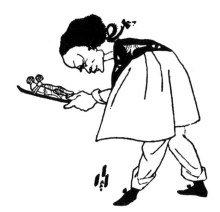

184 Vignette in *Bon-Mots* of Smith and Sheridan (178)

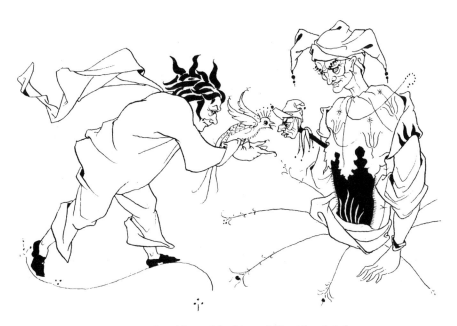

185 Vignette in *Bon-Mots* of Smith and Sheridan (180)

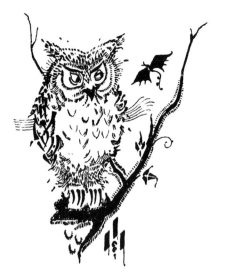

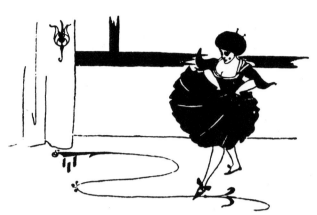

186 Vignettes in *Bon-Mots* of Smith and Sheridan (188)

187 Vignette in *Bon-Mots* of Smith and Sheridan (186)

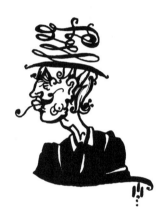

188 Vignette in *Bon-Mots* of Smith and Sheridan (189)

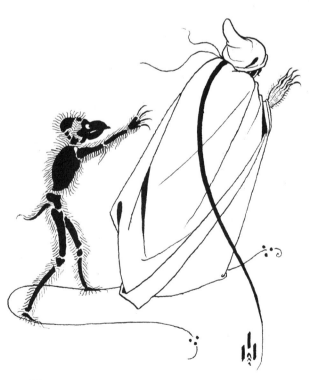

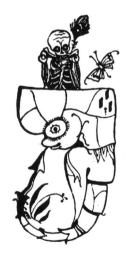

189 Vignette in *Bon-Mots* of Smith and Sheridan (195)

190 Vignette in *Bon-Mots* of Smith and Sheridan (187)

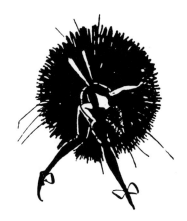

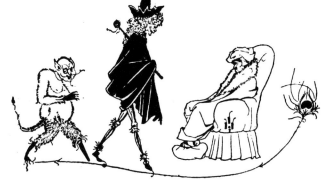

191 Vignette in *Bon-Mots* of Smith and Sheridan (194) 192 Vignette in *Bon-Mots* of Smith and Sheridan (193)

193 Vignette in *Bon-Mots* of Smith and Sheridan (191)

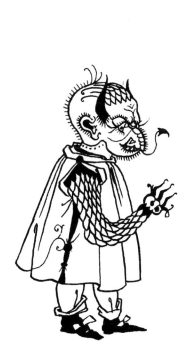

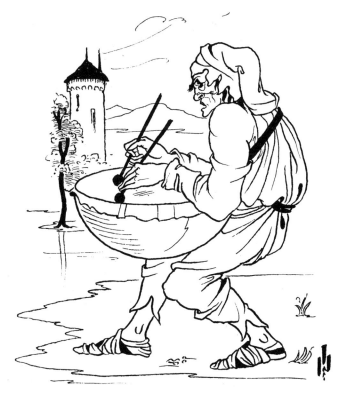

Vignette in *Bon-Mots* of Smith and Sheridan (192) 195 Vignette in *Bon-Mots* of Smith and Sheridan (190)

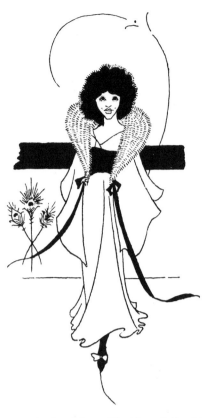

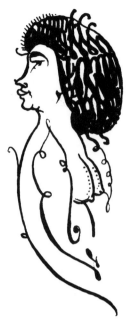

197 Vignette in *Bon-Mots* of Smith and Sheridan (

196 Vignette in *Bon-Mots* of Smith and Sheridan (196)

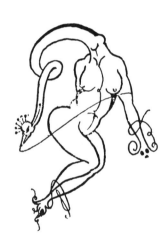

198 Vignette in *Bon-Mots* of Smith and Sheridan (

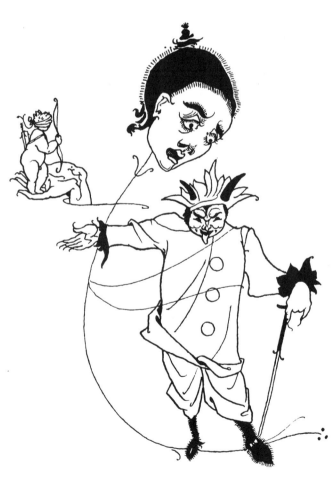

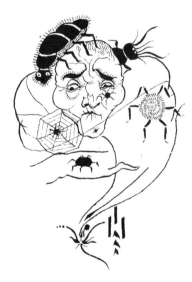

199 Vignette in *Bon-Mots* of Smith and Sheridan (201)

200 Vignette in *Bon-Mots* of Smith and Sheridan (

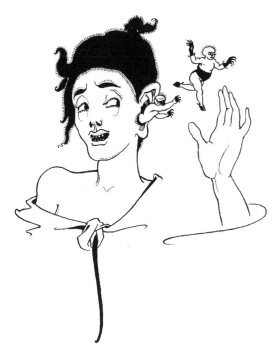

201 Vignette in *Bon-Mots* of Smith and Sheridan (203)

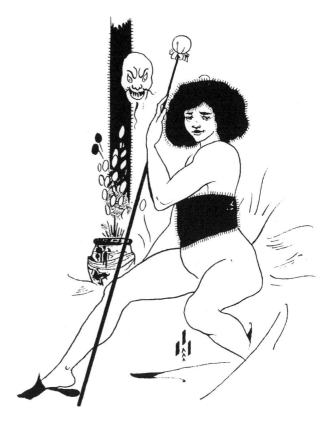

202 Vignette in *Bon-Mots* of Smith and Sheridan (202)

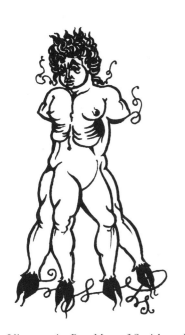

203 Vignette in *Bon-Mots* of Smith and Sheridan (200)

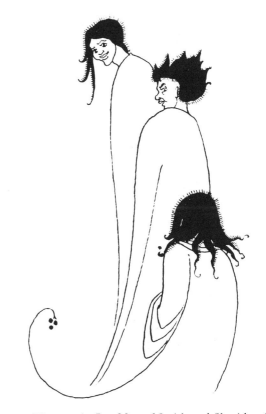

204 Vignette in *Bon-Mots* of Smith and Sheridan (204)

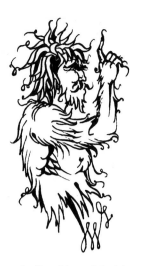

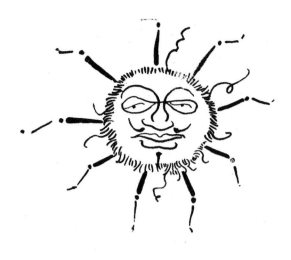

205 Vignette in *Bon-Mots* of Smith and Sheridan (205)

206 Vignette in *Bon-Mots* of Smith and Sheridan (208)

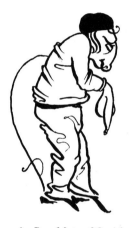

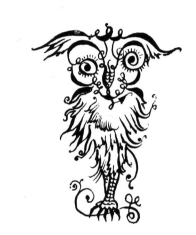

207 Vignette in *Bon-Mots* of Smith and Sheridan (209)

208 Vignette in *Bon-Mots* of Smith and Sheridan (207)

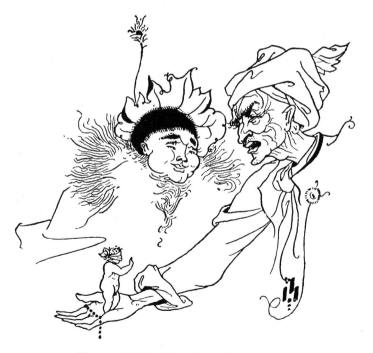

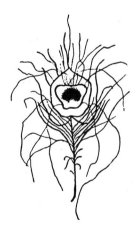

209 Vignette in *Bon-Mots* of Smith and Sheridan (206)

210 Vignette in *Bon-Mots* of Smith and Sheridan (214)

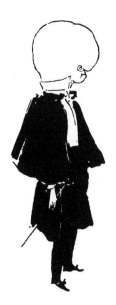

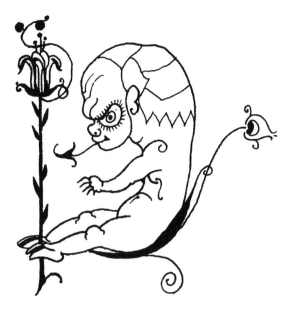

211 Vignette in *Bon-Mots* of Lamb and Jerrold (216)

212 Vignette in *Bon-Mots* of Smith and Sheridan (215)

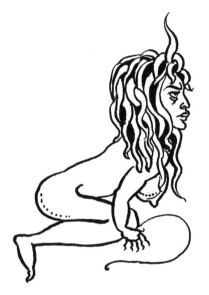

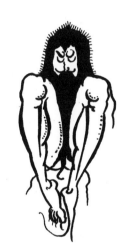

213 Vignette in *Bon-Mots* of Smith and Sheridan (211)

214 Vignette in *Bon-Mots* of Smith and Sheridan (210)

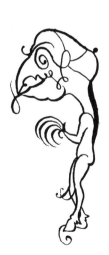

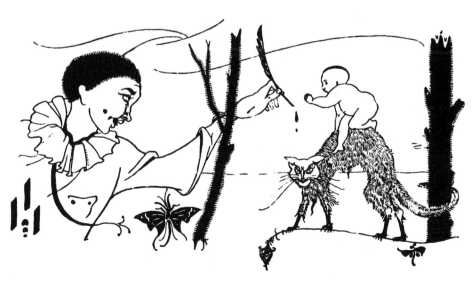

215 Vignette in *Bon-Mots* of Smith and Sheridan (212)

216 Vignette in *Bon-Mots* of Smith and Sheridan (213)

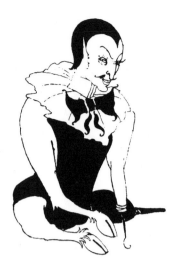

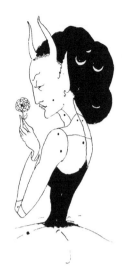

217 Vignette in *Bon-Mots* of Lamb and Jerrold (219) 218 Vignette in *Bon-Mots* of Lamb and Jerrold (2

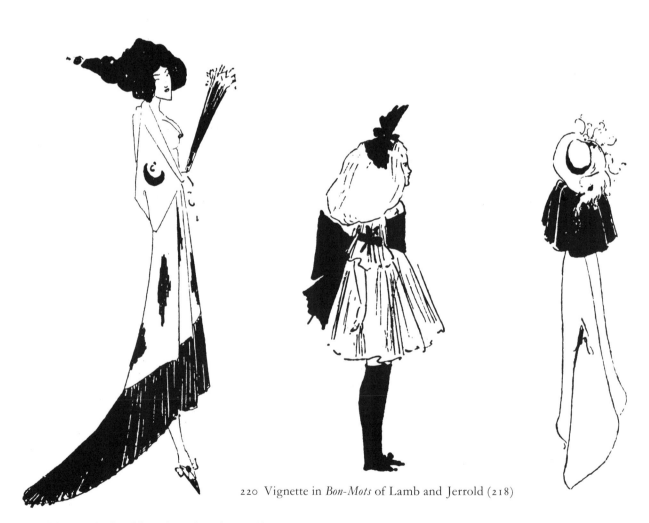

220 Vignette in *Bon-Mots* of Lamb and Jerrold (218)

219 Vignette in *Bon-Mots* of Lamb and Jerrold (217) 221 Vignette in *Bon-Mots* of Lamb and Jerrold (2

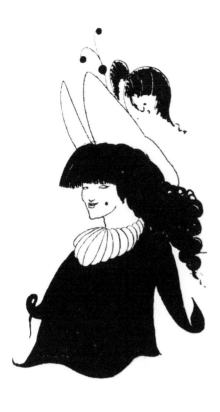

222 Vignette in *Bon-Mots* of Lamb and Jerrold (225)

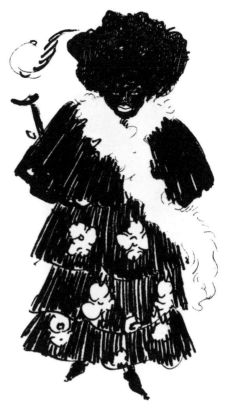

223 Vignette in *Bon-Mots* of Lamb and Jerrold (224)

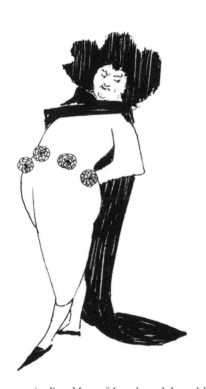

224 Vignette in *Bon-Mots* of Lamb and Jerrold (222)

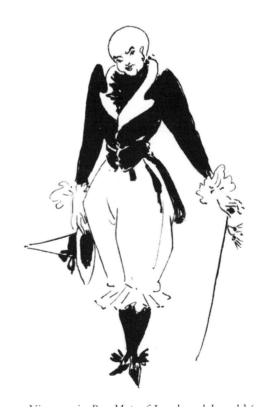

225 Vignette in *Bon-Mots* of Lamb and Jerrold (223)

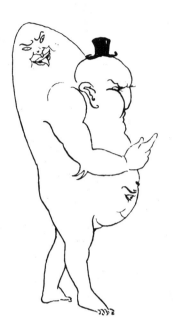

226 Vignette in *Bon-Mots* of Lamb and Jerrold (229)

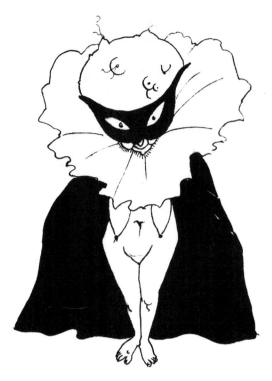

227 Vignette in *Bon-Mots* of Lamb and Jerrold (228)

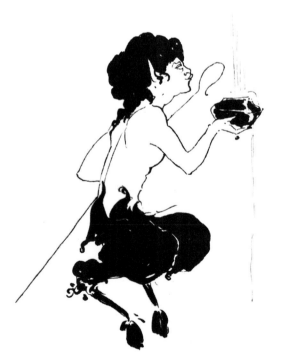

228 Vignette in *Bon-Mots* of Lamb and Jerrold (226)

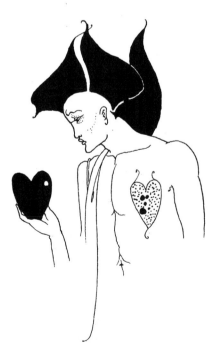

229 Vignette in *Bon-Mots* of Lamb and Jerrold (230)

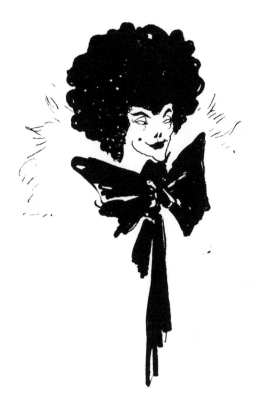

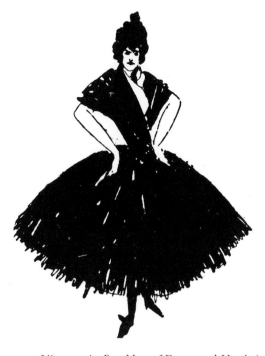

230 Vignette in *Bon-Mots* of Lamb and Jerrold (231)

231 Vignette in *Bon-Mots* of Foote and Hook (233)

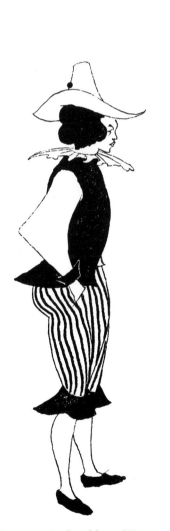

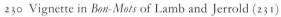

232 Grotesque with half-title in
Bon-Mots of Foote and Hook (232)

233 Grotesque in *Bon-Mots* of Foote and Hook (234)

234 Grotesque in *Bon-Mots* of Lamb and Jerrold (227)

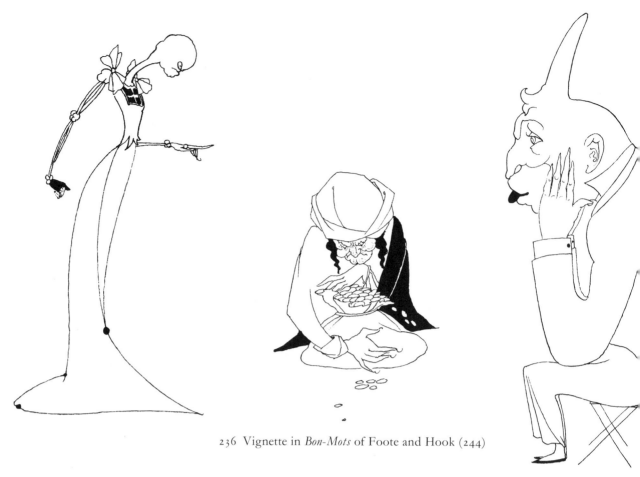

236 Vignette in *Bon-Mots* of Foote and Hook (244)

235 Vignette in *Bon-Mots* of Foote and Hook (237)

237 Vignette in *Bon-Mots* of Foote and Hook

238 Echo of Venice (236)

239 Grotesque in *Bon-Mots* of Foote and Hook

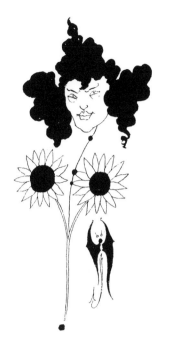

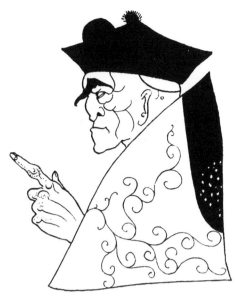

240 Vignette in *Bon-Mots* of Foote and Hook (243)

241 Grotesque in *Bon-Mots* of Foote and Hook (240)

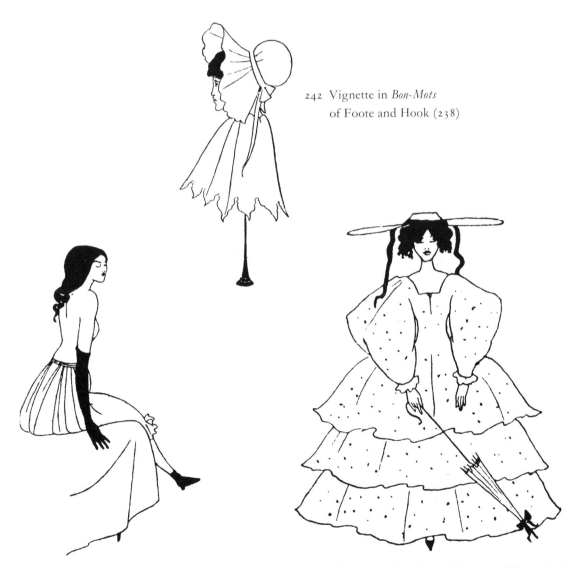

242 Vignette in *Bon-Mots*
of Foote and Hook (238)

243 Vignette in *Bon-Mots* of Foote and Hook (242)

244 Vignette in *Bon-Mots* of Foote and Hook (241)

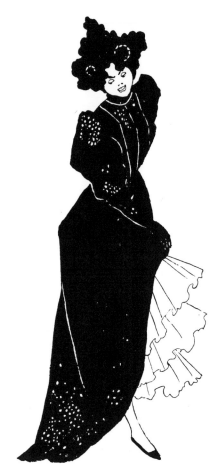

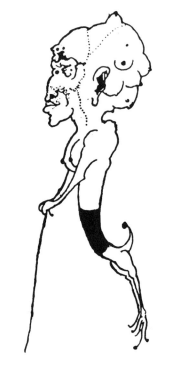

245 Grotesque in *Bon-Mots* of Foote and Hook (245)

246 Vignette in *Bon-Mots* of Foote and Hook (24€

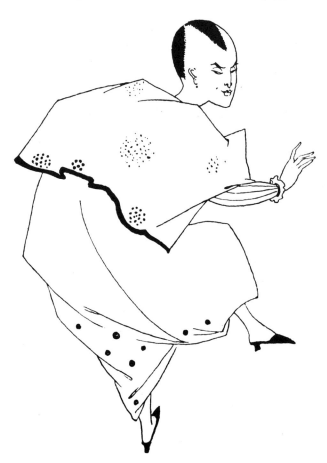

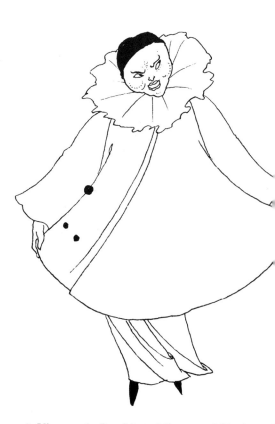

247 Grotesque in *Bon-Mots* of Foote and Hook (247)

248 Vignette in *Bon-Mots* of Foote and Hook (248

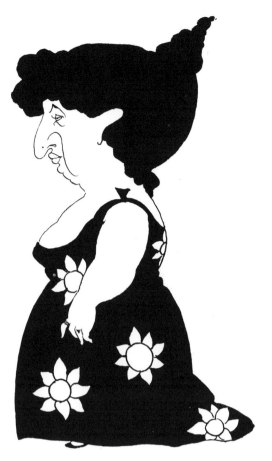

249 Vignette in *Bon-Mots* of Foote and Hook (250)

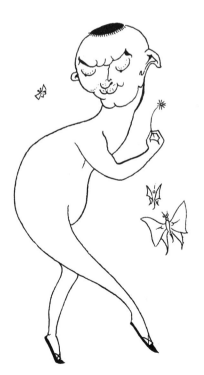

250 Vignette intended for the *Bon-Mots* series (not used) (251)

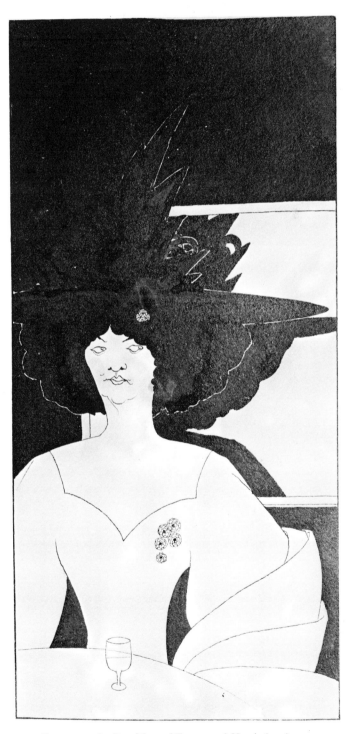

251 Grotesque in *Bon-Mots* of Foote and Hook (249)

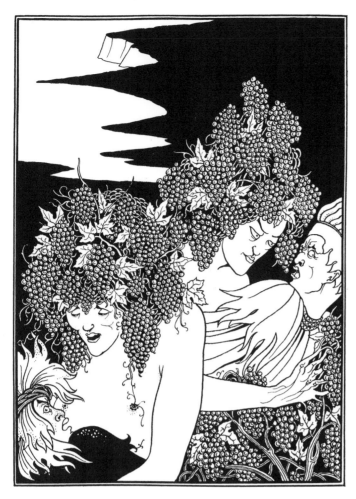

252 A Snare of Vintage, for *Lucian's True History* (254)

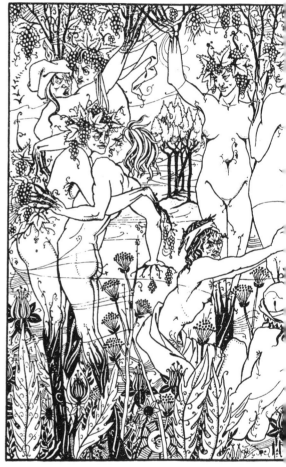

253 A Snare of Vintage, from *Lucian's True History* (2

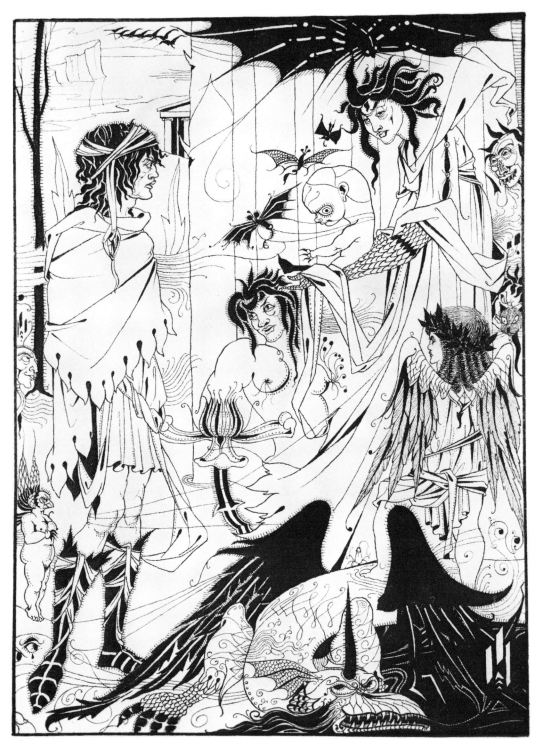

254 Dreams, for *Lucian's True History* (256)

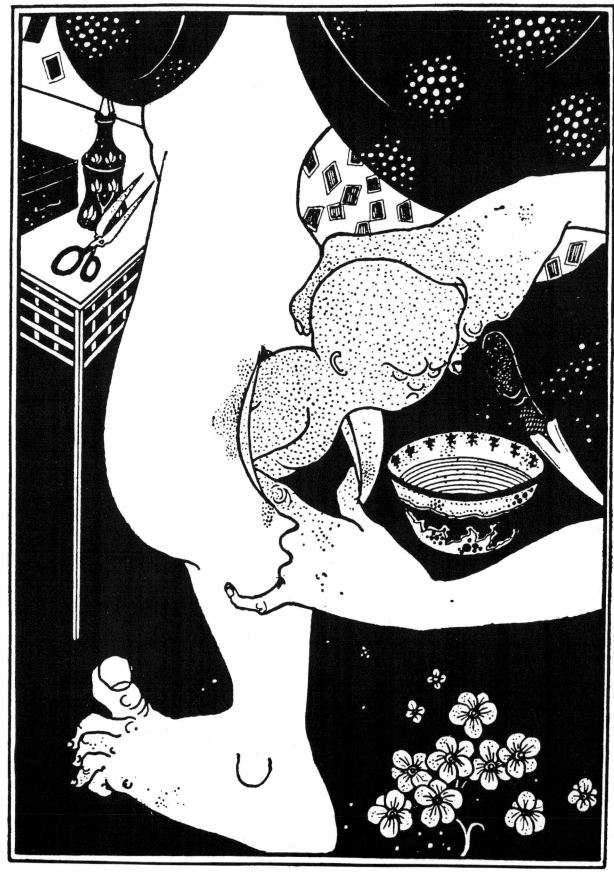

255 Birth from the Calf of the Leg, for *Lucian's True History* (not used) (258)

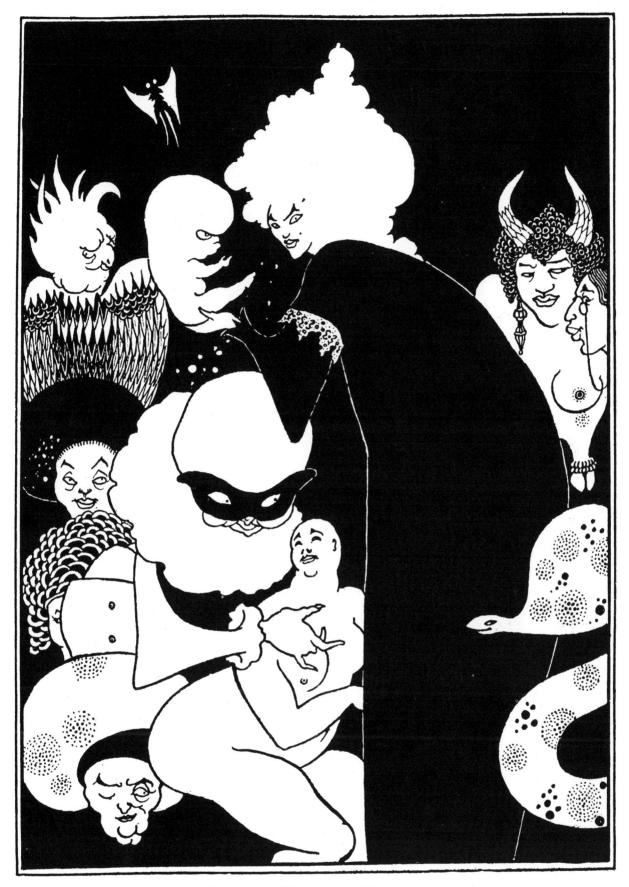

256 Lucian's Strange Creatures, for *Lucian's True History* (not used) (257)

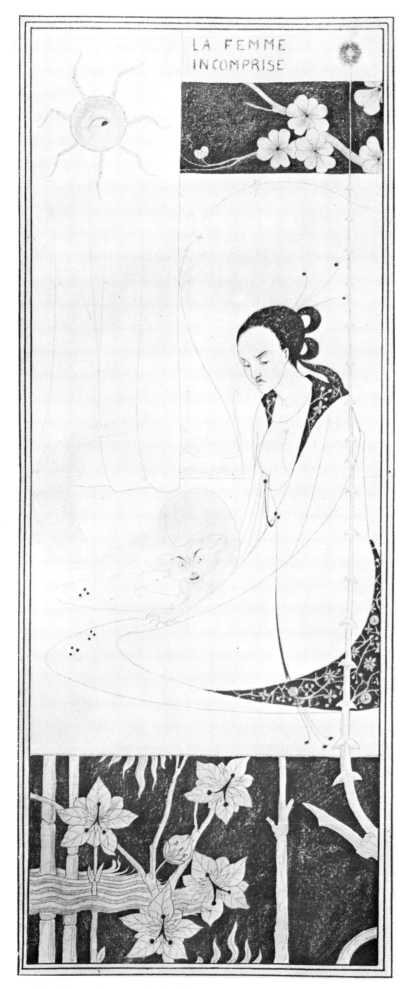

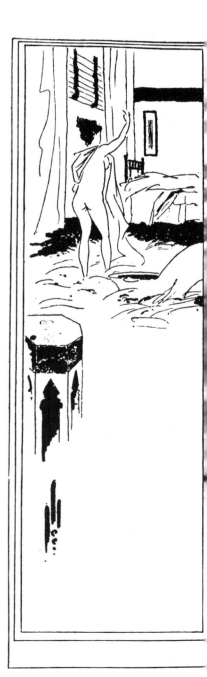

257 La Femme Incomprise (252)

258 Design for a book-marker (253)

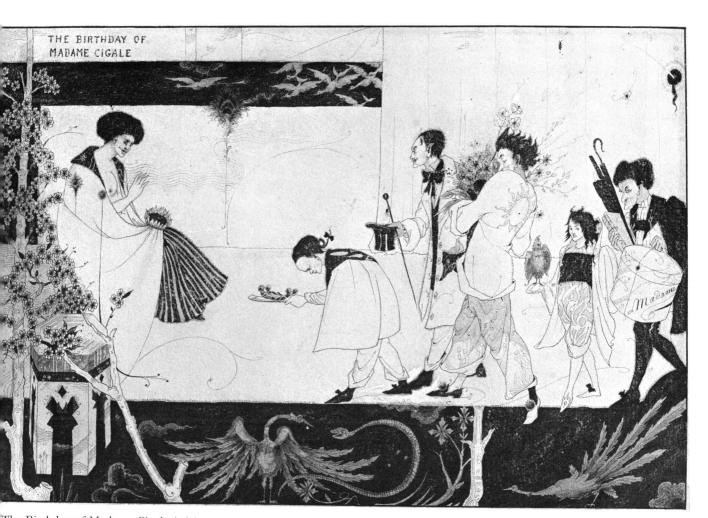

The Birthday of Madame Cigale (260)

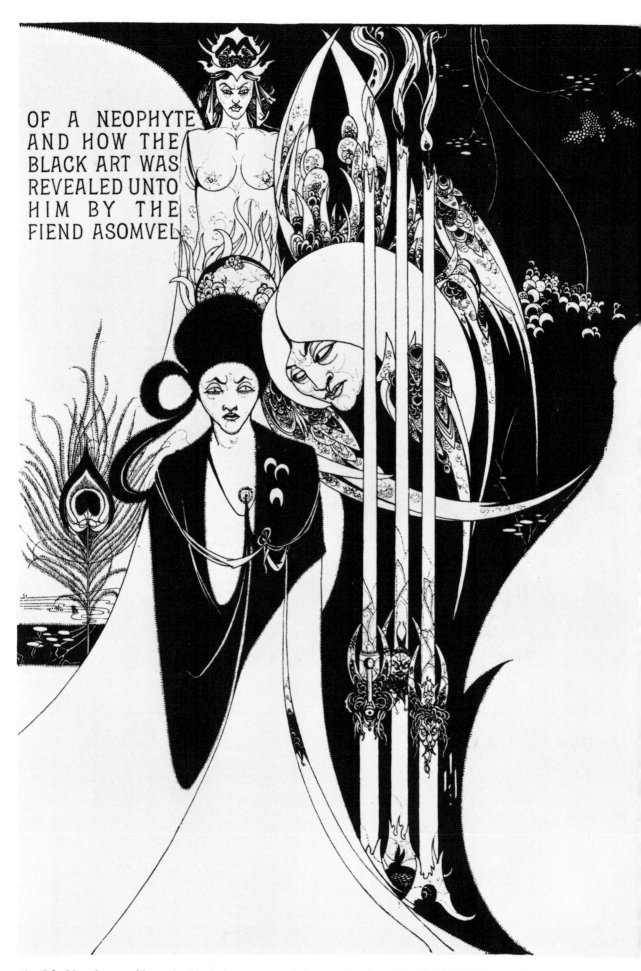

OF A NEOPHYTE
AND HOW THE
BLACK ART WAS
REVEALED UNTO
HIM BY THE
FIEND ASOMVEL

260 Of a Neophyte and how the Black Art was revealed unto him, from *The Pall Mall Magazine* (262)

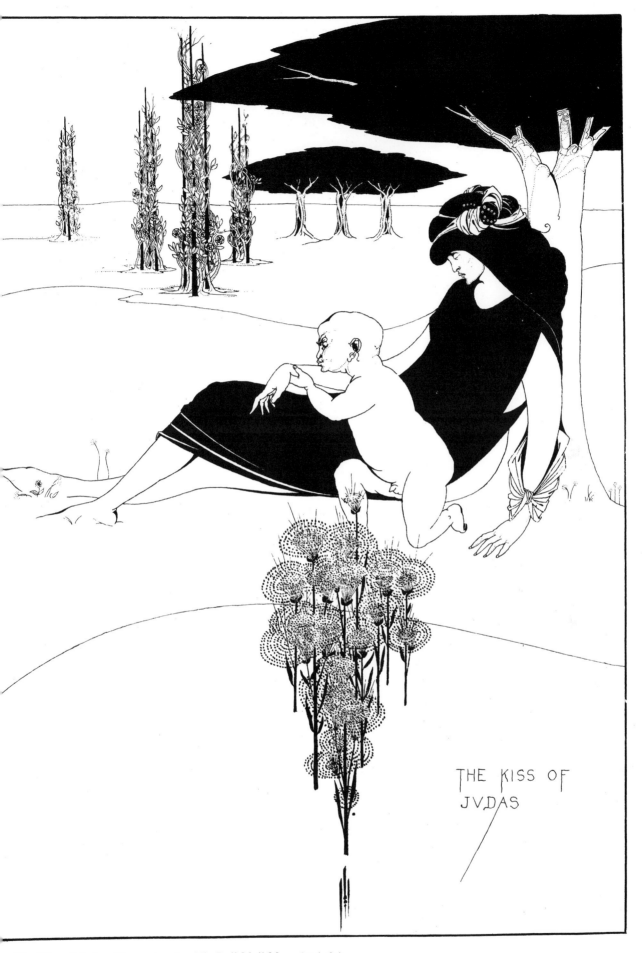

THE KISS OF
JVDAS

1 The Kiss of Judas, illustration for *The Pall Mall Magazine* (263)

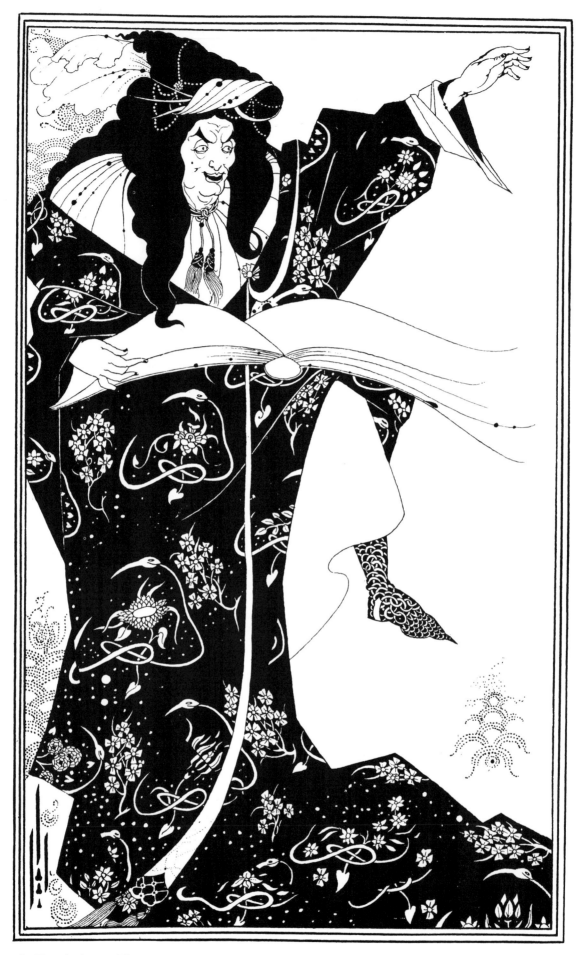

262 Frontispiece to *The Wonderful History of Virgilius the Sorcerer of Rome* (267)

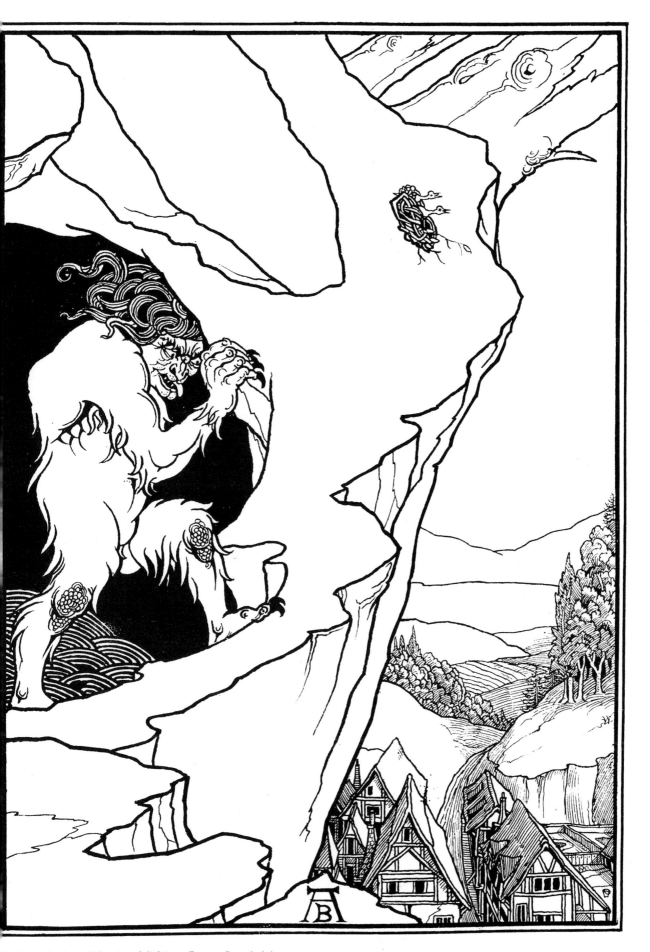

63 Frontispiece (The Landslide) to *Pastor Sang* (264)

VOL. I. NO. 1.

APRIL, 189

THE STUDIO

AN ILLVSTRATED MAGAZINE OF FINE AND APPLIED ART.

Artists as Craftsmen. No. I.
Sir Frederic Leighton as a Modeller.

The Growth of Recent Art.
By R. A. M. STEVENSON.

A New Illustrator: Aubrey
Beardsley. By JOSEPH PENNELL.

Spitalfields Brocades.
By LASENBY LIBERTY.

Designing for Book-plates.

Spain as a Sketching Ground.
By FRANK BRANGWYN.

The Newlyn Point of View.

The Grafton Gallery.
By C. W. FURSE.

News of the Month. Reviews. &c. &c.

With Auto-lithograph (33 × 15),
" *WEED BURNERS IN THE FENS.*"
By R. W. MACBETH, A.R.A.

SIXPENCE

OFFICES: 16 HENRIETTA ST.,
COVENT GARDEN, LONDON

MONTHLY

Annual Subscription, Seven Shillings and Sixpence, Post Fre

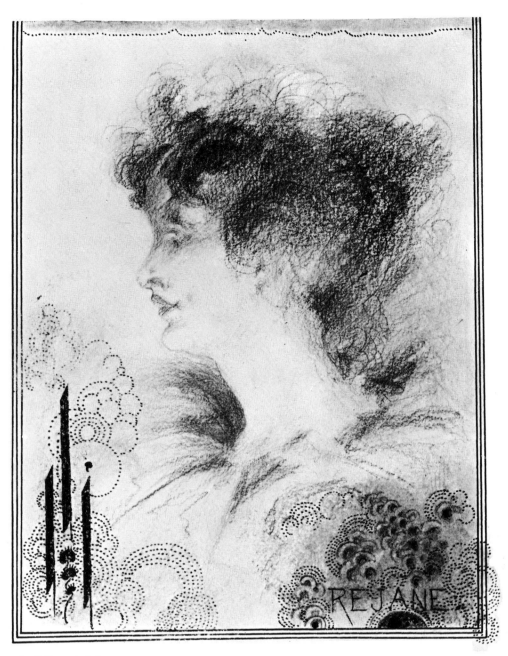

265 Réjane (265)

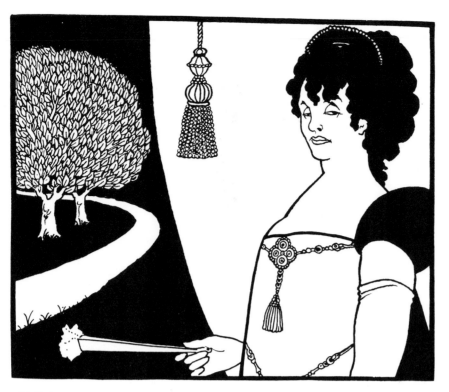

266 Réjane (266)

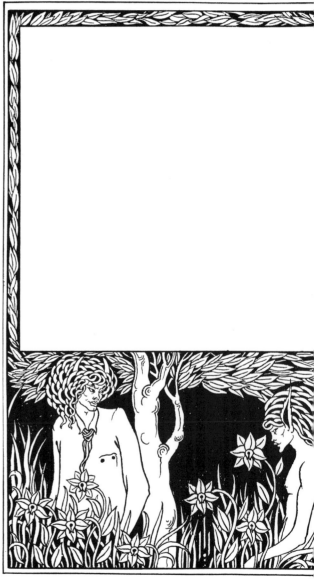

267 Title-page to *Pagan Papers* (268)

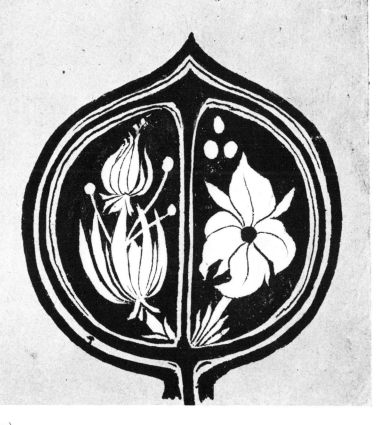

8 Drawings on the cover of *Tristan und Isolde* (270)

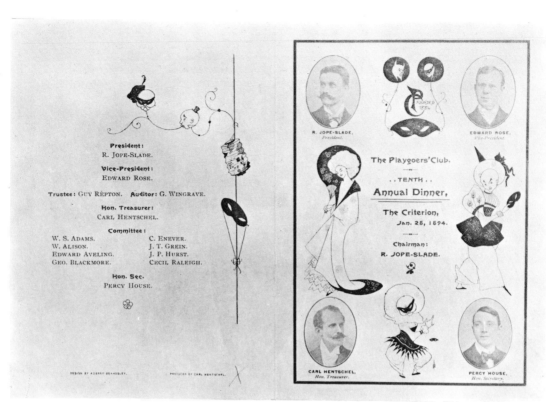

269 The Playgoers' Club Menu (271)

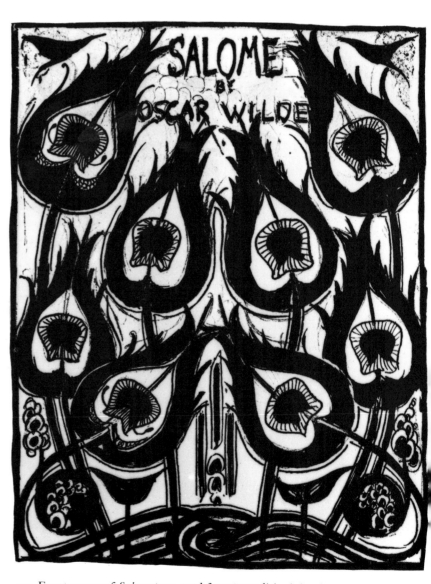

270 Front cover of *Salome* (not used for 1894 edition) (272)

1 Front cover of *Salome* (273)

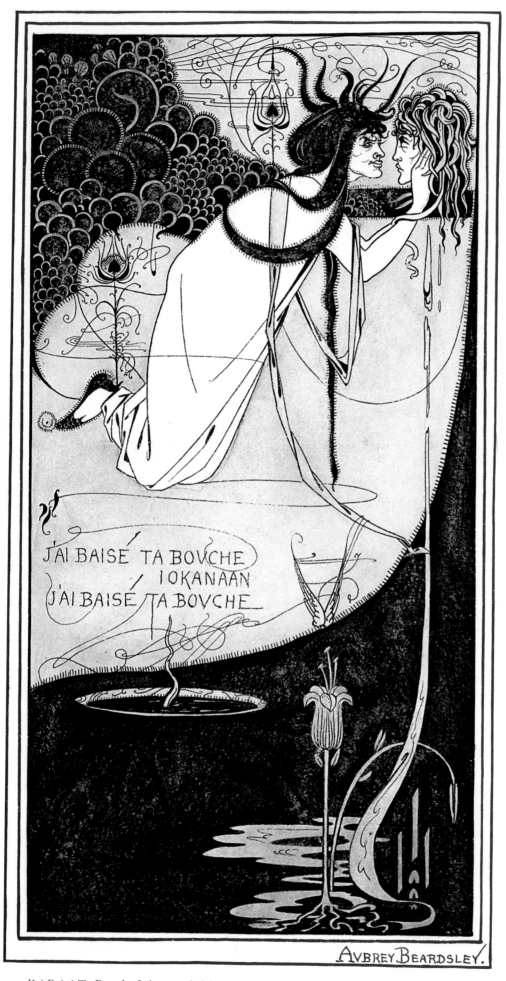

272 J'ai Baisé Ta Bouche Iokanaan (261)

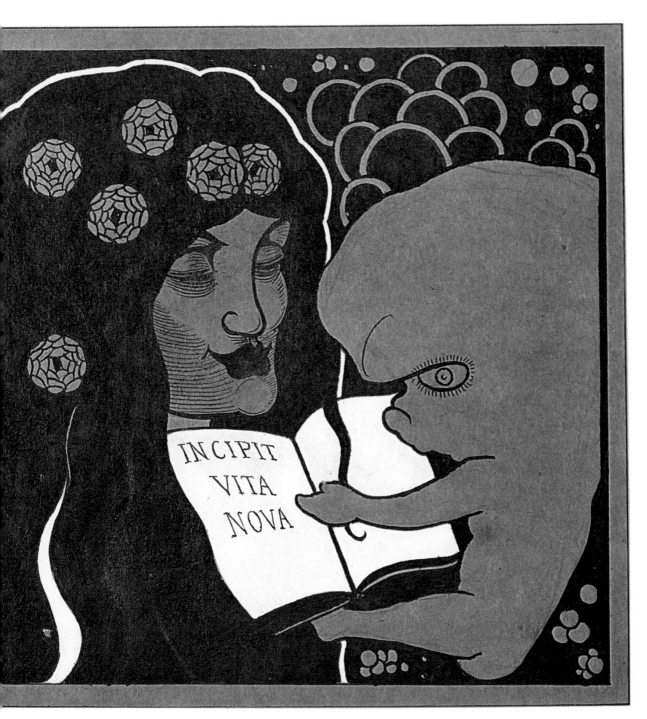

Incipit Vita Nova (269)

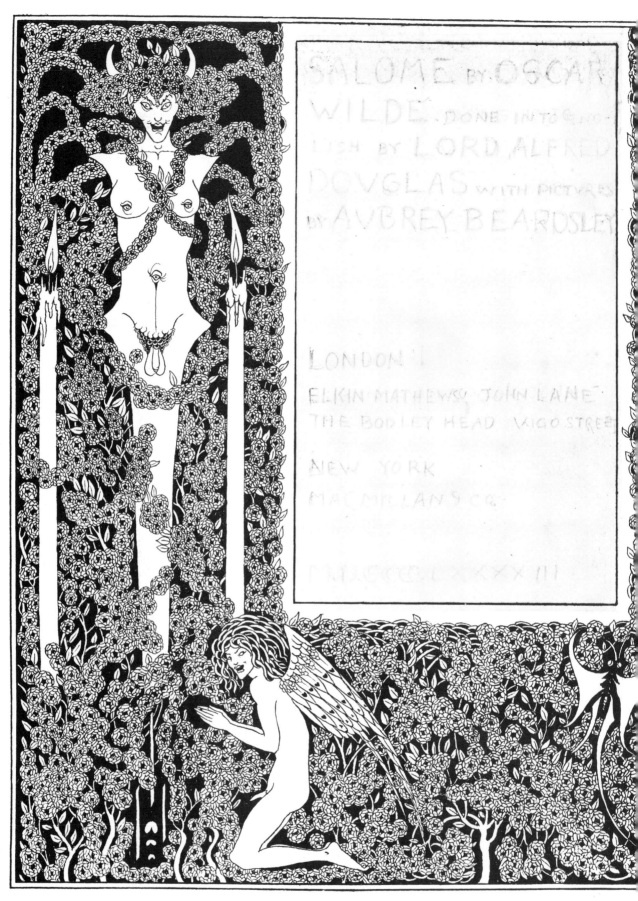

274 Title-page (274)

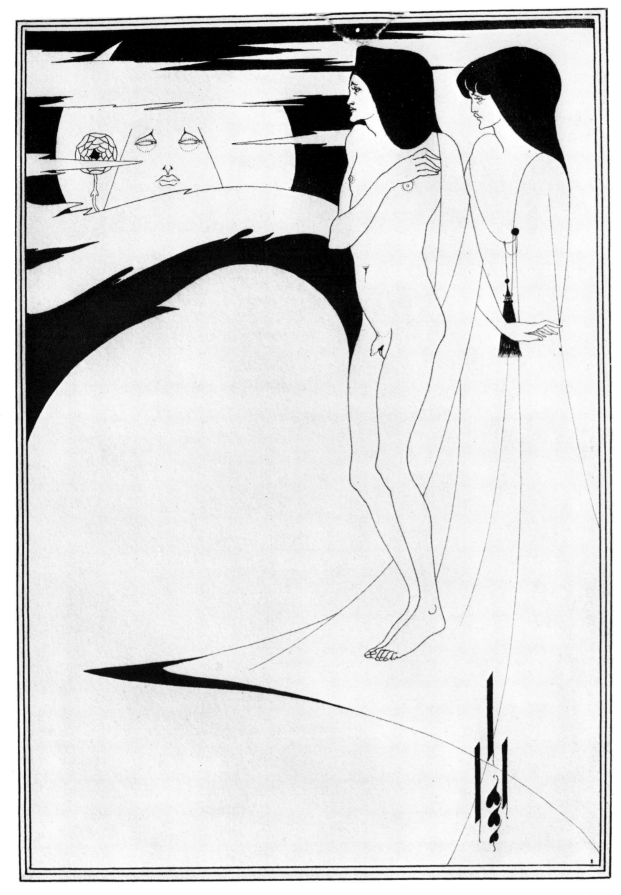

275 The Woman in the Moon (Frontispiece) (275)

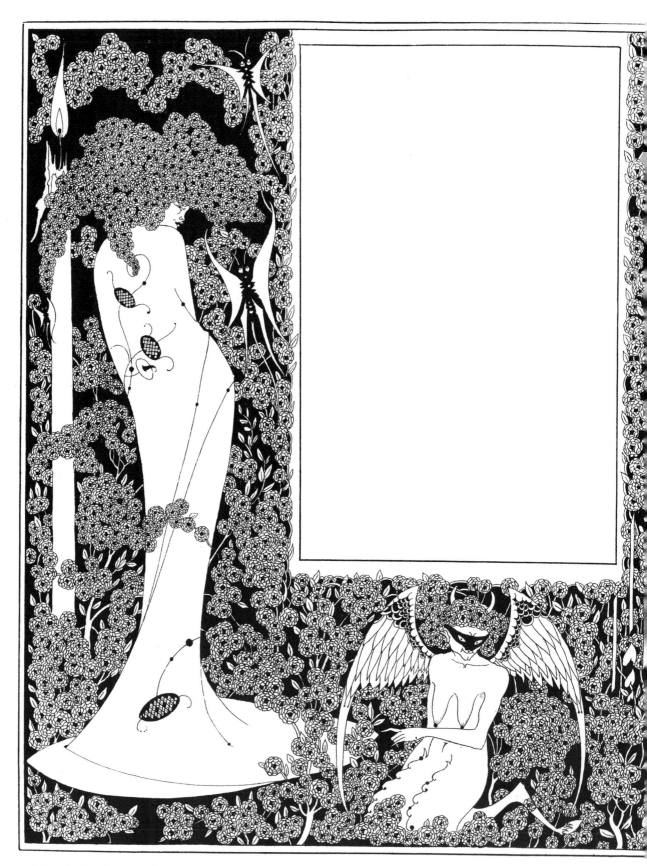

276 Border for the List of Pictures (276)

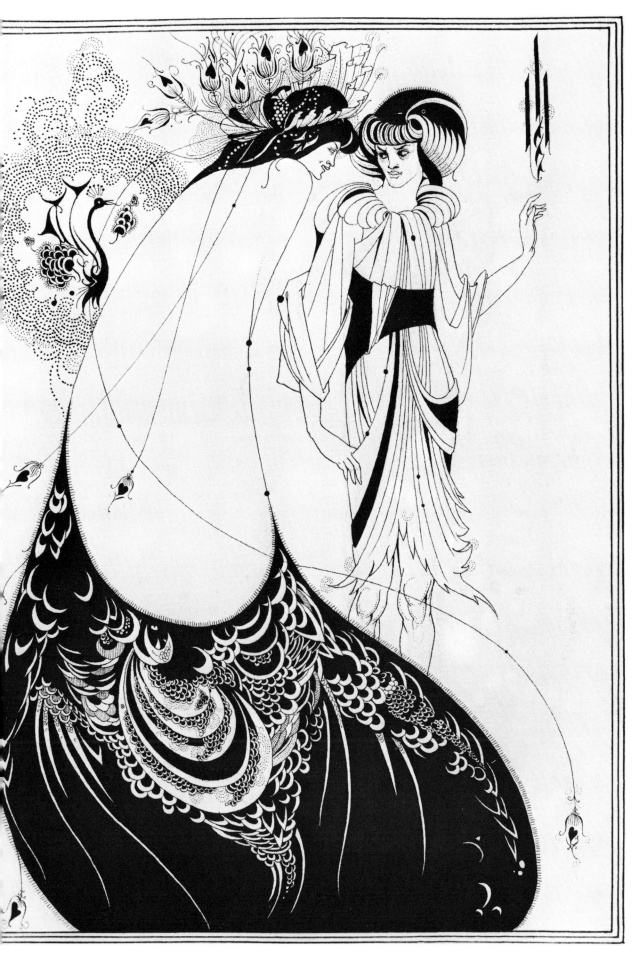

The Peacock Skirt (277)

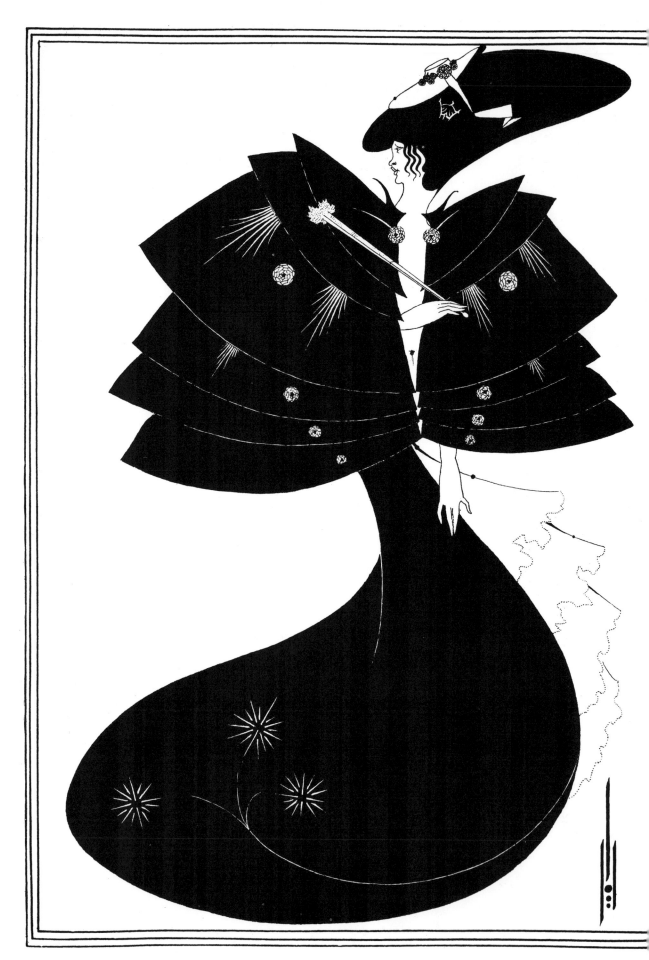

278 The Black Cape (278)

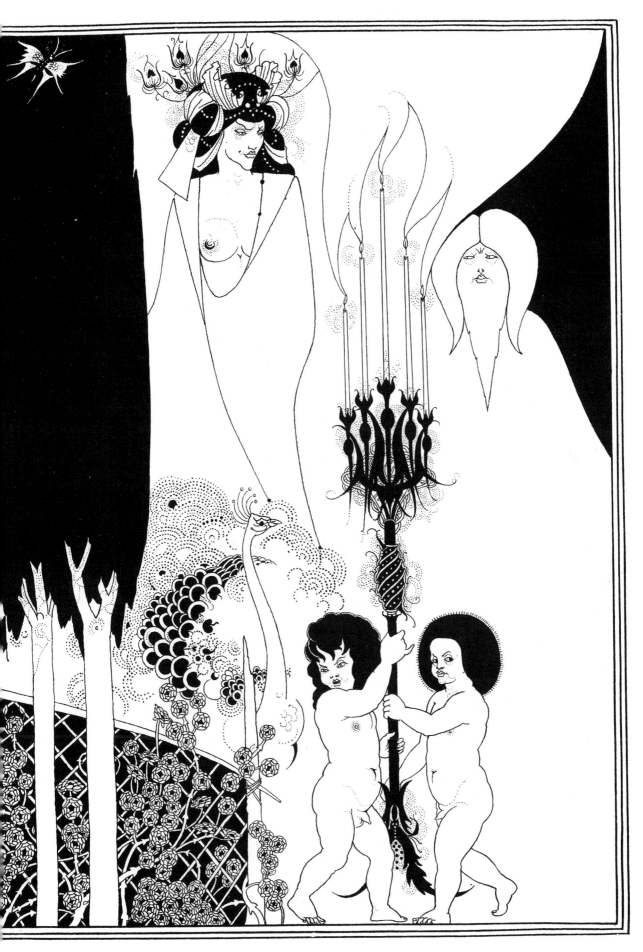

The Eyes of Herod (279)

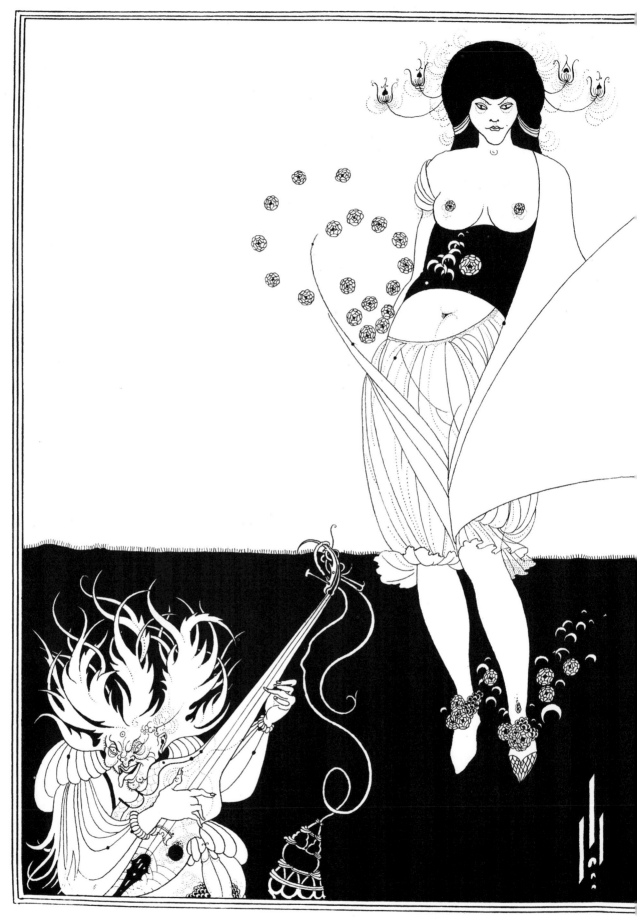

280 The Stomach Dance (280)

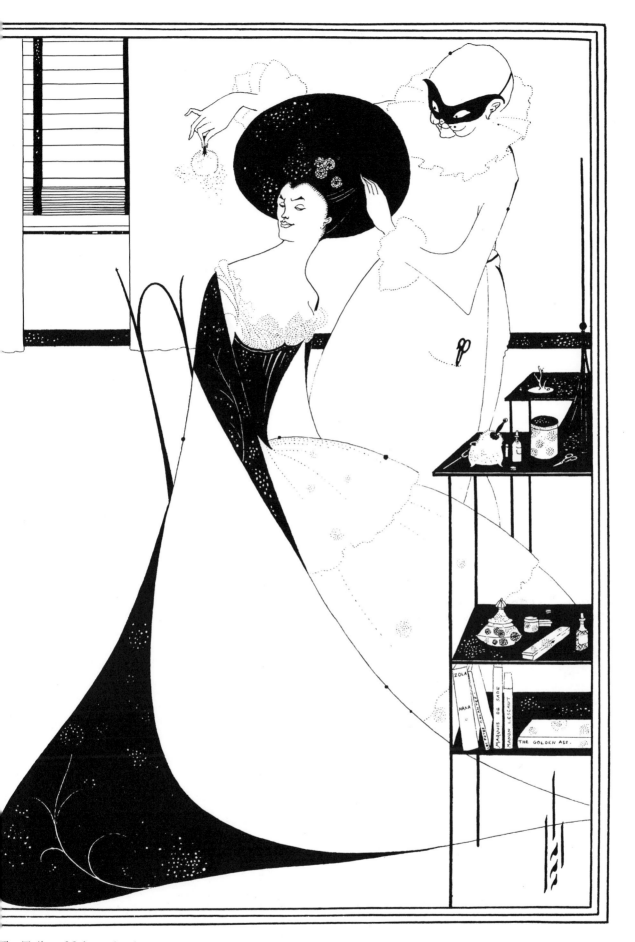

The Toilet of Salome (281)

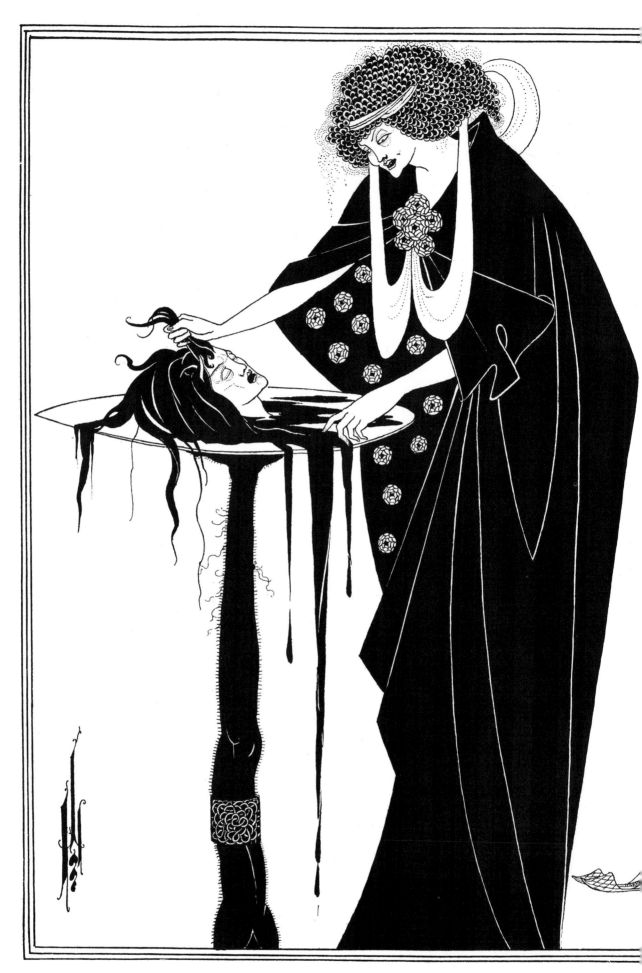

282 The Dancer's Reward (282)

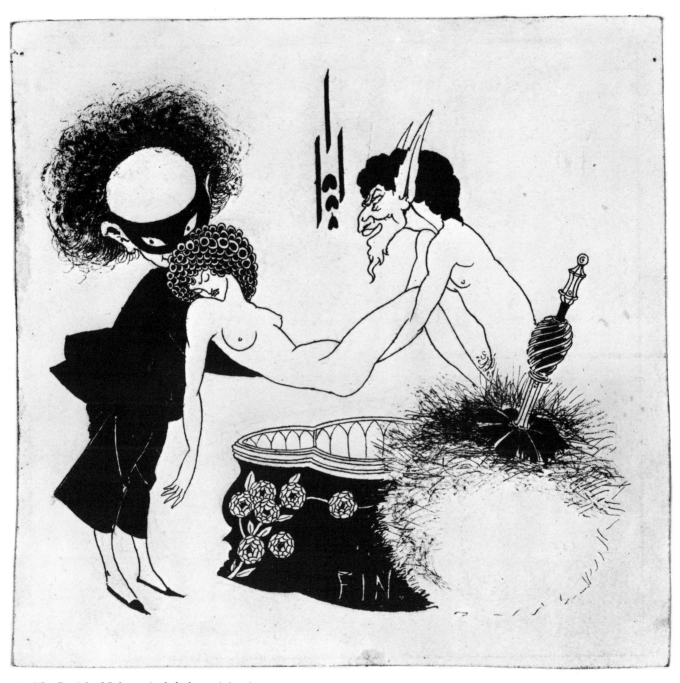

283 The Burial of Salome (cul-de-lampe) (283)

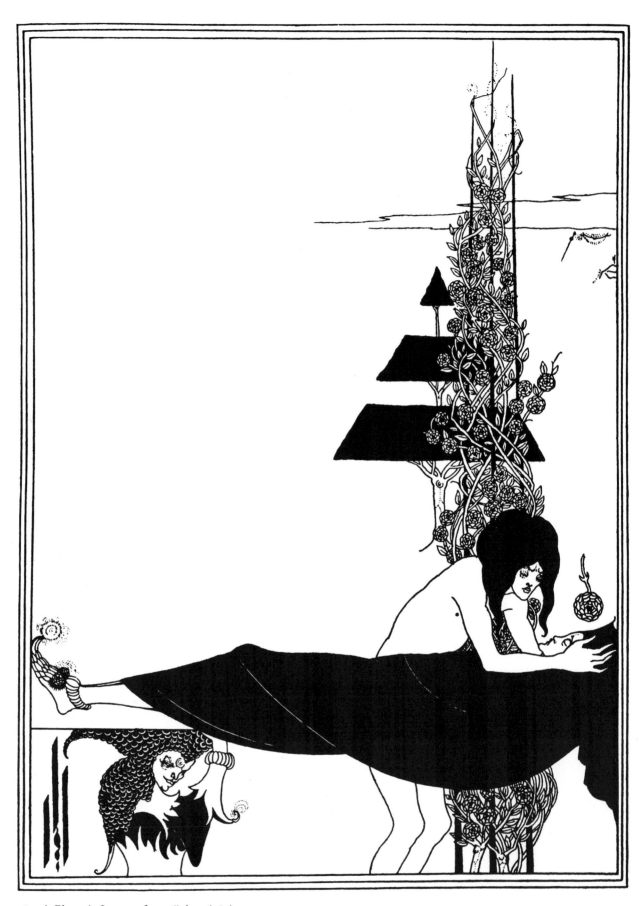

284 A Platonic Lament from *Salome* (284)

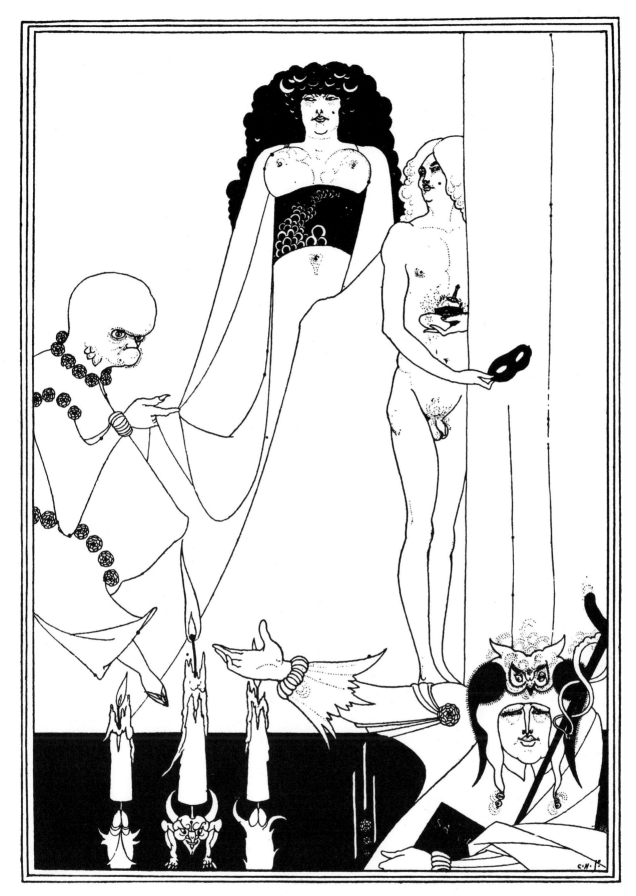

285 Enter Herodias. Proof of an illustration for *Salome* (285)

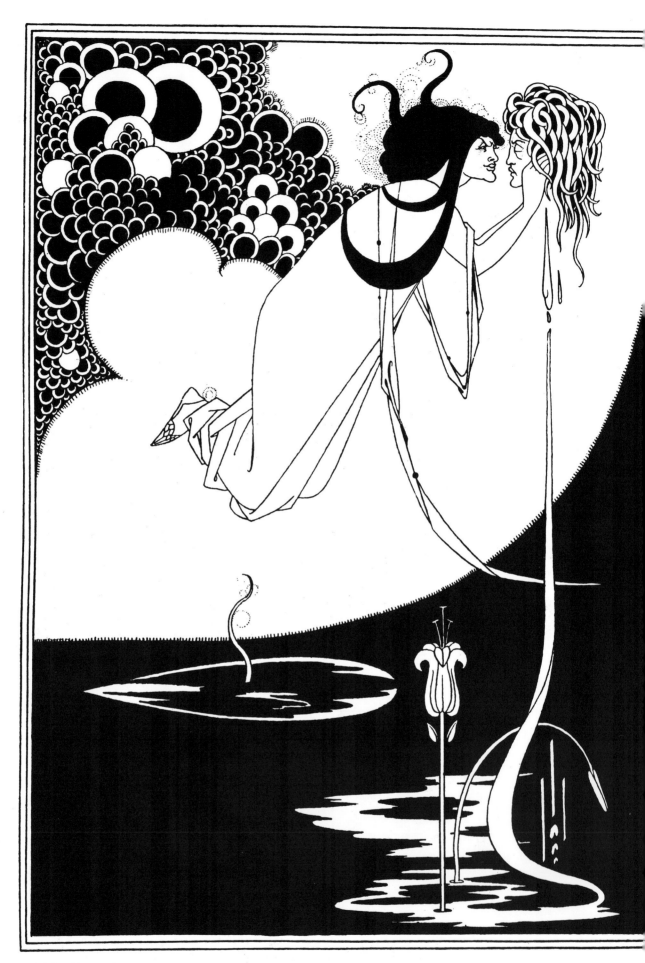

286 The Climax, from *Salome* (286)

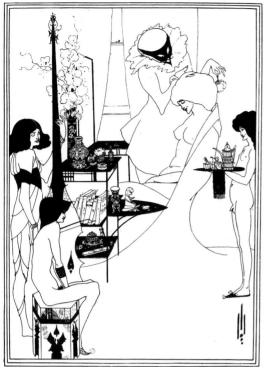

287 The Toilet of Salome. First Version (287)

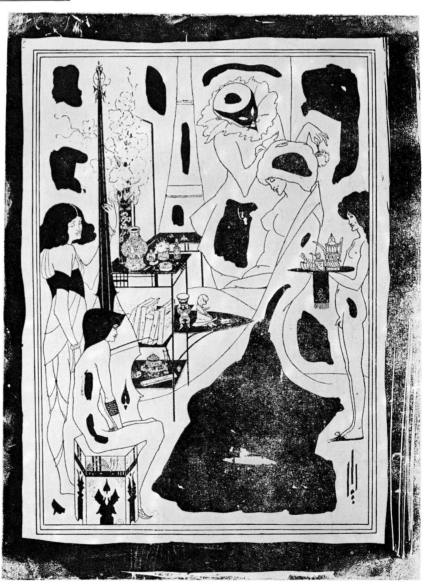

288 The Toilet of Salome. Working proof of a line-block for *Salome* (288)

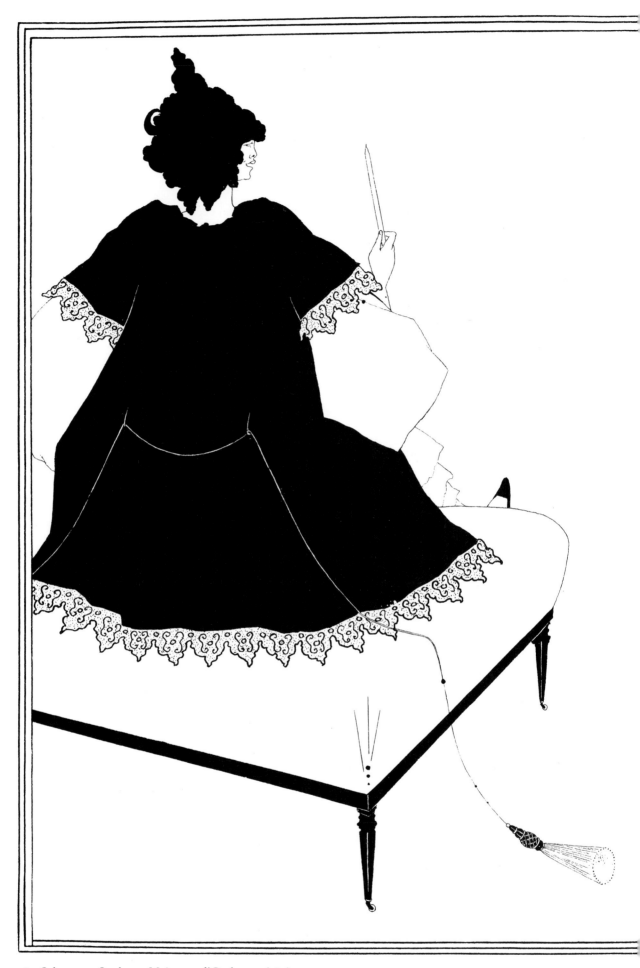

289 Salome on Settle, or Maitresse d'Orchestre (289)

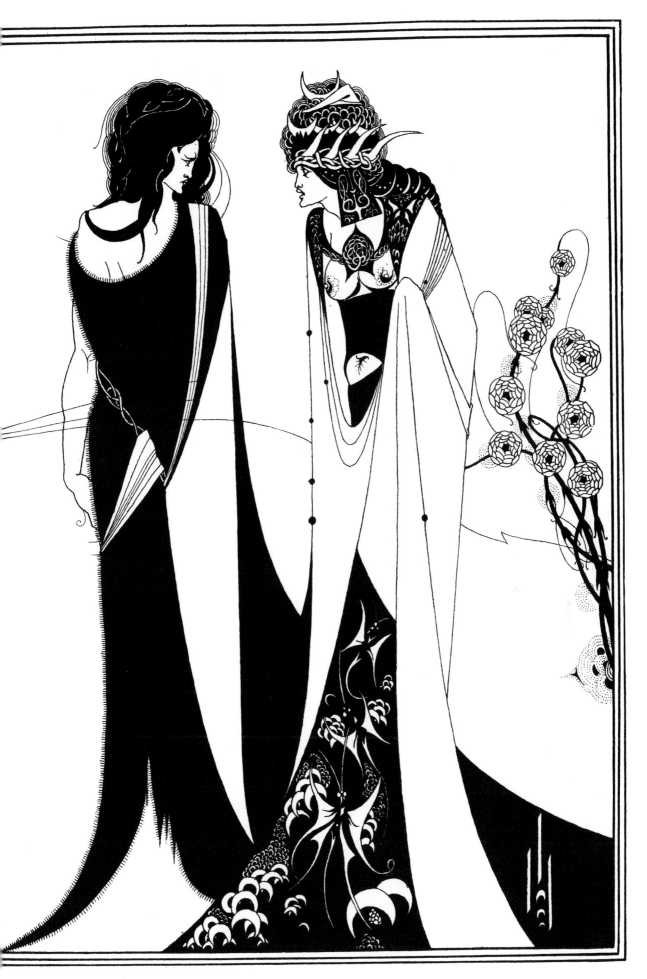

John and Salome (290)

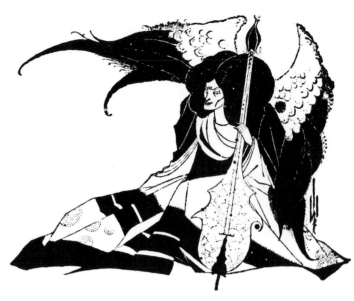

291 Pierrot and cat, from *St Paul's* (294)

292 Music, from *St Paul's* (291)

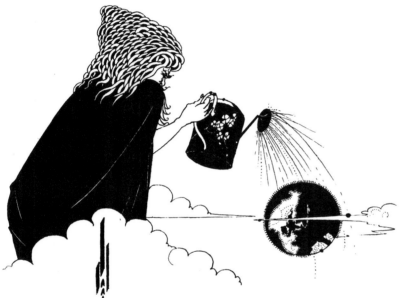

293 The Man that holds the Watering Pot, for *St Paul's* (293)

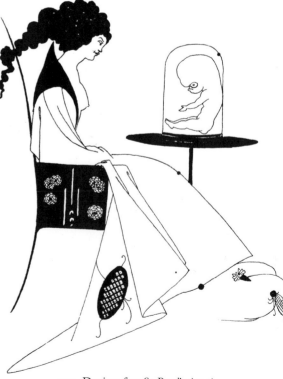

294 Design for *St Paul's* (292)

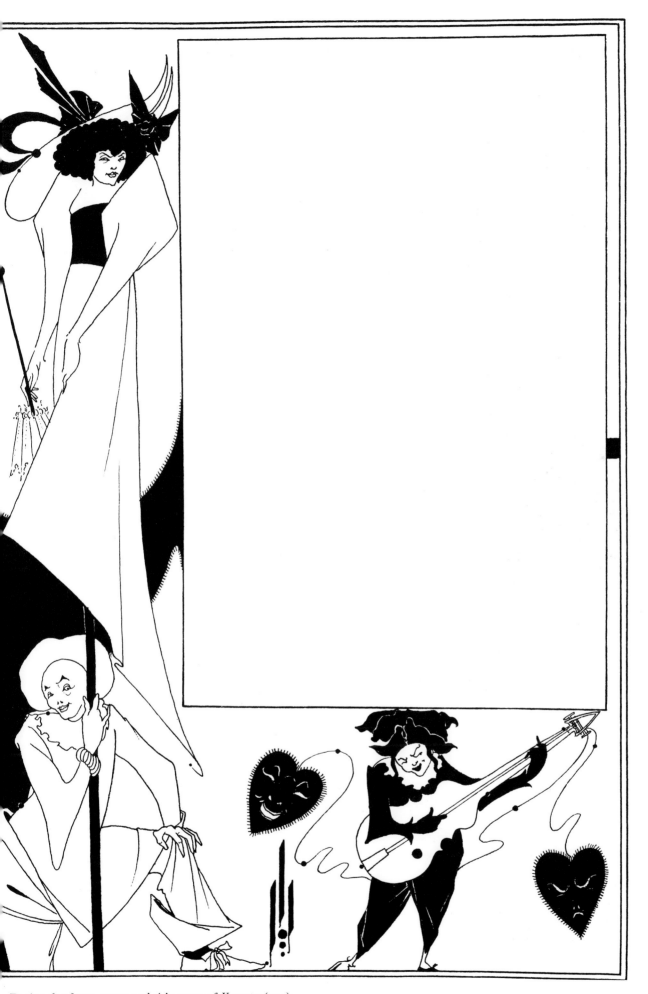

Design for front cover and title-page of *Keynotes* (295)

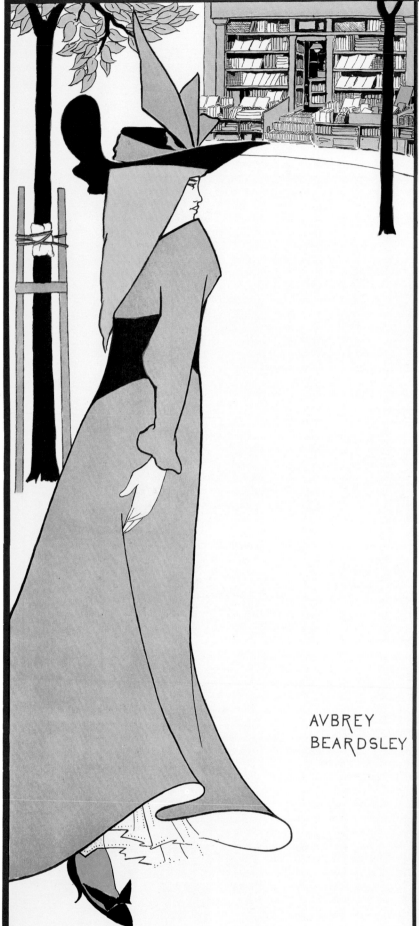

AVBREY
BEARDSLEY

296 Poster advertising The Pseudonym and Autonym Libraries (333)

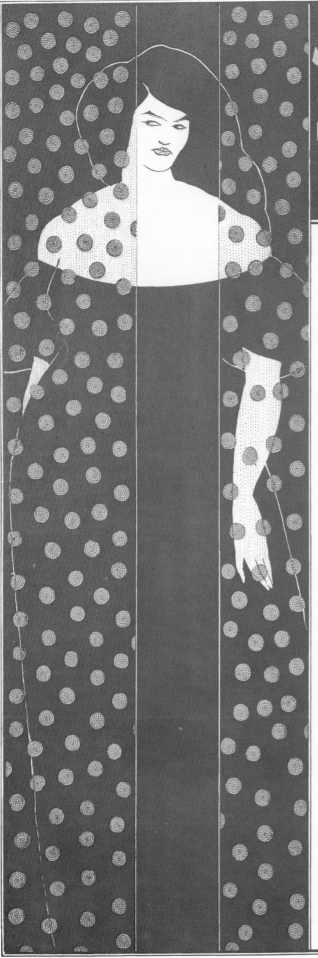

297 Poster advertising *A Comedy of Sighs* (319)

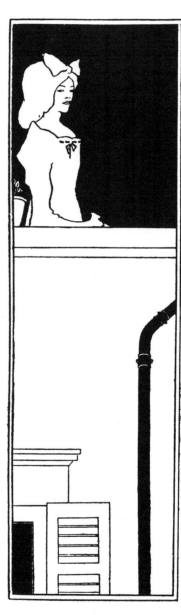

The
Dancing
Faun

by

Florence

Farr

London
Elkin Mathews
and John Lane
——
Roberts Brothers
Boston
1894

Poor Folk

translated
from
the Russian
of
F. Dostoievsky
by
Lena Milman
with an
Introduction
by
George Moore

London
Elkin Mathews
and John Lane
——
Roberts Brothers
Boston
1894

298 Title-page of *The Dancing Faun* (296)

299 Title-page of *Poor Folk* (297)

300 Title-page of *A Child of the Age* (298)

CHILD OF THE AGE

Y FRANCIS ADAMS

Stirb und werde!
Denn so lang du das nicht hast,
Bist du nur ein trüber Gast
Auf der dunkeln Erde.
GOETHE.

NDON : JOHN LANE, VIGO ST.

STON : ROBERTS BROS., 1894

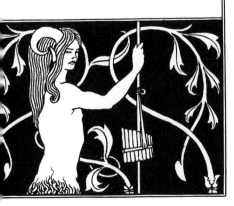

)esign for front cover and title-page
f *The Great God Pan and The Inmost Light* (299)

302 Unfinished and unused design for *The Great God and The Inmost Light* (300)

303 Design for front cover
and title-page of *Discords* (301)

304 Design for front cover
and title-page of *Grey Roses* (302)

At the First Corner

AND OTHER STORIES BY

H. B. Marriott Watson

AUTHOR OF
'DIOGENES OF LONDON'

London : John Lane, Vigo St.
Boston : Roberts Bros., 1895

305 Title-page of *At The First Corner and Other Stories* (303)

MONOCHROMES

BY ELLA D'ARCY

LONDON : JOHN LANE, VIGO ST.
BOSTON : ROBERTS BROS., 1895

306 Title-page of *Monochromes* (304)

307 Designs for front cover, title-page
and key monogram of *The Mountain Lovers* (309)

308 Designs for front cover, and title-page
and key monogram of *The Mirror of Music* (307)

309 Title-page of *At The Relton Arms* (305)

310 Title-page of *The Girl from the Farm* (306)

311 Eight designs in the *Keynotes* series (313)

312 Six designs in the *Keynotes* series, and one for *The Barbarous Britishers* (314)

NOBODY'S FAULT
BY NETTA SYRETT

LONDON: JOHN LANE, VIGO ST
BOSTON: ROBERTS BROS., 1896

313 Title-page of *Nobody's Fault* (310)

314 Designs for front cover and title-page of *Yellow a.* and key monogram for *The Three Impostors* (308)

315 Design for front cover
and title-page of *The British Barbarians* (311)

316 Design for front cover
and title-page of *Platonic Affections* (312)

YOUNG OFEG'S DITTIES

BY OLA HANSSON

TRANSLATED FROM
THE SWEDISH BY
GEORGE EGERTON

LONDON: JOHN LANE, VIGO ST
BOSTON: ROBERTS BROS., 1895

317 Title-page of *Young Ofeg's Ditties* (315)

318 Design for front cover and title-page,
and key monogram of *The Barbarous Britishers* (316)

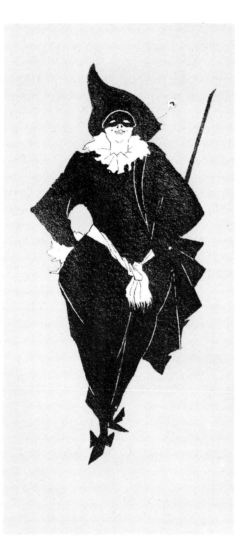

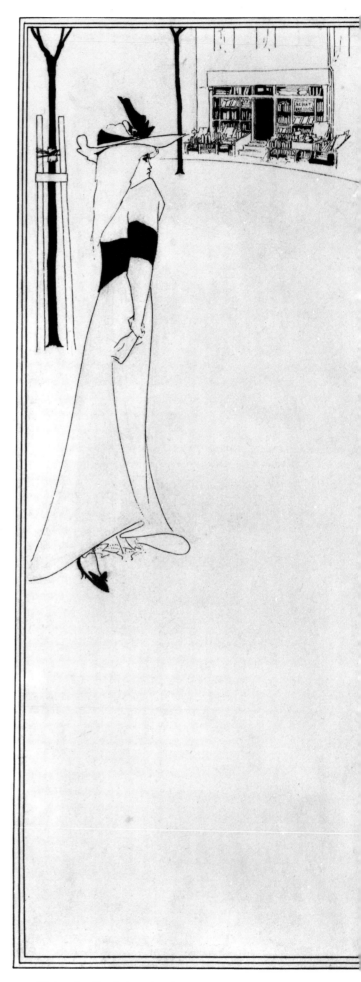

319 Masked Pierrot in black from *Plays*
 by John Davidson (318)

320 Girl and a Bookshop (334)

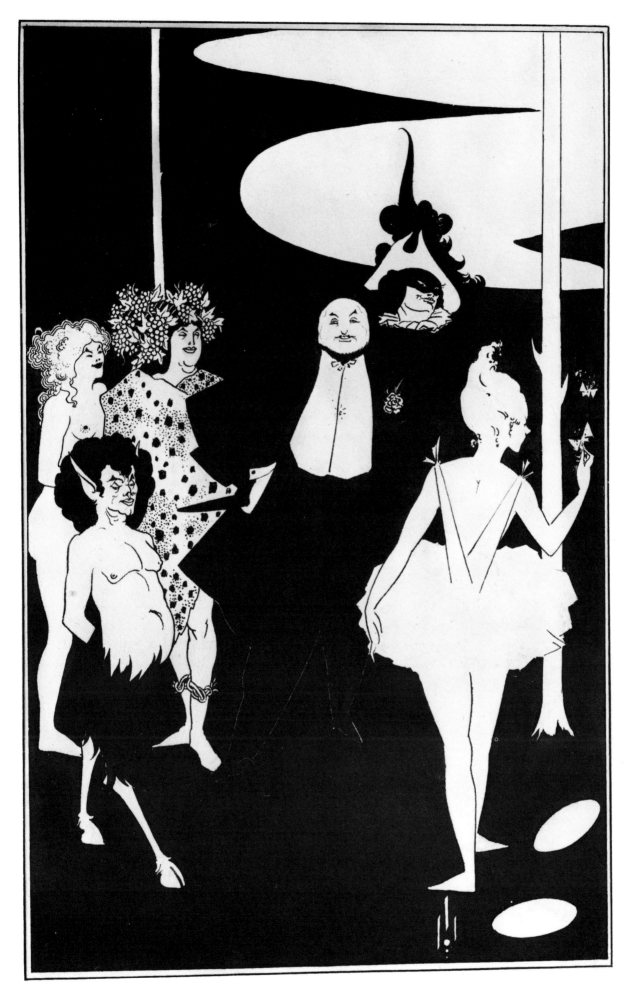

321 Frontispiece to *Plays* by John Davidson (317)

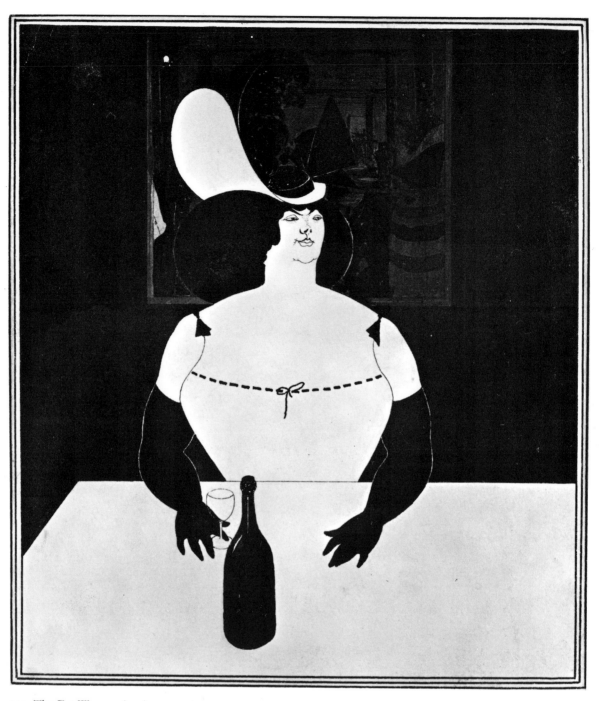

322 The Fat Woman (325)

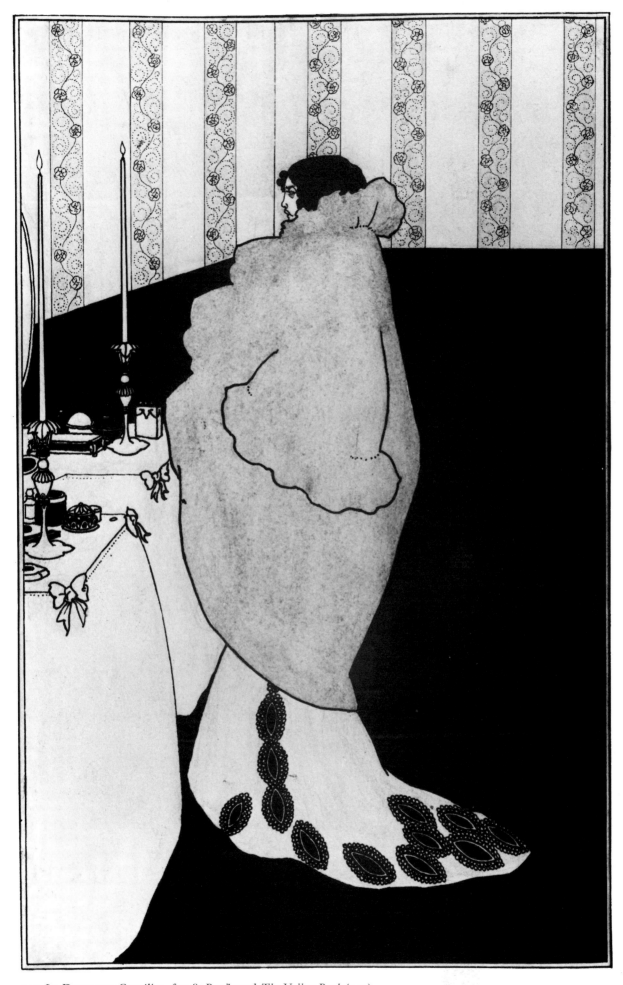

323 La Dame aux Camélias, for *St Paul's* and *The Yellow Book* (322)

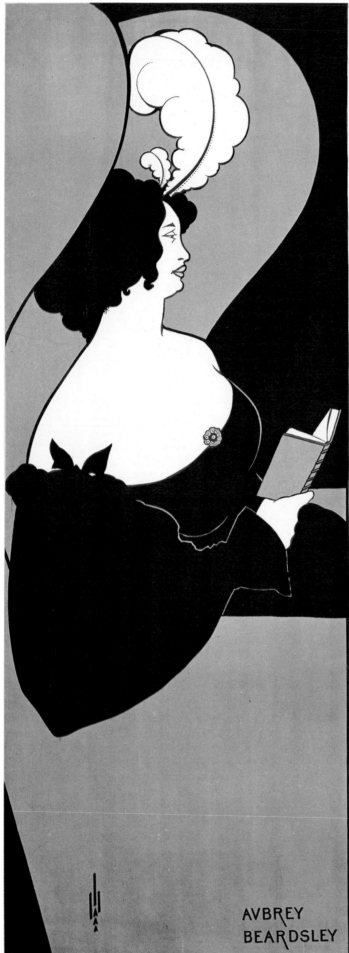

324 Poster advertising *Children's Books* (335)

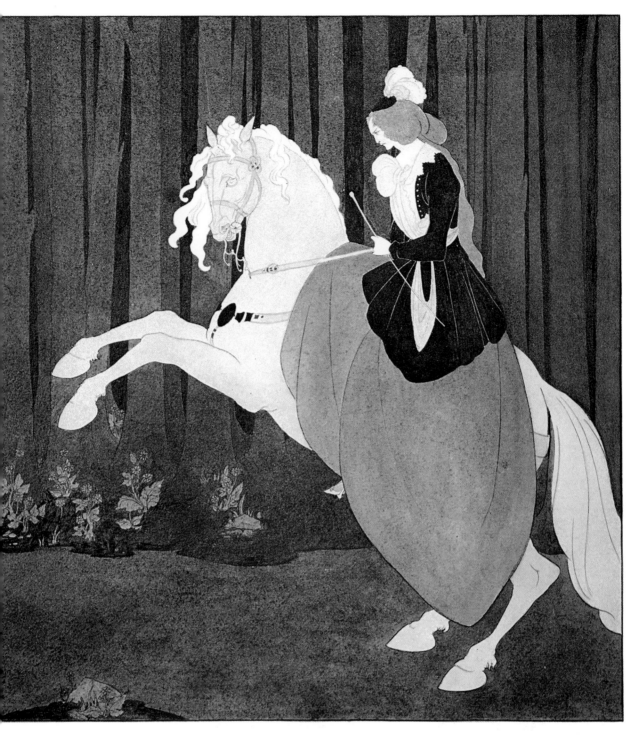

Chopin Ballade III (320)

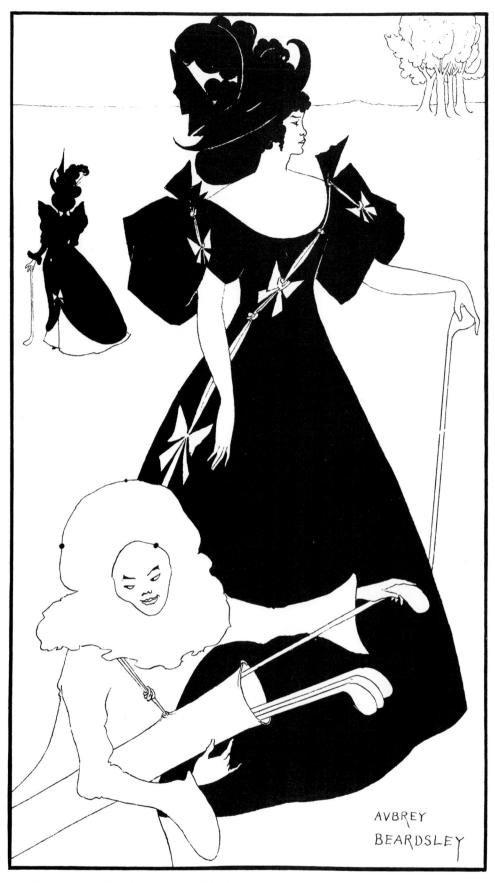

326 Invitation card to the opening of the Prince's Ladies Golf Club (329)

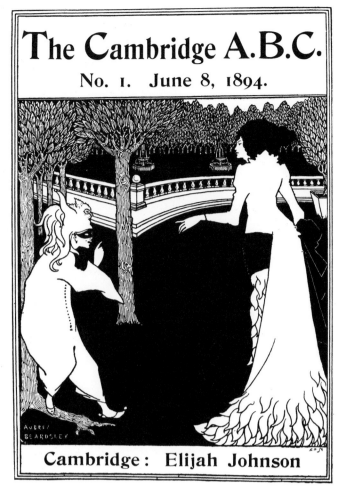

The Cambridge A.B.C.
No. 1. June 8, 1894.

Cambridge: Elijah Johnson

PRICE SIXPENCE

328 Front Wrapper of *The Cambridge A.B.C.* (326)

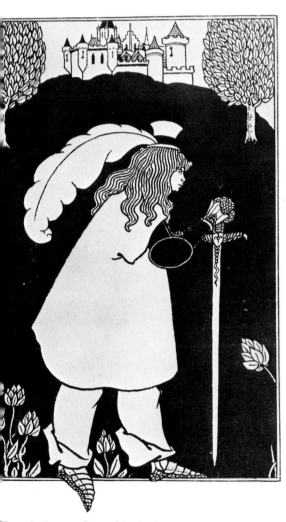

Frontispiece to *Baron Verdigris*.
A Romance of the Reversed Direction (328)

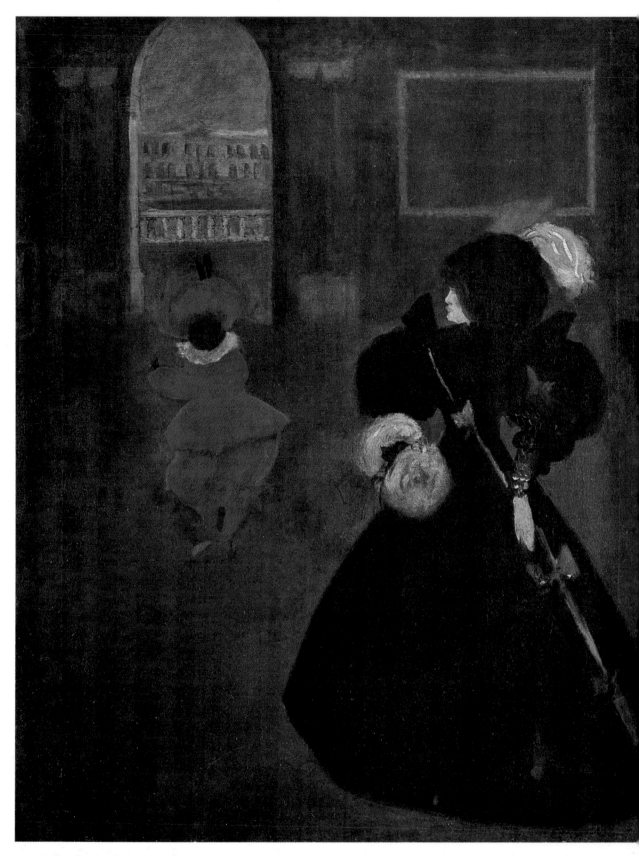

329 A Caprice (323)

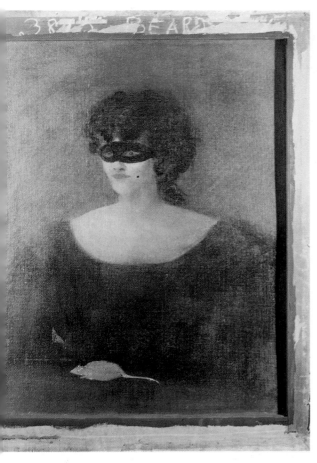

A masked woman (324)

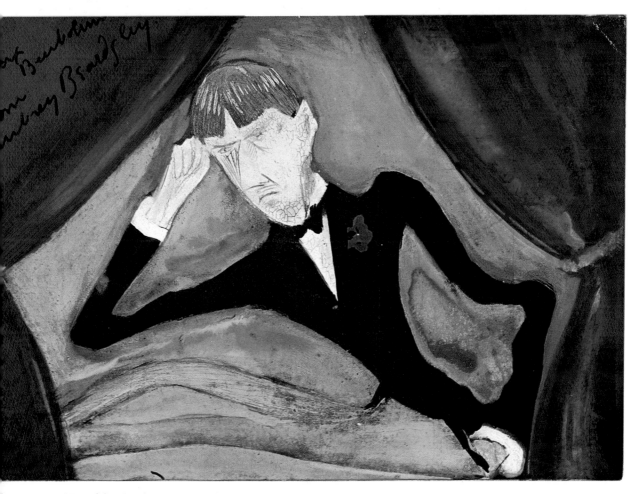

Caricature of Beardsley (379)

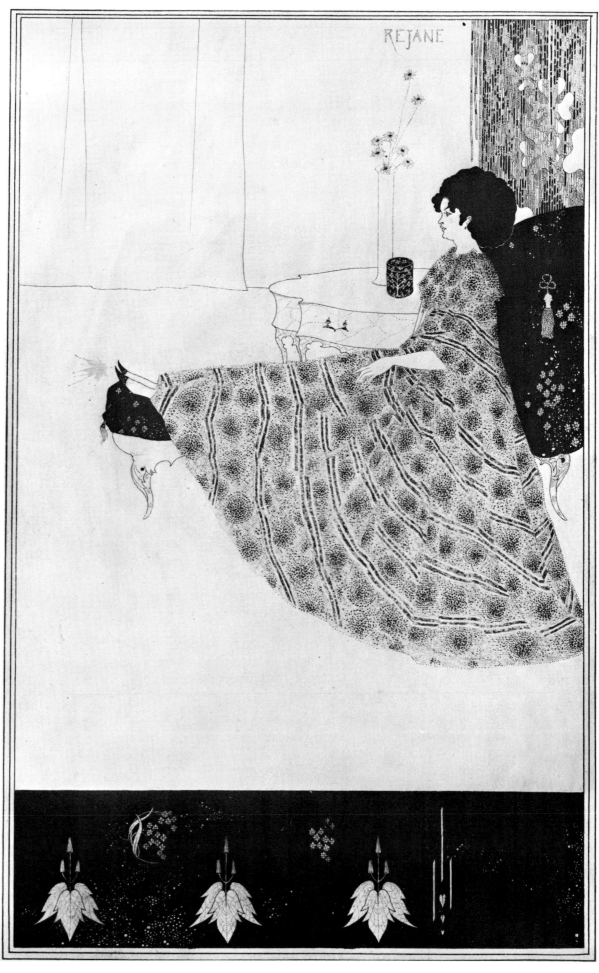

332 Rejane [*sic*] (327)

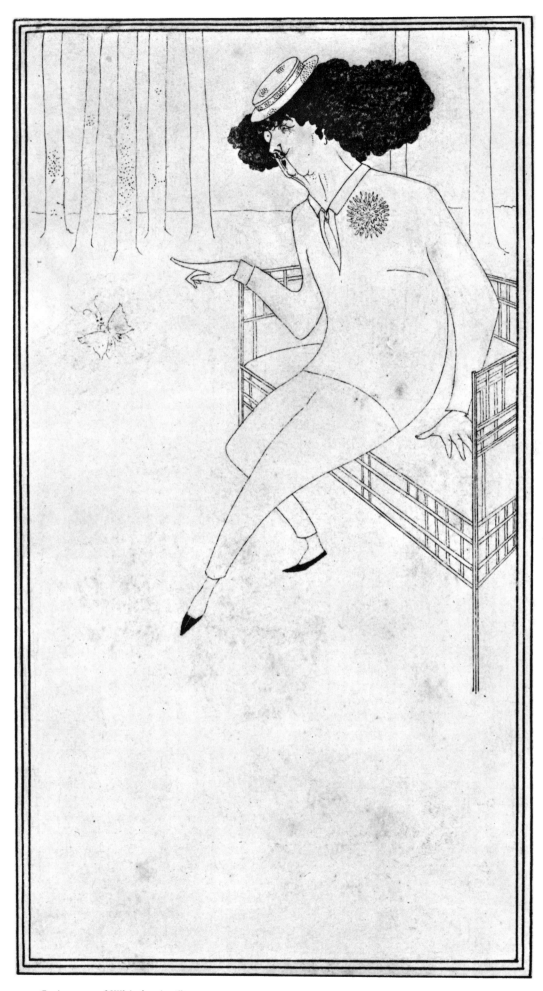

333 Caricature of Whistler (336)

334 The Idler's Club (331)

*How to Court the "Advanc̄
Woman."*

THE DEVELOPMENT OF TH
"EMANCIPATED."
ANGUS EVAN ABBOTT.

THE development of the Em̄
cipated Woman has been
gradual development, and, step
step, as emancipation has proceed̄
on its way to consummation, t̄
conditions of courtship have und̄
gone proportionate change. Loc̄
ing into the subject, it will
found that originally women we
Spoil. In earliest days, Man we
courting with a club. He thir̄
the wood, and lurked in ambū

335 Headpiece from *The Idler* (330)

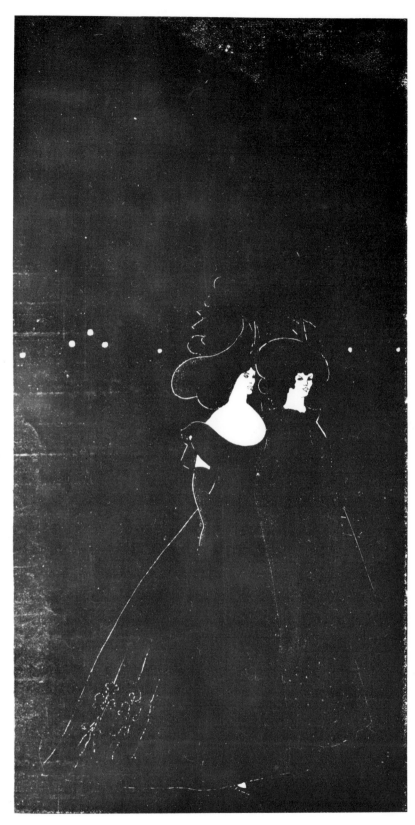

336 Les Passades, from *To-Day* (332)

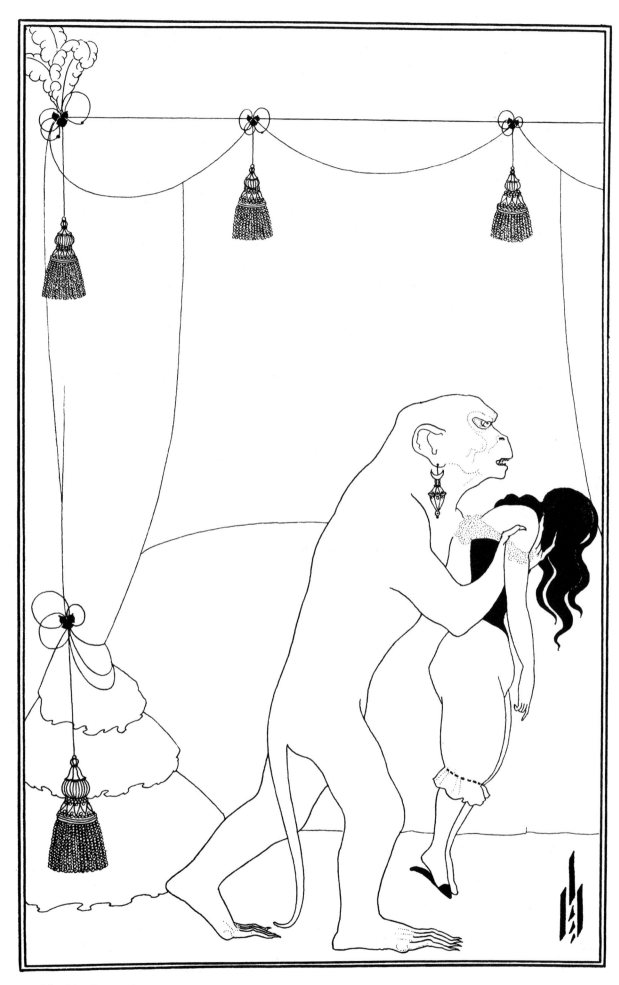

337 The Murders in the Rue Morgue (337)

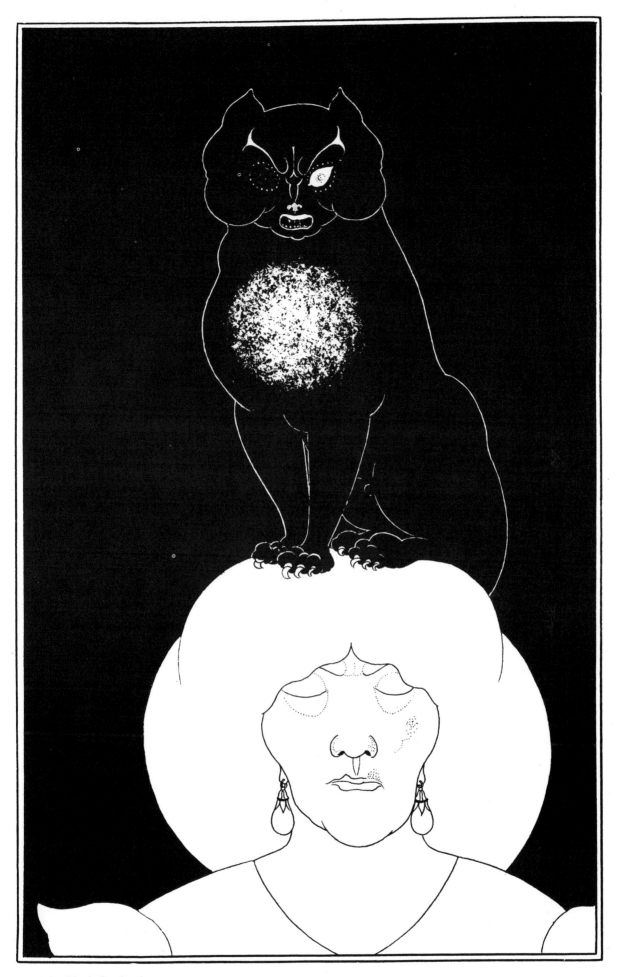

338 The Black Cat (338)

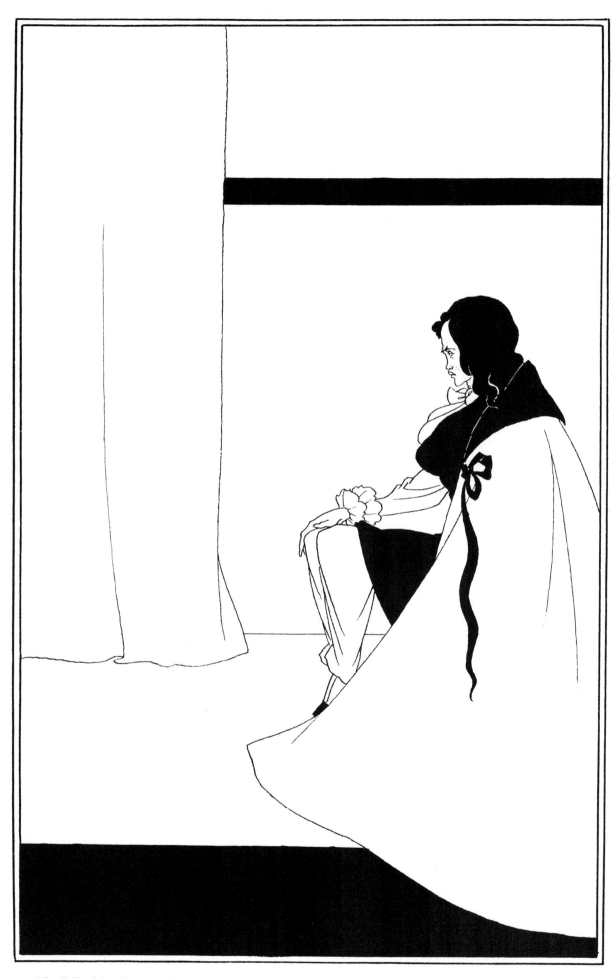

339 The Fall of the House of Usher (339)

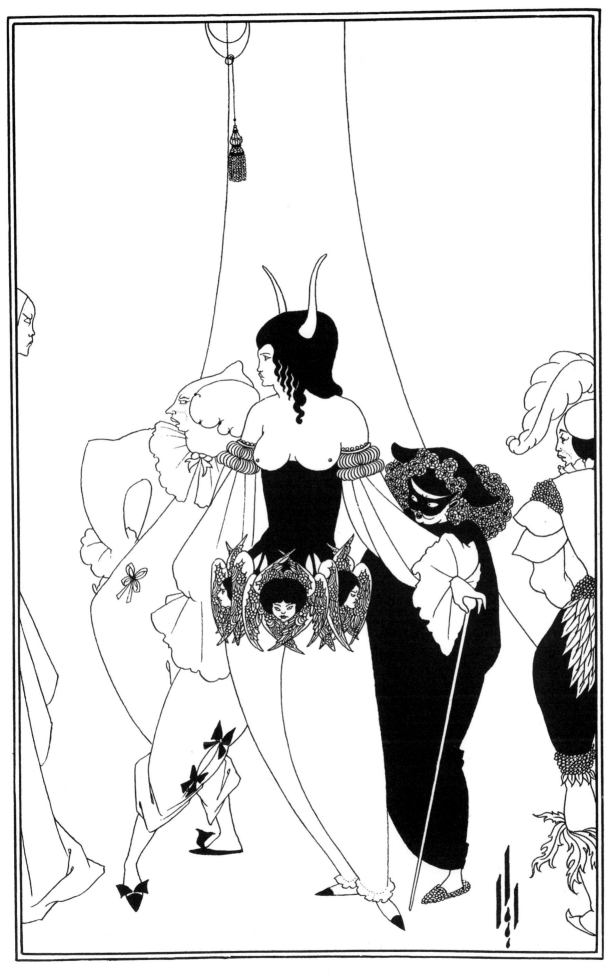

340 The Mask of the Red Death (340)

341 Design for a poster advertising *The Yellow Book* (341)

342 Poster advertising Singer sewing machines (321)

343 Design for the prospectus of *The Yellow Book* (342)

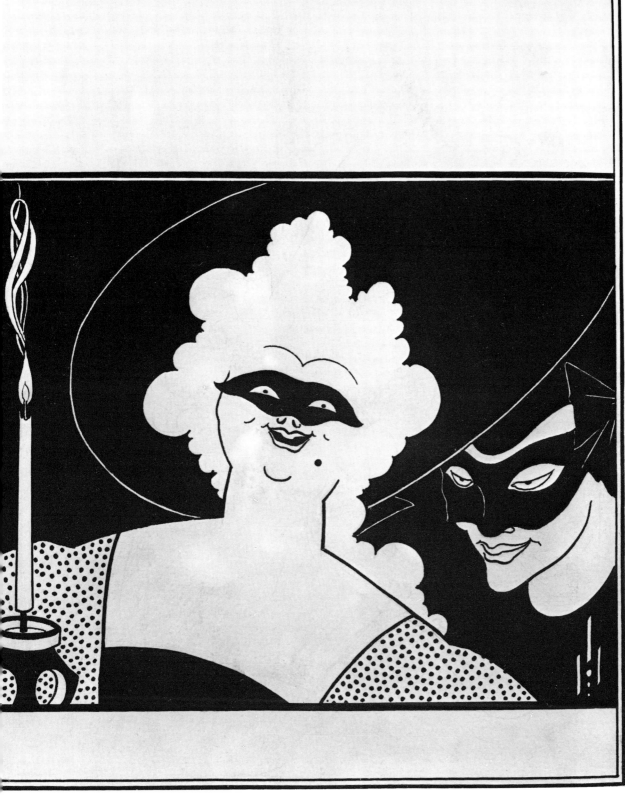

gn for front cover of *The Yellow Book*, Vol. I (343)

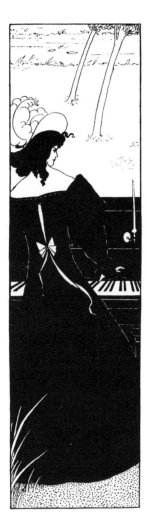

The Yellow Book

An Illustrated Quarterly

Volume I April 1894

London : Elkin Mathews
& John Lane
Boston : Copeland &
Day

345 Title-page of *The Yellow Book*, Vol. I (345)

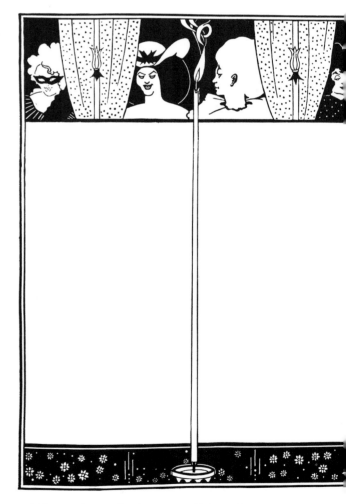

346 Decoration on back covers of *The Yellow Book* (344)

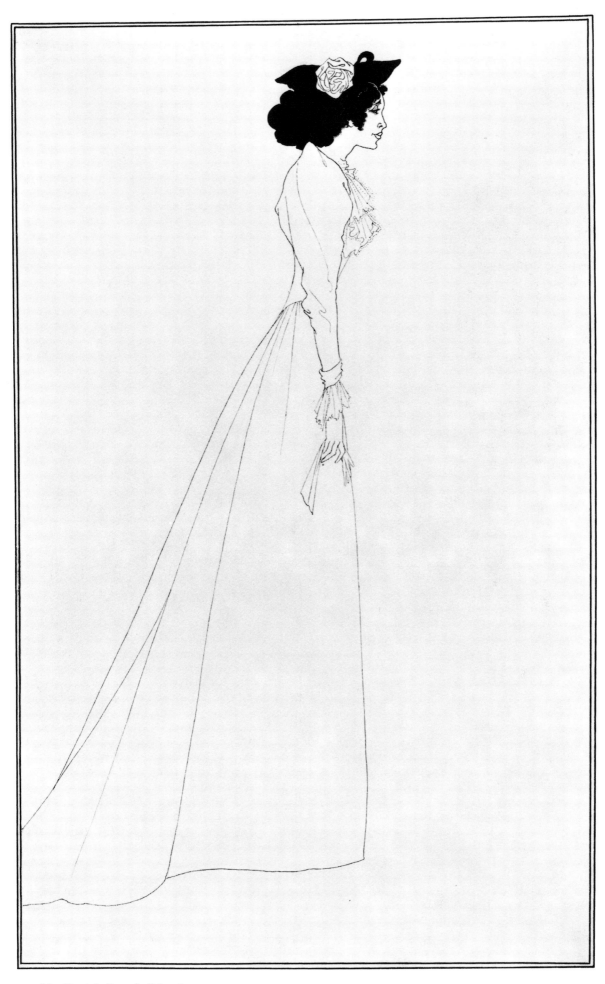

347 Mrs Patrick Campbell (349)

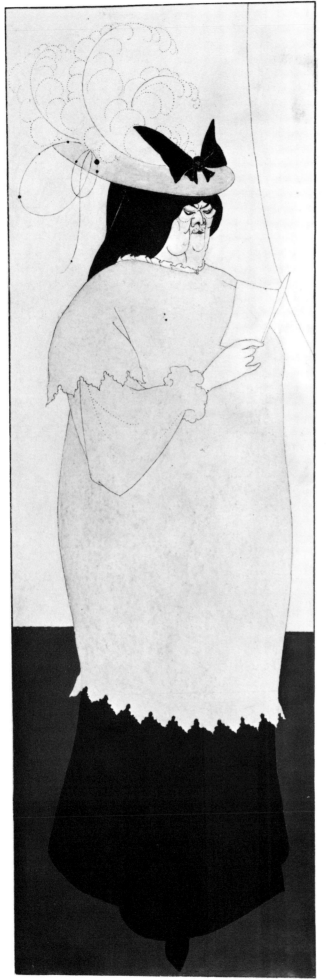

348 Part of the drawing 'L'Éducation Sentimentale' (347)

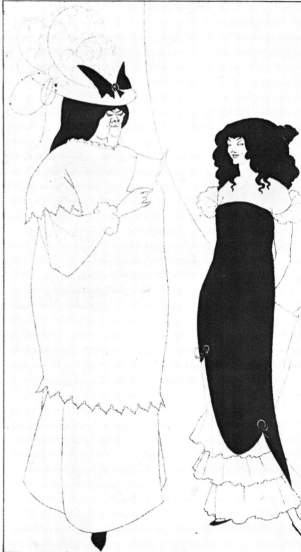

349 L'Éducation Sentimentale (346)

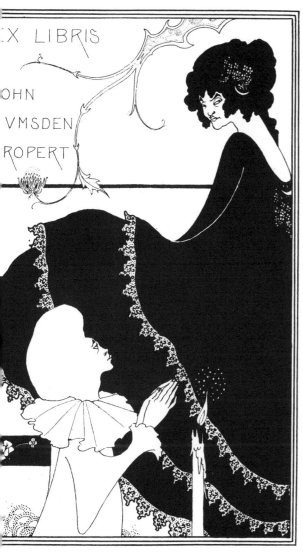

Bookplate of John Lumsden Propert (350)

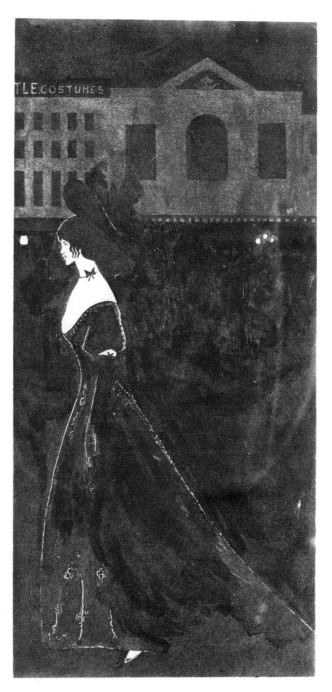

351 A Night Piece (348)

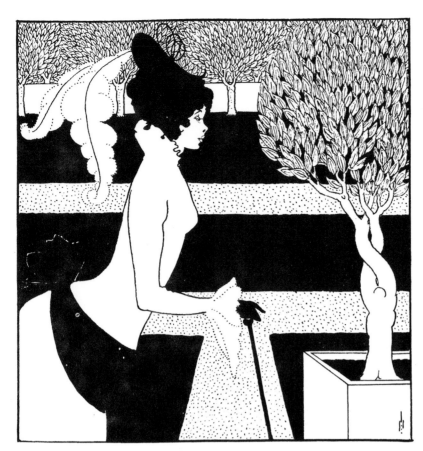

352 Design for title-page of
The Yellow Book, Vol. II (352)

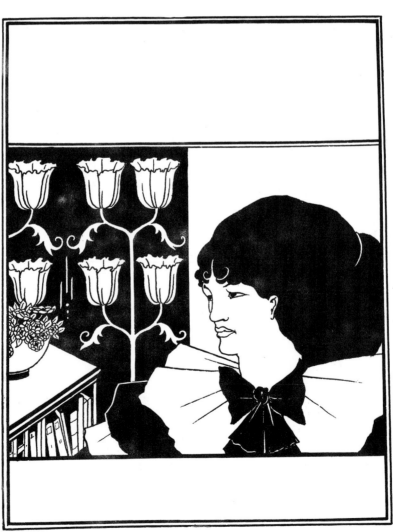

353 Design for front cover of *The Yellow Book*, Vol. II (351)

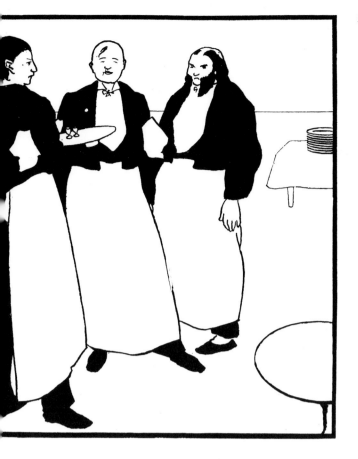

354 Garçons de Café (357)

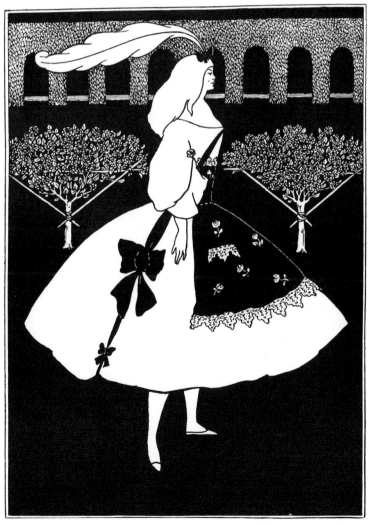

355 The Slippers of Cinderella (358)

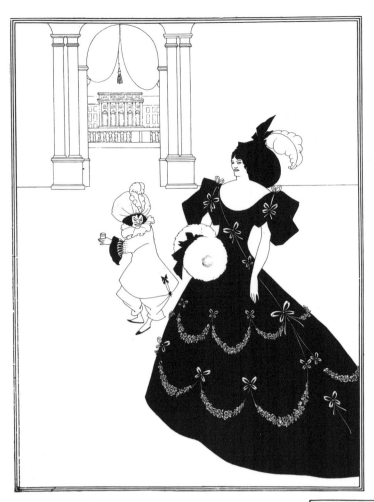

356 No. I of 'The Comedy Ballet of Marionettes' (353)

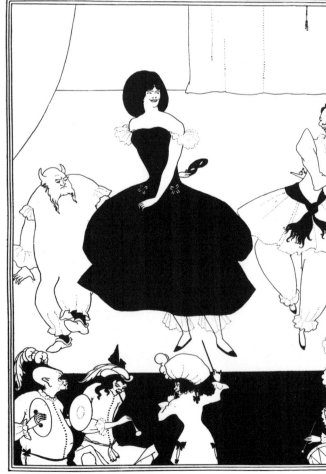

357 No. III of 'The Comedy Ballet of Marionettes' (355)

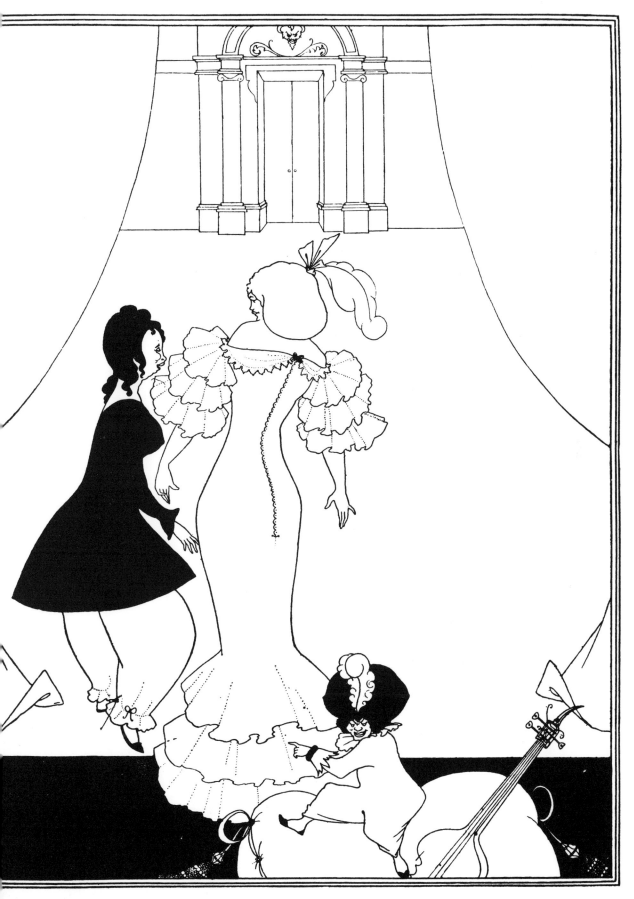

No. II of 'The Comedy Ballet of Marionettes' (354)

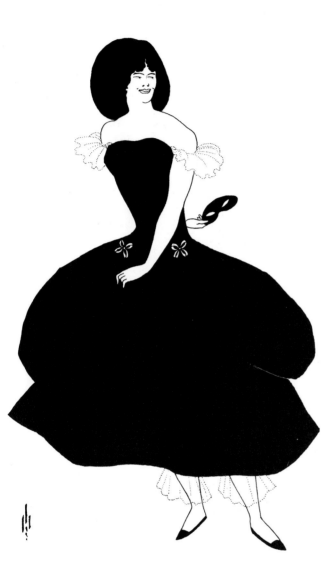

359 The Dancer (356) 360 Madame Réjane (359)

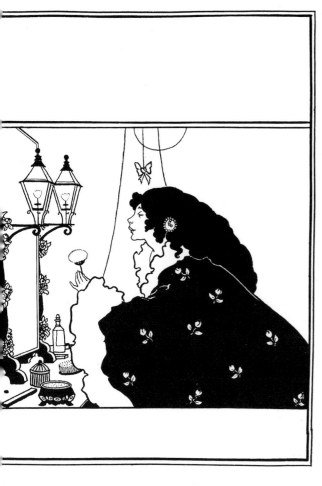

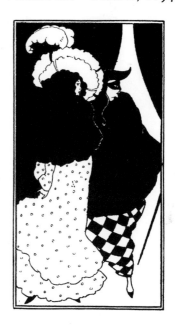

The Yellow Book

An Illustrated Quarterly

Volume III October, 1894

London : John Lane, The Bodley Head, Vigo Street
Boston : Copeland & Day
Agents for the Colonies : Robt. A. Thompson & Co.

Design for front cover of *The Yellow Book*, Vol. III (360)

362 Title-page of *The Yellow Book*, Vol. III (361)

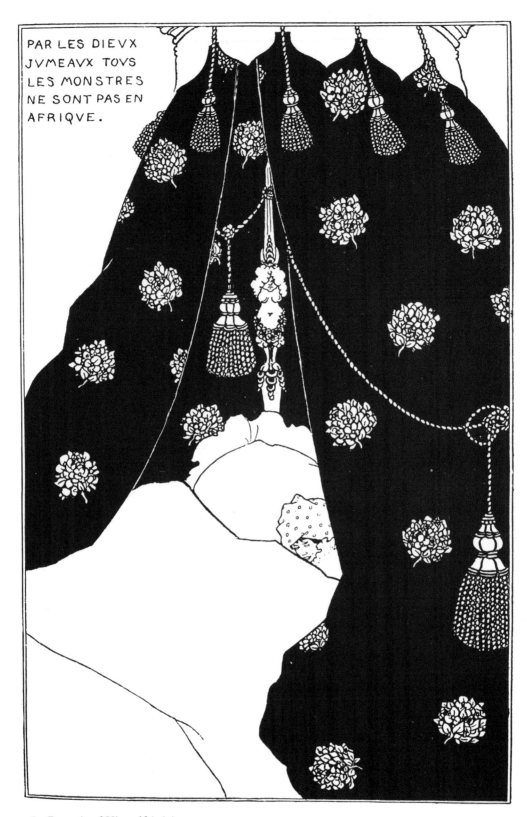

363 Portrait of Himself (362)

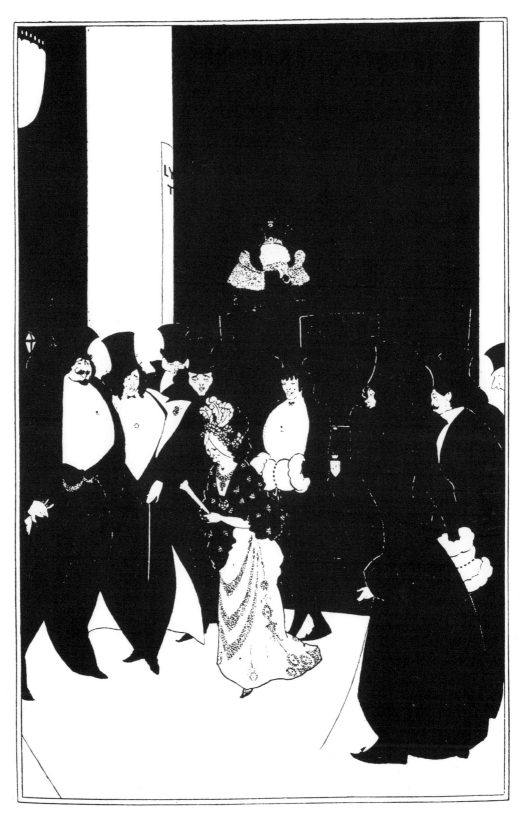

364 Lady Gold's Escort (363)

The
Yellow
Book

An
Illustrated
Quarterly

Vol. IV
January
1895

5/-
Net

John Lane
The
Bodley
Head

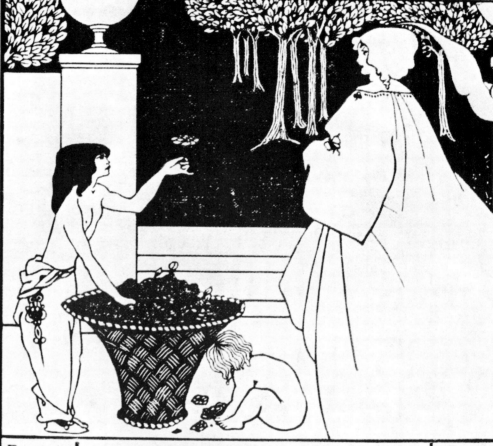

The Yellow Book

An Illustrated Quarterly

Volume IV January 1895

Price
$1.50
Net

London: John Lane
Boston: Copeland & Day

Price
5/-
Net

365 Front cover and spine of *The Yellow Book*, Vol. IV (365)

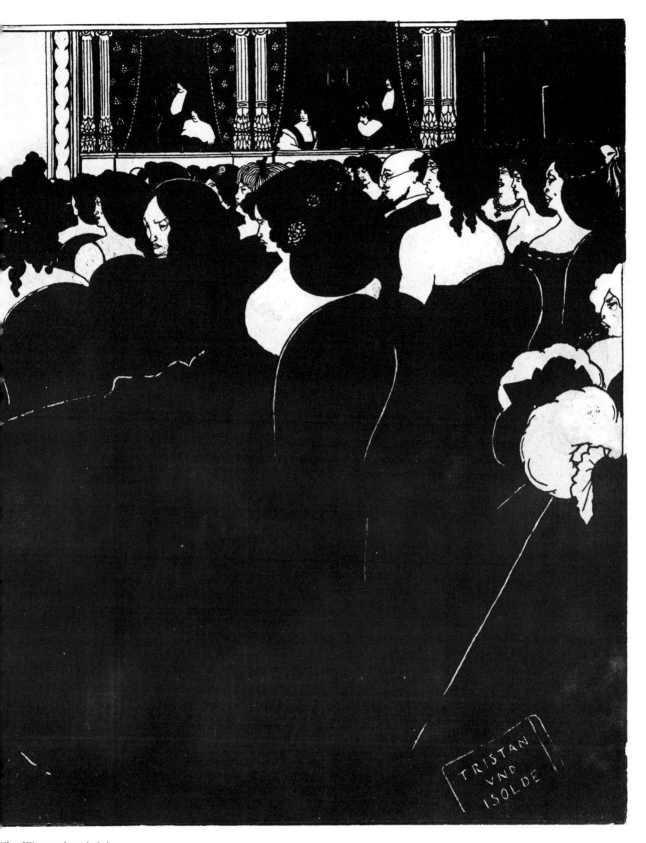

The Wagnerites (364)

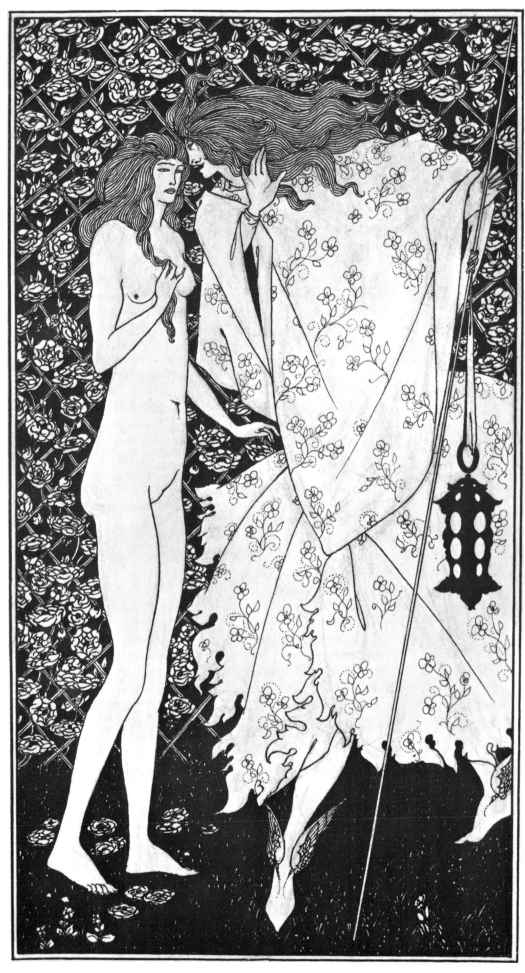

367 The Mysterious Rose Garden (366)

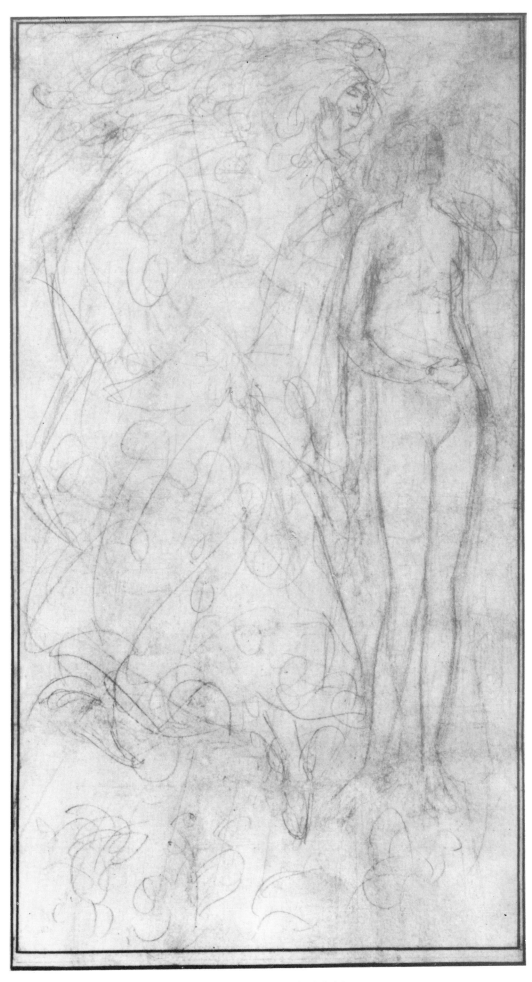

368 Discarded drawing for 'The Mysterious Rose Garden' (367)

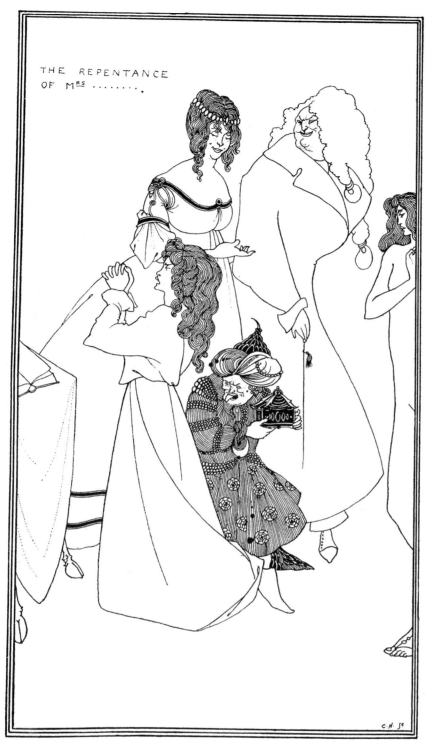

369 The Repentance of Mrs ... (368)

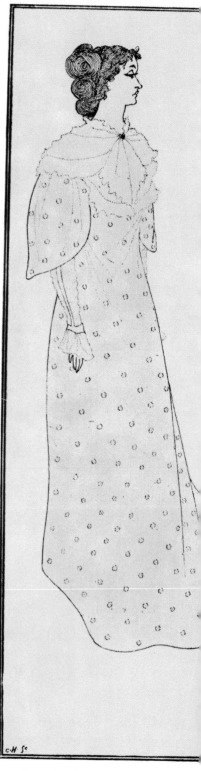

370 Portrait of Winifred Emery (369)

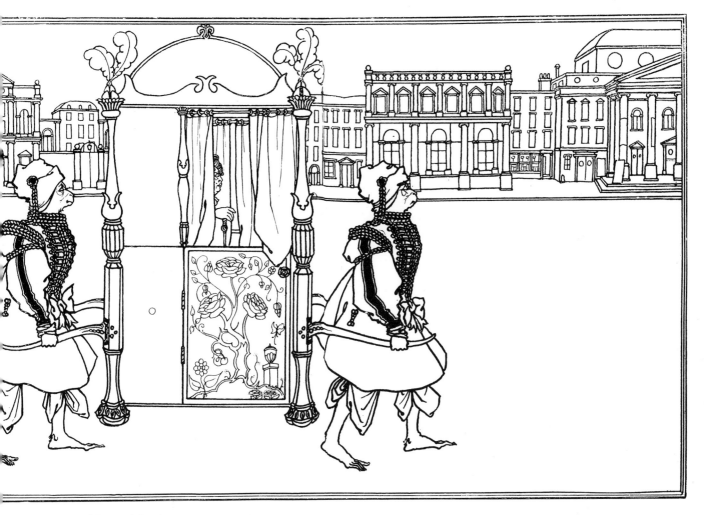

Frontispiece of Juvenal (370)

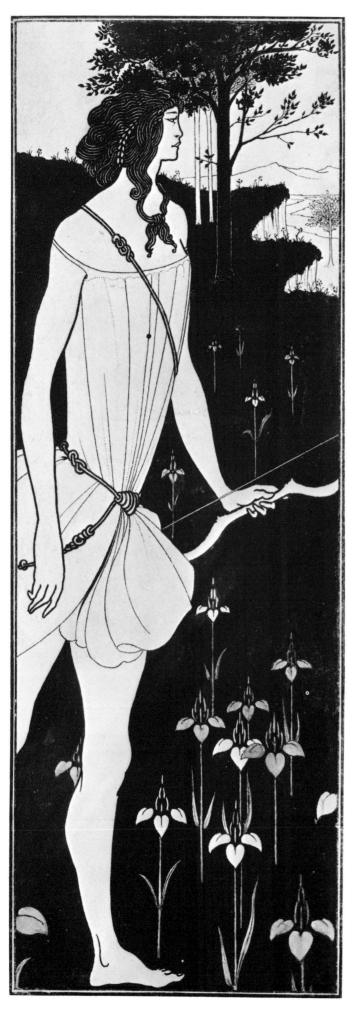

372 Atalanta in Calydon (372)

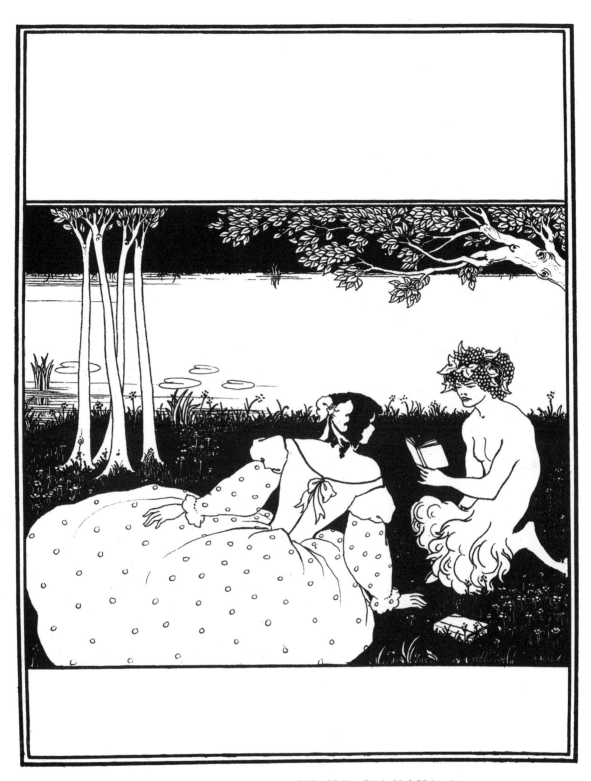

373 Design for the prospectus and the front cover of *The Yellow Book*, Vol. V (371)

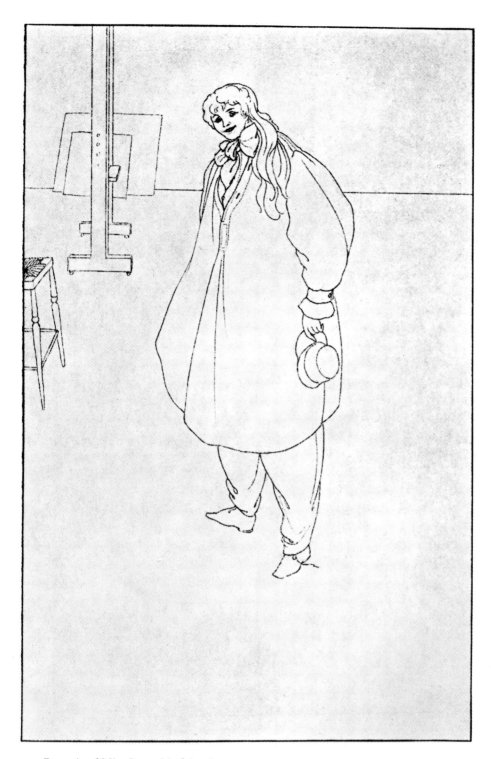

374 Portrait of Miss Letty Lind (373)

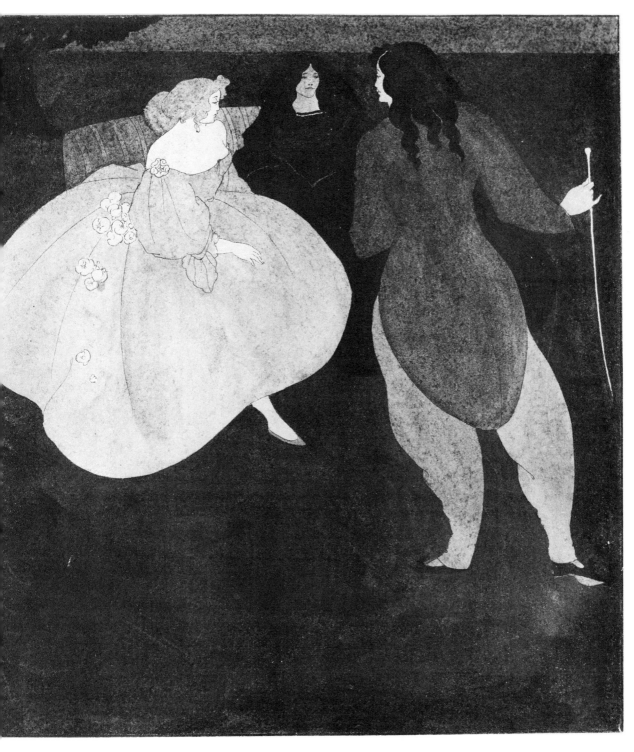

Nocturne of Chopin (374)

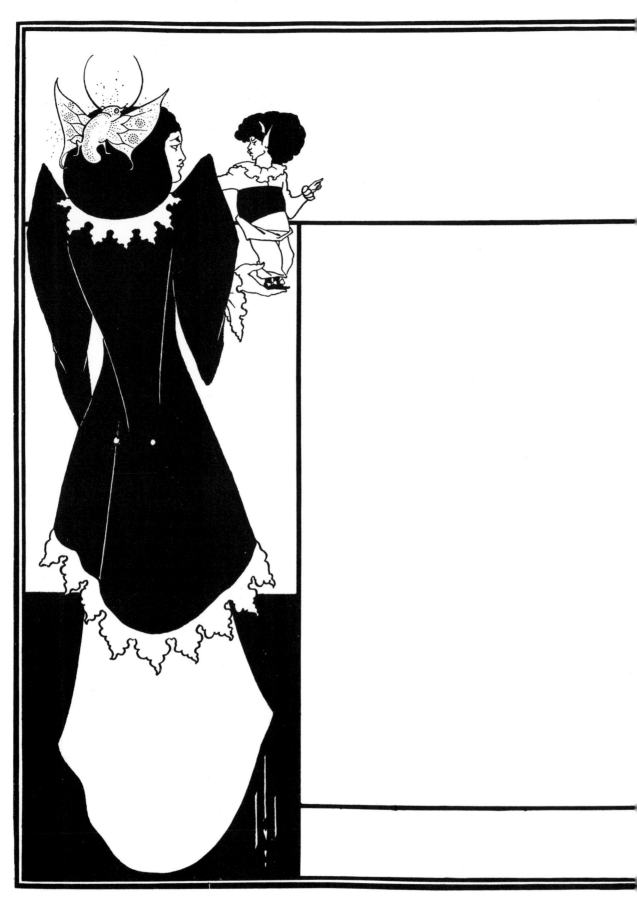

376 Design for a poster advertising *The Yellow Book* (not used) (375)

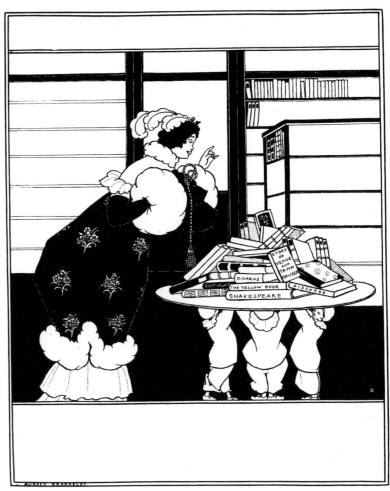

378 Design for a front cover of *The Yellow Book* (not used) (376)

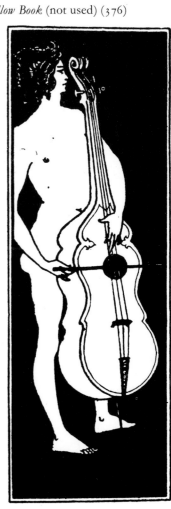

Madame Réjane (378) 379 A title-page ornament (377)

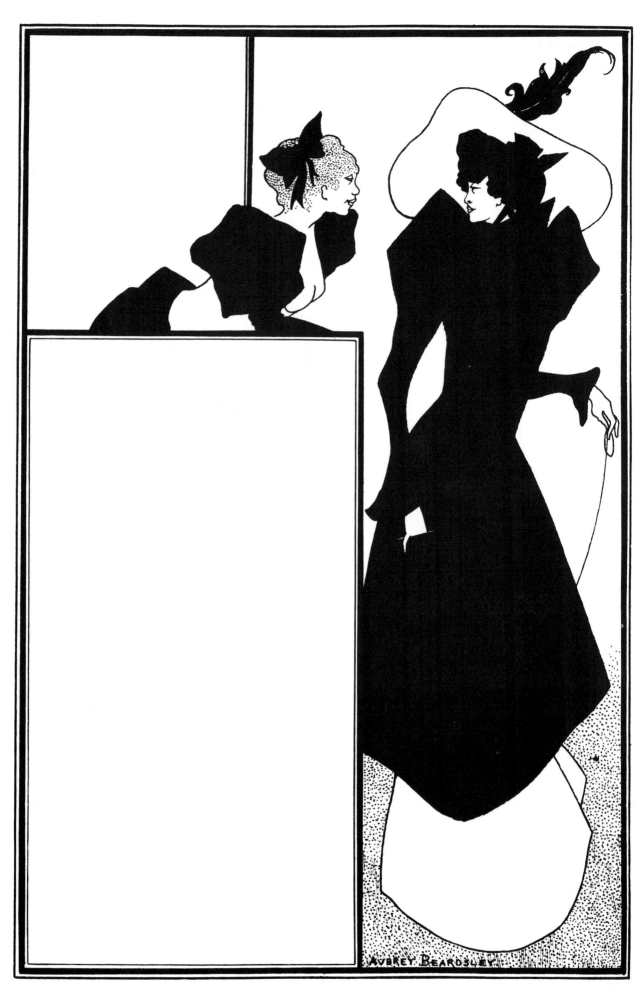

380 Poster advertising *The Spinster's Scrip* (380)

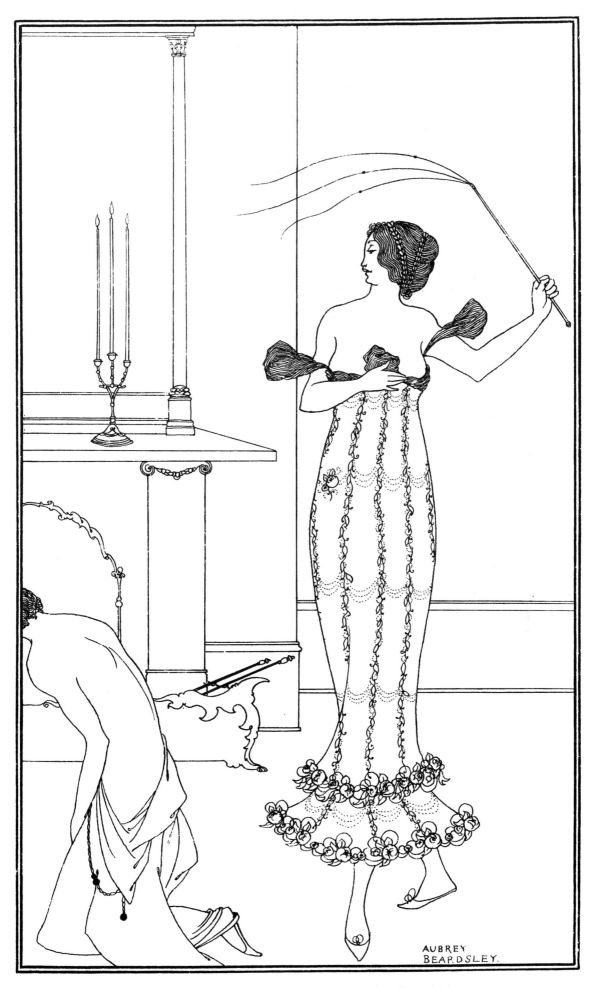

381 Frontispiece to *A Full and True Account of the Wonderful Mission of Earl Lavender* (383)

382 Front cover of *Sappho* (385)

383 Invitation card for John Lane's 'Sette of Odd Volumes Smoke' (382

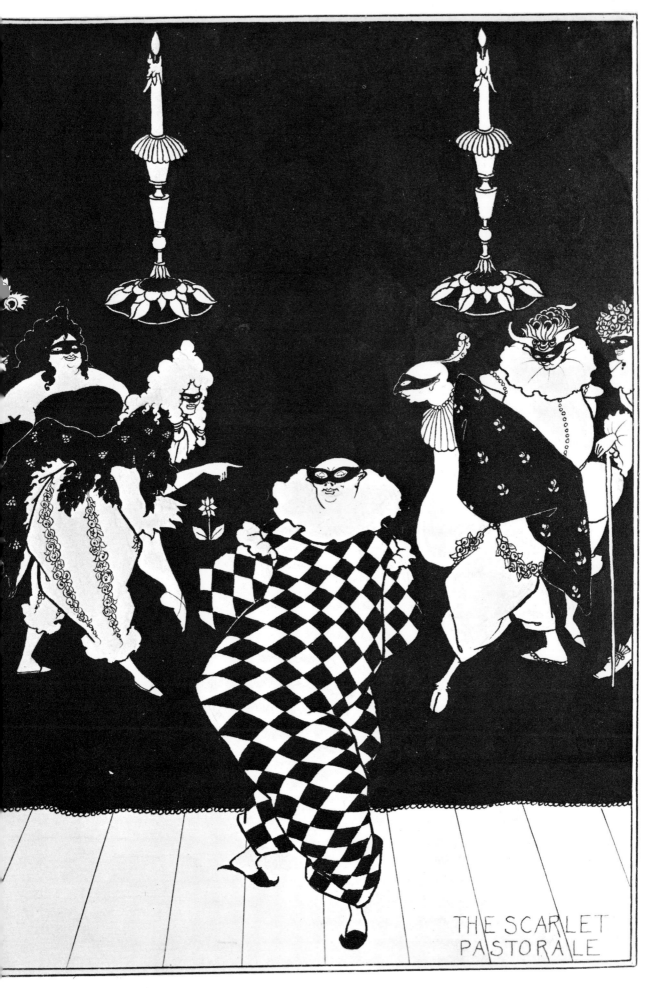

The Scarlet Pastorale (384)

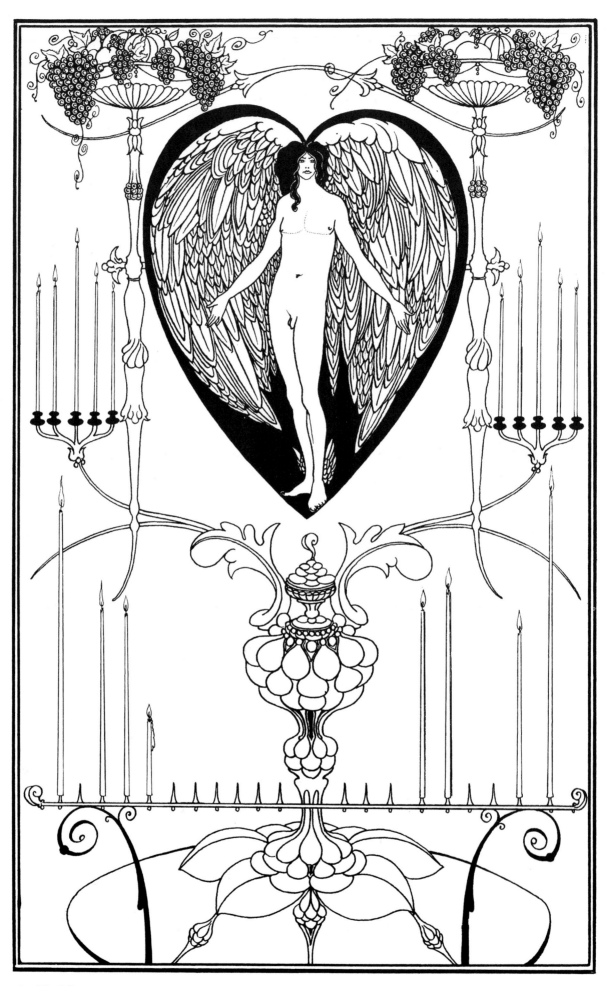

385 The Mirror of Love (386)

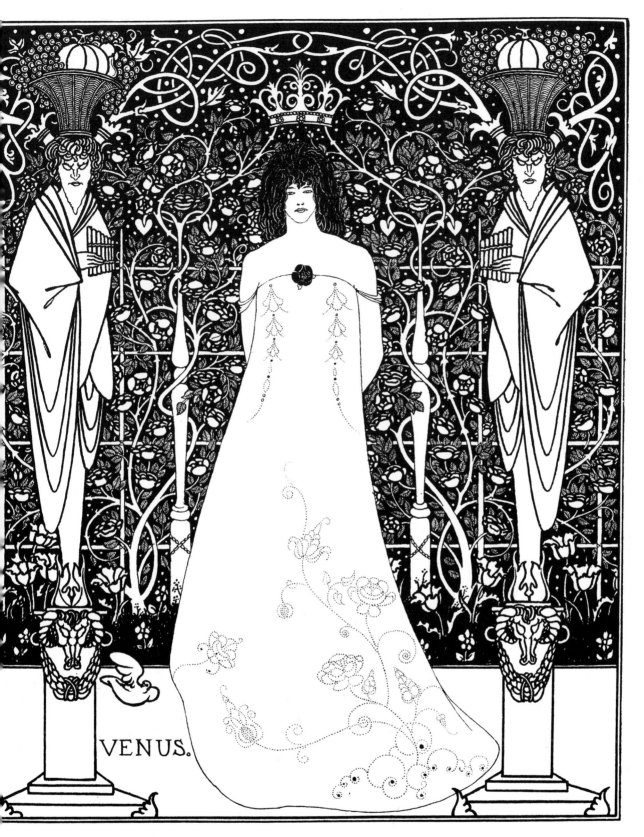

VENUS.

Venus between Terminal Gods (387)

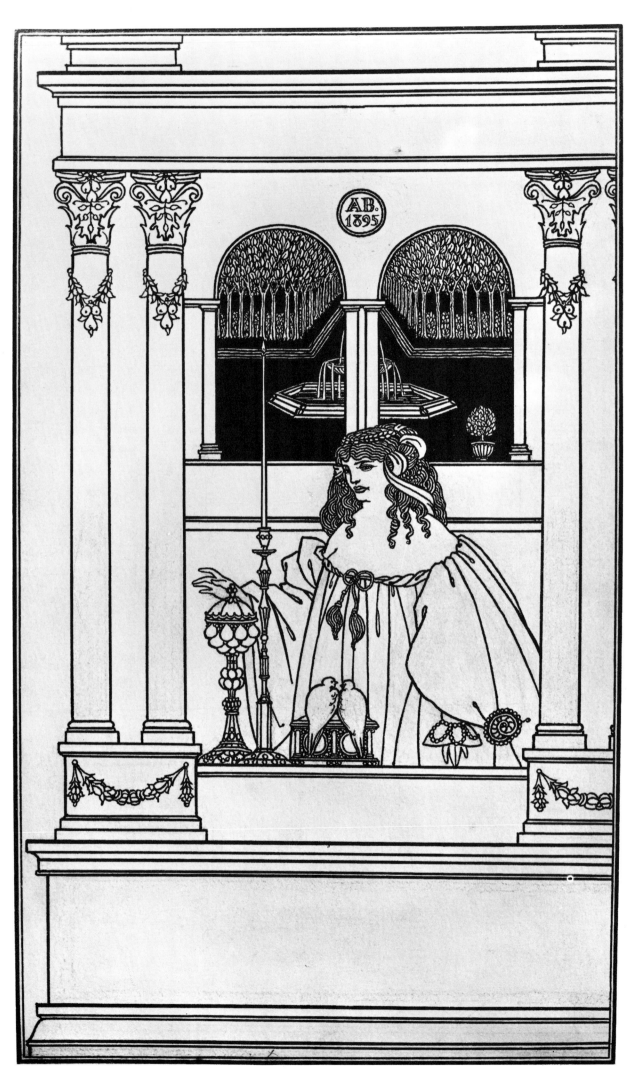

387 Design for a frontispiece to *The Story of Venus and Tannhäuser* (389)

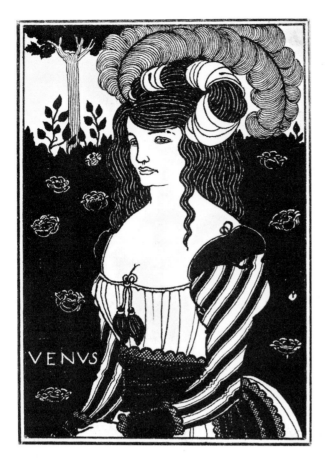

388 Venus (388)

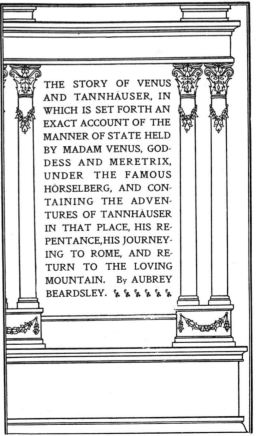

THE STORY OF VENUS AND TANNHÄUSER, IN WHICH IS SET FORTH AN EXACT ACCOUNT OF THE MANNER OF STATE HELD BY MADAM VENUS, GODDESS AND MERETRIX, UNDER THE FAMOUS HÖRSELBERG, AND CONTAINING THE ADVENTURES OF TANNHÄUSER IN THAT PLACE, HIS REPENTANCE, HIS JOURNEYING TO ROME, AND RETURN TO THE LOVING MOUNTAIN. By AUBREY BEARDSLEY.

389 *The Story of Venus and Tannhäuser* (390)

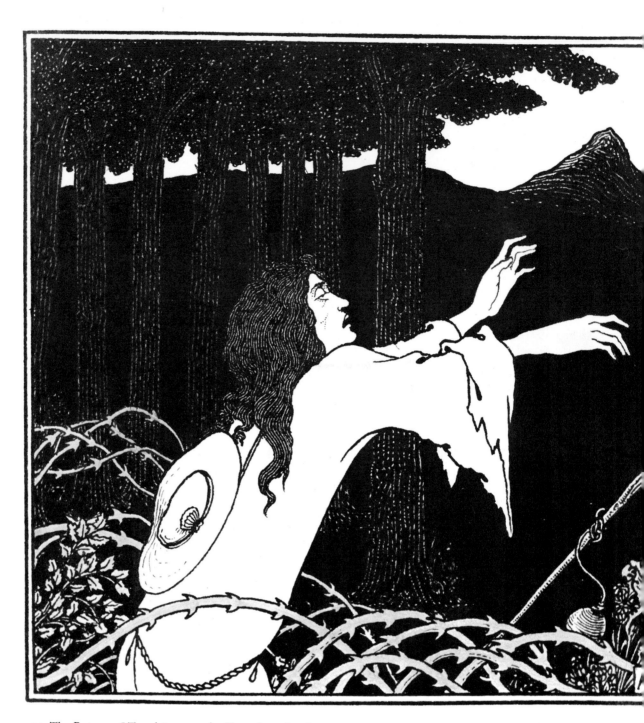

390 The Return of Tannhäuser to the Venusberg (391)

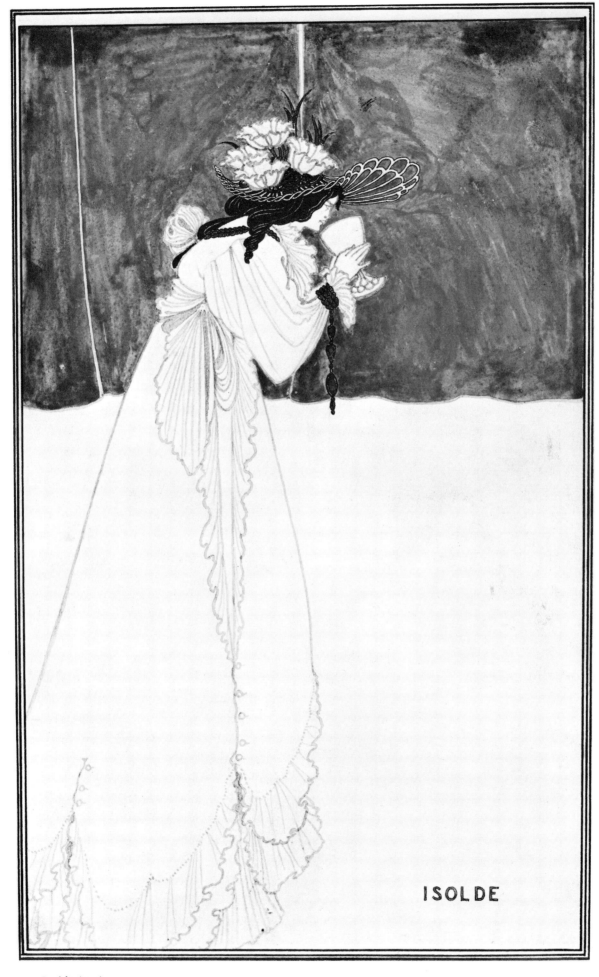

391 Isolde (392)

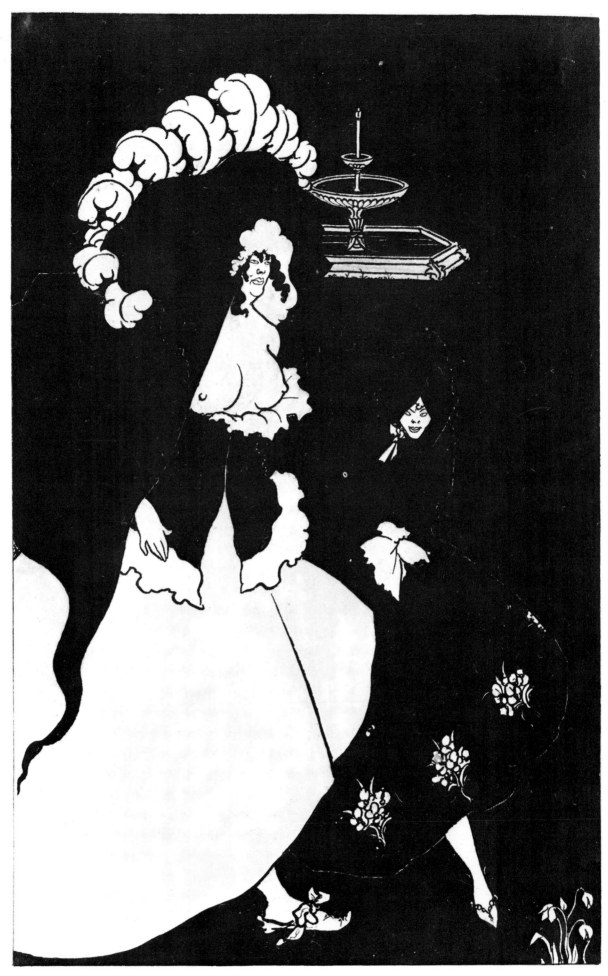

392 Messalina returning home (393)

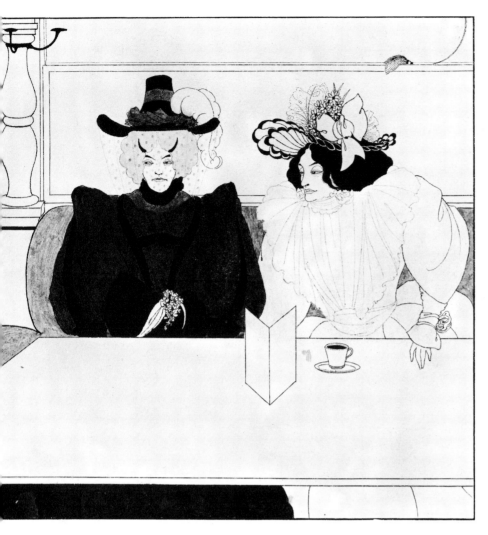

First frontispiece to *An Evil Motherhood* (394)

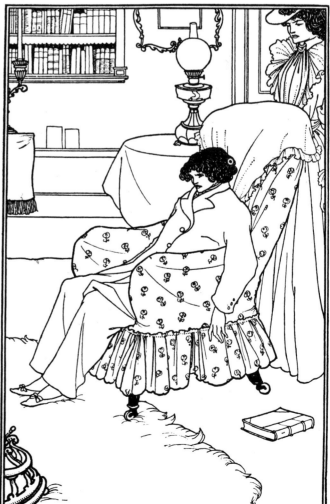

Second frontispiece to *An Evil Motherhood* (395)

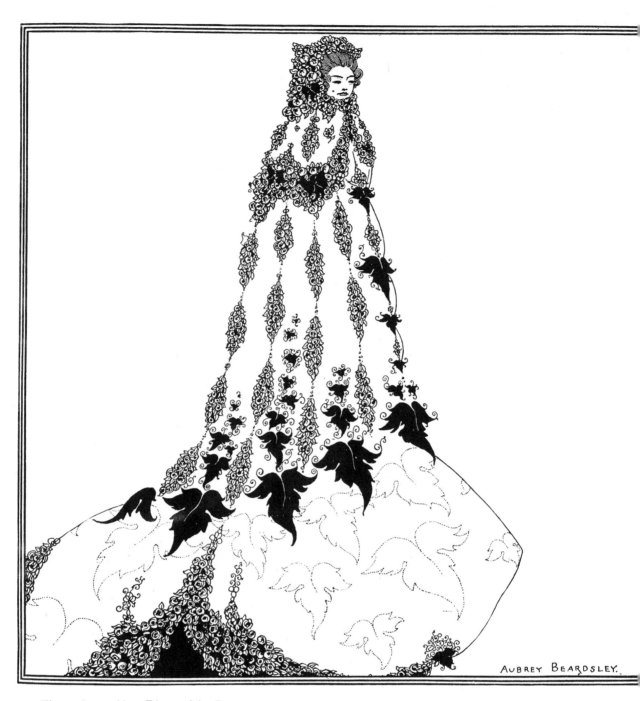

395 Illustration to 'At a Distance' (396)

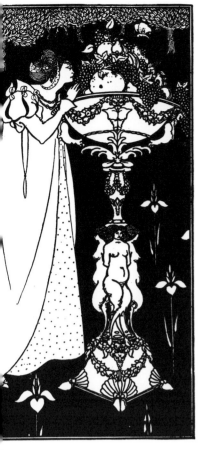

Autumn (381)

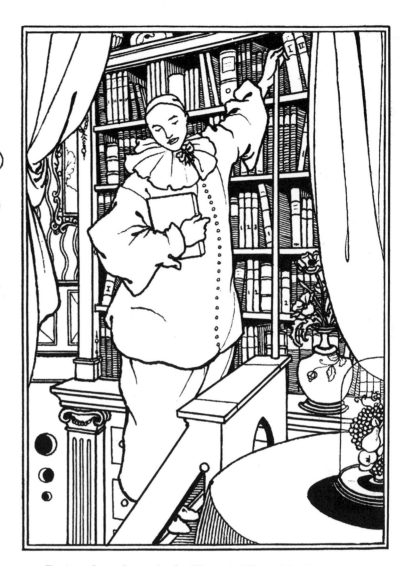

397 Designs for volumes in the 'Pierrot's Library' (397)

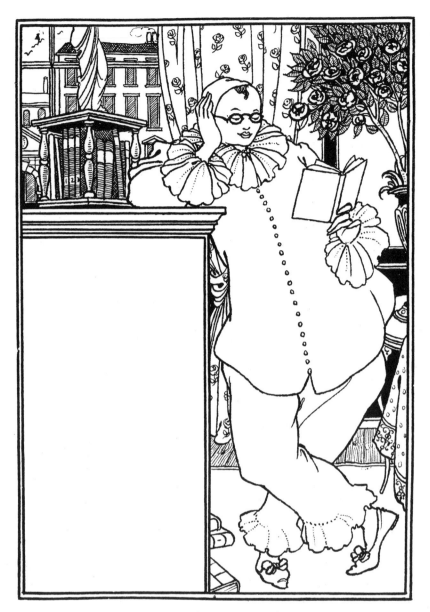

398 Title-pages in the 'Pierrot's Library' (399)

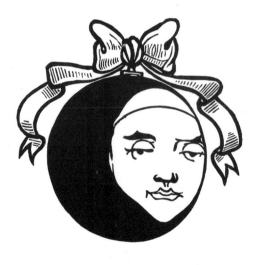

399 Back covers of volumes in the 'Pierrot's Library'

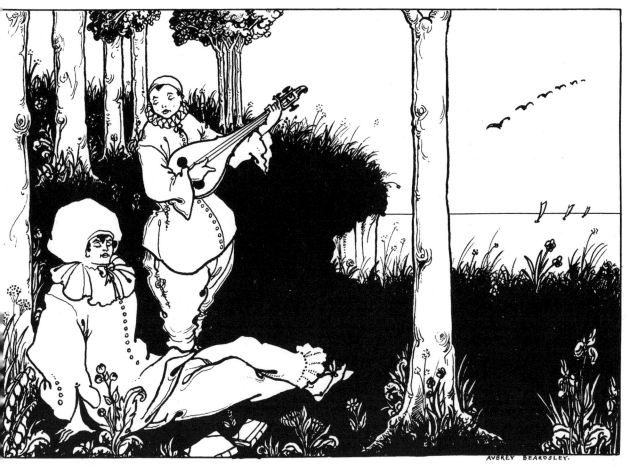

400 Front end-papers of volumes in the 'Pierrot's Library' (400)

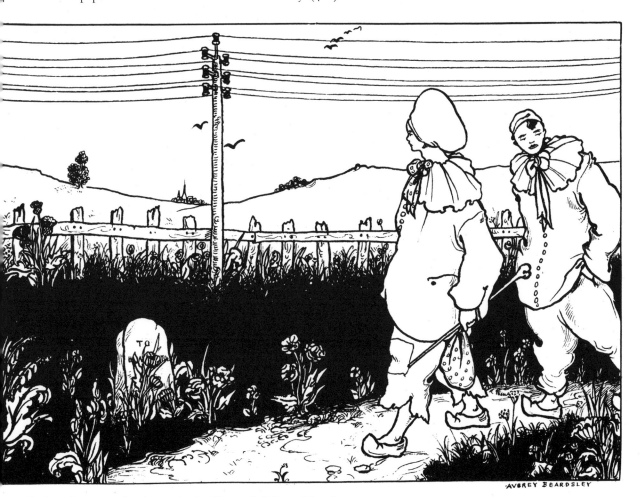

401 Back end-papers of volumes in the 'Pierrot's Library' (401)

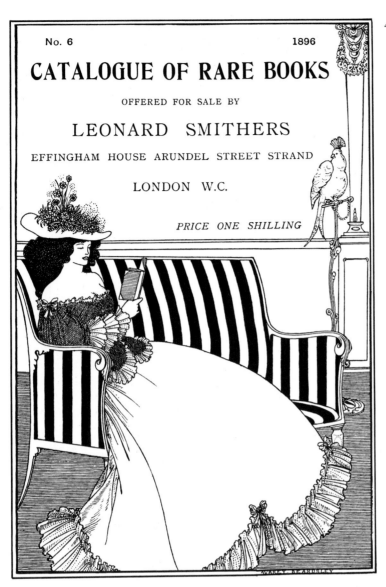

No. 6 1896

CATALOGUE OF RARE BOOKS

OFFERED FOR SALE BY

LEONARD SMITHERS

EFFINGHAM HOUSE ARUNDEL STREET STRAND

LONDON W.C.

PRICE ONE SHILLING

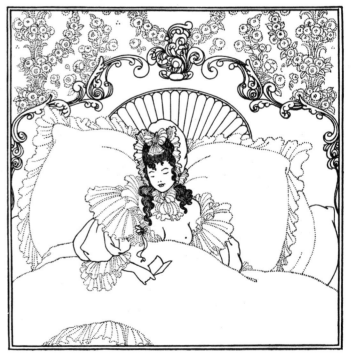

403 The Billet-Doux, from *The Rape of the Lock* (405)

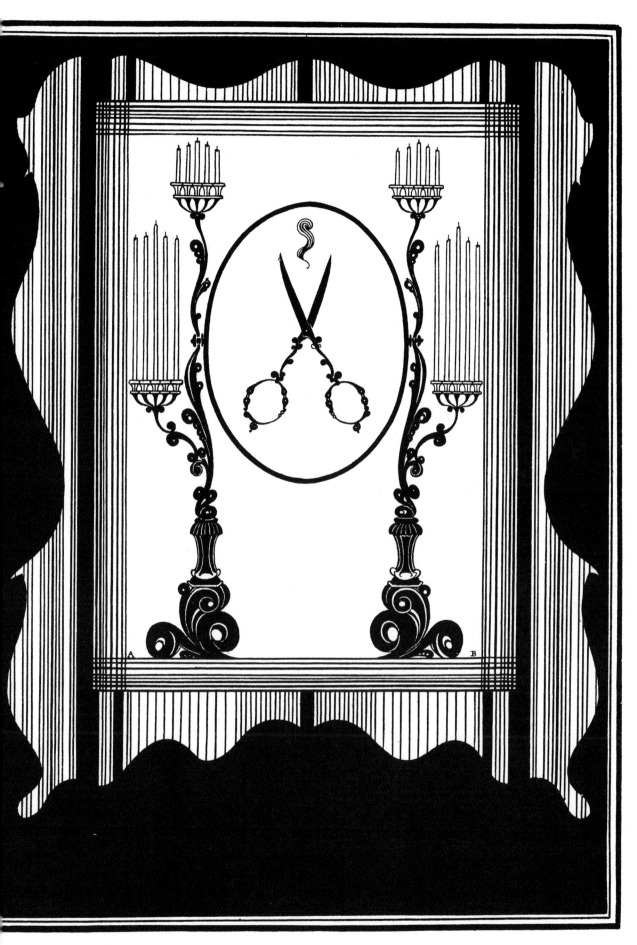

Design for front cover of *The Rape of the Lock* (403)

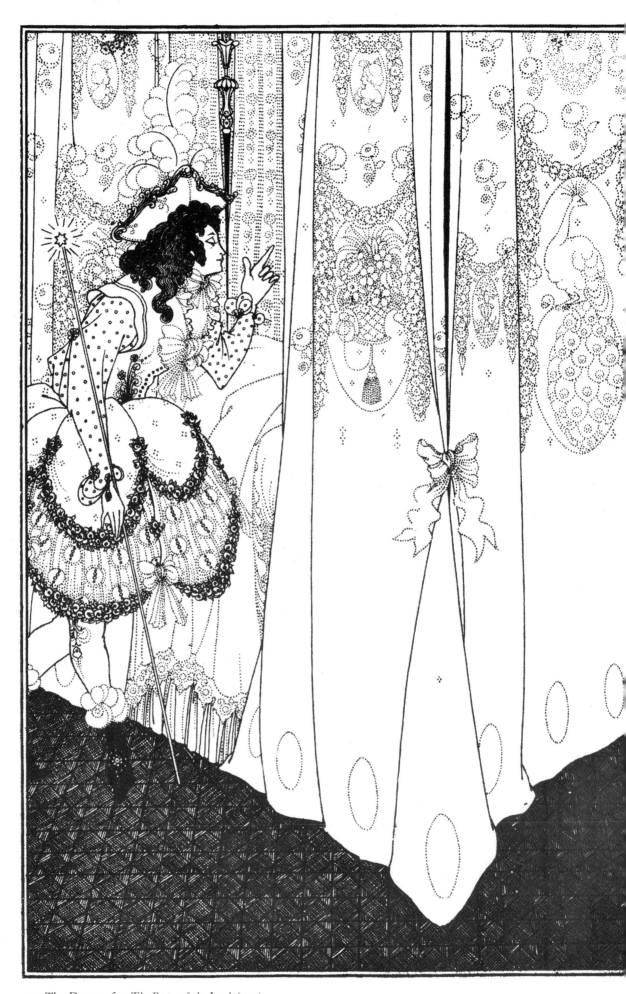

405 The Dream, for *The Rape of the Lock* (404)

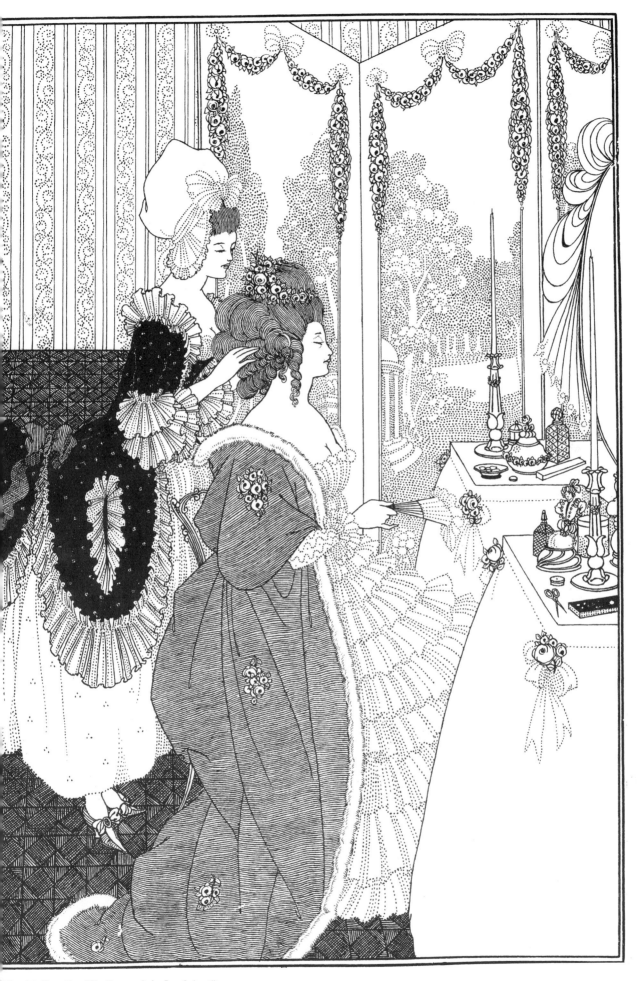

The Toilet, for *The Rape of the Lock* (406)

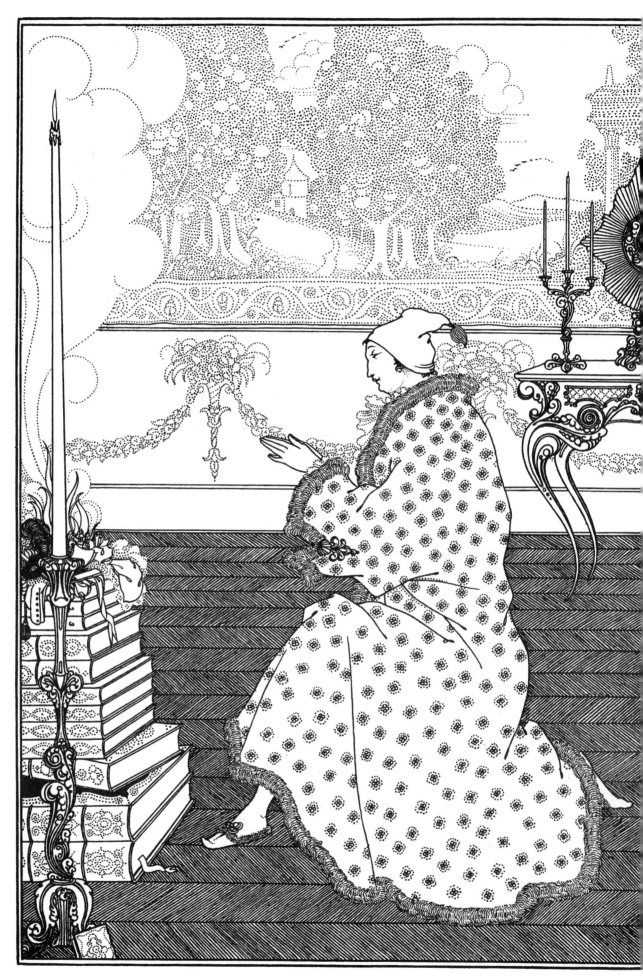

407 The Baron's Prayer, for *The Rape of the Lock* (407)

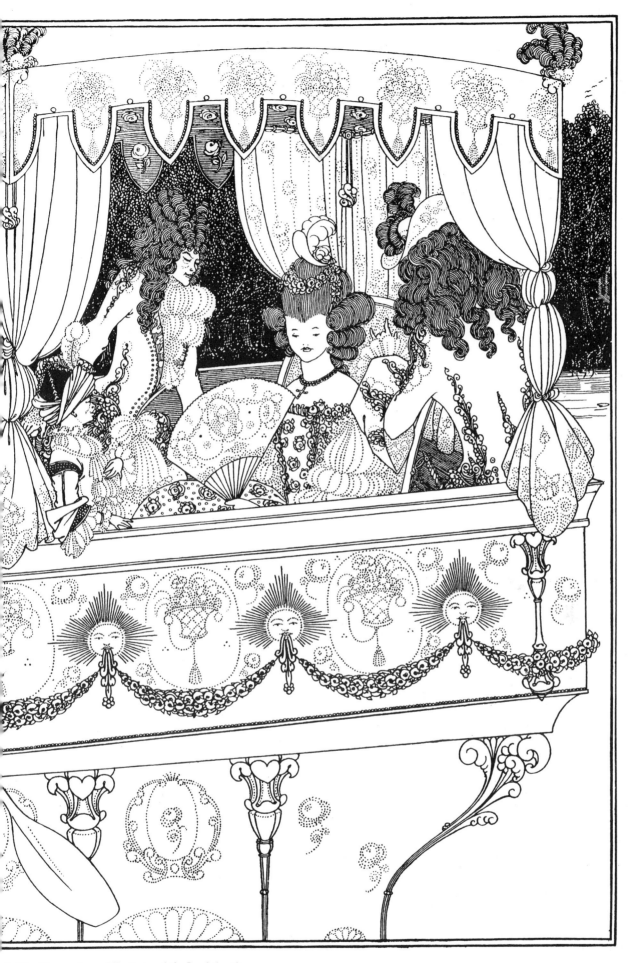

8 The Barge, from *The Rape of the Lock* (408)

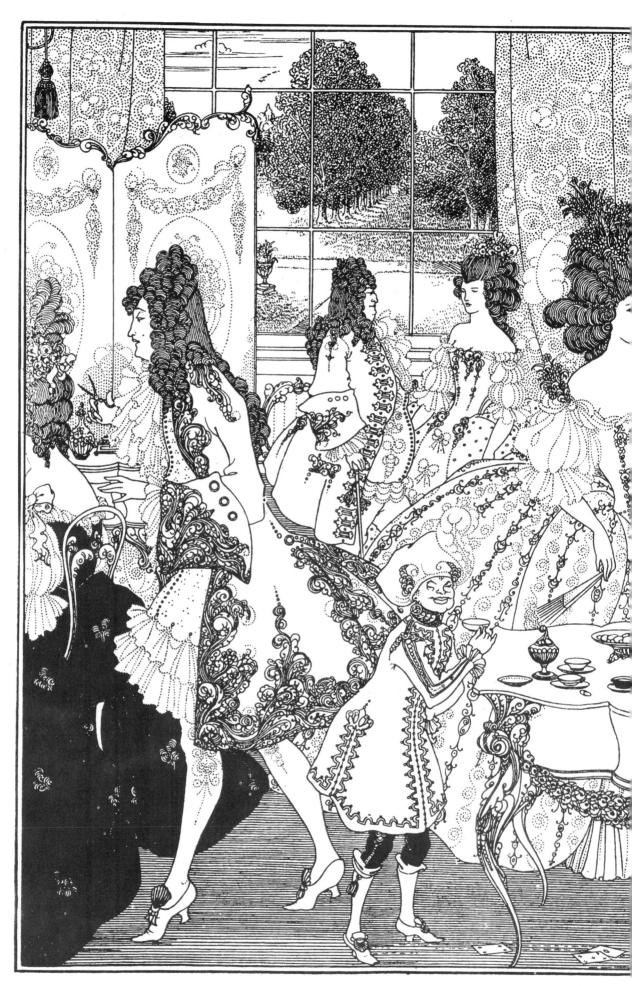

409 The Rape of the Lock (409)

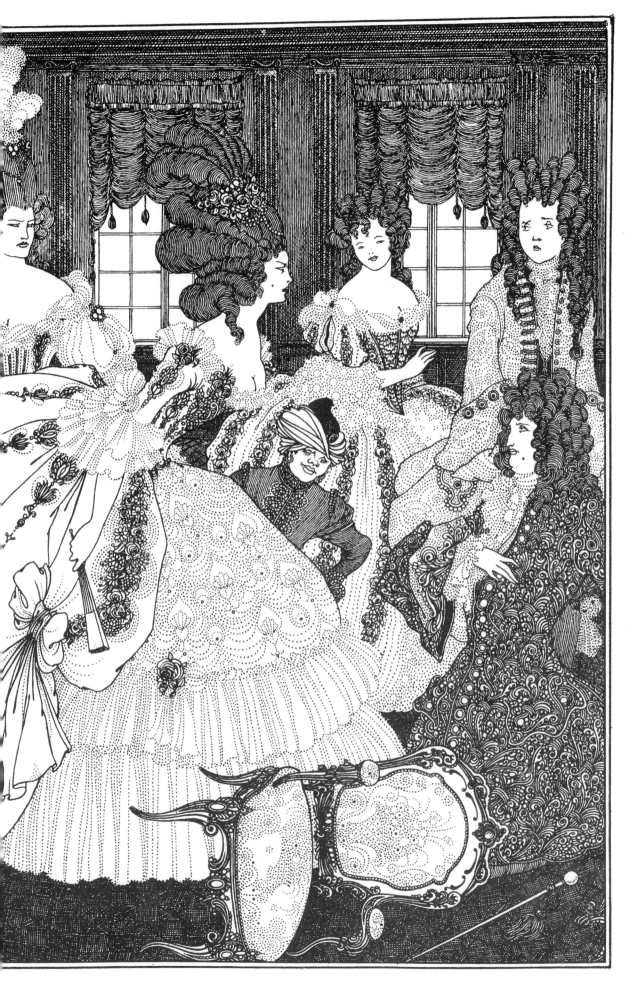

The Battle of the Beaux and the Belles, for *The Rape of the Lock* (411)

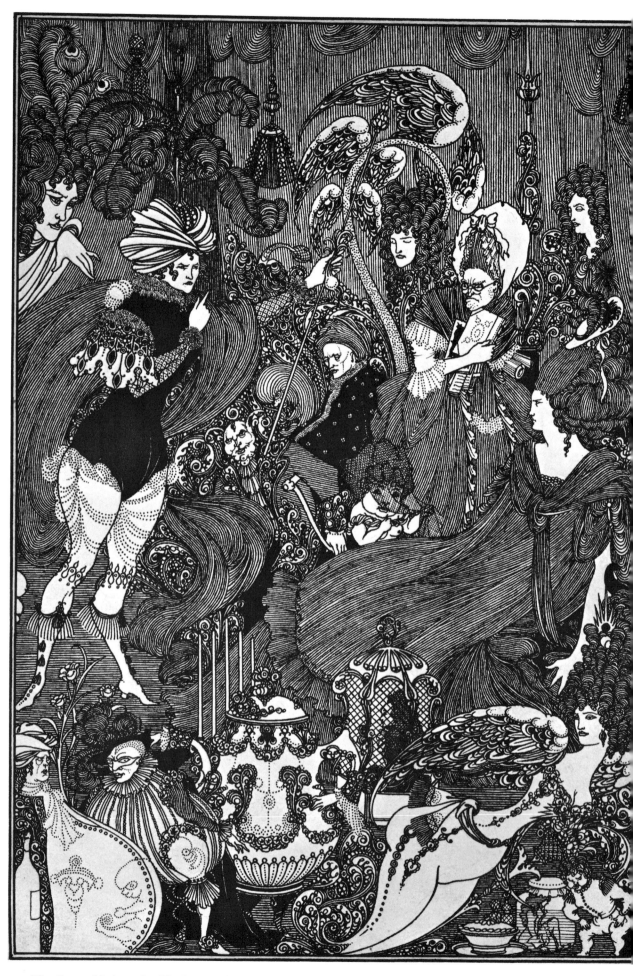

411 The Cave of Spleen, for *The Rape of the Lock* (410)

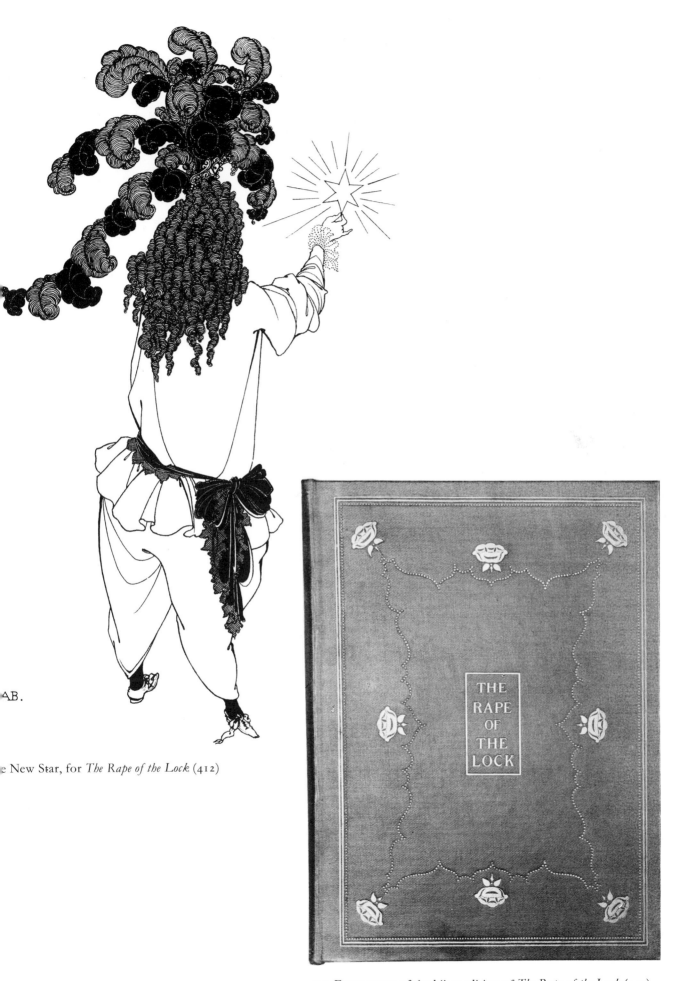

AB.

e New Star, for *The Rape of the Lock* (412)

413 Front cover of the bijou edition of *The Rape of the Lock* (413)

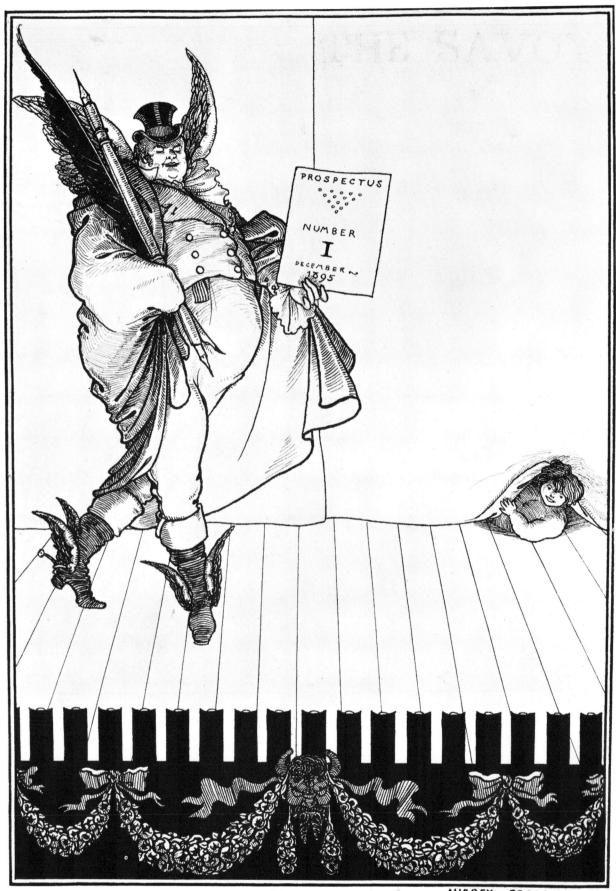

414 Design for front cover of prospectus of *The Savoy*, NO. I (414)

THE SAVOY

Nº 1.
JANUARY
1896

AUBREY BEARDSLEY. 1896.

Design for the front cover of *The Savoy*, NO. 1 (416)

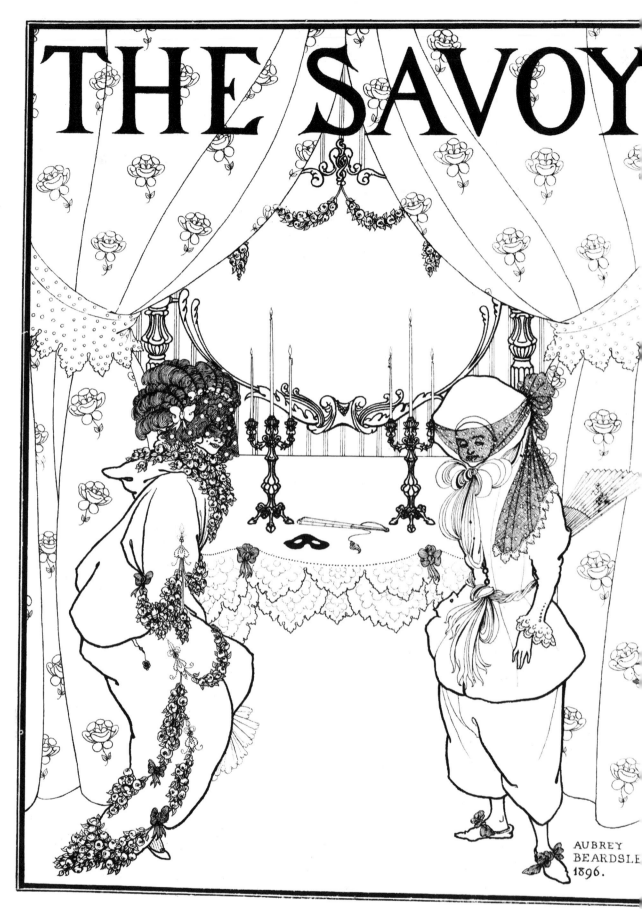

416 Design for title-page of *The Savoy*, NO. 1 (417)

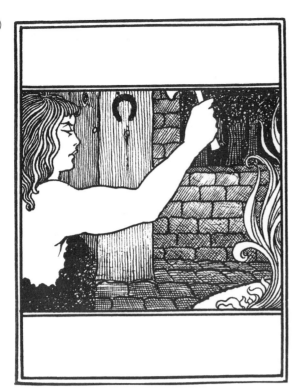

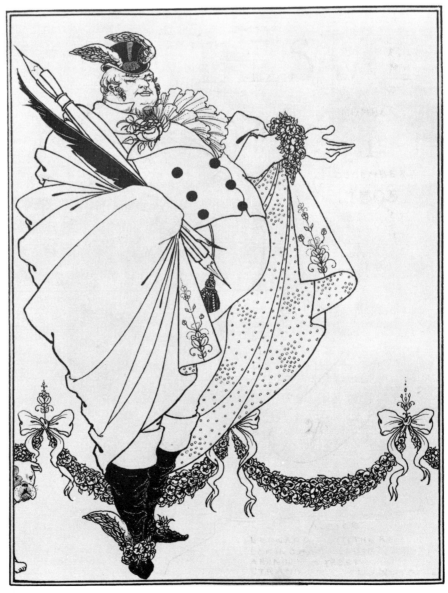

418 Design for page preceding contents list in *The Savoy*, NO. I (418)

419 The Three Musicians
(not used for poem in *Savoy*) (419)

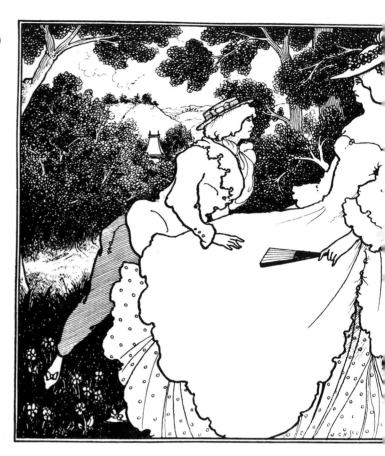

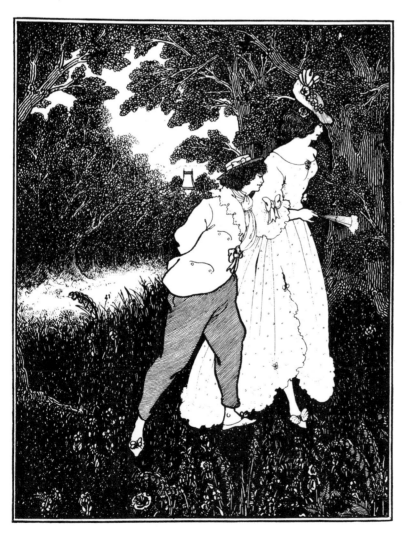

420 The Three Musicians (420)

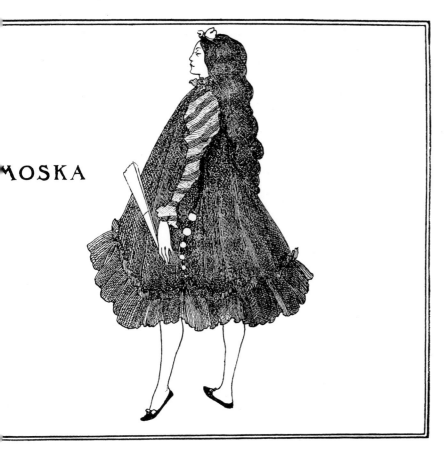

MOSKA

Moska (422)

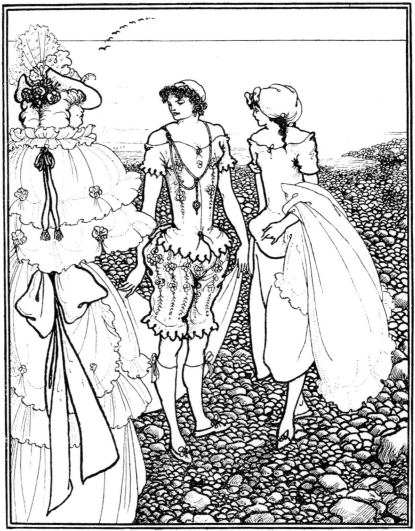

422 The Bathers (421)

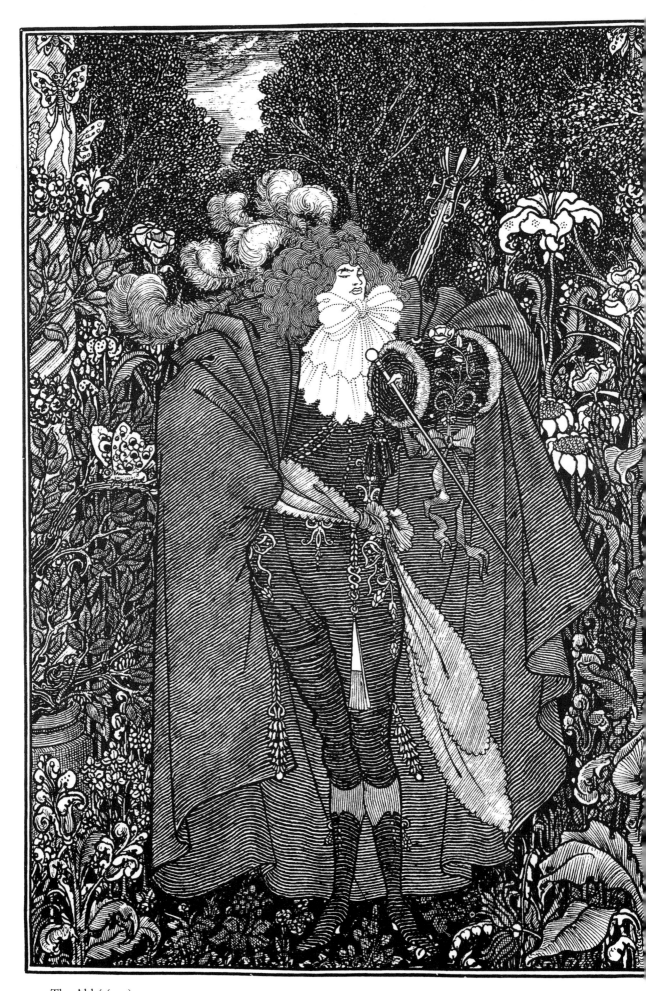

423 The Abbé (423)

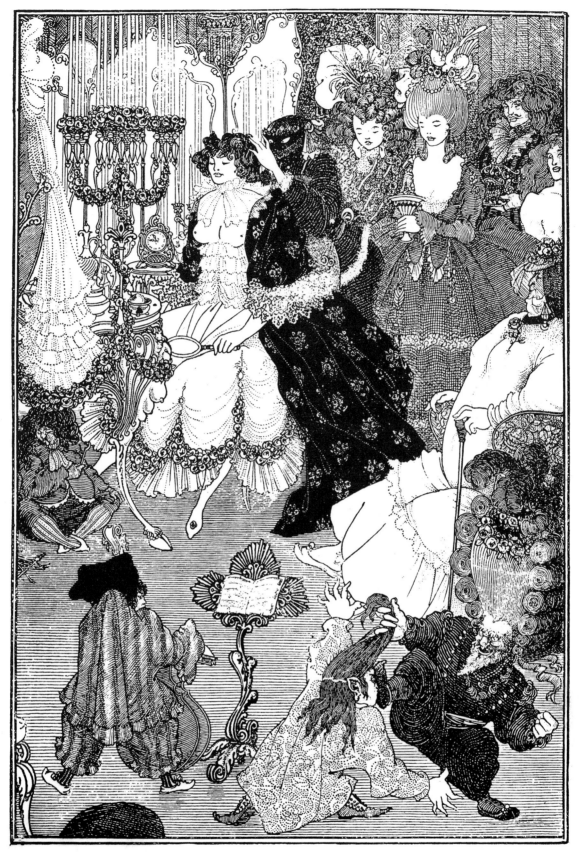

424 The Toilet (424)

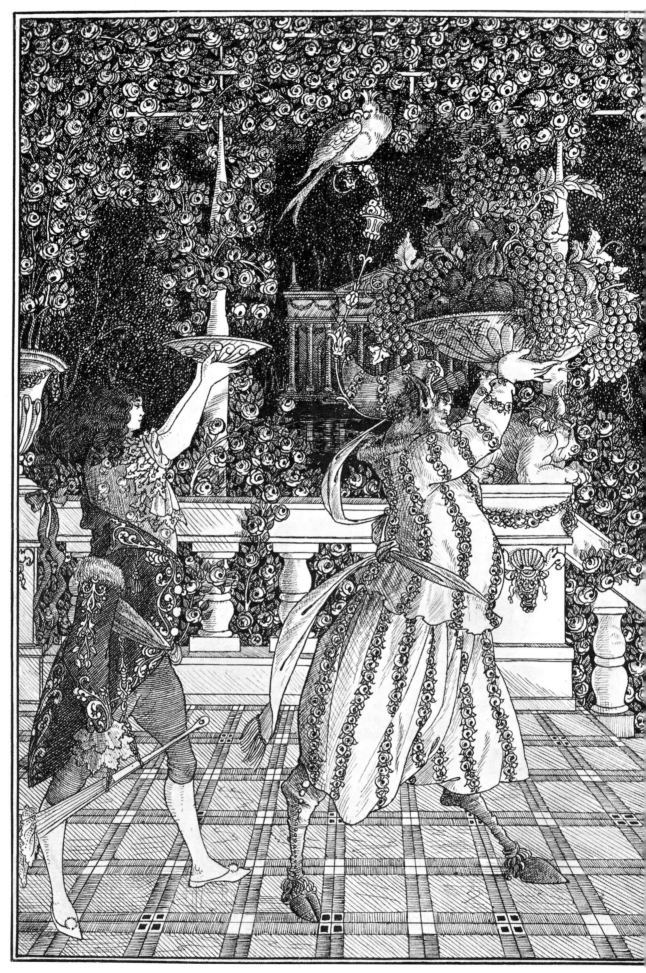

425 The Fruit Bearers (425)

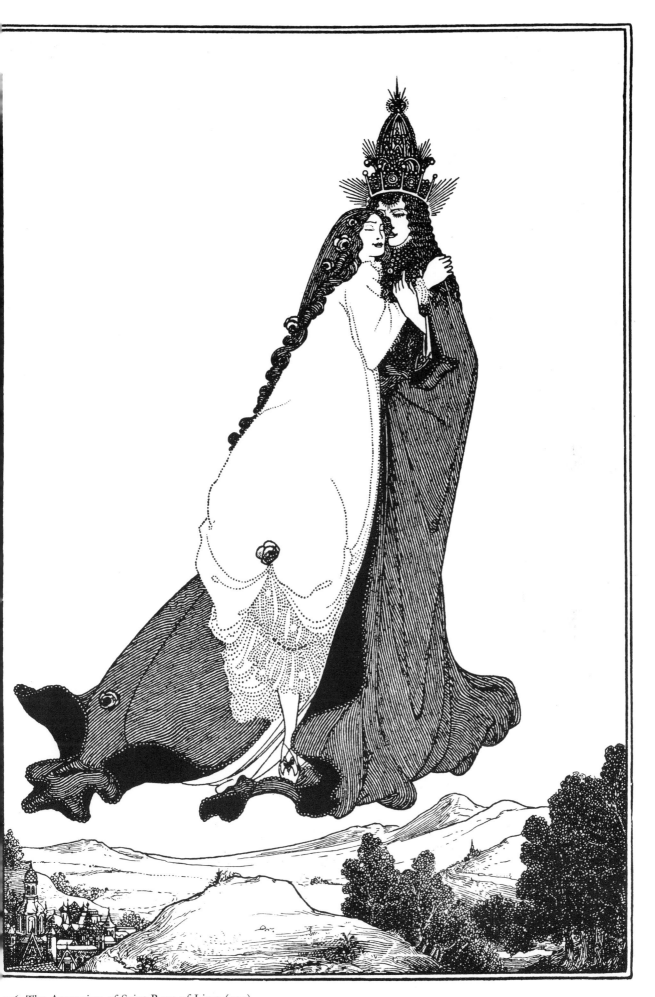

426 The Ascension of Saint Rose of Lima (429)

THE SAVOY

AN ILLUSTRATED QUARTERLY

No. 2 April 1896 Price **2/6** net

EDITED BY ARTHUR SYMONS

AUBREY BEARDSLEY —

427 Choosing the New Hat. Front cover of *The Savoy*, NO. 2 (427)

A Footnote (428)

429 A Large Christmas Card (426)

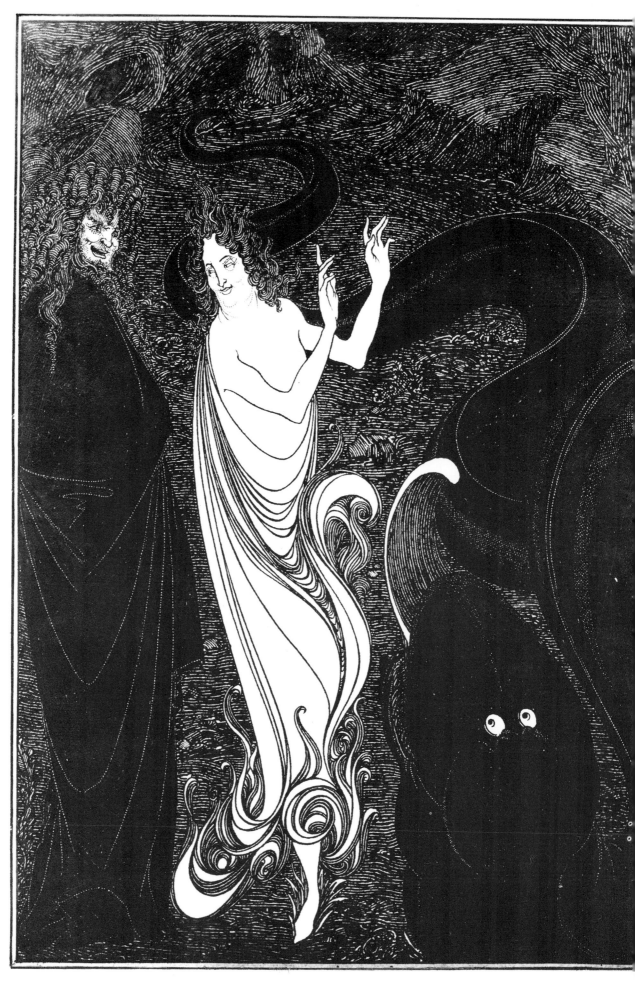

430 The Third Tableau of Das Rheingold (430)

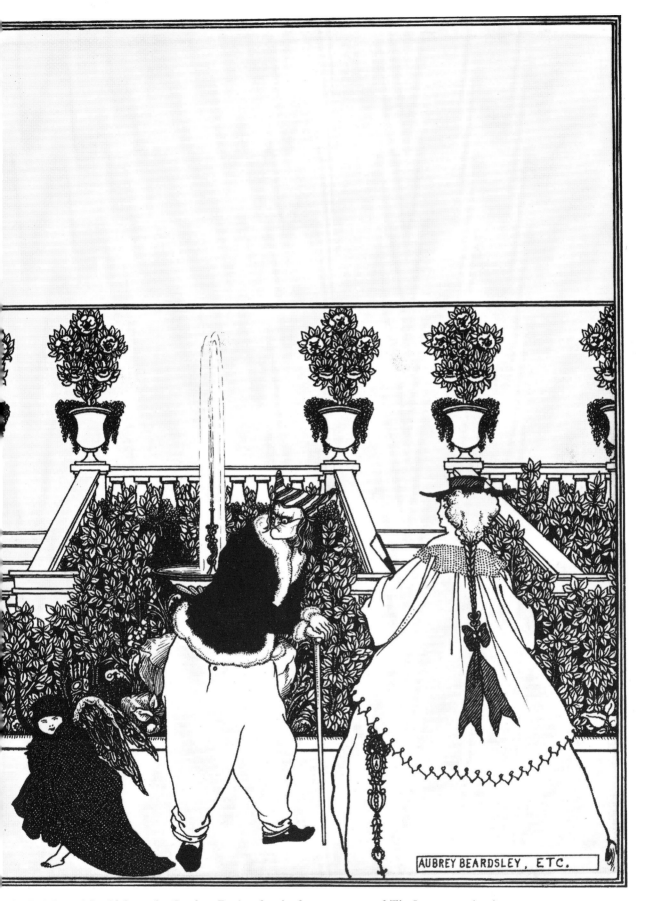

The Driving of Cupid from the Garden. Design for the front wrapper of *The Savoy*, NO. 3 (431)

THE
SAVOY

EDITED BY ARTHUR SYMONS

No. 8 and last
December
1896

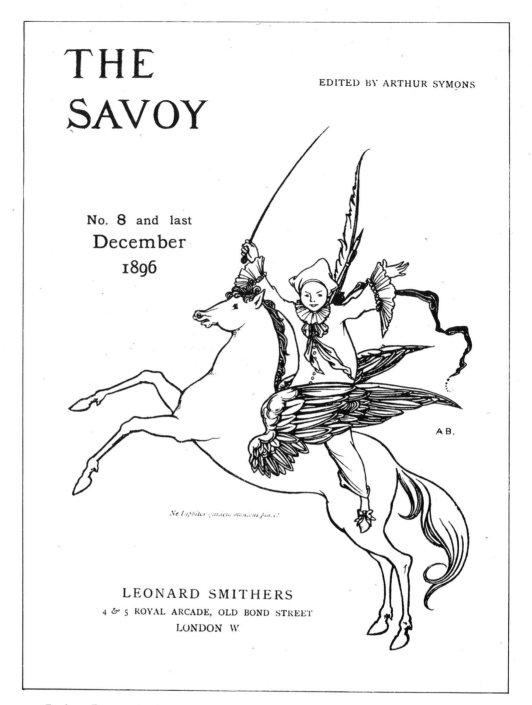

A B.

Ne Iupiter quidem omnibus placet

LEONARD SMITHERS
4 & 5 ROYAL ARCADE, OLD BOND STREET
LONDON W

432 Puck on Pegasus (432)

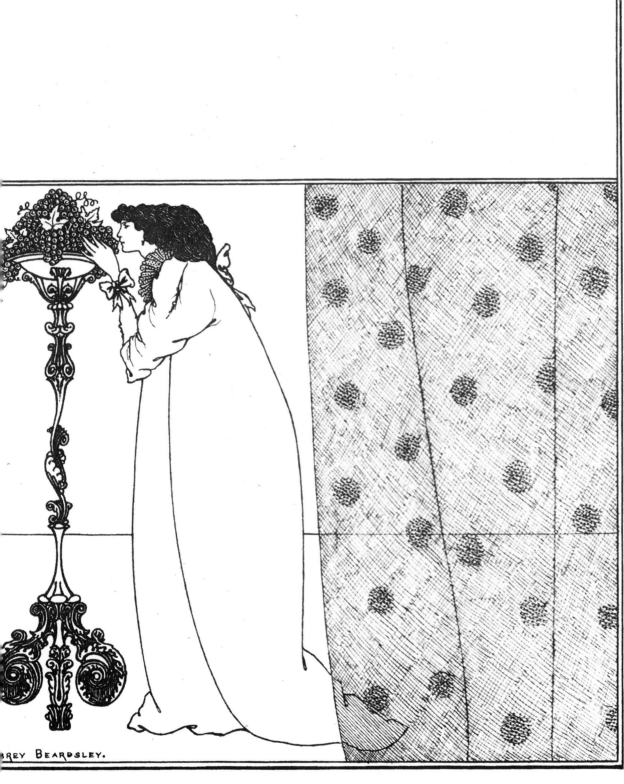

BEARDSLEY.

Design for the front wrapper of *The Savoy*, NO. 4 (435)

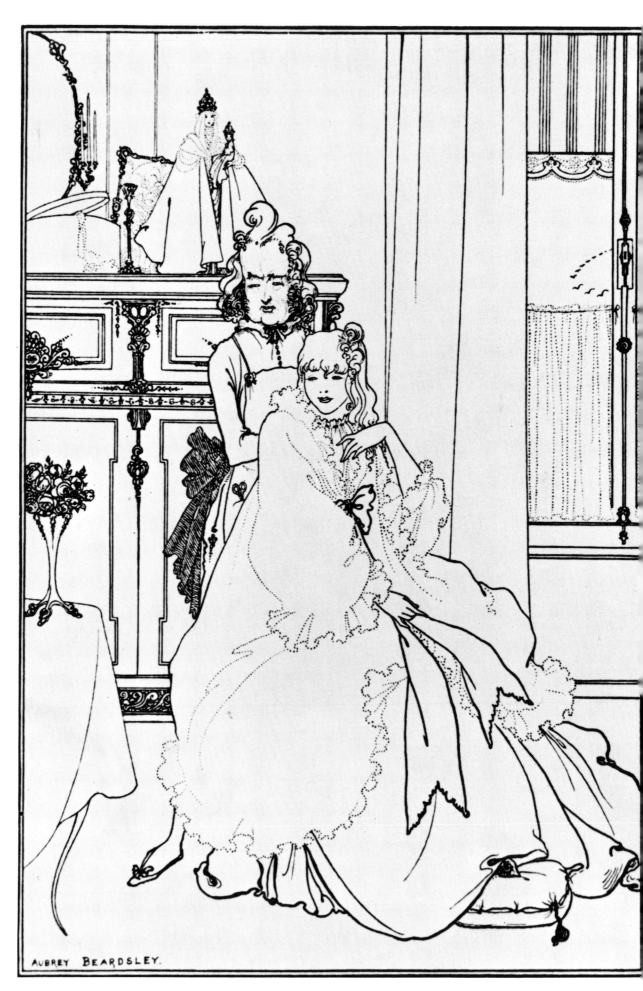

434 The Coiffing, illustrating Beardsley's poem 'The Ballad of a Barber' (433)

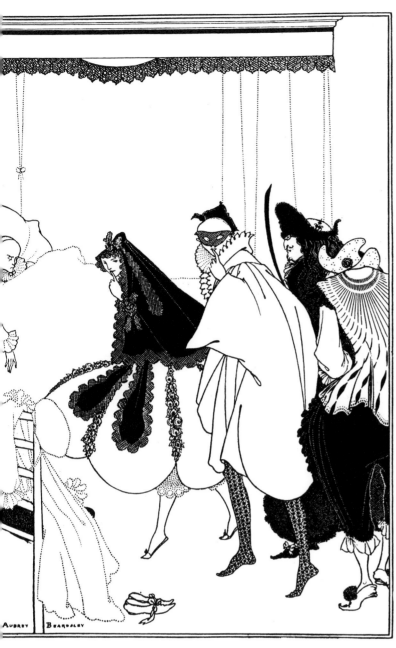

The Death of Pierrot (439)

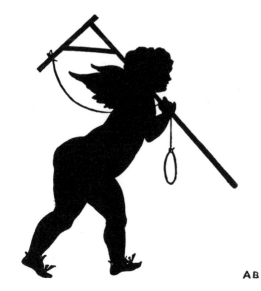

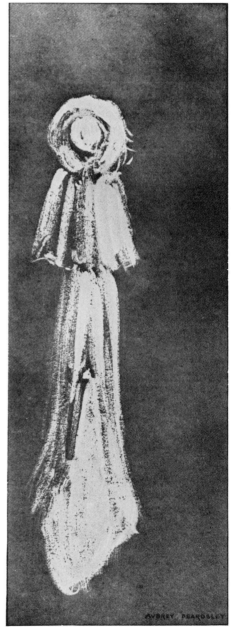

Cul-de-lampe illustrating Beardsley's poem 'The Ballad of a Barber' (434) 437 The Woman in White (437)

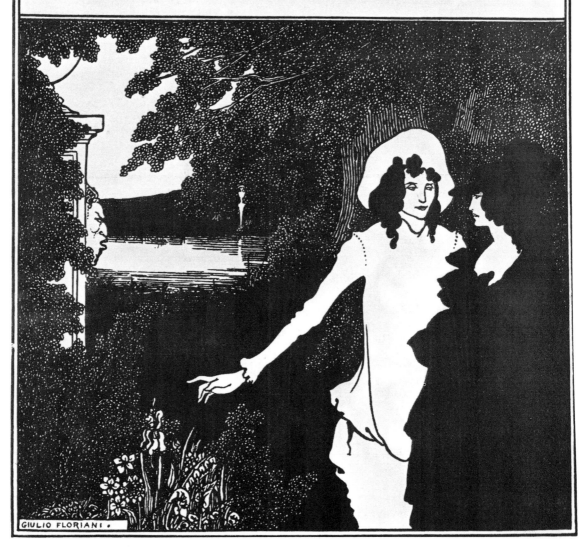

THE SAVOY

AN ILLUSTRATED MONTHLY

No. 5 September 1896 Price 2/-

EDITED BY ARTHUR SYMONS

GIULIO FLORIANI.

438 Front wrapper of *The Savoy*, NO. 5 (436)

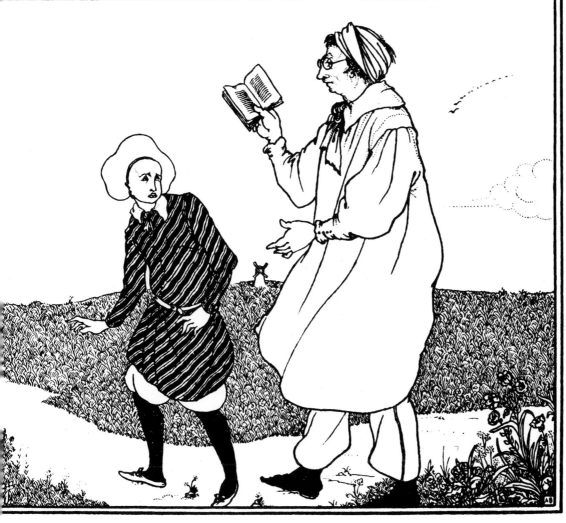

THE SAVOY

AN ILLUSTRATED MONTHLY

No. 7 November 1896 Price 2/-

EDITED BY ARTHUR SYMONS

9 First page of *The Savoy*, NO. 7 (440)

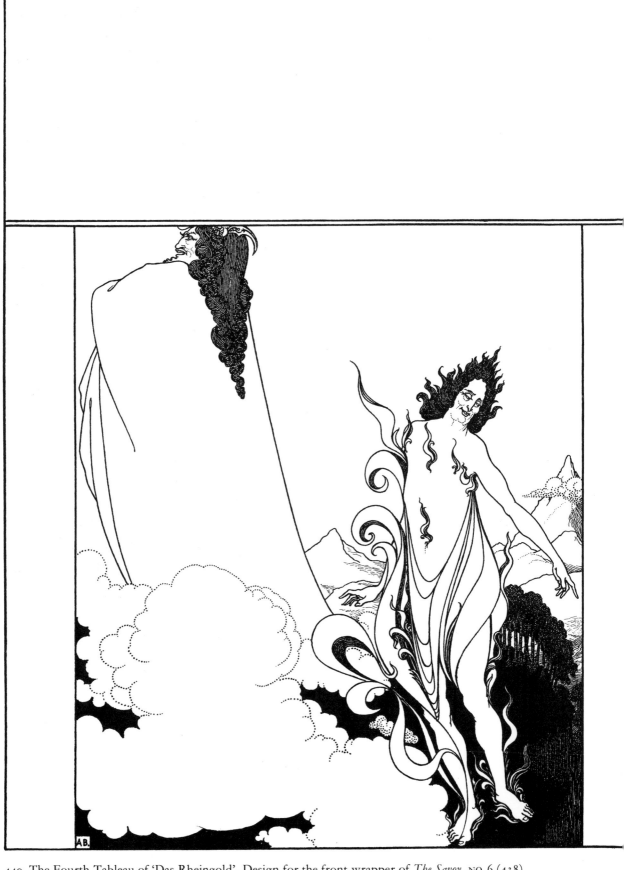

440 The Fourth Tableau of 'Das Rheingold'. Design for the front wrapper of *The Savoy*, NO. 6 (438)

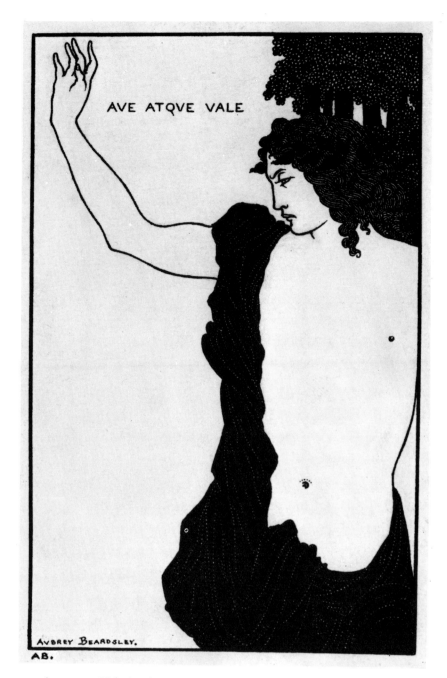

441 Ave atque Vale (441)

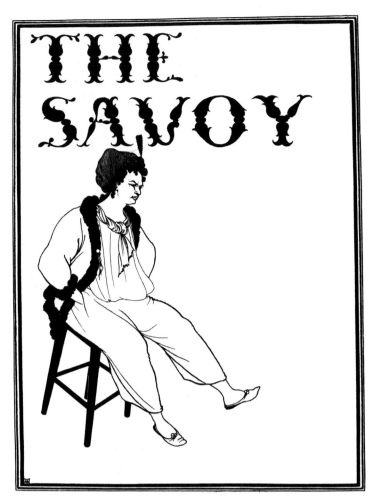

442 First page of *The Savoy*, NO. 8 (442)

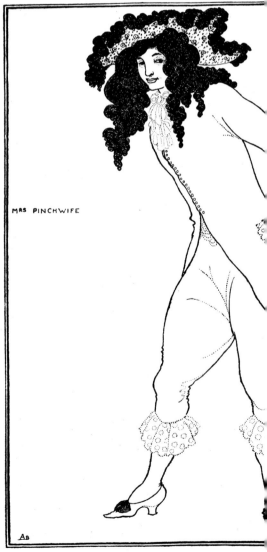

443 Mrs Pinchwife, from Wycherley's *Country W...*

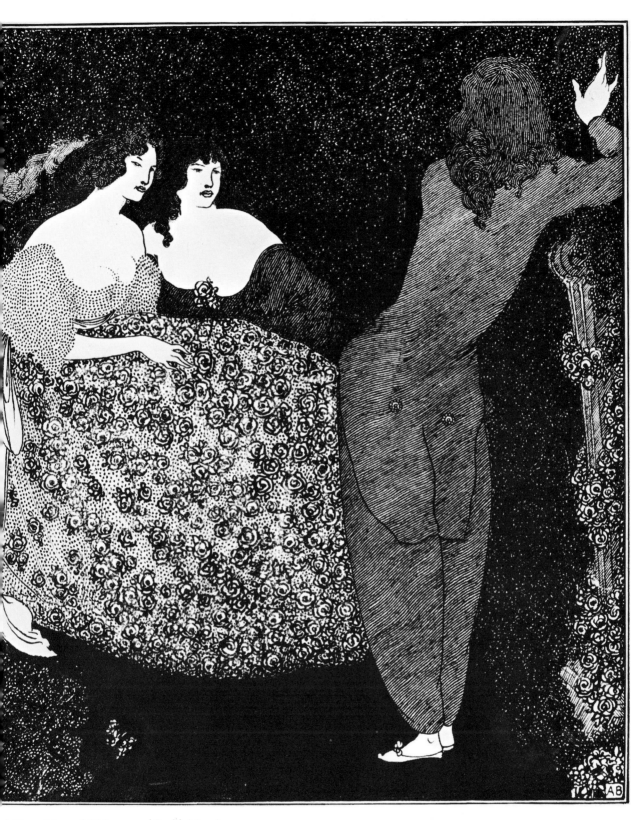

A Repetition of 'Tristan und Isolde' (444)

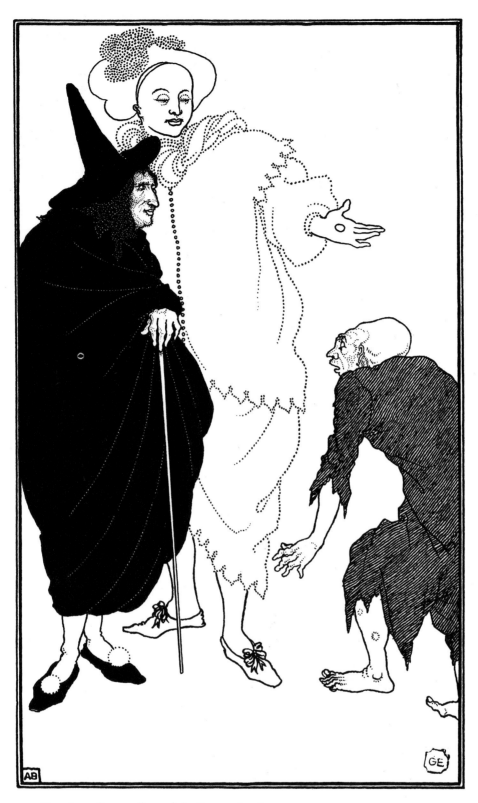

445 Don Juan Sganarelle, and the Beggar (445)

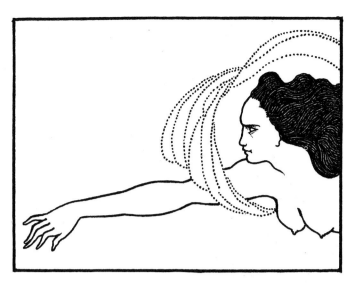

446 Flosshilde (447)

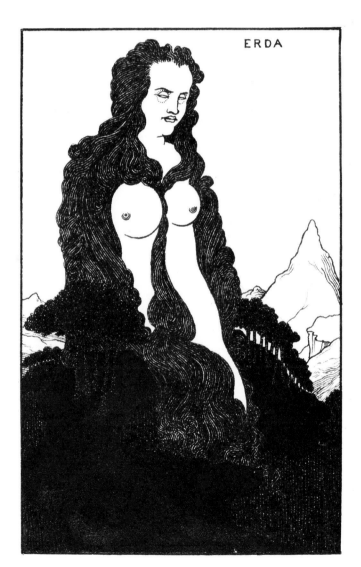

447 Erda (449)

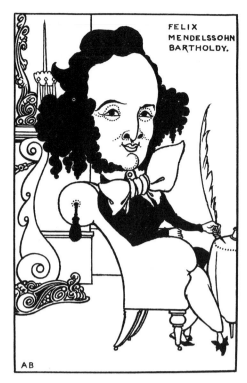

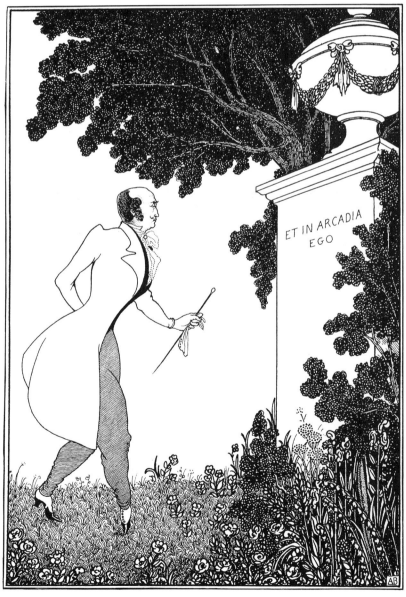

449 Et in Arcadia Ego (452)

450 Frontispiece to
The Comedy of the Rhinegold (446)

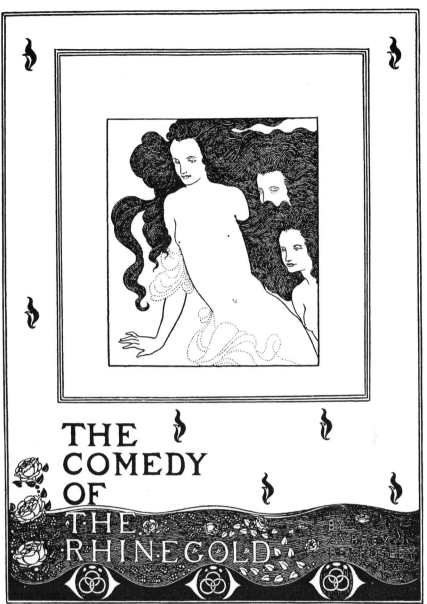

Alberich (448)

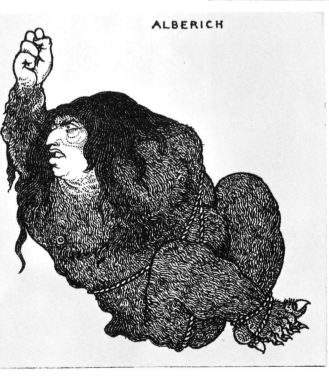

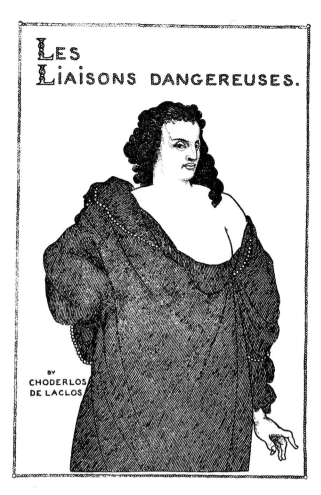

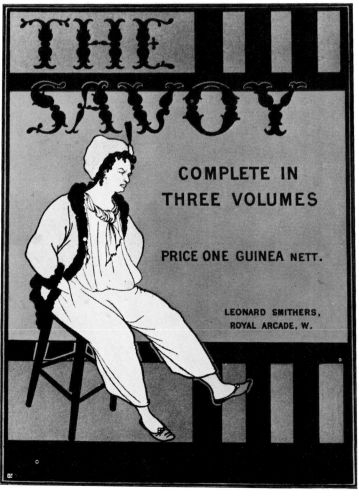

453 Poster for *The Savoy* (453)

Sketch of a young girl (454)

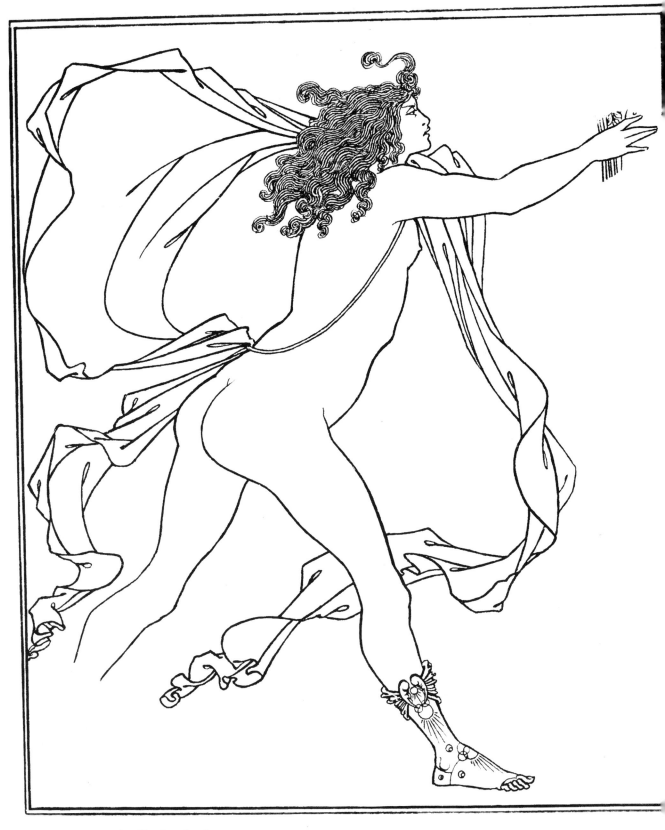

455 Apollo pursuing Daphne (455)

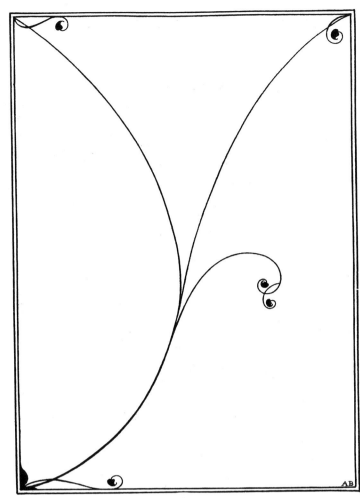

457 Design for front cover of *Verses* by Ernest Dowson (457)

Design for front cover of *The Life and Times of Madame Du Barry* (456)

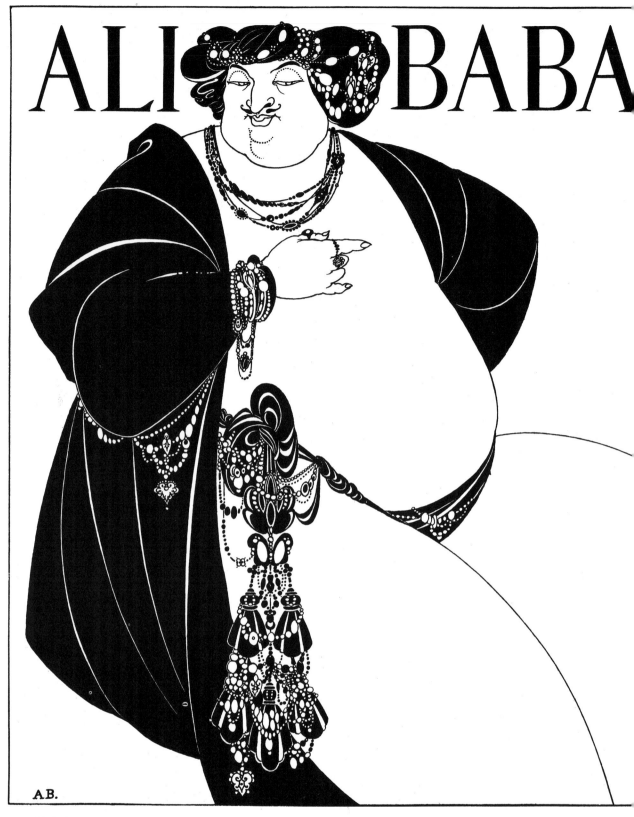

458 Ali Baba (458)

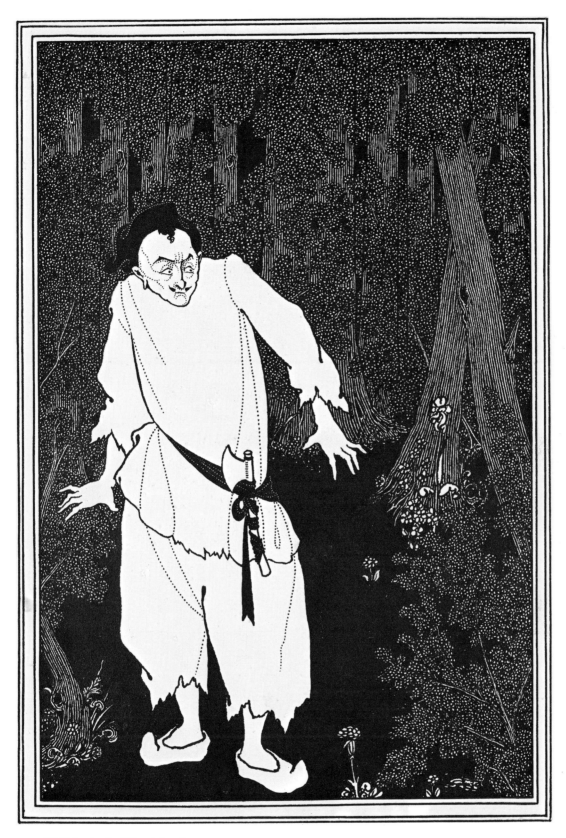

459 Ali Baba in the Wood (459)

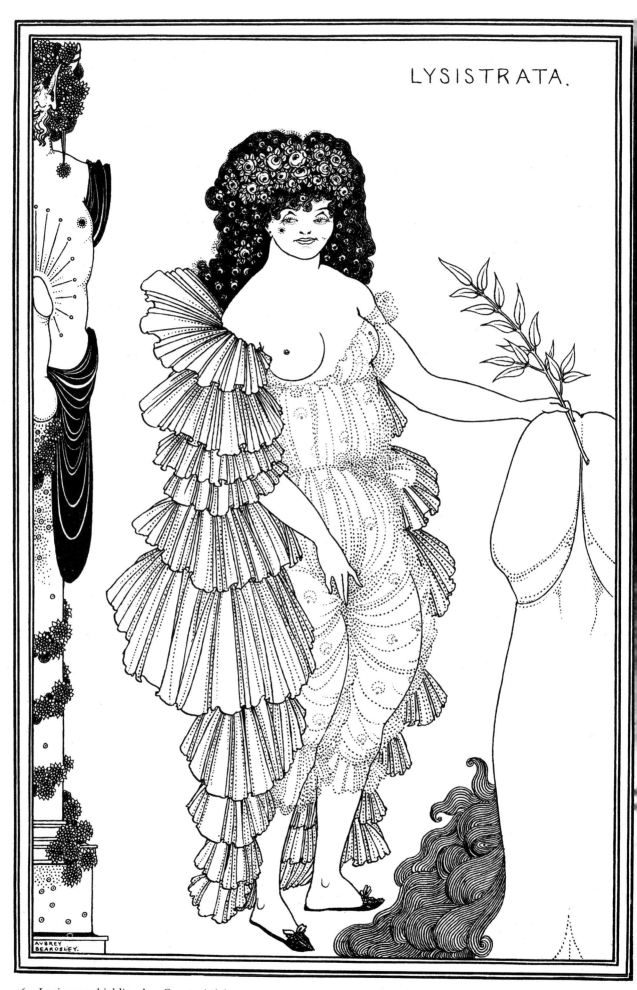

460 Lysistrata shielding her Coynte (460)

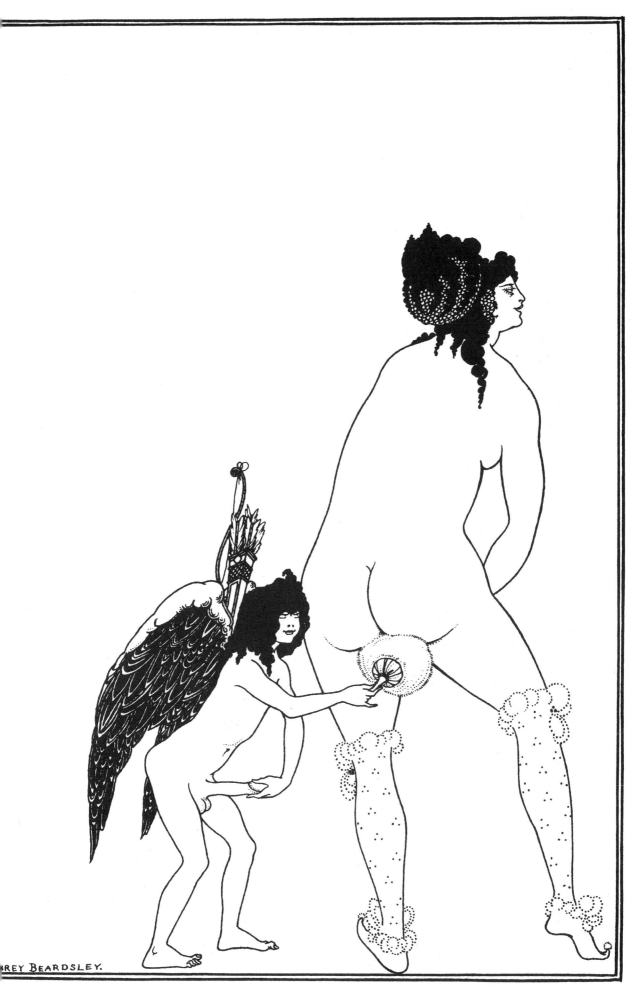

The Toilet of Lampito (461)

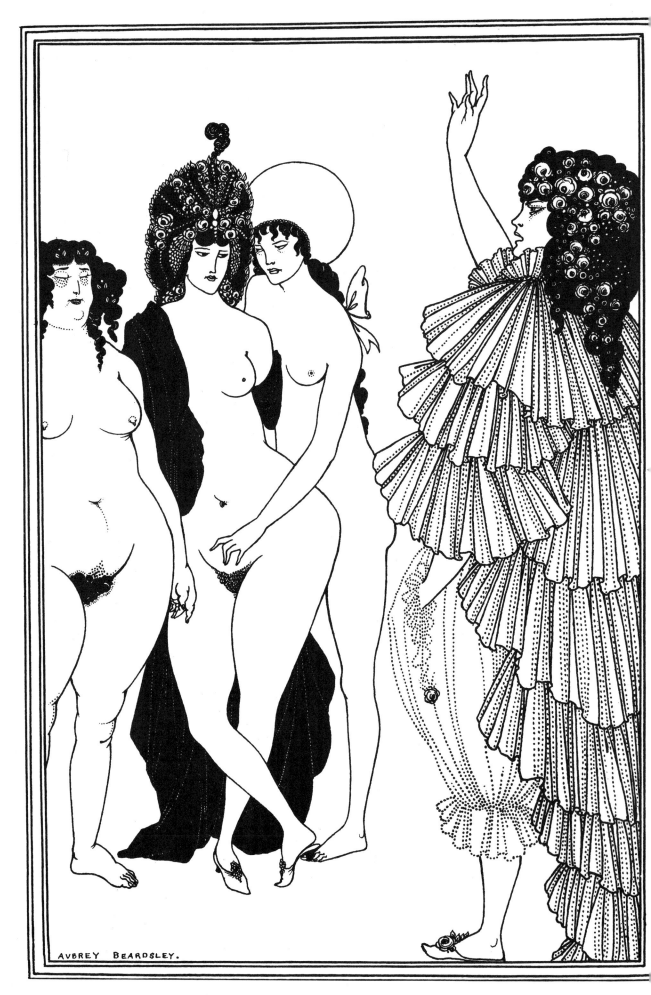

462 Lysistrata Haranguing the Athenian Women (462)

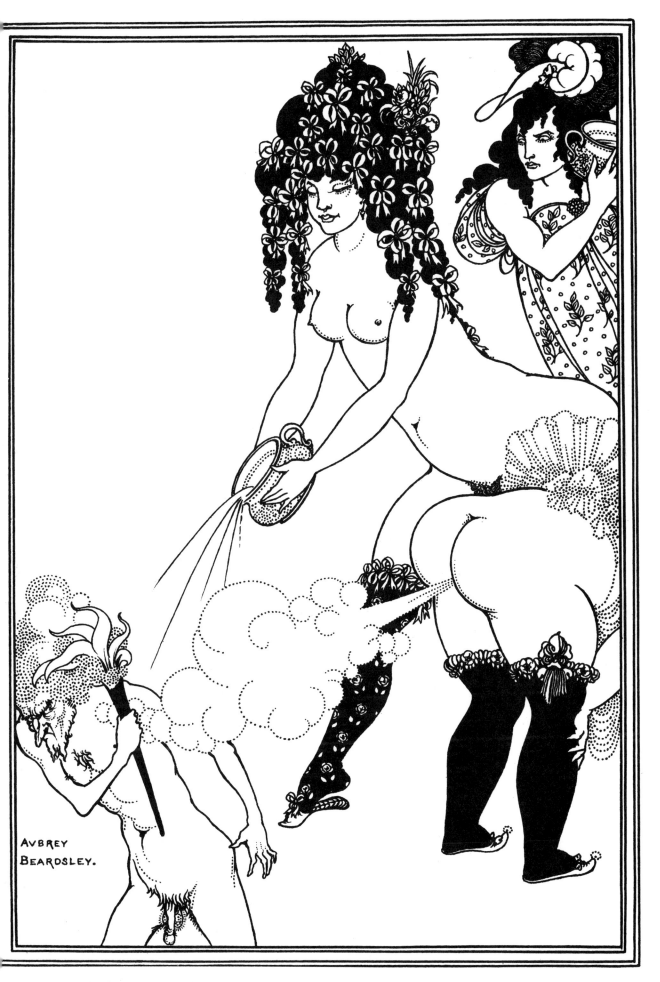

63 Lysistrata Defending the Acropolis (463)

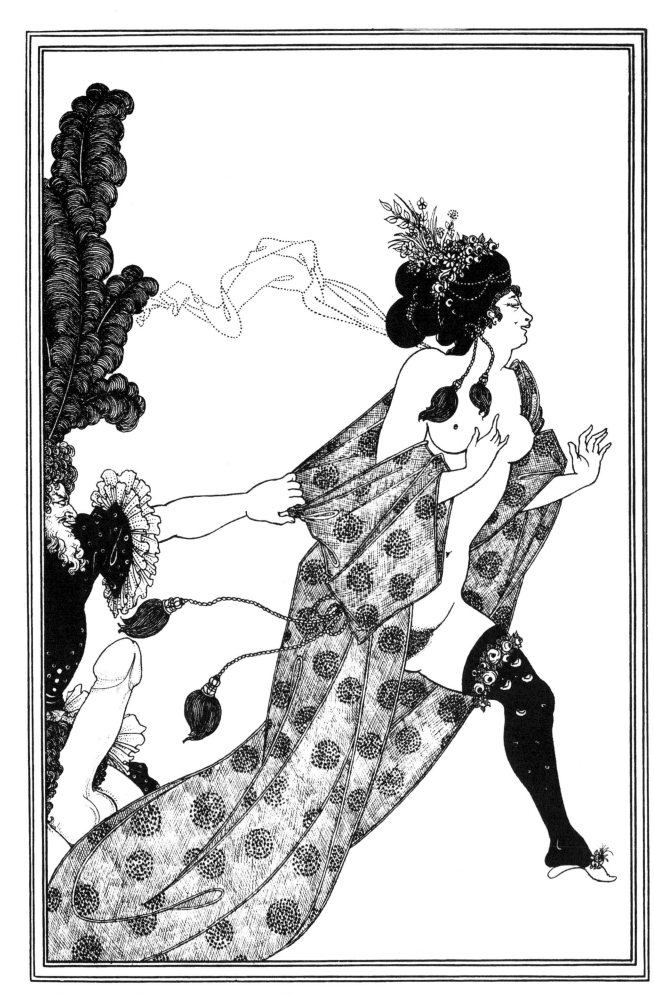

464 Cinesias Entreating Myrrhina to Coition (464)

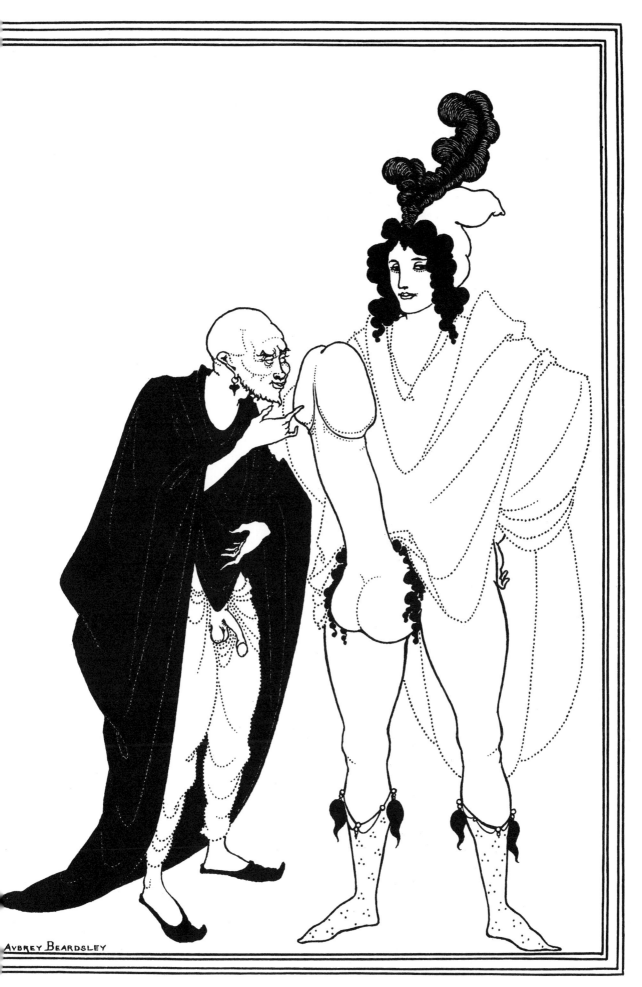

AVBREY BEARDSLEY

The Examination of the Herald (465)

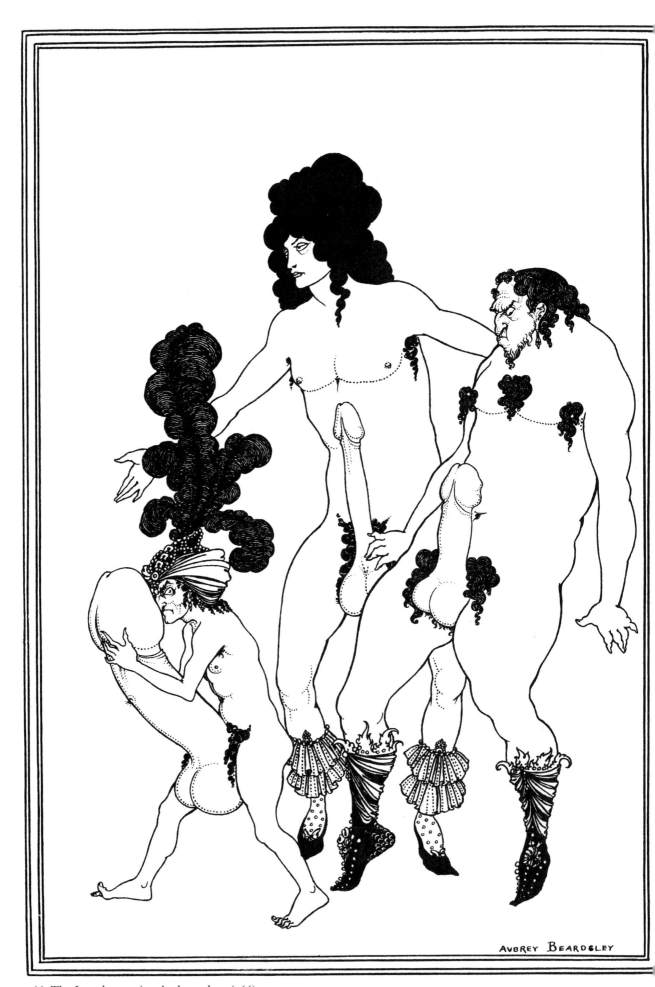

466 The Lacedaemonian Ambassadors (466)

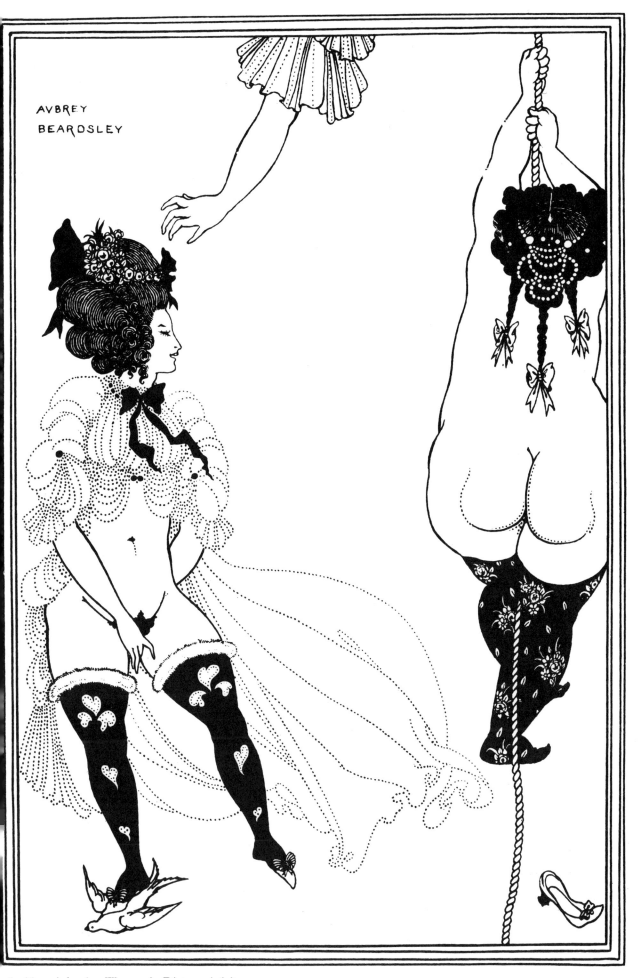

AVBREY
BEARDSLEY

467 Two Athenian Women in Distress (467)

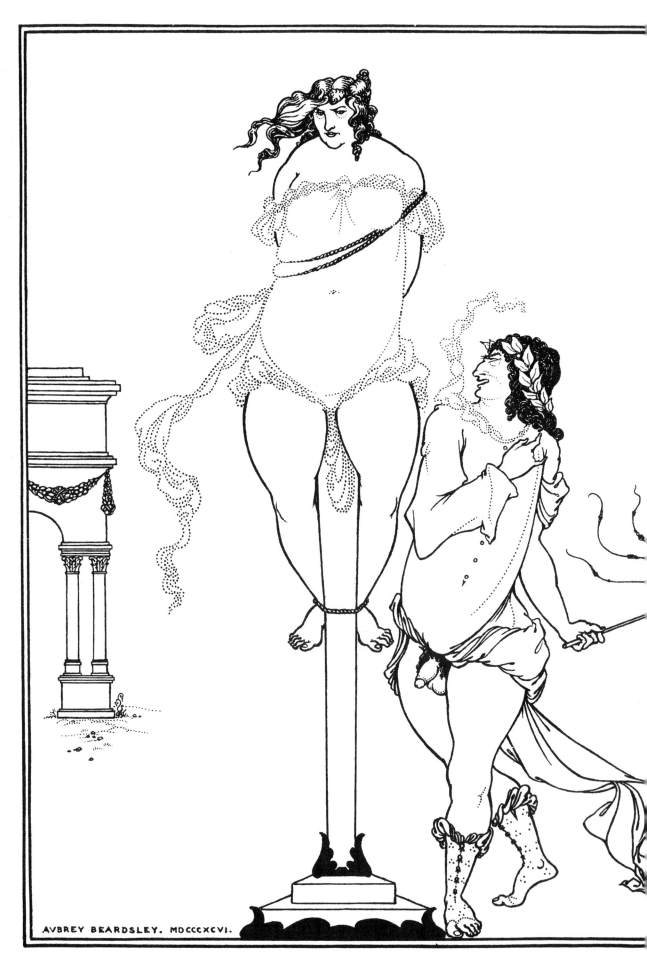

AVBREY BEARDSLEY. MDCCCXCVI.

468 Juvenal Scourging Woman (468)

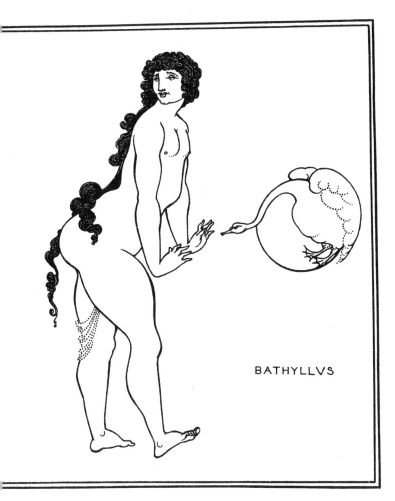

BATHYLLVS

Bathyllus in the Swan Dance (469)

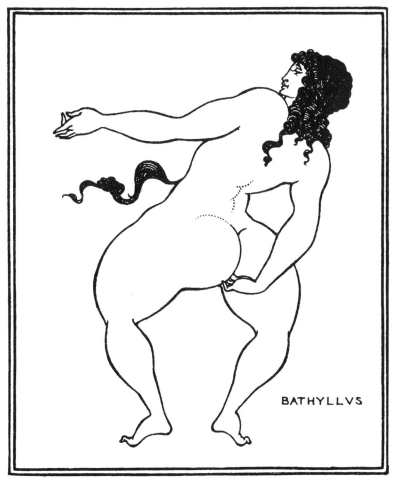

BATHYLLVS

470 Bathyllus Posturing (470)

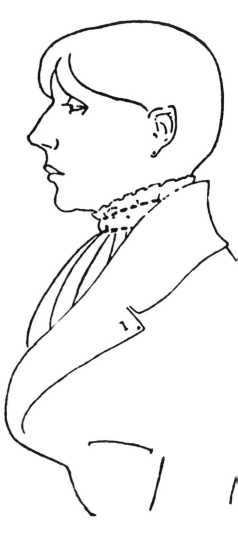

472 Self-portrait (472)

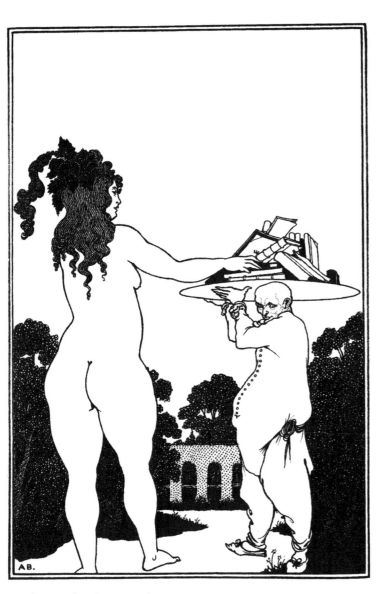

471 Design for the artist's bookplate, used by Pollitt (471)

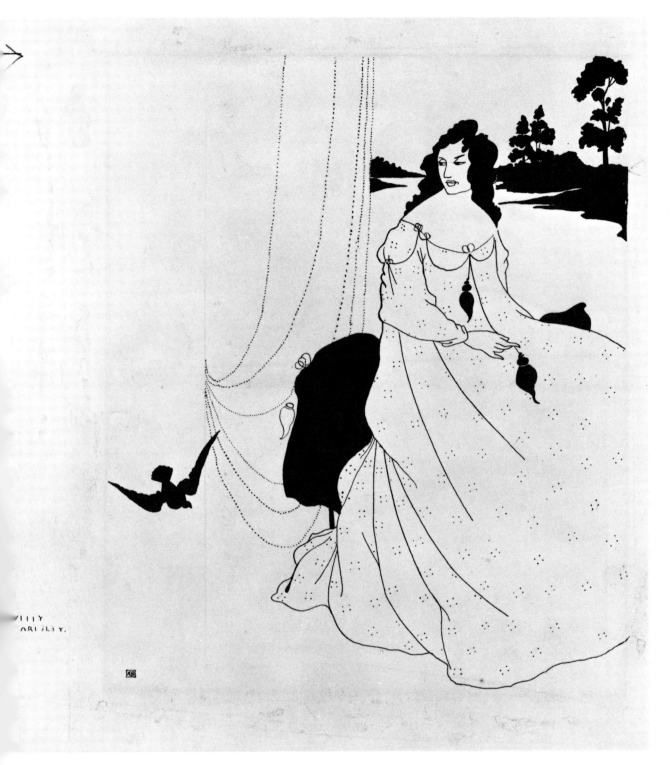

Design for front cover of *A Book of Fifty Drawings by Aubrey Beardsley* (473)

474 Title-page of *The Parade* (474)

THE PARADE
AN ILLUSTRATED
GIFT BOOK FOR
BOYS AND GIRLS
1897

LONDON H. HENRY AND CO. LTD.
93 ST. MARTIN'S LANE W.C. 1897

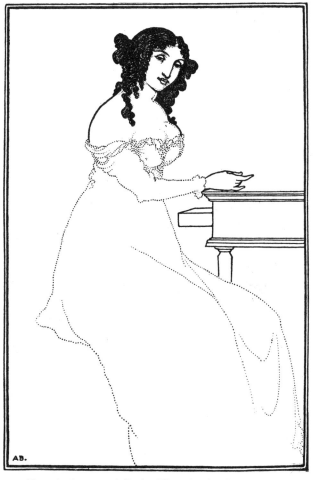

475 Frontispiece to *A Book of Bargains* (475)

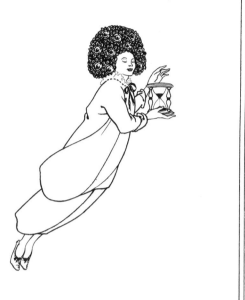

476 Design for front cover of *The Pierrot of the Minute* (476)

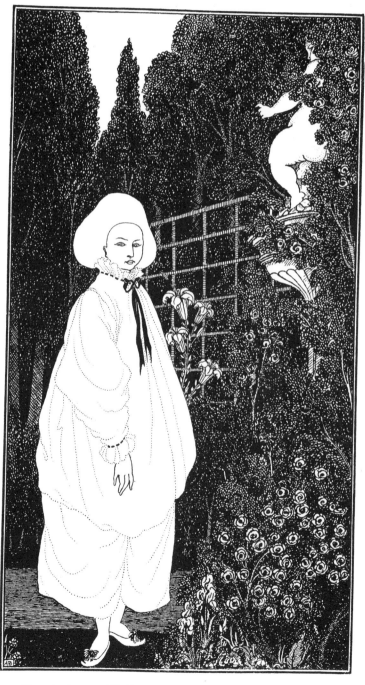

477 Frontispiece to *The Pierrot of the Minute* (477)

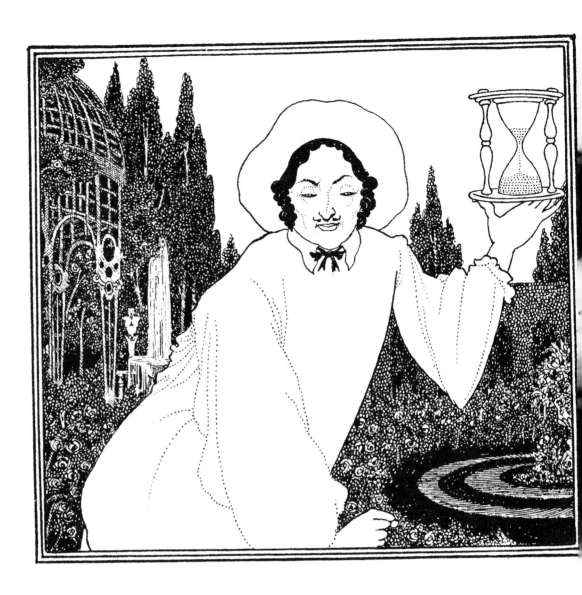

478 Headpiece and the initial letter P in *The Pierrot of the Minute* (478)

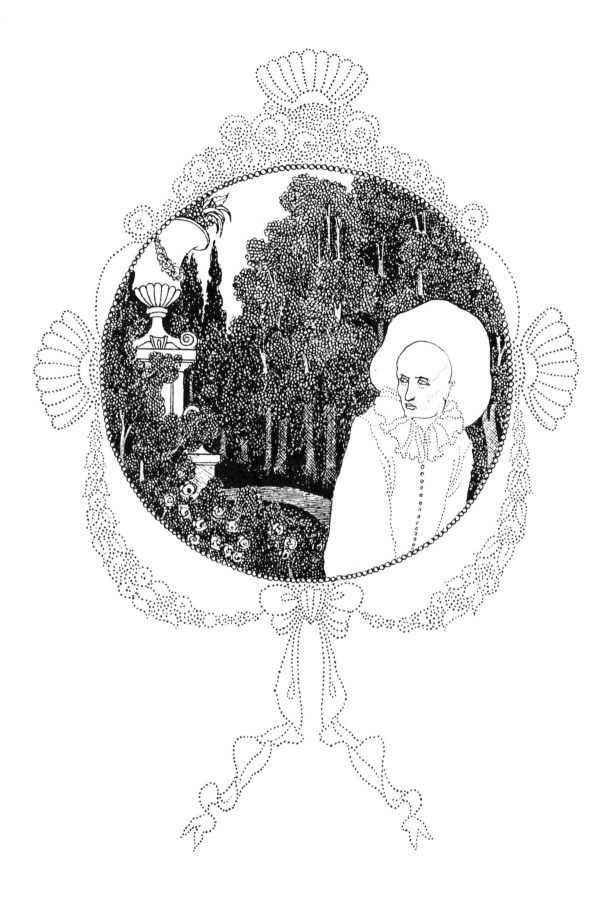

479 *Cul-de-lampe* in *The Pierrot of the Minute* (479)

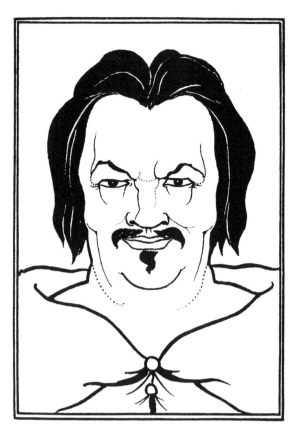

480 Head of Balzac for front covers of *Scenes of Parisian Life* (480)

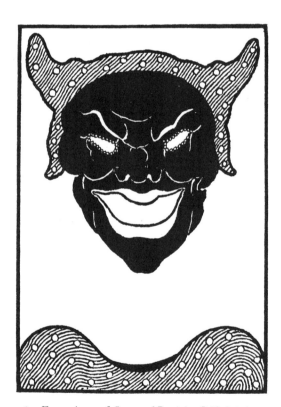

481 For spines of *Scenes of Parisian Life* (481)

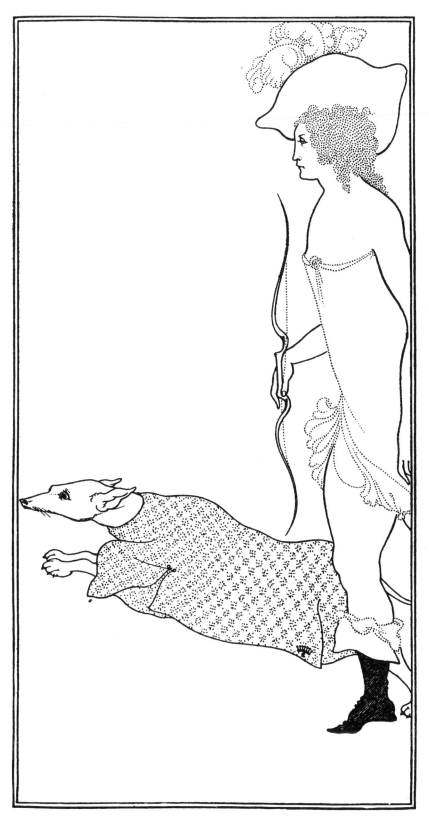

482 Atalanta in Calydon, with the hound (482)

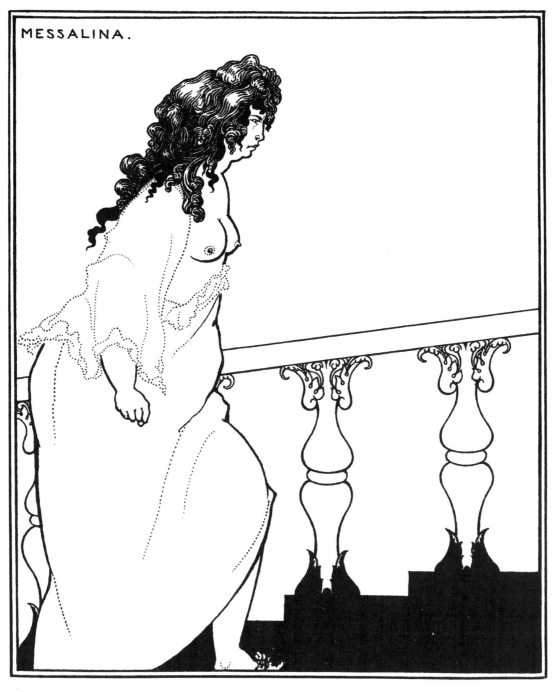

483 Messalina returning from the bath (483)

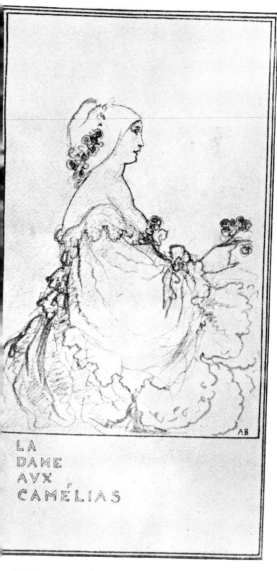

4 La Dame aux Camélias (484)

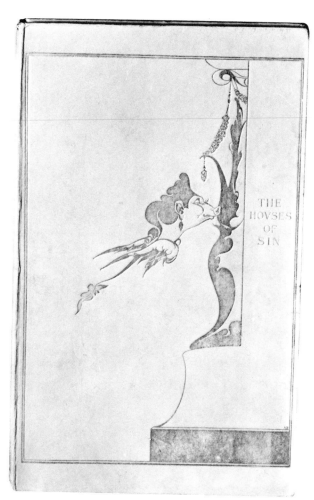

485 Front cover of *The Houses of Sin* (485)

486 Front cover of *The Souvenirs of Léonard,*
Hairdresser to Queen Marie Antoinette (486)

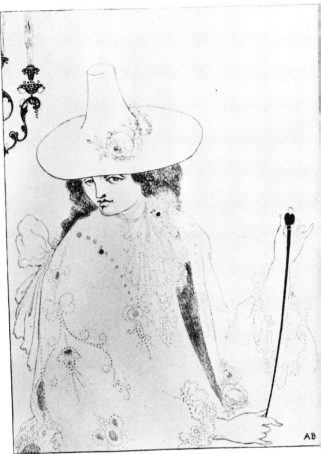

488 D'Albert (488)

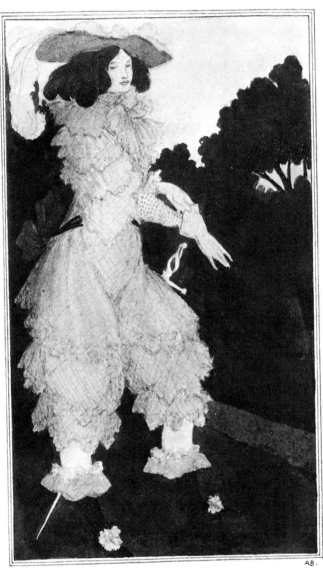

487 Mademoiselle de Maupin (487)

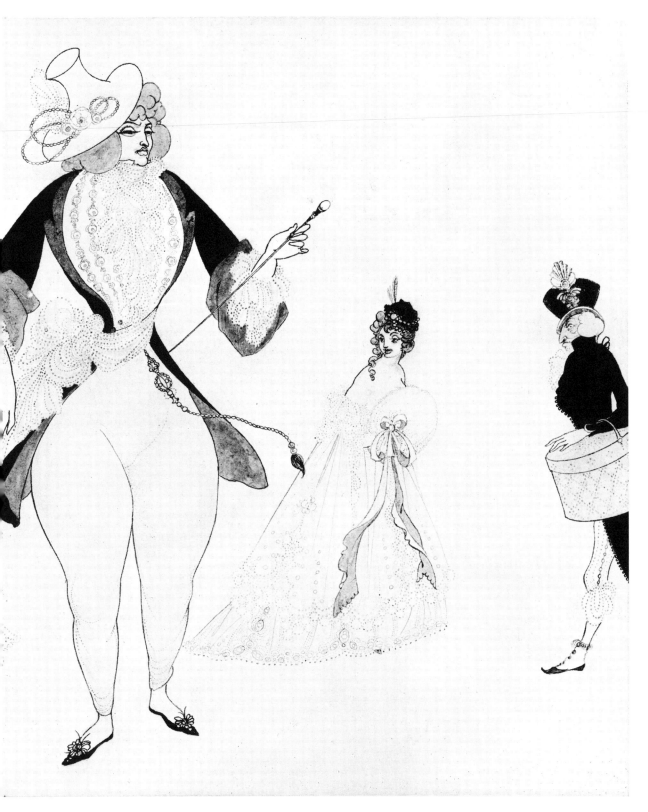

D'Albert in Search of His Ideals (489)

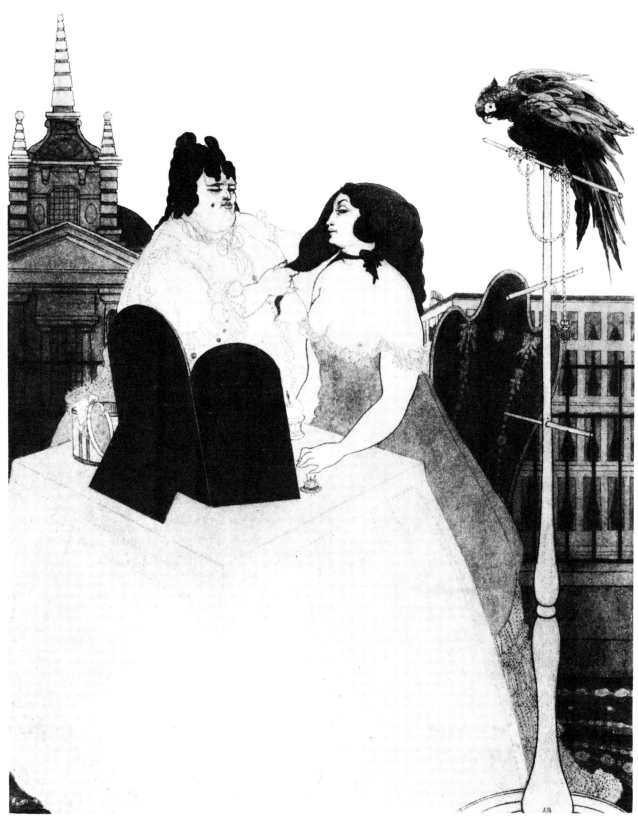

490 The Lady at the Dressing Table (490)

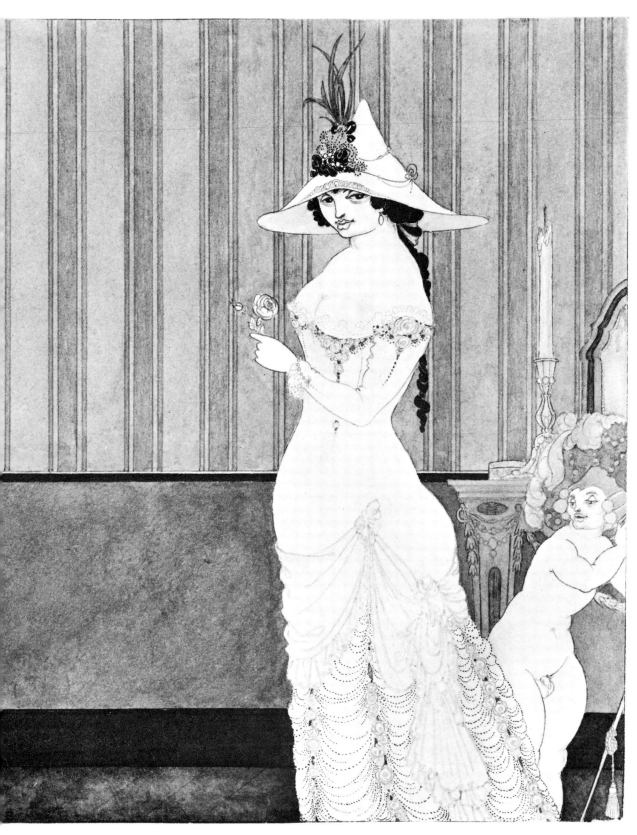

e Lady with the Rose (491)

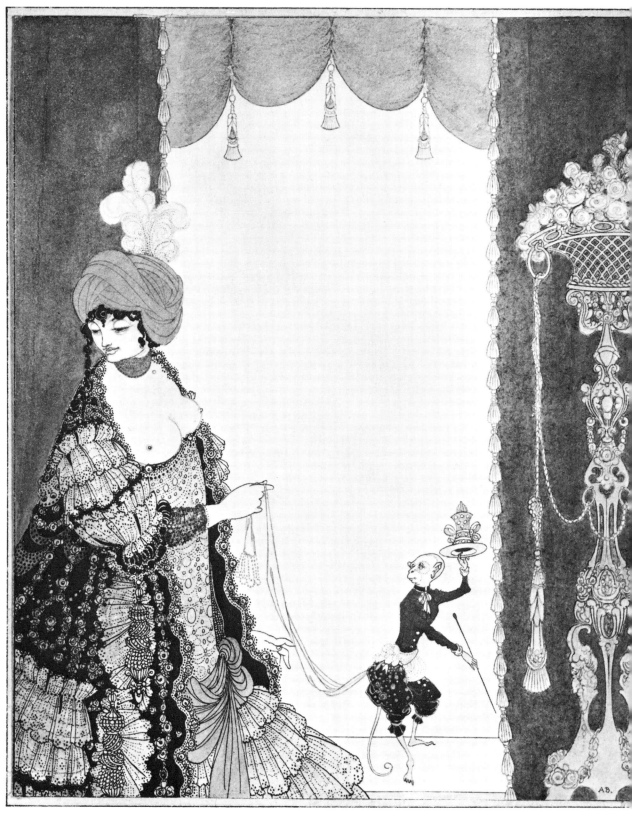

492 The Lady with the Monkey (492)

EX LIBRIS
OLIVE
CVSTANCE

AB.

493 Book-plate of
the poetess Olive Custance (493)

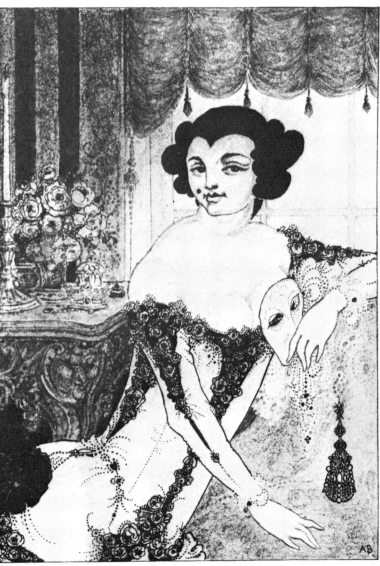

Arbuscula (494)

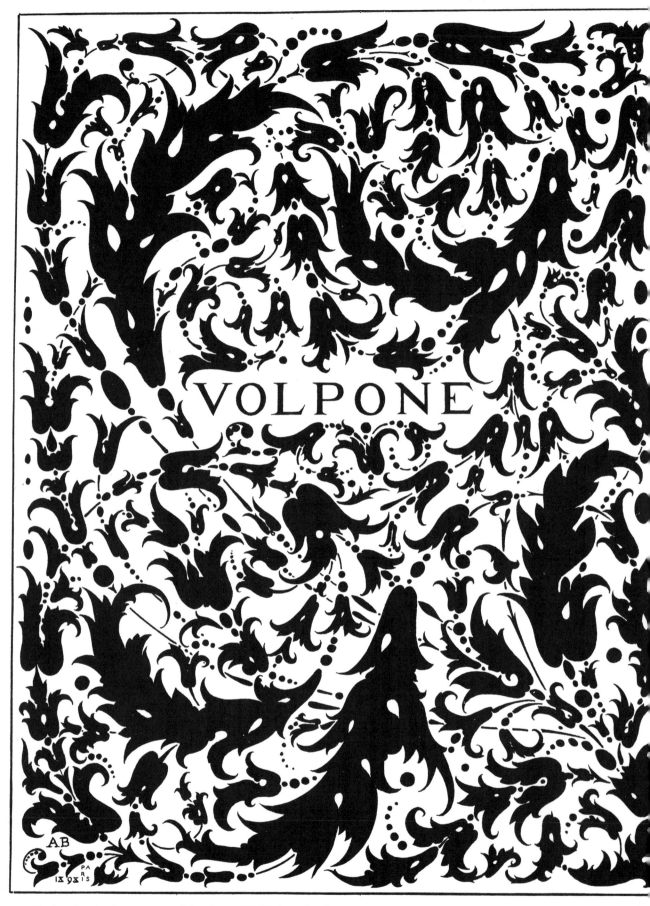

495 Design for the front cover of *Ben Jonson His Volpone* (495)

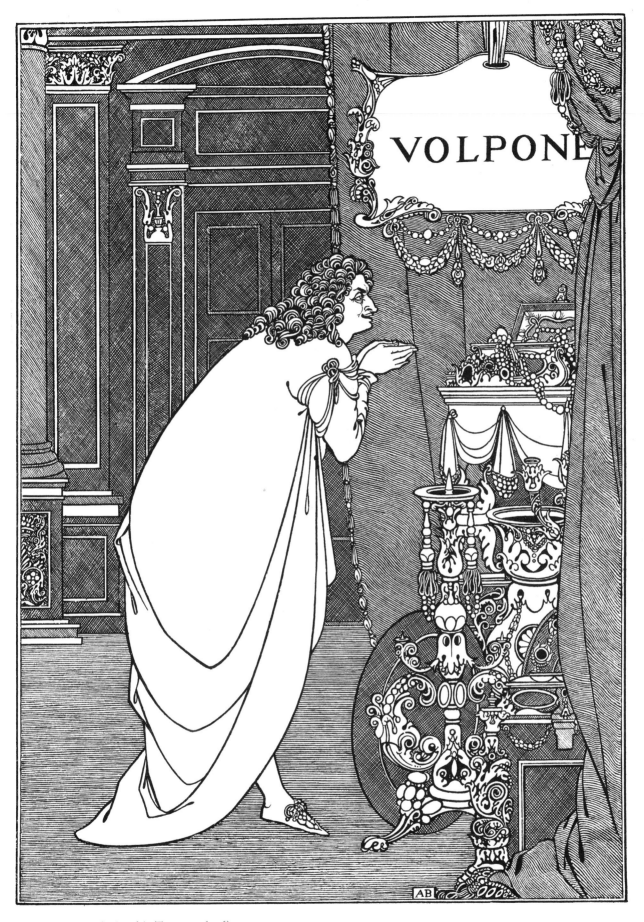

496 Volpone Adoring his Treasure (496)

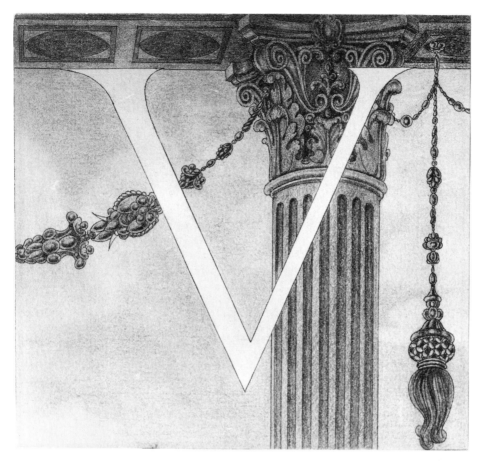

497 Initial V for *Ben Jonson his Volpone* (497)

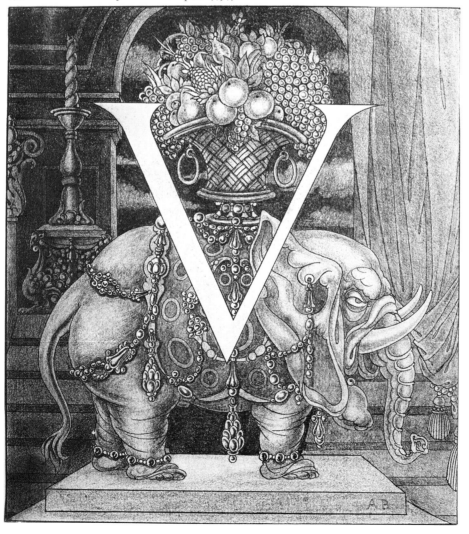

498 Initial V for *Ben Jonson his Volpone* (498)

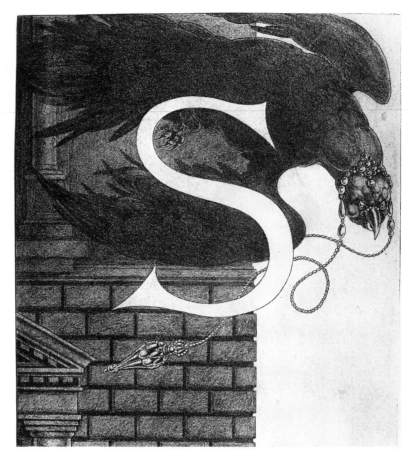

499 Initial S for *Ben Jonson his Volpone* (499)

Sketch for a variant of initial S for *Ben Jonson his Volpone* (500)

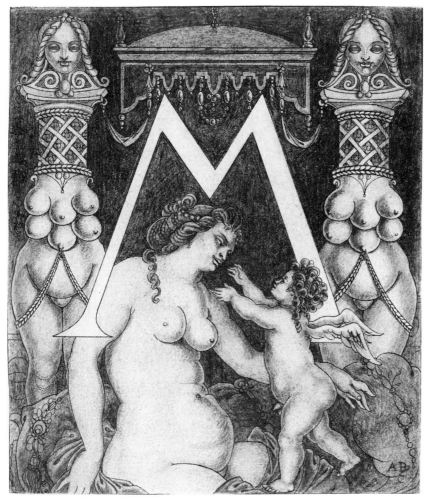

501 Initial M for *Ben Jonson his Volpone* (501)

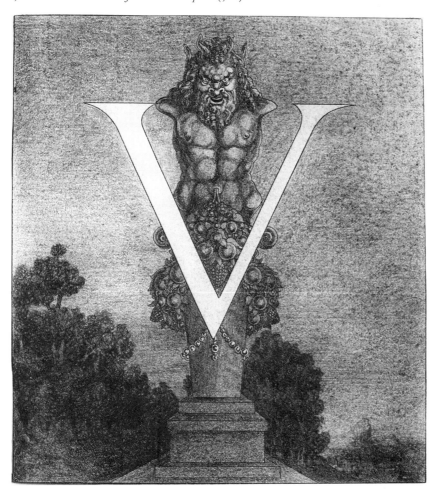

502 Initial V for *Ben Jonson his Volpone* (502)

notes. references to plate numbers are given at the end of the first paragraph. References to other notes are given in brackets.

ing based on an illustration by Kate Greenaway. Done
ardsley at the age of eleven, 1884. Pl. 1
nd crayon, $3\frac{1}{2} \times 2\frac{1}{8}$ inches
vald Collection, National Gallery of Art, Washington

oloured drawing and the one reproduced at No. 2 were
ted in an album containing thirteen other drawings of
ne kind, and a letter from 'Aubrey V. Beardsley' dated
ruary [1884], in which it is stated that all the drawings
copied from different books sent to him by Lady
etta Pelham, for whom the drawings were made.
er letter, hinged into the album, is from Sir Edmund
, dated 20 March 1928, and explains that the drawings
he earliest known to be by Beardsley. He says therein
ady Henrietta Pelham helped Beardsley's parents, who
at the time 'in destitute circumstances', and that she
or Aubrey Beardsley's music lessons.

ing based on an illustration by Kate Greenaway. Done
ardsley at the age of eleven, 1884. Pl. 2
nd crayon, $2\frac{5}{8} \times 3\frac{3}{4}$ inches
vald Collection, National Gallery of Art, Washington

rawing is a companion to No. 1 and is mounted in the
album.

course. A caricature of Mr Marshall, Beardsley's head-
r at Brighton Grammar School, c. 1885–1888. Pl. 3
nd violet ink, $8\frac{1}{4} \times 6\frac{3}{8}$ inches
ton University Library

cture. A caricature of Mr Marshall, Beardsley's head-
r at Brighton Grammar School, c. 1885–1888. Pl. 4
nd violet ink, $8 \times 6\frac{1}{4}$ inches
ton University Library

ymist. A caricature of Mr Marshall, Beardsley's head-
r at Brighton Grammar School, c. 1885–1888. Pl. 5
nd violet ink, $7\frac{3}{4} \times 6\frac{1}{4}$ inches
ton University Library

uring the apple tart. A caricature of Mr Marshall,
Isley's headmaster at Brighton Grammar School, c.
-1888. Pl. 6
nd violet ink, $7\frac{3}{4} \times 6\frac{1}{4}$ inches
ton University Library

le chamber music. Drawing with a caricature of Mr
hall (on the left), Beardsley's headmaster at Brighton
mar School, c. 1885–1888. Pl. 7
of sheet $6\frac{1}{4} \times 7$ inches
ton University Library

8 The Jubilee Cricket Analysis. Reproduction facing p. 48 in
Past and Present, Vol. XII, NO. 2, June 1887, 8vo. Signed
A. V. Beardsley. Pl. 8
From the line-block
Brighton and Hove Grammar School, England

Past and Present was the Brighton Grammar School magazine,
and this plate was the first reproduction of any drawing by
Beardsley. He attended the school from the end of 1884 until
the summer of 1888. The eleven sketches illustrate visual
puns on cricketing terms.

9 Sketches (four on one sheet) of violinists, c. 1885–1888. Pl. 9
Size of sheet $7\frac{3}{8} \times 10\frac{3}{4}$ inches
Princeton University Library

Beardsley's taste for music developed early. As a child he
sang, recited and gave piano performances to his mother's
friends; and since she taught the piano as well as French, her
son's interest in music must be accredited partly to her.

10 Illustrations to *The Pay of the Pied Piper,* A Legend of Hamelin
Town, written by Fred Edmonds, composed by C. T. West:
representing the first syllable of the Charade, invented and
arranged by Mr C. T. West for the Dome Entertainment of
the Brighton Grammar School, Christmas 1888. Reprinted
in *Past and Present,* the magazine of the School, February
1889, Vol. XIV, NO. 1. Pl. 10
Line-blocks
Brighton and Hove Grammar School, England

Beardsley produced eleven drawings illustrating the text of
The Pay of the Pied Piper, of which two are here reproduced.
He also designed the costumes, acted the part of Herr
Kirschwasser in this comic opera, and appeared too as
Mercury in the Prologue by his house-master, A. W. King.
The entertainment was held at the Dome on 19 December
1888; Beardsley had left the School at the end of the
Michaelmas term of that year, and he was therefore by
Christmas time an Old Boy.

11 Paganini. Sketch in pen and pencil made in 1888. Reproduced
as NO. 50 in *The Uncollected Work of Aubrey Beardsley,* John
Lane, London, 1925. Pl. 11
From the half-tone plate

At the time when this sketch was made, Beardsley had
evolved a style of grotesque drawing quite distinct from his
comic style, and somewhat sinister, as in this conception of
Paganini.

12 Sarah Bernhardt. Head and shoulders. Drawing made by
Beardsley c. 1888 in a scrap-album belonging to his family.
Pl. 12
Pencil, $9\frac{1}{2} \times 7\frac{1}{4}$ inches
Princeton University Library

13 Holywell Street, London. Sketch in ink wash reproduced as NO. 4 in *The Early Work of Aubrey Beardsley,* John Lane, London, 1899. Pl. 13
From the half-tone plate

This early drawing was reproduced first on a small scale as an illustration on p. 104 in an article by Charles B. Cochran in *The Poster,* Vol. I, August–September 1898, pp. 102–105, entitled 'Aubrey Beardsley at School'. There the drawing is said to have been done when Beardsley was sixteen, that is in 1888. It is one of his very few and immature attempts to draw in an Impressionist style—an attempt which has a certain crude merit.

14 The Cambridge Theatre of Varieties. Drawing for the programme of an amateur theatrical performance by Mabel and Aubrey Beardsley, *c.* 1888–1889. Pl. 14
Pen, ink and wash, 7 × 4½ inches
Princeton University Library

The name of the 'Theatre' was taken from the address, 32 Cambridge Street, Pimlico, London, where the Beardsleys were living at the time. Madame 'Mâbélè' was Mabel Beardsley and 'André' was of course her brother, the artist himself.

15 The Jolly Mashers. Drawing for the programme of an amateur theatrical performance by Mabel and Aubrey Beardsley, *c.* 1888–1889. Pl. 15
Pen, ink and wash, 7 × 4½ inches
Princeton University Library

These burlesque drawings, NOS. 14–16, have something of the spidery character of the manner of George Cruikshank, and of the silhouette images in optical toys of the mid-nineteenth century.

16 Songs. Drawing for the programme of an amateur theatrical performance by Mabel and Aubrey Beardsley, *c.* 1888–1889. Pl. 16
Pen, ink, wash and water-colour, 7 × 4½ inches
Princeton University Library

17 Dante in Exile. Reproduced from a pen, ink and wash drawing as NO. 6 in *The Later Work of Aubrey Beardsley,* John Lane, 1901. Signed with the initials A.V.B. Pl. 17
From the half-tone plate

This 'illuminated' sonnet dates probably from 1890, when Beardsley was drawn towards the study of Dante by A. H. Pargeter, a fellow clerk at the Guardian Fire and Life Insurance offices. The script used for writing out the poem and the rustic-romantic style of the surrounding ornament are in the manner of William Blake's illustrated works; but not the trailing wisps, which are Beardsley's own.

18 Drawing illustrating a scene in Ibsen's play *Ghosts,* Act I, *c.* 1890. In a scrap-book which belonged to the Beardsley family. Pl. 18
Pencil, pen and ink, 8 × 8½ inches
Princeton University Library

19 Tannhäuser. 1891. Inscribed with title. Pl. 19
Indian ink and wash
Rosenwald Collection, National Gallery of Art, Washington

The theme of Tannhäuser had a fascination for Bear
The composition of this amateur drawing became the
for one of his finest designs (NO. 391).

20 The Litany of Mary Magdalen. 1891. Inscribed with
Pl. 20
Pencil, 8 × 6 inches
Chicago Institute of Art

This was one of the drawings made by Beardsley sh
after his visit to Burne-Jones on 12 July 1891. It reveal
the young amateur artist had studied the figure of St Jo
Mantegna's engraving *The Entombment* (Armand-Du
No. 3) for the kneeling figure of Mary Magdalen. A si
kneeling figure, linked in form to the Mary Magdaler
the St John, occurs in Beardsley's *Repentance of Mrs*
published in *The Yellow Book,* Vol. IV, October 1894 (NO.

21 Hail Mary. Head in profile to the left with a lily, *c.* 1891.
Pencil, $5\frac{7}{16} \times 4\frac{5}{8}$ inches
Princeton University Library

In 1891 Beardsley was a clerk in the Guardian Life Insu
Company, near which stood the bookshop of Jones
Evans in Queen Street. Having visited the shop often
lunch-hours and made friends with Frederick H. E
Beardsley presented him with this drawing in 1891. A
end of the following year Evans showed it to John L
who was sufficiently impressed by it, and others by Bear
to commission the young man to illustrate *Le Morte Dar*

22 Hamlet Patris Manem Sequitur. Drawing reproduce
lithography in light red as a frontispiece to *The Bee,* the jo
of the Blackburn Technical Institute, Vol. II, Part 2, No
ber 1891. Inscribed with title. Pl. 21
Pencil, $11\frac{1}{2} \times 5\frac{3}{8}$ inches
British Museum

Beardsley's design was redrawn professionally on the
graphic stone for the frontispiece. A. W. King, who had
his housemaster at Brighton Grammar School, and in
had become Secretary of the Institute, arranged for
frontispiece to be made and wrote a notice of it in the
number of the journal. Beardsley met Burne-Jones fo
first time on 12 July 1891, and the present drawing
example of how at this date he chose to borrow ce
mannerisms of the painter, giving them a twist of his
The subject is Hamlet following the ghost of his Fath

23 Self-portrait. Head and shoulders, full face, *c.* 1892. Pl.
$9\frac{3}{4} \times 3\frac{1}{2}$ inches
British Museum

Beardsley's own idea of his appearance in the year he
the acquaintance of Robert Ross, to whom he gav
drawing.

:ssor Fred Brown. Signed with monogram (AVB) and
bed 'Fred Brown N.E.A.C.', 1892. Pl. 24
l, pen and ink, 10 × 10 inches
Gallery, London

:ssor Brown was a founder-member of the New English
Club, which explains the initials in the drawing. He
aught at the Westminster School of Art where Beardsley
to evening classes from the autumn of 1891 for a year.
drawing is intended to be in the manner of an etching by
tler.

Götterdämmerung. Lettered with title, 1892. On the
, rough sketch in pencil and indian ink of Siegfried,
I ($14\frac{11}{16}$ × 12 inches). Pl. 25
ink wash and chinese white, $12\frac{1}{8}$ × $20\frac{1}{4}$ inches
eton University Library

generalized forms in this drawing have a sculpturesque
ty not to be seen in any other work of Beardsley. It was
ted in a manner employed by Burne-Jones in sketches
etalwork.

:us. Design for a panel. Above the standing nude figure
:rseus is a frieze of small figures. On the back, a pencil
h of two unfinished figures, c. 1892. Pl. 26
n ink and pencil, $17\frac{1}{2}$ × $6\frac{1}{5}$ inches
Pierre Matisse, New York

391 Beardsley had made an inferior drawing, 'Perseus
he Monstre', in pencil, showing the kneeling figure of a
ified Perseus with draperies burlesquing the style of
e-Jones, holding out the head of Medusa.

ered Spring. Inscribed with title and (on the gate) 'Ars
ga', c. 1892. Pl. 27
nwald Collection, National Gallery of Art, Washington

ng the earliest designs for chapter headings in Le Morte
hur is one for Book I, Chapter VI, p. 10, adapted from
drawing. The allegory expresses half-consciously per-
the tragedy of Beardsley's own life. Walter Crane's
ence in the somewhat heavy style of the drawn lines is
rnible here.

sky [sic]. Representation of Katharina Klavsky, full-
h, as Isolde in Wagner's opera Tristan und Isolde. In-
ed 'Klafsky' and 'Isolde', c. 1892. Pl. 28
ink and water-colour, $12\frac{1}{2}$ × $4\frac{3}{8}$ inches
eton University Library

arina Klavsky (1855–1896) appeared in the part of
le in London in 1892. The opera was to remain a
urite with Beardsley.

Maria von Weber. c. 1892. Pl. 30
$4\frac{3}{8}$ inches
eton University Library
of Beardsley's earliest drawings in the personal manner
h distinguished him later.

ael Sanzio. Inscribed with title, c. 1892. Pl. 31
× $4\frac{3}{16}$ inches
eton University Library

ing 1892 Beardsley evolved what he called his 'Japones-
style. The dramatic and decorative use of black areas

was arrived at, it appears, by means of experiments with
blots of indian ink, and the value of asymmetry in the placing
of these areas of black was observed by him in the works of
the Japanese print-makers. In his earliest drawings in the
'Japonesque' manner Beardsley lightened the areas of black
ink by scratching and rubbing the dried surfaces, so that, as
in this case and also in the following drawing, the areas
have a richness of texture especially when descriptive of
textiles, which is not at all Japanese. In time Beardsley
abandoned the practice of varying the texture of his blacks
by abrasions.

31 Le Dèbris [sic] d'un Poète. c. 1892. The wreck of a poet. Pl. 32
Pen, indian ink and wash, 13 × $4\frac{7}{8}$ inches
Victoria and Albert Museum, London

An early example of Beardsley's 'Japonesque' style which
was evolved by him during 1892. The drawing com-
memorates his digust with the life which at this date he was
obliged to lead as a clerk in the Guardian Life Insurance
Company.

32 Max Alvary. Portrait of Alvary, half-length in profile to the
left. Signed with monogram and inscribed 'Alvary'. Pl. 29
Indian ink on brown paper, $9\frac{1}{2}$ × 5 inches
Princeton University Library

Max Alvary (1856–1898) appeared in the roles of Tristan and
Tannhäuser at Covent Garden during 1892 (see Catalogue of
Aubrey Beardsley Exhibition at the Victoria and Albert Museum,
1966, NO. 132).

33 The Achieving of the Sangreal. Drawing for the frontispiece
to Vol. II of Le Morte Darthur, 1893–4. Pl. 33
Indian ink and wash, $14\frac{1}{4}$ × $11\frac{1}{4}$ inches
Mr F. J. Martin Dent, London

After his introduction by Frederick Evans to John Dent in
the bookshop of Jones and Evans, Beardsley was com-
missioned to illustrate Le Morte Darthur, which Dent was
planning to publish with line-block embellishments instead
of ornaments and illustrations from hand-engraved wood-
blocks as used at the Kelmscott Press by William Morris.
Before actually confirming this decision to employ Beardsley
for the work, Dent required a sample illustration by him of a
theme in the book. The drawing of the 'Sangreal' was the
sample Dent received in the autumn of 1892. In it Beardsley
has not freed himself from the conventional illusionism of
a line-and-wash technique, and the drawing therefore had to
be reproduced by photogravure and not by line-block. 'How
King Arthur saw the Questing Beast' (56) was the only other
drawing for Le Morte Darthur to be reproduced by this
method. Paintings by Crivelli, Pollaiuolo and Burne-Jones
were the chief sources of details in this drawing.

34 Front cover of Evelina by Frances Burney, as edited by R.
Brimley Johnson, illustrated by W. Cubitt Cooke and pub-
lished in two volumes by J. M. Dent and Company, London,
1893, 8vo. (Small paper edition.) Pl. 34
Buff cloth boards stamped with title in gold
Mr W. G. Good, England

Writing to André Raffalovich in November 1896, Beardsley

says 'Thank you so much for the volumes of Miss Burney. I was so amused to find that they had covers and title-pages of my own early designing'. (J. Gray [ed.], *Last Letters of Aubrey Beardsley*, London, 1904, No. LI.) The decoration on the spine too was undoubtedly his work.

35 Title-page of *Evelina* by Frances Burney, as edited by R. Brimley Johnson, illustrated by W. Cubitt Cooke and published in two volumes by J. M. Dent and Company, London, 1893, 8vo. Signed with the artist's monogram. Pl. 35

From the lineblock and letterpress
Mr W. G. Good, England

Both the large and small-paper volumes of this edition had the same title-page design, which has features of late Regency and early Victorian ornament, decorated with hair-line arabesques.

36 Evelina and her Guardian. Illustration in pen, ink and wash intended for *Evelina* as published in two volumes by J. M. Dent in 1893, but not used. Reproduced on p. 81 in *Aubrey Beardsley* by Arthur Symons, London, 1905 (large paper edition only), 4to. Pl. 36
From the photogravure
Victoria and Albert Museum, London

The carpet is in Beardsley's 'Japonesque' style 'invented' by him during 1892; but in the rest of the drawing he has made an effort to compete with the conventional book-illustrations of his period, using ink wash for smooth tone transitions. An early example of a recurrent motif in his work can be seen in the flight of birds outside the window. These always symbolized open air.

He was commissioned by Dent to illustrate *Evelina* at the end of 1892, but had so much else to do by the beginning of the following year that he made only the designs for the title-page, front cover and spine of this edition, and the illustrations were done finally by W. Cubitt Cooke.

37 Title-page design. Reproduced for the title-page of *The Early Work of Aubrey Beardsley,* with a prefatory note by H. C. Marillier, published by John Lane, The Bodley Head, London and New York, 1899, 4to. Pl. 37
From the half-tone plate

In certain regions of Brighton, in Oriental Place for example, the architectural adornments in stucco have an assertive baroque quality that is at the same time entirely of the early nineteenth century and not to be seen elsewhere. Something of this quality, and of the almost brutal eclecticism of the decorations in the Royal Pavilion, seem to have been absorbed by Beardsley and intensified by his own grotesque fantasies in this design. It is similar in principle to the published title-page of *Evelina* (NO. 35), except that the drawing is not calligraphic but 'solid', and the effect is of a record of some actual architectural feature. It represents a deviation, albeit a convincing one, from Beardsley's natural form as an artist, to be encountered again in his last work, the initial letters for *Volpone* (NOS. 497–502), where at the end of his life he strived, so it seems, to make tangible in the *trompe l'oeil* idiom of the seventeenth century the conceptions of his brain.

The present design was described in *The Early Work* as unpublished and it is neither signed nor dated. It seems likely

that it was made at about the same time as the title-pag Evelina.

38–40 Three caricatures from a series of four entitled 'The Coinage. Four designs which were not sent in for com tion'. Reproduced as illustrations on p. 154 of *The Pall Budget,* 9 February 1893. Inscribed with simulated signat and in pencil with notes. (See also NO. 41.)
Indian ink and pencil, diameter 4 inches
Victoria and Albert Museum, London

38 A little girl seated on a sand castle in the style of a pair by Sir John Millais, R.A. Pl. 38
39 Caricature of Whistler's signature. Pl. 39
40 Caricature of Walter Crane's socialist opinions. Pl. 40
The fourth of these caricatures, of which the original dra is not available for reproduction here, is shown in No. 1. *The Early Work of Aubrey Beardsley,* 1899. It carica Britannia and has the simulated signature BURNE JO ARA.

41 Caricature of Queen Victoria as a ballet dancer in the f of a design for a coin. One of the suppressed designs for ' New Coinage . . .' intended for reproduction in *The Pall.* Budget, 9 February 1893. Pl. 41

Indian ink and pencil, diameter 4 inches
Victoria and Albert Museum, London

Beardsley worked for a short time early in 1893 ma journalist drawings for *The Pall Mall Budget,* of which L Hind had become the editor. In search of topical sub both men amused themselves by visiting the Mint to ins the plaster casts for the new coinage, and Beardsley ma series of caricatures of the designs. Four of these caricat were published in *The Pall Mall Budget.* The rest were sidered too provocative: 'I suppressed them', Hind recor 'because Aubrey made them comic, and I think I tore t up', (See *The Uncollected Work of Aubrey Beardsley,* 1 p. XX.) This drawing however survived (See also 38–40.)

42 Miss Terry. Caricature of Ellen Terry as Rosamun Tennyson's *Becket,* produced by Henry Irving at the Lyc Theatre, London, 6 February 1893. Published in *The* Mall Budget, 9 February 1893, p. 188. Signed A. Beardsley inscribed with title. Pl. 47
$7\frac{3}{8} \times 3\frac{3}{8}$ inches
Mr Vyvyan Holland OBE, London

43–46 Caricatures of C. V. Stanford, composer of the music Tennyson's *Becket,* and of three actors in the productic the play by Henry Irving at the Lyceum Theatre, Lon 6 February 1893. Published on pp. 188 and 190 of *The* Mall Budget, 9 February 1893. Signed with initials in ink inscribed in ink with titles and in pencil with notes.
Pen and indian ink over pencil, $4\frac{1}{2} \times 3$ inches
Victoria and Albert Museum, London

43 Master Leo (Master Leo Byrne as Godfrey). Pl. 42
44 Margery (Kate Phillips). Pl. 43
45 The Composer (Sir Charles Villiers Stanford). Pl. 44
46 The King makes a move on the Board (William Terriss). I

Disappointment of Émile Zola. Caricature published in
Pall Mall Budget, 9 February 1893, p. 202. Signed A V
dsley. Pl. 48
4¼ inches
yvvan Holland, OBE, London

llier in his preface to *The Early Works of Aubrey Beardsley,*
lon, 1899, regarded this and the sketches for 'The New
age' (see NOS. 38–41) as the only successful journalistic
ings made by Beardsley for *The Pall Mall Budget.*

Leo XIII's Jubilee. The Pilgrim (Old Style); and The
im (New Style). Illustration on p. 270 of *The Pall Mall
et,* 23 February 1893. Signed with the monogram A V B.
ribed in pencil and pen. Stamped 'Ronald Searle'
ection). Pl. 50
an ink over pencil, together 6 × 7 inches
R. A. Harari, London

caature of Forbes Robertson as Julian Beauclerc in
omacy, a play by B. C. Stephenson and Clement Scott,
ted from *Dora* by Victorien Sardou and produced at the
ick Theatre, London, 18 February 1893. Reproduced
similar caricatures on p. 281 of *The Pall Mall Budget.*
ebruary 1893. Inscribed with title and in pencil with
s. Pl. 49
2⅜ inches
oria and Albert Museum, London

caature of Arthur Cecil as Baron Stein in *Diplomacy* (see
ious caption). Reproduced with similar caricatures on
1 of *The Pall Mall Budget,* 23 February 1893. Inscribed
title and in pencil with notes. Pl. 46
3 inches
oria and Albert Museum, London

Bullet-Proof Uniform: Tommy Atkins thinks it rather
' Drawing reproduced in *The Pall Mall Budget,* 30 March
, p. 491. Inscribed in ink 'What our military artist saw in
eam after reading an account of the uniform'. Pl. 51
10½ inches
ent owner unknown

et. Henry Irving as Becket in Tennyson's play of that
e produced by Irving at the Lyceum Theatre, London,
bruary 1893. Proof from steel-faced copperplate. Signed
ardsley. Pl. 52
ning and aquatint, 8½ × 5¼ inches
W. G. Good, England

n undated letter of 1893 Beardsley told Robert Ross that
s morning Pennell has been giving me Lessons in
ing'. This pull, with the copperplate from which it was
n by Beardsley, seems to be the only known etching by
A reproduction of his wash drawing of the same subject
published in *The Pall Mall Budget,* 9 February 1893.

caature of Norman O'Neill. 1. N begs from Mayor per-
ion to play golf. 2. N the Masher. Inscribed with titles by
nt Eric Stenbock, c. 1893. Pl. 53
6¼ inches
Derek Hudson, London

man O'Neill was a young friend of Eric Stenbock, a

Count of Swedish origin who had been for a short time at
Oxford and later lived in Campden Hill, London. W. B. Yeats
called him 'scholar, connoisseur, drunkard, poet, pervert,
most charming of men'. He was a friend of More Adey and of
Robert Ross, and made Beardsley's acquaintance through
Ross in 1892. O'Neill (1875–1934), later well-known as a
theatre composer, studied music at the Hoch Conservatorium
at Frankfurt from 1893 to 1897. Soon after he went to Frank-
furt, Stenbock persuaded Beardsley to make these caricatures,
which were inscribed by Stenbock and sent with a covering
note from Beardsley (see also NO. 54).

54 Caricature of Norman O'Neill. The English flower in the
German Conservatory. Inscribed with title by Count Eric
Stenbock, c. 1893. Pl. 54
4⅛ × 6⅜ inches
Mrs Derek Hudson, London

See note to NO. 53. The word 'Conservatory' here alludes to
the Hoch Conservatorium at Frankfurt where O'Neill was
studying music. There was a fourth caricature showing
O'Neill masked and fighting a students' duel in the German
style (see Derek Hudson, *Norman O'Neill,* London, 1945).

55 Projected design for the front wrappers of the parts of *Le
Morte Darthur,* published by J. M. Dent, London, 1893–4.
Pl. 55
Platinotype, 8½ × 7 inches
Mr W. G. Good, England

The original drawing was in yellowish-green water-colour
on white paper. The platinotype was made by Frederick H.
Evans, partner in the bookshop of Jones and Evans where
Beardsley spent his lunch hours when he was a clerk at the
Guardian Life Insurance Company nearby. The naïveté of
the design, with its Burne-Jones brambles, its Botticelli
lilies, its Japanese ground rendered in wavy lines and its
childish lettering was superseded by the more complicated
design that was actually used for the same purpose and which
had the character of a thicket of vegetation somewhat in the
style of the *Studio* wrapper and poster (see NO. 259).

56 How King Arthur saw the Questing Beast, and thereof had
great marvel. Drawing for the frontispiece to Vol. I of *Le
Morte Darthur,* 1893–4. Signed on the trees with the artist's
name and dated 8 March 1893; also with the artist's emblem.
Pl. 56
Pen, ink and wash, 14 × 10⅝ inches
Mr R. A. Harari, London

This is the most elaborate of Beardsley's drawings in the
hair-line manner, which was used also for 'Siegfried' (NO.
164) and for many of the *Bon-Mots* vignettes. There is a strange
profusion of what amounts almost to automatic drawing in
the details that decorate every part of the landscape: these
include a treble clef, a signature, a spider's web, a phallus and
calligraphic flourishes in the manner of the seventeenth-
century writing masters. The Beast is a pseudo-Japanese
dragon, with overlapping discs representing scales, but in
fact memorized from the scale-like feathers in Whistler's
decorations in the Peacock Room (1878). The lines defining

Arthur's garments imitate the gougings of the burin on the copperplate reproduced in the lines of a fifteenth-century engraving. The beautifully precise castle in the distance reveals, apart from the rest of the work, how in March 1893 Beardsley was still entranced a little by the legend he was illustrating.

57 Drawing for the headpiece on the title-page of *Le Morte Darthur*, 1893–4. The support was extended by extra strips at each end to accommodate the design. Pl. 57
$4\frac{1}{2} \times 13\frac{3}{8}$ inches
Mr F. J. Martin Dent, London

In *Le Livre et l'Image*, Vol. XII, March 1894, this design was reproduced as the headpiece of an article in which Beardsley was mentioned and his drawings described as a 'mélange de germanisme et de japonisme', alongside those of Granville Fell, which were said to have been influenced by Walter Crane. The convoluted design here is certainly Beardsley's greatest advance on the type of foliated ornament he adapted from Morris and Burne-Jones.

58 Design for the headpiece of the preface (p. xi of Vol. I) in *Le Morte Darthur*, 1893–4. On the back, part of a design showing a male figure holding a dagger, etc. (see NO. 162). Pl. 58
$3\frac{7}{16} \times 8\frac{11}{16}$ inches
Victoria and Albert Museum, London

59 Merlin. Drawing for the roundel on the verso of the contents page in *Le Morte Darthur*, Vol. I, 1893–4. Pl. 59
Diameter 6 inches
Rosenwald Collection, Library of Congress, Washington

60 Design for the chapter-heading of Chapter III, Book I (p. 5 of Vol. I) in *Le Morte Darthur*, 1893–4. Repeated elsewhere in the book. Pl. 60
$4\frac{3}{8} \times 3\frac{1}{4}$ inches
Western Australian Art Gallery, Perth, Western Australia

One of the earliest drawings made for the book, appearing in Part I.

61 Design showing figures in a sailing vessel, for the chapter-heading of Chapter IV, Book I (p. 6 of Vol. I) in *Le Morte Darthur*, 1893–4. Repeated elsewhere in the book. Pl. 63
$2\frac{7}{16} \times 1\frac{13}{16}$ inches
Mr W. G. Good, England

An example of the smallest type of chapter-heading, reproduced in two sizes. It was one of the earliest drawings made for the book, appearing in Part I.

62 Design for a small chapter-heading in *Le Morte Darthur*, 1893–4; appearing in Vols. I and II, on pp. 7, 138, 359, 715, 818, 891 and 905. Pl. 64
$2\frac{1}{8} \times 1\frac{11}{16}$ inches
Mr Draper Hill, Worcester, Massachusetts

One of the earliest drawings made for the book, appearing in Part I.

63 Design for the chapter-heading of Chapter VIII, Bo (p. 13 of Vol. I) in *Le Morte Darthur*, 1893–4. Repe elsewhere in the book. Pl. 61
$3\frac{1}{4} \times 3$ inches
The Rosenwald Collection, Library of Congress, Washington

64 Design for the chapter-heading of Chapter XI, Book I (of Vol. I) in *Le Morte Darthur*, 1893–4. Repeated elsew in the book. Pl. 62
$3\frac{1}{4} \times 2\frac{1}{4}$ inches
Victoria and Albert Museum, London

The tail of the mermaid is composed of forms derived f the short feathers in Whistler's Peacock Room (18 Similar groups of overlapping discs were adapted by Bea ley to various formulae, in the *Salome* illustrations, instance, and in other drawings of 1893. The water is ventionalized after the fashion of water-forms in Japa art, but the varying and complicated undulations of the l forecast the macaroni lines in *art nouveau*—usually associ with hair, as in Toorop's poster *Delfsche Slaolie* (1895).

65 Design for a small chapter-heading in *Le Morte Dar* 1893–4; appearing in Vols. I and II on pp. 22, 474 and Pl. 65
$2\frac{1}{4} \times 1\frac{1}{2}$ inches
Mr Anthony d'Offay, London

66 Design for the chapter-heading of Chapter XIV, Bo (p. 23 of Vol. I) in *Le Morte Darthur*, 1893–4. Repeated where in the book. Pl. 66
$5\frac{1}{4} \times 3\frac{1}{4}$ inches
Rosenwald Collection, Library of Congress, Washington

The figure of the piper was recalled from the pipe Beardsley's illustrations to *The Pay of the Pied Piper* in programme and book of words of the comic opera so-nar performed at the Dome in Brighton as part of the Brigh Grammar School's Christmas entertainment on 19 Decem 1888. The design appeared in Part I.

67 Design for the chapter-heading of Chapter XIX, Bo (p. 36 of Vol. I) in *Le Morte Darthur*, 1893–4. Signed monogram. Repeated elsewhere in the book. Pl. 67
$4\frac{11}{16} \times 3\frac{3}{8}$ inches
Western Australian Art Gallery, Perth, Western Australia

This drawing was executed apparently in the style of an e woodcut. It was published in Part I and must have l among the earliest ones made for the book. It was not l before Beardsley gave up such archaisms. The twigs ir rectangle were replaced in the line-block by chapter nume

68 Design for the chapter-heading of Chapter XXI, Book 40 in Vol. I) of *Le Morte Darthur*, 1893–4. Repeated where in the book. Pl. 68
Measurements not known
Formerly the property of Mr Godfrey Pilkington, Picca Gallery, London

One of the earliest of the smaller designs for heading

lorte Darthur, appearing first in Part I, and frequently
e later Parts. The winged, heraldic beast surmounts the
nbent body of a fallen angel, who supports his head
his hands and looks forward with a flippant expression
signed worry. It is hard to think of anyone but Beardsley
would have deliberately given such an expression to
ngel. The background is filled in with the knotted tail of
east, and disconnected dots, leaves, scales and enlace-
:s which have been put into the drawing in order to
uce the dense effect of a design by Morris or Burne-
s. But this was really a juvenile evasion of Beardsley's
nature: for if there was one dominant trait that Beards-
acked, it was the *horror vacui* of these other artists.

l A of Chapter I, Book II (p. 51 of Vol. I) in *Le Morte
hur,* 1893–4. Pl. 69
2⅝ inches
oria and Albert Museum, London

early contribution to *Le Morte Darthur,* following the
r vacui principles of William Morris, but using the briar
f of Burne-Jones transformed by bentwood lines and
c interlacings.

er and initial A with the text of the opening of Chapter
ok II (p. 51 of Vol. I) in *Le Morte Darthur,* 1893–4. Pl. 70
n the line-block and letterpress

lso NO. 69 which reproduces the original drawing for the
nitial. The dense twisting briars show what Beardsley
earned in the way of decoration from Morris and Burne-
s. But the restless feeling transmitted to this decoration,
the idea of female fauna climbing in and out of it,
est a conflict in Beardsley between what he admired and
he was.

gn for the chapter-heading of Chapter III, Book II
of Vol. I) in *Le Morte Darthur,* 1893–4. Repeated else-
re in the book. Pl. 75
½ inches
wald Collection, Library of Congress, Washington*

ving for a full-page border for the beginning of Chapter
ok III (p. 81 of Vol. I) in *Le Morte Darthur,* 1893–4.

× 9¼ inches
eton University Library*

891 the artist visited the room decorated by Whistler
878 at 49 Prince's Gate. The stylized peacock feathers
ch are so prominent in these decorations made a deep
ession on Beardsley, who by 1893 was introducing his
versions of them in *Le Morte Darthur* and *Salome.* Those
fs can be seen here, alongside the figures of knights in
nanner of Burne-Jones, but reduced to simple terms.

ving for the chapter-heading of Chapter III, Book III
4 of Vol. I) in *Le Morte Darthur,* 1893–4. Repeated
where in the book. Pl. 73
× 2½ inches
nwald Collection, Library of Congress, Washington*

74 Design for the chapter-heading of Chapter VII, Book III
(p. 90 of Vol. I) in *Le Morte Darthur,* 1893–4. Repeated else-
where in the book. Pl. 74
5 7/16 × 3¼ inches
Mr Brian Reade, London

The drawing appeared in Part I and would date from late
1892 or early 1893. The influence of Burne-Jones is generally
evident, though the features of the face have an added glower-
ing expression typical of Beardsley's heads. The breeze-
blown curves of the scarf reflect cetain *art nouveau* trends.

75 Design for the chapter-heading of Chapter XII, Book III
(p. 98 of Vol. I) in *Le Morte Darthur,* 1893–4. Pl. 72
5¾ × 2½ inches
Mrs B. S. Clauson, England

76 Merlin and Nimue. Full-page illustration facing p. 106
(Chapter I, Book IV) of *Le Morte Darthur,* Vol. I, 1893–4.
Pl. 78
From the line-block

The figure of Merlin seems quite likely to have been based on
a reminiscence of the pilgrim in the picture *Love Leading the
Pilgrim* by Burne-Jones, though the form of Merlin is also
influenced by the style of early woodcuts. Other elements in
the composition have a Burne-Jones iconographical history,
but are rendered more broadly and boldly. The honeysuckle
border on the right has as much of the rigidity of art-school
anthemion as Beardsley could reconcile with an essentially
serpentine instinct, which pervaded his art always, and par-
ticularly during this period. The illustration was published
in Part II.

77 Design for the chapter-heading of Chapter V, Book IV
(p. 112 of Vol. I) in *Le Morte Darthur,* 1893–4. Pl. 76
6¼ × 3½ inches
Rosenwald Collection, Library of Congress, Washington

An early drawing for the book, containing more detail than
those produced in the later stages, as the work got wearisome.
It appeared in Part II.

78 Design for the chapter-heading of Chapter X, Book IV
(p. 121 of Vol. I) in *Le Morte Darthur,* 1893–4. Repeated
elsewhere in the book. Pl. 77
5⅝ × 2¾ inches
Victoria and Albert Museum, London

An example of one of the earlier drawings for the book,
showing the strong influence of Burne-Jones. It appeared in
Part II.

79 Drawing for a full-page illustration facing p. 132, Chapter
XVI, Book IV, Vol. I of *Le Morte Darthur,* 1893–4. Pl. 83
11½ × 9 inches
Mr John Hay Whitney, New York

It is typical of Beardsley that the heroic face of King Arthur
should be conceived as a refined profile, emphasized by
heavy Medusan locks. The bat's-wing forms in his armour
surpass in idiosyncrasy the equivalent inventions of Burne-
Jones. This page illustrates a passage in Chapter XVI, where

it is related how the lady represented by the artist as gentle, sleek and pious-looking, was in fact a sinister messenger, and when King Arthur ordered her first to put on the mantle which she had brought, she put it over herself and was burnt to a cinder. In the distance is the Wagnerian castle, as it were, another Neuschwanstein built by the mad king Ludwig II of Bavaria.

80 Heading of Chapter XIX, Book IV (p. 137 of Vol. I) in *Le Morte Darthur*, 1893–4. Repeated elsewhere in the book. Pl. 81
From the line-block

The woman is shown playing what is evidently a bass-viol, in which case her hand is holding the bow the wrong way. A less rigid version of the subject, with an angel in place of a woman, was adopted by Beardsley for the title and front-cover design of *The Mirror of Music* by Stanley Makower in the *Keynotes* series (see NO. 307). This design, which appeared in Part II of *Le Morte Darthur*, is an early example of Beardsley's use of white silhouettes against a flat black background.

81 Design for the chapter-heading of Chapter XXVII, Book IV (p. 152 of Vol. I) in *Le Morte Darthur*, 1893–4. Pl. 80
$3\frac{7}{8} \times 2\frac{3}{4}$ inches
Rosenwald Collection, Library of Congress, Washington

82 Design for the chapter-heading of Chapter IV, Book V (p. 161 of Vol. I) in *Le Morte Darthur*, 1893–4. Pl. 82
$5\frac{7}{8} \times 2\frac{5}{8}$ inches
Scofield Thayer Collection, Fogg Art Museum, Harvard University, Massachusetts

83 Design for the chapter-heading of Chapter V, Book V (p. 162 of Vol. I) in *Le Morte Darthur*, 1893–4. Inscribed on the back in pencil 'Reduce by $\frac{1}{3}$' etc. Repeated elsewhere in the book. Pl. 79
$4\frac{11}{16} \times 3\frac{3}{8}$ inches
Mr F. M. Gross, London

84 Design for the chapter-heading of Chapter VI, Book V (p. 166 of Vol. I) in *Le Morte Darthur*, 1893–4. Pl. 85
$4\frac{13}{16} \times 3\frac{3}{8}$ inches
Scofield Thayer Collection, Fogg Art Museum, Harvard University, Massachusetts

85 Heading of Chapter VIII, Book V (p. 170 of Vol. I) in *Le Morte Darthur*, 1893–4. Pl. 84
From the line-block

The twining briars and vertical trees are bold simplifications, qualified by Beardsley's organic energy, of familiar Burne-Jones features. The exaggerated length of the wings, and the convention for the hair, based on the artist's own forward-brushed fringe, are essentially Beardsleyesque.

86 Design for the chapter-heading of Chapter X, Book V (p. 175 of Vol. I) in *Le Morte Darthur*, 1893–4. Pl. 86
$5 \times 3\frac{3}{8}$ inches
Mr John Hay Whitney, New York

Japanese stylization of water somewhat in this fashion oc in prints by Hiroshige and in lacquer work: similar in p ciple is the stylization of water by Burne-Jones in Karlsefne and Gudrida cartoons of 1883 for stained g (at Newport, Rhode Island, U.S.A. See Malcolm Bell, *Edward Burne-Jones*, London, reprint of 1901, after p. Beardsley used these serpentine ribbons for other purpo sometimes decorative, as in the border of 'Merlin Nimue' (NO. 76). The rectangle for letterpress has b blacked out.

87 Design for the chapter-heading of Chapter XI, Boo (p. 178 of Vol. I) in *Le Morte Darthur*, 1893–4. Inscribe the back in pencil 'Reduce by $\frac{1}{3}$' and with measurements Repeated elsewhere in the book. Pl. 87
$4\frac{5}{8} \times 3\frac{3}{8}$ inches
Mr F. M. Gross, London

88 Drawing for a full-page border for the beginning of Cha I, Book VI (p. 183 of Vol. I) in *Le Morte Darthur*, 189: Pl. 88
$11 \times 8\frac{7}{8}$ inches
Mr Draper Hill, Worcester, Massachusetts

The drawing for the initial S within this border is reprodu at NO. 89.

89 Design for an initial S for Chapter I, Book VI (p. 183 of I) in *Le Morte Darthur*, 1893–4. Pl. 89
$3\frac{13}{16} \times 2\frac{7}{8}$ inches
Victoria and Albert Museum, London

The initial was used for the word 'Soon' with which B VI began and was set inside the border reproduced at NO

90 How Four Queens Found Launcelot Sleeping. Full-illustration facing p. 18, Chapter I, Book VI (Vol. I) in Morte Darthur, 1893–4. Lettered with title. Pl. 90
$12 \times 9\frac{5}{16}$ inches
Scofield Thayer Collection, Fogg Art Museum, Harvard Un sity, Massachusetts

91 Heading of Chapter V, Book VI (p. 190 of Vol. I) i Morte Darthur, 1893–4. Pl. 91
From the line-block

The figure seems to have been based on a study of a liv female nude, possibly at the Westminster School of which Beardsley had attended in the evenings from autumn of 1891 to the same season in 1892; or it may poss have been based on a study or memory of his sister Ma The figure is in fact facing a dado and what looks li Morris wallpaper in a typical modern room of 1890.

92 Design for the chapter-heading of Chapter XIV, Boo (p. 209 of Vol. I) in *Le Morte Darthur*, 1893–4. Repe elsewhere in the book. Pl. 92
$4\frac{5}{8} \times 4$ inches
The Rosenwald Collection, Library of Congress, Washington

93 Sir Launcelot and the Witch Hellawes. Drawing for the

illustration facing p. 212, Chapter XV, Book VI (Vol. I)
 Morte Darthur, 1893–4. Pl. 93
9¼ inches
eton University Library

ding of Chapter VI, Book VII (p. 228 of Vol. I) in Le
 Darthur, 1893–4. Repeated elsewhere in the book. Pl. 96
 the line-block.

strange trees with their flat tops and visible roots sway
unterpoint to the pose of the woman, which is taken
 a reminiscence of some Japanese print. The design is
ingly *proto-art nouveau;* but the boldness of conception
touch, and the occasional over-refinement of detail, as
e face, are Beardsley's hallmarks.

gn for the chapter-heading of Chapter IX, Book VII
34 of Vol. I) in *Le Morte Darthur,* 1893–4. Pl. 98
4 inches
Steven Cohen, Cambridge, Massachusetts

lines across the drapery represent folds, in the flat mural
 of Puvis de Chavannes. It is possible Beardsley
horized something of the work of Puvis, whom he went
e in Paris with an introduction from Burne-Jones in the
dle of 1892. The conventionalized treatment of the valley
e distance is very odd, but similar features are to be seen
ther designs for *Le Morte Darthur.* The design appeared
art III.

ding of Chapter XIV, Book VII (p. 244 of Vol. I) in
Morte Darthur, 1893–4. Pl. 95
n the line-block

rst glance this figure appears to be that of a boy; at second
ce a female breast will be noticed. The person is there-
hermaphrodite. The twining rose-bush is descended
 the ones in *The Briar Rose* by Burne-Jones, but bleakly
capriciously stylized.

ign for the chapter-heading of Chapter XIX, Book VII
34 of Vol. I) in *Le Morte Darthur,* 1893–4. On the back
ncil drawing of nude figures surrounded by a one-line
der in pen and ink; also various inscriptions in pencil.
4
× 3⅜ inches
R. A. Harari, London

blue-grey mount window preserved with the drawing
s from Beardsley's lifetime and was inscribed by him,
Miss Mallam from Aubrey Beardsley'.

ign for the chapter-heading of Chapter XXXI, Book VII
80 of Vol. I) in *Le Morte Darthur,* 1893–4. Repeated else-
re in the book. Pl. 97
 2¹¹⁄₁₆ inches
R. A. Harari, London

e 291 in Vol. I of *Le Morte Darthur,* 1893–4. Pl. 99
m the line-block and letterpress

compare these designs for an initial and a border with

equivalent designs by William Morris is to note at once that
Beardsley's lines conveyed an energy that Morris's dense and
tranquil drawings lacked. The difference in temperament
between the two men was so great that after one meeting
neither could be induced to see the other again.

100 How La Beale Isoud Nursed Sir Tristram. Full-page illus-
tration facing p. 306 (Chapter IX, Book VIII) of *Le Morte
Darthur,* Vol. I, 1893–4. Pl. 100
11 × 8¾ inches
*Scofield Thayer Collection, Fogg Art Museum, Harvard Univer-
sity, Massachusetts*

The concept of ruled lines for the bed and curtain, making a
rectangular frame for the figures, has perhaps a distant
relationship to the rectilinear furniture and backgrounds in
certain Japanese prints. The grotesque shape of the molten
wax at the top of the candle and the singular emphasis given
to the candlestick are pure Beardsley features, often to be
found in his later designs.

101 Design for the chapter-heading of Chapter X, Book VIII
(p. 307 of Vol. I) in *Le Morte Darthur,* 1893–4. Repeated
elsewhere in the book. Pl. 101
4¼ × 2⅞ inches
Princeton University Library

102 Design with a motif of conventional veronica for the chapter-
heading of Chapter XIII, Book VIII (p. 313 of Vol. I) in *Le
Morte Darthur,* 1893–4. Repeated elsewhere in the book.
Pl. 102
2½ × 2½ inches
Mr W. G. Good, England

Beardsley designed chapter-headings of varying sizes for
the book. This is of the medium size, and is one of a minority
without any human, bird or animal figures.

103 Design for the chapter-heading of Chapter XIX, Book VIII
(p. 324 of Vol. I) in *Le Morte Darthur,* 1893–4. Repeated else-
where in the book. Pl. 103
4⅛ × 2⅜ inches
Victoria and Albert Museum, London

The rectangle cut in the top right corner to leave a white
space for the chapter number in letterpress has been enlarged
by pasting over it an oblong piece of white paper.

104 How Sir Tristram Drank of the Love Drink. Illustration to
a passage in Chapter XXIV, Book VIII (facing p. 334 in
Vol. I) of *Le Morte Darthur,* 1893–4. Pl. 105
11 × 8 inches
*Scofield Thayer Collection, Fogg Art Museum, Harvard Univer-
sity, Massachusetts*

One of the boldest of Beardsley's drawings for *Le Morte
Darthur,* or indeed of his whole career. The long worm-like
stem of Beardsley's symbolic flower, which seems to have
been derived from the passion-flower, the *Clematis viticella* or
Bush Bower, and the tulip, makes the border more restless
than any of the others in the book, while this quality is
counteracted by the delicate tensed-up petals of the blossoms

growing out of it. Symbolic roses of the diagrammatic form that was to be so popular as an *art nouveau* motif are seen, detached from any support, alongside. In the pictorial panel two curtains, treated like Japanese screens, nearly shut out the distant view, again stylized in a Japanese fashion. Across each curtain, with a curious parallel emphasis, a clematis flower with a harshly arabesque stalk sways rightwards. The passion-flower-tulip appears again stylized with great assurance on what is a simplified version of the peacock skirt in the illustration of that name for *Salome,* made probably not so very long afterwards. The hair of Isolde is in the Medusan style much favoured by Beardsley throughout *Le Morte Darthur* and taken up with relish by *art-nouveau* designers like Privat-Livemont. The strong perspective of the floorboards gives dramatic support to the tension of this scene of idealized love, which became one of Beardsley's obsessions. Isolde's high-shouldered reaction to Sir Tristram's gesture is, from the standpoint of the Wagnerian opera, which Beardsley knew so well, psychologically accurate. A smaller version of this composition was published in *The Savoy,* No. 7, November 1896, p. 91.

105 Heading of Chapter XXXIII, Book VIII (p. 348 of Vol. I) in *Le Morte Darthur,* 1893–4. Repeated elsewhere in the book. Pl. 104
From the line-block

The hair fetishism, which we can discern in the art of Frederick Sandys, and of Rossetti, is symbolized and mocked in this design by quantities of lines undulating on one plane. Beardsley's weakness for sensationalism, which he later refined away, is shown in the eyes of the lower head. The design was published in Part IV.

106 Design for the chapter-heading of Chapter XXXV, Book VIII (p. 353 of Vol. I) in *Le Morte Darthur,* 1893–4. Repeated elsewhere in the book. Pl. 109
$4\frac{1}{8} \times 3\frac{1}{8}$ inches
Mrs B. S. Clauson, England

107 Border and initial A with the text of the opening of Chapter I, Book IX (p. 367 of Vol. I) in *Le Morte Darthur,* 1893–4. Pl. 107
From the line-block and letterpress

It is instructive to compare this initial A with the one at NO. 70. Already Beardsley has given up aiming to make a rich thicket of decorative foliage as in the earlier example, and has asserted, de-naturalized and silhouetted the forms of the plants, while the restlessness has become frankly dramatic. The flower motif in the bottom margin was used again in the title-page and front cover design for *The Woman Who Did,* by Grant Allen, Vol. VIII in the *Keynotes* series, 1895.

108 How La Beale Isoud Wrote to Sir Tristram. Drawing for a full-page illustration facing p. 384 in Vol. I, Chapter X, Book IX in *Le Morte Darthur,* 1893–4. Pl. 106
$10\frac{13}{16} \times 8\frac{7}{16}$ inches
In private possession, England

The table, although at a different angle from the table in Dürer's engraving 'St Jerome in his Study', is probably based on it. But the construction of it has been misunder-

stood by the artist. The drawing shows that the hair originally delineated in heavy waves, but was blacked before reproduction.

109 Drawing for the chapter-heading of Chapter XVI, Book (p. 396 of Vol. I) in *Le Morte Darthur,* 1893–4. Pl. 108
$4\frac{3}{8} \times 2\frac{15}{16}$ inches
Rosenwald Collection, Library of Congress, Washington

A white rectangle was left by Beardsley for the cha numerals and these were put in, but the rectangle was l blacked over to match the background above the wall.

110 How King Mark found Sir Tristram sleeping. Drawing the full-page illustration facing p. 404, Chapter XX, Book (Vol. I) in *Le Morte Darthur,* 1893–4. Lettered with t which omits the word 'sleeping'. Pl. 112
$8\frac{1}{8} \times 6\frac{5}{8}$ inches
Mr F. J. Martin Dent, London

111 Heading of Chapter XXIV, Book IX (p. 413 of Vol. I) in *Morte Darthur,* 1893–4. Pl. 111
From the line-block

For the figure Beardsley was indebted to Whistler's 'Prin from the Land of Porcelain', painted in 1864, an early stone of the Aesthetic movement, which Beardsley hanging in 49 Prince's Gate in July 1891.

112 Design for the chapter-heading of Chapter XXXIX, B IX (p. 446 of Vol. I) in *Le Morte Darthur,* 1893–4. Pl. 110
$4\frac{3}{8} \times 2\frac{7}{8}$ inches
Princeton University Library

This design was published in Part VI, by which time Bea ley had given up bothering with details in background archaistic forms. The figure of the rushing girl seems nei mediaeval nor of the Nineties, but of the middle of the tw tieth century; one of Beardsley's strange anticipations o styles and the features of future women.

113 How Morgan le Fay Gave a Shield to Sir Tristram. Draw for a full-page illustration facing p. 450 in Chapter XL, B IX (Vol. I) in *Le Morte Darthur,* 1893–4. Inscribed on back with numerals in pencil and pen. Pl. 118
$10\frac{5}{8} \times 8\frac{5}{16}$ inches
Fitzwilliam Museum, Cambridge, England

114 La Beale Isoud at Joyous Gard. Drawing on one sheet f double-page illustration between pp. 556 and 557, Cha LII, Book X (Vol. II) in *Le Morte Darthur,* 1893–4. On back are slight scribbles, a sketch of part of the border, a c cature and an inscription, all in pencil by the artist. Pl. 11
$10\frac{5}{16} \times 17\frac{1}{8}$ inches
In private possession, England

The drawing was reproduced on one sheet of paper and margin between the two halves was taken up as the s was sewn in with the rest of the volume when the tw parts were bound in separate cases. This brought the halves closer together and the train of La Beale Iso garment continued on either side more convincingly —a

h was evidently calculated by the artist. Between the
ial and the larger tree on the lawn in the right-hand
re, there are traces of another figure which was blacked
by Beardsley. The pears, it will be noted, have un-
cious, or perhaps even deliberate, sexual symbols in
orifices and breast-like features.

gn for the chapter-heading of Chapter LXXI, Book X
oo of Vol. II) in *Le Morte Darthur,* 1893–4. Pl. 115
3⅜ inches
ern Australian Art Gallery, Perth, Western Australia

gn for the chapter-heading of Chapter LXXXV, Book
630 of Vol. II) in *Le Morte Darthur,* 1893–4. Pl. 114
3 inches
nd Mrs W. M. Schwab, London

e are very few chapter-headings in *Le Morte Darthur*
h which have no massed blacks in their designs. This is one
out any mass of black, in the thick-line style typical of
ater drawings for the book: another example is to be
at Chapter LXXXII, Book X (p. 603 of Vol. II).
dsley here makes use of linear formulae for land which
also adopted by Burne-Jones, but were derived origin-
from Japanese art.

639 in Vol. II of *Le Morte Darthur,* 1893–4. Pl. 119
n the line-block and letterpress

re are several chapter-headings in *Le Morte Darthur*
ving figures emerging out of flowers, as in this border.
idea goes back to early herbals, such as the *Ortis Sanitatis*
491 in which superstitions about semi-human plants are
trated as facts. It is possible that Beardsley saw books of
kind at the bookshop of Evans and Jones in Queen Street.

ding of Chapter VI, Book XI (p. 649 of Vol. II) in *Le*
te Darthur, 1893–4. Pl. 117
n the line-block

idea of the fence stylized in this way comes from Burne-
es's 'L'Amant' in the 'Romaunt of the Rose' series, and
dsley used it again, reversing the elements of the original
position, in his heading of Chapter II, Book XX, p. 909
142). The relation between the absurdly elongated white
d and the hood, which is opposed in tone and direction,
a similar shape, is typical of Beardsley's optical wit.

ign for a full-page border with the initial A for the
inning of Chapter I, Book XII (p. 665 of Vol. II) in *Le*
te Darthur, 1893–4. Pl. 120
an ink wash, 11 × 8 inches
ceton University Library

ign for the chapter-heading of Chapter IV, Book XII
70 of Vol. II) in *Le Morte Darthur,* 1893–4. Pl. 116
× 3 1/16 inches
B. S. Clauson, England

lear example of Beardsley's pen-line treatment of the
vy Pre-Raphaelite hair, which has become in his hands a

self-sufficient optical invention. Also a good example of the
soft-nosed, large-lipped, anti-genteel profile which at this
date Beardsley gave to his women's heads.

121 Double-page illustration between pp. 670 and 671 (Vol. II),
Chapter IV, Book XII in *Le Morte Darthur,* 1893–4. Pl. 121
From the line-block

The stems of the lilies-of-the-valley have pronounced *art
nouveau* lines, long curves with short returns; and for once
the two halves of the border are symmetrical. The trees in
the illustration have the characteristic plumage of stylized
leaves, and the trunks have the usual breast-like boles. The
clothes of the women seem either to be partly Japanese or
partly Victorian.

122 Heading of Chapter XI, Book XII (p. 681 of Vol. II) in *Le
Morte Darthur,* 1893–4. Pl. 124
from the line-block

Published in Part IX. The design is unique in the *Morte
Darthur* series, being all in diagrammatic outlines, with one
small area of massed black. The curves of the raised arm are
generalized in contradiction to the known form, with
reference to the looseness of the woman's sleeve. Such
curious swervings will be found often in Beardsley's later
work, as in the cut-away figure on the right in *The Repentance
of Mrs . . .* (see NO. 368). The drawing for this design, formerly
in the Pickford Waller Collection, was sold by Christie,
London, on 12 November 1965.

123 Border and initial A, with the text of the opening of Chapter
I, Book XIII (p. 689 of Vol. II) in *Le Morte Darthur,* 1893–4.
Pl. 122
From the line-block and letterpress

Compared with the other borders designed by Beardsley for
the book, this one is the least flamboyant and reflects very
little of the *art nouveau* spirit already moving in the rest. The
simplified pattern of conventionalized flowers is nearest per-
haps to the domestic embroidery of the time (and later) based
on the principles of William Morris.

124 Design for the chapter-heading of Chapter XVII, Book XIII
(p. 718 of Vol. II) in *Le Morte Darthur,* 1893–4. Pl. 126
4 15/16 × 3 3/8 inches
Victoria and Albert Museum, London

The simple form and the somewhat thick line are characteris-
tic of Beardsley's later drawings for the book. This appeared
in Part IX.

125 Initial N and full-page border of Chapter I, Book XIV (p.
725 of Vol. II) in *Le Morte Darthur,* 1893–4. Pl. 123
From the line-block

The design has a restless quality which separates it from
anything of the kind produced in this period by other artists.
Behind the perversely shaped initial N the four stems rise
together in the rhythm of a wave, the six Canterbury Bells
are blown in a backward direction, and the barren ends
twine in *art nouveau* enlacements. As usual in *Le Morte Darthur,*
the border is a little too dramatic for the letterpress.

126 Design for the chapter-heading of Chapter III, Book XIV (p. 728 of Vol. II) in *Le Morte Darthur*, 1893–4. Pl. 125
$4\frac{3}{8} \times 3\frac{7}{16}$ inches
Mr R. A. Harari, London

One of the later drawings for *Le Morte Darthur*, in which Beardsley has simplified the design to white silhouettes against a plain black background. It appeared in Part IX.

127 Heading of Chapter VI, Book X (p. 733 of Vol. II) in *Le Morte Darthur*, 1893–4. Pl. 127
From the line-block

Beardsley's immaturity is revealed by his journalistic debasement of a Rossetti head, added to the body of a female faun; but all is redeemed by his mastery of black and white and the careless force of the drawing.

128 Heading of Chapter IX, Book XIV (p. 738 of Vol. II) in *Le Morte Darthur*, 1893–4. Repeated elsewhere in the book. Pl. 129
From the line-block

Appearing first on p. 738 in Part X on a small scale, this heading was repeated on a larger scale for Chapter XXII, Book XX (p. 953 in Vol. II) which came out in Part XII. The subject seems to have been inspired by representations of the drowned Ophelia, but the idea of the dead and severed head was clearly transferred from the head of John the Baptist in 'The Dancer's Reward' of *Salome*, on which Beardsley was working at about the time when this late contribution to *Le Morte Darthur* was made. The unrelieved black of the background above the water, unrelieved, that is, except for an attenuated tree-trunk, is the kind of dramatic excess that was soon copied by graphic artists in every field, to become one of the recognition features of design between the Nineties and the 1914 War.

129 Border and initial W with the text of the opening of Chapter I, Book XV (p. 741 of Vol. II) in *Le Morte Darthur*, 1893–4. Pl. 130
From the line-block and letterpress

This shows Beardsley getting into his stride as an *art nouveau* designer. By comparison with the book decorations of Morris and Burne-Jones, the border is meagre and unbalanced, and the initial eccentric. The element of wildness in the poppies and their foliage is not an element in the character of these plants, so much as a passion in the mind of the draughtsman.

130 Design for the chapter-heading of Chapter III, Book XVI (p. 755 of Vol. II) in *Le Morte Darthur*, 1893–4. Pl. 128
Measurements not known
J. S. Maas and Company, London

A black background typical of the later drawings made for *Le Morte Darthur*. Beardsley was becoming tired of his work for the book, his designs tended to bold simplifications, and the clothes of his figures, as here, began to have the characteristics of the late nineteenth century instead of the Middle Ages.

131 How a Devil in a Woman's likeness would have tem... Sir Bors. Two drawings together forming a design f... double-page illustration in Chapter XII, Book XVI (betw... pp. 768 and 769, Vol. II) in *Le Morte Darthur*, 1893–4. Pl...
$10\frac{3}{16} \times 7\frac{5}{8}$ inches: $10\frac{3}{8} \times 7\frac{1}{2}$ inches
The Art Institute of Chicago

132 Drawing for a full-page border with the initial N for... beginning of Chapter I, Book XVII (p. 779 of Vol. II) i... *Morte Darthur*, 1893–4. Pl. 134
$8\frac{5}{16} \times 6\frac{1}{2}$ inches
Princeton University Library

The foliated ornament springing from one corner is deri... in principle from the border ornaments by William M... in the books of the Kelmscott Press, but is bolder and ... erudite.

133 Heading of Chapter XVI, Book XVII (p. 807 of Vol. I... *Le Morte Darthur*, 1893–4. Pl. 133
From the line-block

This extraordinary scene through a gully, from the sid... which trees grow to form a roof of leaves, is one of Beards... most original developments of the idea of a stylized v... which he presents in such designs as that at NO. 95.

134 Design for the chapter-heading of Chapter XIX, Book X... (p. 812 of Vol. II) in *Le Morte Darthur*, 1893–4. Pl. 132
$4 \times 3\frac{3}{8}$ inches
The Cooper Union Museum, New York

The design appeared in Part IX.

135 Design for the chapter-heading of Chapter XX, Book X... (p. 814 of Vol. II) in *Le Morte Darthur*, 1893–4. Pl. 135
$5\frac{3}{4} \times 3\frac{3}{8}$ inches
The Hon. Christopher Lennox-Boyd, London

136 Border and initial S with the text of the opening of Chapt... Book XVIII (p. 823 of Vol. II) in *Le Morte Darthur*, 189... Pl. 136
From the line-block and letterpress

It was typical of Beardsley that he did not avoid, he gras... the opportunity of identifying leaves with the feather... angels' wings. The angels' heads with their folded w... were based presumably on memories of Burne-Jon... 'Angels of Creation', originally designed for stained glas... Tamworth church and begun in 1872. It so happened ... these six panels were exhibited for the third time in 1... at the New Gallery in London. Beardsley's design has n... of their complexity and is the work of a different typ... mind, having the direct shock of an epigram.

137 Heading of Chapter III, Book XVIII (p. 827 of Vol. II) in... *Morte Darthur*, 1893–4. Pl. 140
From the line-block

Half a woman, clipped away vertically, and half a c... clipped off horizontally, as in the manner of a snaps...

tograph, and a not very successful one at that. This of
rse burlesques in a distant way the camera-style impres-
ism which attracted Degas and others from the 1870s
ard.

ign for the chapter-heading of Chapter IX, Book XVIII
39 of Vol. II) in *Le Morte Darthur*, 1893–4. Pl. 139
. 3¼ inches
nwald Collection, Library of Congress, Washington

ding of Chapter XIV, Book XVIII (p. 851 of Vol. II) in
Morte Darthur, 1893–4. Pl. 141
m the line-block

drawing for this chapter-heading was until recently in
possession of Dr Catherine Boelcke, Wiesbaden.

ign for the chapter-heading of Chapter XXI, Book XVIII
67 of Vol. II) in *Le Morte Darthur*, 1893–4. Pl. 138
× 3¼ inches
tional Gallery of Canada, Ottawa

s drawing appeared first in Part XI of the book and must
e been one of the last Beardsley made for it. By that time
had almost given up the attempt to clothe his figures in a
diaeval fashion. His boredom with the work of producing
many drawings for *Le Morte Darthur* is shown by his
ifference to the fact that he has drawn the woman leaning
inst the apple tree as if she were of his own period.

w Queen Guenever rode on Maying. Two drawings to-
her forming a design for a double-page illustration in
pter I, Book XIX (between pp. 880 and 881 of Vol. II)
e Morte Darthur, 1893–4. Pl. 137
× 6⅝ inches: 8⅛ × 6⅝ inches
R. A. Harari, London

rdsley's interpretation of this scene, with all the figures
ull profile, is very much in the manner of a pageant.

ign for the chapter-heading of Chapter II, Book XX
909 of Vol. II) in *Le Morte Darthur*, 1893–4. Pl. 146
asurements not recorded
ent owner unknown

s is a very loose, freehand drawing for Beardsley. It has
ertain charm; but apart from the well, the imagery has
n plagiarized from 'L'Amant' in the series 'The Romaunt
he Rose' by Burne-Jones, even to the gesture of the figure.
rose-bush and the figure are the other way round in
Amant' and of course very much more elaborate, while
rdsley's figure is behind the fence, not in front of it, and
face in the large rose in 'L'Amant' has not been imitated.
drawing appeared in Part XII and may have been among
last done for *Le Morte Darthur*.

ding of Chapter IV, Book XX (p. 913 of Vol. II) in *Le
rte Darthur*, 1893–4. Pl. 143
m the line-block

144 Design for the chapter-heading of Chapter VI, Book XX
(p. 918 of Vol. II) in *Le Morte Darthur*, 1893–4. Pl. 145
6¾ × 2⅛ inches
Victoria and Albert Museum, London

145 Design for the chapter-heading of Chapter X, Book XX
(p. 926 of Vol. II) in *Le Morte Darthur*, 1893–4. Pl. 142
4⅜ × 2⅞ inches
Princeton University Library

This design appeared in Part XII, the last part of the book.

146 Design for the chapter-heading of Chapter XII, Book XX
(p. 931 of Vol. II) in *Le Morte Darthur*, 1893–4. Pl. 148
5¼ × 3½ inches
Victoria and Albert Museum, London

This design appeared in Part XII, the last part of the book.

147 Design for the chapter-heading of Chapter XVIII, Book XX
(p. 945 of Vol. II) in *Le Morte Darthur*, 1893–4. Pl. 147
4¹³⁄₁₆ × 3⅜ inches
Victoria and Albert Museum, London

This design appeared in Part XII, the last part of the book.

148 Design for the chapter-heading of Chapter XX, Book XX
(p. 949 of Vol. II) in *Le Morte Darthur*, 1893–4. Pl. 144
4¼ × 3 inches
Mrs B. S. Clauson, England

The drawing of the hair shows uncertainty, and Beardsley's
technique of leaving white forms in reserve has failed him
in the detail of the hand. The tree in a rectangular tub and the
topiary work in the background remind one of his preference
for extremes of artificiality, even in gardens.

149 How Sir Belvidere cast the sword Excalibur into the water.
Drawing for the full-page illustration facing p. 967, Chapter
V, Book XII (Vol. II) in *Le Morte Darthur*, 1893–4. Pl. 149
8⅜ × 6½ inches
Mr F. J. Martin Dent, London

150 How Queen Guenever Made Her a Nun. Illustration facing
p. 975 in Chapter IX, Book XXI, Vol. II, in *Le Morte Darthur*,
1893–4. Pl. 150
From the line-block

Probably the best early example of the mysterious massed
blacks that later constituted a feature of Beardsley's style.

151 Drawing for the front cover design stamped in gold on the
bound volumes of *Le Morte Darthur*, published by J. M.
Dent and Company in parts, 1893–4. Pl. 151
10¾ × 8 inches
Mr Brian Reade, London

This design has ingeniously thought-out serpentine lines
which symbolize twisting leaves and stems moving in unison,
contrasted with the hard and horizontal clematis flowers that
recur as a theme in the *Morte Darthur* illustrations. The

masterful simplicity of it, which had a considerable influence on *art nouveau* artists, suggests that it was made by Beardsley towards the end of the period when he was working on this book and had developed away from the kind of design he made for the wrappers of the parts. See also NO. 152.

The plant forms are Beardsley hybrids, part passion-flower, part *Clematis viticella,* part tulip—perhaps.

152 Front cover and spine of Vol. I of *Le Morte Darthur.* From one of three volumes specially bound in vellum cases. No. 117 of 300 copies printed on Dutch hand-made paper, with publisher's imprint on the title-page and initials in the text printed in red. Published by J. M. Dent and Company, London, 1893–4, 4to. Pl. 152
Designs stamped in gold on vellum
Mr R. A. Harari, London

The small paper issue of the first edition of *Le Morte Darthur* was limited to 1500 copies published in parts at 2s 6d each, having green wrappers with a front cover design by Beardsley. The large paper edition, limited to 300 copies, was published in parts at 6s 6d each, with grey wrappers bearing the same design. Cases for the small paper issue were of cream cloth with the design as shown here stamped in gold: these were supplied by the publishers at 3s per volume, with binding costs for two volumes at 4s 6d per volume. The large paper edition was divided for binding into three sections instead of two, and cases were supplied at 3s 6d per volume, with binding costs at 5s per volume. Vellum was recommended for the large paper edition, but the cases of this material were not supplied, the binding costs of it being 8s 6d per volume.

The original drawing for the front cover of the bound volumes is reproduced at NO. 151. The dramatic effect of the swaying clematis stems points to a date either late in 1893 or in early 1894. The design for the wrappers was less masterly and more in the style of *The Studio* poster and cover.

153 Design for a chapter-heading, used for Chapter VII, Book IV, p. 75 in the edition of 1909 of *Le Morte Darthur.* Repeated elsewhere in the book. Pl. 155
$4\frac{3}{4} \times 3\frac{1}{2}$ inches
Victoria and Albert Museum, London

This was one of the ten designs omitted from the first edition of *Le Morte Darthur* as published in 1893–4, and included in Dent's one-volume edition of 1909. It may have been rejected because the chapter-heading rectangle obliterated the top of the largest of the female figures.

154 Design for a chapter-heading, used for Chapter IX, Book VI, p. 128 in the edition of 1909 of *Le Morte Darthur.* Repeated elsewhere in the book. Pl. 154
$4\frac{3}{4} \times 3\frac{5}{8}$ inches
Victoria and Albert Museum, London

This was one of ten designs omitted, possibly by mistake, from the first edition of *Le Morte Darthur* as published in 1893–4, and included in Dent's one-volume edition of 1909. Like many of the later drawings for the book it has little relevance to the text, while the scene and details are anachronistic.

155 Design for a chapter-heading, used for Chapter XII, B[ook] VI, p. 133 and elsewhere in the edition of 1909 of *Le M[orte] Darthur.* Pl. 153
$2\frac{3}{16} \times 1\frac{5}{8}$ inches
Princeton University Library

This was one of the ten designs omitted from the first edi[tion] of 1893–4 and first published in the edition of 1909.

156 Design for a chapter-heading, used for Chapter XX[,] Book IX, p. 276 in the edition of 1909 of *Le Morte Dart[hur.]* Pl. 159
$6\frac{1}{8} \times 3\frac{3}{8}$ inches
Mr F. J. Martin Dent, London

This design was omitted from the first edition of 1893–4 [and] not published until it was included in the one-volume edit[ion] of 1909. The blue-grey mount-window, which has been p[re]served with it, dates from Beardsley's lifetime and is the sa[me] size as that referred to at NO. 97.

157 Design for a chapter-heading, used for Chapter VIII, B[ook] X, p. 302 in the edition of 1909 of *Le Morte Darthur.* Pl.
$4\frac{1}{4} \times 2\frac{1}{2}$ inches
Mrs B. S. Clauson, England

This was one of the ten designs omitted from the first edit[ion] of 1893–4 and first published in the edition of 1909.

158 Chapter-heading for *Le Morte Darthur,* used in Book X[,] chapter XI, p. 368 in the edition of 1927. Pl. 156
$7\frac{1}{4} \times 4\frac{3}{8}$ inches
Princeton University Library

This design, which dates from *c.* 1893, was omitted from editions of 1893–4 and 1909, possibly because the foli[age] spread into the margin in a way out of keeping with other ornaments in the book.

159 Design for a chapter-heading in *Le Morte Darthur,* 1893[–4] but not used. Pl. 161
$4\frac{3}{4} \times 3\frac{3}{8}$ inches
The Cooper Union Museum, New York

160 Design for an initial J possibly intended for *Le Morte Dart[hur,]* 1893–4, but not used. Pl. 160
$5\frac{7}{16} \times 3\frac{9}{16}$ inches
Princeton University Library

R. A. Walker did not consider this drawing to be by Bear[ds]ley. Certainly the adaptation of Celtic ornament is rare in [his] work.

161 Unfinished drawing for a border intended for a page in [*Le*] *Morte Darthur,* 1893–4. Pl. 158
Pencil, pen and ink, $11\frac{7}{16} \times 8\frac{3}{16}$ inches
Princeton University Library

At some time in 1893 the artist gave this drawing to his schoolfriend, George Scotson-Clark, who was born in [the] same year as himself, and had gone to the United States

x there first as an actor and then as an illustrator. son-Clark returned to England in 1897 and died in 1927.

ale figure holding a dagger and descending a staircase, a chafing dish on a tripod supported by a column on the . Inscribed in pencil with an oval flourish and instruc- for reduction. On the back, a design for *Le Morte hur* in pen (see NO. 58). Pl. 163
< 5⅝ inches
oria and Albert Museum, London

drawing is unusual in that it shows Beardsley using a il to make the sort of firm outline he generally reserved enwork over rough pencil lines. It is not clear what the ect represents, and the instructions for reduction would to the drawing on the other side.

esque figure of a man wearing a monocle. On the reverse of the drawing 'La Beale Isoud at Joyous Gard' for *Le e Darthur* (see NO. 114). Pl. 157
il
ivate possession, England

little grotesque has not been published before, or even seen, since the back of the drawing on the recto side detached in 1967 from the remains of an old mount. in the style of the vignettes in the *Bon-Mots* series: these done concurrently with the work for *Le Morte Darthur* furnished Beardsley with an outlet for his comic fan- s. On other parts of the verso of 'La Beale Isoud at us Gard' are some sketches for the border of pears which rate that illustration.

fried, Act II. Drawing illustrating Wagner's lyric drama. ed AVB. Pl. 164
an ink and wash, 15¾ × 11¼ inches
oria and Albert Museum, London

drawing was given by the artist to Burne-Jones, after se death in 1898 Lady Burne-Jones gave it to Beardsley's her. It is in the hairline style cultivated by Beardsley in .–3 and belongs to the group that includes 'How King ur saw the Questing Beast' (see NO. 56) and, on a ler scale, many of the *Bon-Mots* drawings. The distant rscape has been translated from similar details in Pollai- 's *Martyrdom of St Sebastian* in the National Gallery, don. Siegfried's figure is notable for its feminine spavin- ed posture, to be seen again in Beardsley's caricature of self (NO. 428) and in his drawing 'The Abbé' (NO. 423). re is little attempt at recession: most of the forms are rated and most of the details seem to be on the same e; and the tree-trunk on the right is stylized in the pole- e soon to become a formula of *art nouveau* decoration.

-page of *Bon-Mots* of Sydney Smith and R. Brinsley idan, edited by Walter Jerrold and published by J. M. t and Company, London, 1893, 8vo. Pl. 165
n the line-block and letterpress (in black and red)
Brian Reade, London

sign with motifs extended in linear scrolls. Among the fs is Whistler's butterfly emblem, and a figure with a l headdress in the manner of Grandville's *Les Fleurs*

Animées (1847), though Beardsley is more likely to have found this idea in *Flora's Feast* (1889) or some other book illus- trated by Walter Crane.

166 Vignette on p. 7 in *Bon-Mots* of Sydney Smith and R. Brinsley Sheridan, edited by Walter Jerrold and published by J. M. Dent and Company, London, 1893. Repeated on p. 84 in *Bon-Mots* of Charles Lamb and Douglas Jerrold, etc., 1893. Pl. 167
From the line-block

Beardsley has represented the cat on two legs: the other two legs would have confused the design, he must have thought. There are other instances of this economy (see NO. 294). The cat's hair on end and its tail in a brush with excitement are wittily stylized in a way that was entirely Beardsley's own.

167 Vignette for p. 13 in *Bon-Mots* of Sydney Smith and R. Brin- sley Sheridan, edited by Walter Jerrold and published by J. M. Dent and Company, London, 1893. Signed with the artist's emblem. Pl. 166
1⅜ × 3⅛ inches
Mr Brian Reade, London

These heads, Beardsley's own head amongst them, with a fringe, may have been suggested by the somewhat ghostly heads drawn by Simeon Solomon in his later years.

168 Vignette for p. 15 in *Bon-Mots* of Sydney Smith and R. Brin- sley Sheridan, edited by Walter Jerrold and published by J. M. Dent and Company, London, 1893. Repeated on p. 80 in *Bon-Mots* of Samuel Foote and Theodore Hook, etc., 1894. Pl. 168
2⅛ × 1¾ inches
Mr Charles Alan, New York

169 Vignette for p. 17 in *Bon-Mots* of Sydney Smith and R. Brin- sley Sheridan, edited by Walter Jerrold and published by J. M. Dent and Company, London, 1893. Repeated on p. 120 in *Bon-Mots* of Charles Lamb and Douglas Jerrold, etc., 1893. Signed with the artist's emblem. Pl. 169
2½ × 4⅝ inches
Mr M. H. Schwab, Maidenhead, England

The extraction of teeth in the nineteenth century was simply a matter of drawing them out roughly with pincers. An assistant pulling the dentist to add to his drawing power was one of the bizarre elements in this operation. The idea of the patient's eye coming out on stalks is akin to similar ideas ex- pressed by Cocteau in his illustrations to *Opium* (1930).

170 Vignette for p. 19 (small) in *Bon-Mots* of Sydney Smith and R. Brinsley Sheridan, edited by Walter Jerrold and published by J. M. Dent and Company, London, 1893; and for p. 117 (large) in *Bon-Mots* of Charles Lamb and Douglas Jerrold, etc., 1893. Pl. 170
2⅜ × 1 13/16 inches
Grenville L. Winthrop Bequest, Fogg Art Museum, Harvard University, Massachusetts

In this excellently drawn fantasy the black plaits of the Dark Angel, which Lionel Johnson had only just invented (1893)

and certainly not published, look like a wing. Or is it perhaps a wing that looks like plaits?

171 Vignette on p. 23 in *Bon-Mots* of Sydney Smith and R. Brinsley Sheridan, edited by Walter Jerrold and published by J. M. Dent and Company, London, 1893. Repeated on p. 29 in a smaller version in *Bon-Mots* of Charles Lamb and Douglas Jerrold, etc., 1893. Pl. 172
From the line-block

172 Vignette for p. 26 in *Bon-Mots* of Sydney Smith and R. Brinsley Sheridan, edited by Walter Jerrold and published by J. M. Dent and Company, London, 1893. Repeated on p. 151, and as full-page illustration facing p. 122, in *Bon-Mots* of Charles Lamb and Douglas Jerrold, etc., 1893; and on p. 165 in *Bon-Mots* of Samuel Foote and Theodore Hook, etc., 1894. Signed with the artist's emblem. Pl. 173
$2\frac{1}{8} \times 3\frac{7}{8}$ inches
Mr R. A. Harari, London

In 1892 or 1893 Beardsley must either have seen an actual foetus or some representation of one: in either case the experience made a strong impression. The obsessional foetus is here an abortion pointing to the creature in a fur-lined cloak, who puts out a dark hand with long finger-nails to give it to its mother. The object in the pocket of the cloak is presumably an abortionist's instrument, but also a displaced phallic symbol, likewise the guttering candle with the flame pointing towards the woman.

173 Vignette for p. 27 in *Bon-Mots* of Sydney Smith and R. Brinsley Sheridan, edited by Walter Jerrold and published by J. M. Dent and Company, London, 1893. Pl. 171
$1\frac{15}{16} \times 1\frac{13}{16}$ inches
Mr R. A. Harari, London

174 Vignette on p. 30 in *Bon-Mots* of Sydney Smith and R. Brinsley Sheridan, edited by Walter Jerrold and published by J. M. Dent and Company, London, 1893. Pl. 176
From the line-block

The gallows-tree is alive and looking at the cat, whose extremities are attenuated in hair-line whorls. The more macabre etchings of Callot and of Cruikshank come to mind, but it is doubtful whether Beardsley could be said to have imitated them here.

175 Vignette for p. 40 in *Bon-Mots* of Sydney Smith and R. Brinsley Sheridan, edited by Walter Jerrold and published by J. M. Dent and Company, London, 1893. Pl. 175
$2\frac{1}{8} \times 2\frac{1}{4}$ inches
Mr Joseph T. Butler, New York

176 Vignette for p. 41 in *Bon-Mots* of Sydney Smith and R. Brinsley Sheridan, edited by Walter Jerrold and published by J. M. Dent and Company, London, 1893. Repeated on a smaller scale on p. 13 in *Bon-Mots* of Charles Lamb and Douglas Jerrold, etc., 1893. Pl. 174
$3\frac{1}{8} \times 2\frac{3}{4}$ inches
Mr F. J. Martin Dent, London

In the *Bon-Mots* of Smith this design is switched so that beetle appears on the left. In the Lamb *Bon-Mots* the bee in the same position as here. The idea of a round-sh spider with a human eye may well have been suggeste Beardsley by Odilon Redon's lithograph 'Araignée' (lerio, 72), which shows a spider with a grotesque s human face and two wide-open eyes. For another versic this possible link with Redon's spider, see NO. 208. Se other *Bon-Mots* vignettes show probable memorization lithographs by Redon, which Beardsley could have either at the Jones and Evans bookshop in London, or du his visit to Paris in 1892.

177 Vignette for p. 44 in *Bon-Mots* of Sydney Smith and R. E sley Sheridan, edited by Walter Jerrold and published J. M. Dent and Company, London, 1893. Repeated on p. of *Bon-Mots* of Samuel Foote and Theodore Hook, etc., 1 Pl. 177
$2\frac{7}{16} \times 1\frac{3}{4}$ inches
Princeton University Library

178 Vignette on p. 47 in *Bon-Mots* of Sydney Smith and R. B sley Sheridan, edited by Walter Jerrold and published J. M. Dent and Company, London, 1893. Signed with artist's emblem. Pl. 183
From the line-block

179 Vignette for p. 50 in *Bon-Mots* of Sydney Smith and R. B sley Sheridan, edited by Walter Jerrold and published J. M. Dent and Company, London, 1893. Repeated on p of *Bon-Mots* of Charles Lamb and Douglas Jerrold, etc., 1 Pl. 179
$1\frac{9}{16} \times 1$ inches
Mr R. A. Harari, London

180 Vignette for p. 55 in *Bon-Mots* of Sydney Smith and Brinsley Sheridan, edited by Walter Jerrold and publis by J. M. Dent and Company, London, 1893. Repeated p. 177 and p. 132 (smaller version) in *Bon-Mots* of Cha Lamb and Douglas Jerrold, etc, 1893. Pl. 185
$2\frac{5}{8} \times 4\frac{1}{16}$ inches
Mr Brian Reade, London

181 Vignette for p. 58 in *Bon-Mots* of Sydney Smith and Brinsley Sheridan, edited by Walter Jerrold and published J. M. Dent and Company, London, 1893. Repeated as a f page grotesque facing p. 146 in *Bon-Mots* of Charles La and Douglas Jerrold, etc, 1893. Pl. 183
$3\frac{3}{8} \times 3$ inches
The Art Institute of Chicago

182 Vignette for p. 61 in *Bon-Mots* of Sydney Smith and R. B sley Sheridan, edited by Walter Jerrold and published J. M. Dent and Company, London, 1893. Repeated on p in *Bon-Mots* of Charles Lamb and Douglas Jerrold, etc., 1 Signed with the artist's emblem. Pl. 180
$2\frac{1}{4} \times 1\frac{3}{4}$ inches
Princeton University Library

ette on p. 70 in *Bon-Mots* of Sydney Smith and R. Brin-
Sheridan, edited by Walter Jerrold and published by
.Dent and Company, London, 1893. Repeated on p. 119
n-Mots of Samuel Foote and Theodore Hook, etc., 1894.
ed with the artist's emblem. Pl. 182
n the line-block

large head seems to have been based on a seventeenth-
ury portrait (? Molière): the small heads seem to have
developed from the eyes of peacock feathers. If the head
horns represents a cuckold, the allusion is to a sex
gle, manipulated by strings as in puppetry.

ette for p. 73 in *Bon-Mots* of Sydney Smith and R. Brin-
Sheridan, edited by Walter Jerrold and published by
.Dent and Company, London, 1893. Repeated on a
ller scale on p. 65 of *Bon-Mots* of Charles Lamb and
iglas Jerrold, etc., 1893, and on p. 117 of *Bon-Mots* of
uel Foote and Theodore Hook, etc., 1894. Pl. 178
× 2$\frac{3}{16}$ inches
P. J. Mayer, London

ette for p. 76 in *Bon-Mots* of Sydney Smith and R. Brin-
Sheridan, edited by Walter Jerrold and published by
.Dent and Company, London, 1893. Repeated on p. 46
smaller version in *Bon-Mots* of Charles Lamb and Douglas
old, etc., 1893. Pl. 181
3$\frac{1}{16}$ inches
John Hay Whitney, New York

form of the female figure, which seems about to be liquid-
into the ground on which she is sitting, is of course
ired by Japanese prints. The twist of the wide-faced, wild-
king cat however seems to have been based upon Beards-
s own observations. The tip of the curve of the garment
the ground to the right has unfortunately been clipped
y when the paper was trimmed.

ette on p. 85 in *Bon-Mots* of Sydney Smith and R.
sley Sheridan, edited by Walter Jerrold and published
. M. Dent and Company, London, 1893. Repeated on p. 5,
in a smaller version on p. 36, in *Bon-Mots* of Charles Lamb
Douglas Jerrold, etc, 1893. Signed with the artist's
lem. Pl. 187
n the line-block

ette on p. 88 in *Bon-Mots* of Sydney Smith and R. Brin-
Sheridan, edited by Walter Jerrold and published by
.Dent and Company, London, 1893. Signed with the
t's emblem. Pl. 190
n the line-block
foetus idea emerges here in the shape of a prawn, with a
top to its head as though it were some kind of corbel,
le over it a Whistlerian butterfly provokes a skeleton
ing an Aesthetic peacock's feather.

ette on p. 96 in *Bon-Mots* of Sydney Smith and R. Brin-
Sheridan, edited by Walter Jerrold and published by
.Dent and Company, London, 1893. Repeated in a

smaller version on p. 153 in *Bon-Mots* of Charles Lamb and
Douglas Jerrold, etc, 1893. Signed with the artist's emblem.
Pl. 186
From the line-block

189 Vignette for p. 101 in *Bon-Mots* of Sydney Smith and R.
Brinsley Sheridan, edited by Walter Jerrold and published
by J. M. Dent and Company, London, 1893; and on p. 101
in *Bon-Mots* of Samuel Foote and Theodore Hook, etc, 1894.
Signed with the artist's emblem. Pl. 188
1$\frac{15}{16}$ × 1$\frac{9}{16}$ inches
Mr R. A. Harari, London

Parts of the head and the whole of the hat are made up of
calligraphic flourishes in the manner of seventeenth- and
eighteenth-century writing masters, which Beardsley may
have had opportunities of noting in the embellishments of
copperplate penmanship to be seen in old manuscripts and
in engraved books on handwriting. His compulsion to dis-
cover breast-forms in pears and trees (see NO. 114) sometimes
took him a step further, and led to the summary indications
of female breasts in odd places, as in this instance on the
man's jaw, where the only possible equivalents would be
ulcers.

190 Vignette for p. 107 in *Bon-Mots* of Sydney Smith and R.
Brinsley Sheridan, edited by Walter Jerrold and published
by J. M. Dent and Company, London, 1893. Repeated as full-
page illustration facing p. 110 in *Bon-Mots* of Charles Lamb
and Douglas Jerrold, etc, 1893. Signed with the artist's
emblem. Pl. 195
3$\frac{3}{8}$ × 3 inches
The Art Institute of Chicago

191 Vignette for p. 109 in *Bon-Mots* of Sydney Smith and R.
Brinsley Sheridan, edited by Walter Jerrold and published
by J. M. Dent and Company, London, 1893. Repeated verti-
cally on p. 142 in *Bon-Mots* of Samuel Foote and Theodore
Hook, etc, 1894. Pl. 193
1$\frac{5}{16}$ × 2$\frac{1}{8}$ inches
Mr R. A. Harari, London

An example of one of the *Bon-Mots* drawings inspired by the
pen flourishes of seventeenth-century calligraphers.

192 Vignette for p. 111 in *Bon-Mots* of Sydney Smith and R.
Brinsley Sheridan, edited by Walter Jerrold and published
by J. M. Dent and Company, London, 1893. Repeated on
p. 60 in *Bon-Mots* of Charles Lamb and Douglas Jerrold,
etc, 1893. Pl. 194
2 × 1$\frac{3}{8}$ inches
Mr Charles Alan, New York

A miniature monster with Mephistophelian tongue, toast-
ing-fork hand, and other endearing features.

193 Vignette on p. 119 in *Bon-Mots* of Sydney Smith and R.
Brinsley Sheridan, edited by Walter Jerrold and published
by J. M. Dent and Company, London, 1894. Repeated on
p. 182 in *Bon-Mots* of Charles Lamb and Douglas Jerrold, etc,
1893. Signed with the artist's emblem. Pl. 192
From the line-block

Balancing on an Aesthetic feather, an apothecary and his Mephistophelian apprentice come to visit a sick person in a loose-covered Victorian armchair. A more elaborate version of the idea of the figure in the armchair appears in the second frontispiece to *An Evil Motherhood* (see NO. 395).

194 Vignette on p. 121 in *Bon-Mots* of Sydney Smith and R. Brinsley Sheridan, edited by Walter Jerrold and published by J. M. Dent and Company, London, 1893. Pl. 191
From the line-block

195 Vignette for p. 123 of *Bon-Mots* of Sydney Smith and R. Brinsley Sheridan, edited by Walter Jerrold and published by J. M. Dent and Company, London, 1893. Signed with the artist's emblem. Pl. 189
$3 \times 2\frac{3}{4}$ inches
Mr and Mrs Marvin Small, New York

196 Vignette on p. 126 in *Bon-Mots* of Sydney Smith and R. Brinsley Sheridan, edited by Walter Jerrold and published by J. M. Dent and Company, London, 1893. Repeated on p. 87 as full-page illustration in *Bon-Mots* of Charles Lamb and Douglas Jerrold, etc, 1893. Pl. 196
From the line-block

197 Vignette for p. 129 in *Bon-Mots* of Sydney Smith and R. Brinsley Sheridan, edited by Walter Jerrold and published by J. M. Dent and Company, London, 1893. Pl. 197
$2\frac{13}{16} \times 1\frac{13}{16}$ inches
Mr R. A. Harari, London

A figure almost entirely made up of pen flourishes. Pendulous breasts appear facing backwards below the hair.

198 Vignette for p. 131 of *Bon-Mots* of Sydney Smith and R. Brinsley Sheridan, edited by Walter Jerrold and published by J. M. Dent and Company, London, 1893. Repeated on p. 168 of *Bon-Mots* of Charles Lamb and Douglas Jerrold, etc, 1893. Signed with the artist's emblem. Pl. 200
$2\frac{1}{8} \times 1\frac{1}{2}$ inches
Dr and Mrs Richard W. Levy, New Orleans

199 Vignette on p. 133 in *Bon-Mots* of Sydney Smith and R. Brinsley Sheridan, edited by Walter Jerrold and published by J. M. Dent and Company, London, 1893. Pl. 198
From the line-block

A doodle on the lines of least resistance. The curious knotted goose-neck, which occurs in other *Bon-Mots* vignettes and in *Le Morte Darthur*, ends in a peacock's head. The torso is female. The single arm ends in a calligraphic version of Beardsley's initials over three dots, somewhat after the manner of his emblem. The feet are evaded and the legs end in a treble clef on the return, and in an untranslatable shape with twisted flourishes echoing the twisted neck.

200 Vignette for p. 136 in *Bon-Mots* of Sydney Smith and R. Brinsley Sheridan, edited by Walter Jerrold and published

by J. M. Dent and Company, London, 1893. Repeated p. 113 in *Bon-Mots* of Samuel Foote and Theodore Hook 1894. Pl. 203
$2\frac{3}{4} \times 1\frac{1}{2}$ inches
Mr R. A. Harari, London

A hermaphrodite with the cut-away arms of an An torso, and with four legs ending in cloven hoofs.

201 Vignette for p. 139 in *Bon-Mots* of Sydney Smith an Brinsley Sheridan, edited by Walter Jerrold and publ by J. M. Dent and Company, London, 1893. Repeate p. 72 in *Bon-Mots* of Charles Lamb and Douglas Jerrold 1893. Pl. 199
$3\frac{7}{8} \times 2\frac{7}{8}$ inches
Mr F. J. Martin Dent, London

The showman's gesture of the pierrot was a favouri Beardsley's, the most notable example of his use of it in 'Enter Herodias' (see NO. 285).

202 Vignette for p. 147 in *Bon-Mots* of Sydney Smith an Brinsley Sheridan, edited by Walter Jerrold and publ by J. M. Dent and Company, London, 1893. Signed wit artist's emblem. Pl. 202
$3\frac{1}{2} \times 2\frac{5}{8}$ inches
Victoria and Albert Museum, London

Beardsley visited Paris in the middle of 1892 and again i middle of 1893. The first collection of *Bon-Mots* came c June 1893, so that the influence of Chéret, which is sh perhaps in the treatment of this figure, may have been ex enced during Beardsley's first visit of 1892. Con Chéret's poster 'Olympia' of that year.

203 Vignette on p. 150 (large) in *Bon-Mots* of Sydney Smith R. Brinsley Sheridan, and on p. 26 (small) in *Bon-Mo* Charles Lamb and Douglas Jerrold, both edited by W Jerrold and published by J. M. Dent and Company, Lon 1893. Pl. 201
$3\frac{15}{16} \times 3\frac{1}{2}$ inches
Grenville L. Winthrop Bequest, Fogg Art Museum, Ha University, Massachusetts

A startling allegory perhaps of Romantic Music, whereb grotesque 'notes' are bred in the mind of Woman by mental energy of Man, which fecundates her aural sen means of an ear. This is one of the most effective of Beards foetal drawings, in spite of the calligraphic flourish fo sleeve, which academic draughtsmen might deprecate.

204 Vignette on p. 157 in *Bon-Mots* of Sydney Smith an Brinsley Sheridan, edited by Walter Jerrold and publi by J. M. Dent and Company, London, 1893. Repeated 21 in a smaller version in *Bon-Mots* of Charles Lamb Douglas Jerrold, etc, 1893. Pl. 204
From the line-block

An early instance of Beardsley's manner of drawing fig which have no visible means of support—which rise o the paper like hallucinations. A similar rendering of f is to be seen in some of the illustrations to *Salome*.

205 Vignette for p. 160 in *Bon-Mots* of Sydney Smith an Brinsley Sheridan, edited by Walter Jerrold and publi by J. M. Dent and Company, London, 1893. Repeated

Bon-Mots of Samuel Foote and Theodore Hook, etc,
Pl. 205
⅜ inches
..*A. Harari, London*

...ette for p. 162 in *Bon-Mots* of Sydney Smith and R.
...ley Sheridan, edited by Walter Jerrold and published
...M. Dent and Company, London, 1893. Repeated on p.
...s full-page illustration in *Bon-Mots* of Charles Lamb
...Douglas Jerrold, etc, 1893. Signed with the artist's
...em. Pl. 209
...the line-block

...ette for p. 170 in *Bon-Mots* of Sydney Smith and R. Brin-
...Sheridan, edited by Walter Jerrold and published by
...Dent and Company, London, 1893. Pl. 208
1 13/16 inches
...*A. Harari, London*

...ette for p. 177 in *Bon-Mots* of Sydney Smith and R. Brin-
...Sheridan, edited by Walter Jerrold and published by
...Dent and Company, London, 1893. Pl. 206
...2⅝ inches
...*A. Harari, London*

...uld seem likely that this spider with a face and pince-nez,
...r like those of Toulouse-Lautrec, was suggested by
...on Redon's lithograph 'Araignée' (Mellerio, 72); see
...o. 176.

...ette for p. 181 in *Bon-Mots* of Sydney Smith and R. Brin-
...Sheridan, edited by Walter Jerrold and published by
...Dent and Company, London, 1893. Pl. 207
...1⅛ inches
...*A. Harari, London*

...ette for p. 183 in *Bon-Mots* of Sydney Smith and R. Brin-
...Sheridan, edited by Walter Jerrold and published by
...Dent and Company, London, 1893. Pl. 214
1 1/16 inches
...*ceton University Library*

...nette for p. 185 of *Bon-Mots* of Sydney Smith and R. Brin-
...Sheridan, edited by Walter Jerrold and published by
...Dent and Company, London, 1893. Pl. 213
...⅛ inches
...*ceton University Library*

...nette for p. 186 in *Bon-Mots* of Sydney Smith and R. Brin-
...Sheridan, edited by Walter Jerrold and published by
...Dent and Company, London, 1893. Repeated on p. 98
...*Bon-Mots* of Samuel Foote and Theodore Hook, etc,
...Pl. 215
...1 3/16 inches
R. *A. Harari, London*

...ariant of the obsessional foetus of 1893, this time with
...fs, hair fingers and arabesque tongue, drawn in a calli-
...hic style based on that of the seventeenth-century
...ing masters.

213 Vignette on p. 188 in *Bon-Mots* of Sydney Smith and R. Brin-sley Sheridan, edited by Walter Jerrold and published by J. M. Dent and Company, London, 1893. Repeated on p. 105 in a smaller version in *Bon-Mots* of Charles Lamb and Douglas Jerrold, etc, 1893. Signed with the artist's emblem. Pl. 216
From the line-block

The obsessional foetus has grown here into an elegant putto on the back of a Beardsleyesque cat, being offered a quill by Pierrot—for writing or drawing, or both.

214 Vignette on p. 190 in *Bon-Mots* of Sydney Smith and R. Brin-sley Sheridan, edited by Walter Jerrold and published by J. M. Dent and Company, London, 1893. Repeated on p. 145 in *Bon-Mots* of Samuel Foote and Theodore Hook, etc, 1894. Pl. 210
From the line-block

This adaptation of the form of a ragged peacock feather is a good example of Beardsley's feeling for arabesque.

215 Vignette for p. 192 in *Bon-Mots* of Sydney Smith and R. Brin-sley Sheridan, edited by Walter Jerrold and published by J. M. Dent and Company, London, 1893. Repeated on p. 171 in *Bon-Mots* of Charles Lamb and Douglas Jerrold, etc, 1893. Pl. 212
1¾ × 1¾ inches
Mr Joseph T. Butler, New York

216 Vignette on p. 23 in *Bon-Mots* of Charles Lamb and Douglas Jerrold, edited by Walter Jerrold and published by J. M. Dent and Company, London, 1893. Repeated on p. 156 in *Bon-Mots* of Samuel Foote and Theodore Hook, etc, 1894. Pl. 211
From the line-block

This was supposed to be a caricature of Max Beerbohm, the shape of whose head evoked once again Beardsley's obsession with foetuses.

217 Vignette on p. 33 in *Bon-Mots* of Charles Lamb and Douglas Jerrold, edited by Walter Jerrold and published by J. M. Dent and Company, London, 1893. Pl. 219
From the line-block

The comparatively loose touch, for Beardsley, in the handling of this figure and her clothes seems to belong more to a style of fashion-drawing of the second quarter of the twentieth century than to the Nineties.

218 Vignette on p. 39 in *Bon-Mots* of Charles Lamb and Douglas Jerrold, edited by Walter Jerrold and published by J. M. Dent and Company, London, 1893. Pl. 220
From the line-block

A rare instance in Beardsley's work of loose-line realism.

219 Vignette on p. 42 in *Bon-Mots* of Charles Lamb and Douglas Jerrold, edited by Walter Jerrold and published by J. M. Dent and Company, London, 1893. Pl. 217
From the line-block

220 Vignette on p. 48 in *Bon-Mots* of Charles Lamb and Douglas Jerrold, edited by Walter Jerrold and published by J. M. Dent and Company, London, 1893. Repeated on p. 17 in *Bon-Mots* of Samuel Foote and Theodore Hook, etc, 1894.
Pl. 221
From the line-block

221 Vignette for p. 69 in *Bon-Mots* of Charles Lamb and Douglas Jerrold, edited by Walter Jerrold and published by J. M. Dent and Company, London, 1893. Pl. 218
$3\frac{1}{16} \times 1\frac{5}{8}$ inches
Mr Brian Reade, London

An animated female lay-figure with horns in the form of an archaic symbol of her sex.

222 Vignette for p. 75 in *Bon-Mots* of Charles Lamb and Douglas Jerrold, edited by Walter Jerrold and published by J. M. Dent and Company, London, 1893. Pl. 224
$3\frac{1}{4} \times 1\frac{3}{4}$ inches
Mr R. A. Harari, London

The busy folds of cloth in the hat and cloak of the posturing actor are stylized in white lines left in reserve in the black masses—a technique unusual in Beardsley's work and suggestive of French influence.

223 Vignette for p. 81 in *Bon-Mots* of Charles Lamb and Douglas Jerrold, edited by Walter Jerrold and published by J. M. Dent and Company, London, 1893. Pl. 225
$3\frac{1}{2} \times 2$ inches
Mr R. A. Harari, London

224 Vignette for p. 90 of *Bon-Mots* of Charles Lamb and Douglas Jerrold, edited by Walter Jerrold and published by J. M. Dent and Company, London, 1893. Repeated on p. 139 of *Bon-Mots* of Samuel Foote and Theodore Hook, etc, 1894.
Pl. 223
$3\frac{3}{4} \times 2\frac{1}{4}$ inches
Mr R. A. Harari, London

225 Vignette for p. 102 in *Bon-Mots* of Charles Lamb and Douglas Jerrold, edited by Walter Jerrold and published by J. M. Dent and Company, London, 1893. Pl. 222
$3\frac{7}{16} \times 2\frac{1}{8}$ inches
Mr R. A. Harari, London

226 Vignette for p. 108 in *Bon-Mots* of Charles Lamb and Douglas Jerrold, edited by Walter Jerrold and published by J. M. Dent and Company, London, 1893. Repeated on p. 62 in *Bon-Mots* of Samuel Foote and Theodore Hook, etc, 1894.
Pl. 228
$2\frac{13}{16} \times 2\frac{1}{4}$ inches
Mr R. A. Harari, London

227 Full-page grotesque on p. 131 in *Bon-Mots* of Charles Lamb and Douglas Jerrold, edited by Walter Jerrold and published by J. M. Dent and Company, London, 1893. Repeated in a smaller version on p. 65 in *Bon-Mots* of Samuel Foote Theodore Hook, etc, 1894. Pl. 234
From the line-block

A single example of an attempt by Beardsley to draw Phil May.

228 Vignette for p. 138 in *Bon-Mots* of Charles Lamb and Dou Jerrold, edited by Walter Jerrold and published by Dent and Company, London, 1893. Pl. 227
$3\frac{9}{16} \times 2\frac{11}{16}$ inches
Mr R. A. Harari, London

229 Vignette for p. 156 in *Bon-Mots* of Charles Lamb and Dou Jerrold, edited by Walter Jerrold and published by Dent and Company, London, 1893. Repeated on a red scale on p. 22 in *Bon-Mots* of Samuel Foote and Theo Hook, etc, 1894. Pl. 226
$2\frac{13}{16} \times 1\frac{7}{16}$ inches
Mr R. A. Harari, London

This extraordinary grotesque must be unique in the his of art. It might be said to relate to certain types of sch phrenic drawing.

230 Vignette for p. 159 in *Bon-Mots* of Charles Lamb and Dou Jerrold, edited by Walter Jerrold and published by J. Dent and Company, London, 1893. Repeated on p. 7 *Bon-Mots* of Samuel Foote and Theodore Hook, etc, 1 Pl. 229
$2 \times 1\frac{3}{4}$ inches
The Drawing Shop, New York

231 Vignette for p. 187 in *Bon-Mots* of Charles Lamb and Dou Jerrold, edited by Walter Jerrold and published by J Dent and Company, London, 1893. Repeated on p. 15 *Bon-Mots* of Samuel Foote and Theodore Hook, etc, 1 Pl. 230
$3 \times 1\frac{13}{16}$ inches
Mr F. M. Gross, London

232 Grotesque accompanying half-title after the Introduct on p. 15 of *Bon-Mots* of Samuel Foote and Theodore H edited by Walter Jerrold and published by J. M. Dent Company, London, 1894. Pl. 232
From the line-block

There was another half-title for the section devoted to *bon-mots* of Hook, with the grotesque ornament at NO. The creature was a caricature of Max Beerbohm (see Her Small, 'Aubrey Beardsley', in *The Book-Buyer*, New Y February 1895).

233 Vignette on p. 19 in *Bon-Mots* of Samuel Foote and Theod Hook, edited by Walter Jerrold and published by J. M. D and Company, London, 1894. Pl. 231
From the line-block

wing for the full-page grotesque facing p. 24 in *Bon-Mots*
amuel Foote and Theodore Hook, edited by Walter
old and published by J. M. Dent and Company, London,
. Pl. 233
$1\frac{1}{4}$ inches
Drawing Shop, New York

nette for p. 31 in *Bon-Mots* of Samuel Foote and Theo-
Hook, edited by Walter Jerrold and published by J. M.
t and Company, London, 1894. Pl. 237
$2\frac{3}{8}$ inches
R. *A. Harari, London*

o of Venice. Second version of a subject drawn for the
page illustration facing p. 40 in *Bon-Mots* of Samuel
te and Theodore Hook, edited by Walter Jerrold and
lished by J. M. Dent and Company, London, 1894.
ed with the artist's names. Pl. 238
× 3 inches (on page, 9 × $5\frac{1}{2}$ inches)
william Museum, Cambridge, England

drawing was made either in or before the winter of
when Beardsley sent it to the wife of his friend Alfred
bart. Mrs Enid Lambart was asked to accept it because
disliked the artist's drawings of women. The illustration
which it was based must have been drawn before March
, when the *Bon-Mots* of Foote and Hook were published.

nette for p. 44 in *Bon-Mots* of Samuel Foote and Theodore
k, edited by Walter Jerrold and published by J. M. Dent
Company, London, 1894. Pl. 235
× $1\frac{13}{16}$ inches
oria *and Albert Museum, London*

head of the obsessional foetus is linked here to the
zed form of a skeletal old woman.

nette on p. 56 in *Bon-Mots* of Samuel Foote and Theo-
Hook, edited by Walter Jerrold and published by J. M.
t and Company, London, 1894. Pl. 242
n the line-block

interesting change-over from the head of Iokanaan.
man, or at least sterile Woman, may have the urge to
ess Man's head, cost him what it may; but Man, and
cially a man like Beardsley, has the countervailing ten-
y to have the head of Woman separated from her body
a beautiful bonnet. The drawing for this vignette be-
ed to Pickford Waller, and together with other drawings
he *Bon-Mots* series, it was sold by his daughter Miss Sybil
er through Christie, London, on 12 November 1965.
now the property of Mrs Stephanie Maison, London.
× $1\frac{3}{4}$ inches.)

wing for the full-page grotesque facing p. 58 in *Bon-Mots*
amuel Foote and Theodore Hook, edited by Walter
old and published by J. M. Dent and Company, London,
. Pl. 239
$1\frac{3}{8}$ inches
Drawing Shop, New York

captain of a Rugby football Fifteen could look more
ly gross, arrogant and dangerous.

240 Full-page grotesque on p. 74 in *Bon-Mots* of Samuel Foote
and Theodore Hook, edited by Walter Jerrold and published
by J. M. Dent and Company, London, 1894. Pl. 241
From the line-block

The irrepressible ambivalence of Beardsley's feelings toward
anything that caught his attention is shown in this apparition
of a Roman priest, in which many of the physical attributes
of a type of man who tends to this vocation are rendered so
grotesque as to seem, to the innocent beholder, malignant.

241 Vignette on p. 83 in *Bon-Mots* of Samuel Foote and Theodore
Hook, edited by Walter Jerrold and published by J. M. Dent
and Company, London, 1894. Pl. 244
From the line-block

The style of the clothes is right for the 1860s, including the
wide hat for a young girl; but not including the mahoitered
sleeves, which belong to the 1890s. The arms are drawn in
such dislocated poses that the whole figure with its shut
eyelids and bolt-upright appearance has the semblance of a
marionette. Both Beardsley and his sister Mabel had been,
from childhood upwards, interested in puppets and mario-
nettes.

242 Vignette on p. 95 in *Bon-Mots* of Samuel Foote and Theodore
Hook, edited by Walter Jerrold and published by J. M. Dent
and Company, London, 1894. Pl. 243
From the line-block

The elegance and eroticism of this figure appear now quite
out of context in late Victorian England.

243 Vignette for p. 110 in *Bon-Mots* of Samuel Foote and Theo-
dore Hook, edited by Walter Jerrold and published by J. M.
Dent and Company, London, 1894. Pl. 240
$3\frac{9}{16} \times 1\frac{9}{16}$ inches
Mr Brian Reade, London

A fantasy in the Aesthetic taste, with a parody of Whistler's
emblem.

244 Vignette for p. 133 in *Bon-Mots* of Samuel Foote and Theo-
dore Hook, edited by Walter Jerrold and published by J. M.
Dent and Company, London, 1894. Pl. 236
$2\frac{5}{8} \times 2$ inches
The Drawing Shop, New York

245 Full-page grotesque on p. 136 in *Bon-Mots* of Samuel Foote
and Theodore Hook, edited by Walter Jerrold and published
by J. M. Dent and Company, London, 1894. Pl. 245
From the line-block

Reminiscence of some poster by Chéret perhaps lies behind
the conception of this figure.

246 Vignette on p. 148 in *Bon-Mots* of Samuel Foote and Theo-
dore Hook, edited by Walter Jerrold and published by J. M.
Dent and Company, London, 1894. Pl. 246
From the line-block

A growth of female breasts on odd parts of the body, as on
the back of the head of this preposterous grotesque, was one

of the strange fantasies often expressed by Beardsley (see also NO. 189). It is foreshadowed in the breast-shapes to be found on the trees in many of the *Morte Darthur* illustrations.

247 Full-page grotesque on p. 150 in *Bon-Mots* of Samuel Foote and Theodore Hook, edited by Walter Jerrold and published by J. M. Dent and Company, London, 1894. Pl. 247
From the line-block

A Japanese man seen in a Japanese print undoubtedly, but the fine angular outlines appear to belong to some drawing from a quarter of a century later.

248 Vignette for p. 168 in *Bon-Mots* of Samuel Foote and Theodore Hook, edited by Walter Jerrold and published by J. M. Dent and Company, London, 1894. Pl. 248
$3 \times 2\frac{3}{8}$ inches
Mr F. J. Martin Dent, London

249 Drawing for the full-page grotesque on p. 171 in *Bon-Mots* of Samuel Foote and Theodore Hook, edited by Walter Jerrold and published by J. M. Dent and Company, London, 1894. Pl. 251
$7\frac{5}{8} \times 3\frac{5}{8}$ inches
Mr Brian Reade, London

The drawing has been called 'Waiting' and 'Woman at Café'. The Foote and Hook volume was the last of the little *bon-mots* books to be illustrated by Beardsley. The silhouetted form of the hat suggests that it may have been done after seeing the similar treatment of a hat and a woman in Toulouse-Lautrec's poster *Le Divan Japonais* (1892), in which however the design is quite different. Beardsley was in Paris during the middle of 1893, so that it looks as if the drawing dates from late in that year, or early in 1894. It must be the earliest, or among the very earliest, of drawings in *The Yellow Book* style.

250 Vignette on p. 186 in *Bon-Mots* of Samuel Foote and Theodore Hook, edited by Walter Jerrold and published by J. M. Dent and Company, London, 1894. Pl. 249
From the line-block

251 Vignette intended for the *Bon-Mots* series (1893–4), but not used. Pl. 250
$3\frac{1}{16} \times 1\frac{5}{8}$ inches
Princeton University Library

252 La Femme Incomprise. Reproduced as NO. 9 in *The Uncollected Work of Aubrey Beardsley*, John Lane, London, 1925. Pl. 257
From the half-tone plate

The proportions of the design and the idea of the elongated thistle suggest the influence, possibly indirect, of Carlos Schwabe, which was then appearing in *proto-art nouveau* trends. Here the artist has plagiarized his own grotesque of the one-eyed spider (? after Redon) which was drawn for p. 41 of the *Bon-Mots* of Smith and Sheridan (see NO. 176), and the Japanese woman and cat on p. 76 of the same book, published in June 1893 (see NO. 185). In spite of its many eccentricities, the drawing is evidence of a rapidly cultivated gift of abstract linear design, which happened to be briefly

descriptive and decorative, with emphasis in this cas[e] meagreness of form, on the contrast of S-shapes ag[ainst] vertical lines, and the rectangle-play so fashionable ir[] Eighties and Nineties in England, following the Aest[hetic] craze for Japanese arts and crafts.

253 Design for a book-marker, 1893. Signed with the ar[tist's] emblem. Reproduced as NO. 9 in *The Later Work of A[ubrey] Beardsley,* John Lane, 1901. Pl. 258
From the line-block

The original design once belonged to Sir William Gear[y] It was a rare example of loose, sketchy drawing in ink, none of Beardsley's customary insistence on defin[ite] Another interesting point is that it must have been draw[] memorized) from life. Perhaps the model was Mabel Be[ards]ley getting into bed. The long vertical rectangle encl[osing] the design, and echoed in the framed picture which is sh[own] on the wall, was one of the modish shapes of the Ninet[ies].

254 A Snare of Vintage, *c.* 1893. Drawing for the illustra[tion] facing p. 23 in *Lucian's True History,* translated by Fr[ances] Hickes and illustrated by William Strang, J. B. Clark[,] Aubrey Beardsley, privately printed (251 copies, 4to[) by] Lawrence and Bullen, London, December 1894. Pl. 252
$7\frac{5}{8} \times 5\frac{1}{2}$ inches
Graphische Sammlung Albertina, Vienna

A fake of this drawing is reproduced for compariso[n in] R. A. Walker's *How to Detect Beardsley Forgeries,* Bedf[ord] 1950, pl. V. On about 15 February 1893, Beardsley wro[te in] bed to his old school-fellow, G. F. Scotson-Clark, about [how] he had been thriving. 'Better than the Morte darthur[,]' he observed, 'is the book that Lawrence and Bullen [have] given me, the "Vera Historia" of Lucian. I am illustra[ting] this entirely in my new manner, or, rather, a developme[nt of] it. The drawings are most certainly the most extraordi[nary] things that have ever appeared in a book both in respe[ct of] technique and conception. They are also the most inde[cent.] I have 30 little drawings to do for it 6 inches by 4. L a[nd B] give me £100 for the work. Dent is giving me £250 fo[r the] Morte.' As he got deeper into 1893 however Beardsley fo[und] himself busy on *Salome* and then at the beginning of 189[4 on] *The Yellow Book,* and the Lucian commitments were neg[lect]ed. When the *True History* was published at the end of 1[894] there were only two illustrations by him in it, the rest b[eing] by the other artists mentioned above.

255 A Snare of Vintage. Proof of a first version of the subje[ct of] the plate facing p. 23 in *Lucian's True History,* translate[d by] Frances Hickes, illustrated by William Strang, J. B. C[lark] and Aubrey Beardsley, with an introduction by Ch[arles] Whibley, privately printed (251 copies, 4to) by Lawrence [and] Bullen, London. December 1894. Not used. Pl. 253
From the line-block, $6\frac{1}{8} \times 4\frac{1}{4}$ inches
Mr W. G. Good, England

Although this version of 'A Snare of Vintage' was not u[sed] a line-block existed, from which the proof was ta[ken.] Platinotype copies of the design were made by F. H. E[vans] however and inserted in 54 copies of the book printe[d on] Japanese vellum. Beardsley wrote to his form-master A[. W.] King, on 9 December 1892, telling him that Lawrence [and] Bullen had given him 'Lucian's Comic Voyage' to illust[rate]

the majority of the illustrations were by Strang and
k; only three by Beardsley seem to have been actually
ed with the book, this one resembling in style another
entitled 'Dreams', facing p. 209 (see NO. 256). Two more
e rejected altogether (see NOS. 257, 258). This design is
arkable for the curious web-like lines that link up the
ns, and for the fantastic ornamental hair that grows on
bodies of the creatures. It illustrates the passage in
kes's translation where the travellers came among a
ld of vines 'which towards the earth had firm stocks . . .
the tops of them were women from the hip upwards . . .
heir fingers' ends sprung out branches full of grapes
They also kissed us with their mouths, but he that was so
ed fell drunk . . . Some of them desired to have carnal
ture with us, and two of our company were so bold as to
rtain their offer, and could never afterwards be loosed
n them . . . and their fingers began to spring out with
nches and crooked wires as if they were ready to bring
fruit.'

ams. Drawing for illustration, facing p. 209 of *Lucian's
e History,* translated by Francis Hickes, illustrated by
liam Strang, J. B. Clark and Aubrey Beardsley, privately
ted (251 copies, 4to) by Lawrence and Bullen, London,
:ember 1894. Pl. 254
× 4⅜ inches
ield Thayer Collection, Fogg Art Museum, Harvard Univer-
, Massachusetts

cian's Strange Creatures. Illustration intended for *Lucian's
e History,* published by Lawrence and Bullen, London,
cember 1894, 4to. Not used, but published in *An Issue
Five Drawings Illustrative of Juvenal and Lucian* (120 sets)
lished by Leonard Smithers, London, 1906. Pl. 256
m the line-block, 9 × 5 inches
W. G. Good, England

is illustration and the one reproduced at NO. 258 were
cted from the 1894 and 1902 editions of *Lucian's True
tory.* Among the strange creatures is a caricature of Oscar
de.

th from the Calf of the Leg. Illustration intended for
cian's True History, published by Lawrence and Bullen,
ndon, 1894, 4to. Not used, but published in *An Issue of
e Drawings Illustrative of Juvenal and Lucian* (120 sets) by
nard Smithers, London, 1906. Pl. 255
m the line-block, 9 × 5 inches
W. G. Good, England

is illustration and the one reproduced at NO. 257 were
ected from the 1894 and 1902 editions of *Lucian's True
tory.* At the time when it was drawn the artist was obsessed
foetuses and irregular births; creatures derived from the
tus form occur in the *Bon-Mots* series, in *The Kiss of Judas,
Salome* and elsewhere. That he chose to illustrate this sub-
t suggests that there may have been a latent strain of homo-
uality in Beardsley. Lucian describes in his *True History*
way in which children are born in the kingdom of
dymion on the Moon. 'They are not begotten of women,
of mankind: for they have no other marriage but
males: the name of woman is wholly unknown among
m: until they accomplish the age of five and twenty

years, they are given in marriage to others: from that
time forwards they take others in marriage to themselves:
for as soon as the infant is conceived the leg begins to swell,
and afterwards when the time of birth is come, they give it a
lance and take it out dead: then they lay it abroad with open
mouth towards the wind, and so it takes life: and I think
thereof the Grecians call it the belly of the leg, because there-
in they bear their children instead of a belly'. Lucian also
explains that 'their boys admit copulation, not like unto ours,
but in their hams, a little above the calf of the leg for there
they are open'. (1902 ed. pp. 30–32.)

259 *The Studio,* Vol. I, NO. 1, April 1893. Original wrapper printed
in line-block and letterpress on dark green paper, 4to. Pl. 264
Mr W. G. Good, England

The first number of a new art magazine, *The Studio,* was
planned towards the end of 1892, with C. Lewis Hind as
editor. Hind met Beardsley at Mrs Alice Meynell's during
this period, and he was so impressed by some drawings he
saw in the young artist's portfolio that he commissioned
Joseph Pennell to write for the first number of *The Studio* an
article on Beardsley to be illustrated by a selection from
Beardsley's own work to date. Beardsley was also asked to
design the first wrapper of the magazine. The design for *The
Studio* poster was similar but on a larger scale.

260 The Birthday of Madame Cigale. Drawing reproduced in *The
Studio,* NO. 1, April 1893, p. 15. Pl. 259
Pen, ink and wash, 9¾ × 15⅛ inches
*Grenville L. Winthrop Bequest, Fogg Art Museum, Harvard
University, Massachusetts*

The word 'cigale' means cicada. Could Beardsley have come
across the French book *La Cigale,* a symposium of verse and
prose and musical compositions by various hands, published
in Paris in 1889? He could, but it seems we may never know.
The design is composite, containing one almost identical
Bon-Mots figure, the boy with the slippers (see NO. 178). The
two figures behind him are variations respectively on the
right-hand figure in the *Bon-Mots* of Foote and Hook, p. 17
(the man with a hat and cane) and a vignette on p. 174 of the
same book (the man with flowers, see NO. 177); while the
fantastic birds on the base-line are related to the one in 'King
Arthur and the Questing Beast' (NO. 56), which is dated
8 March 1893. A similar Moorish table supports the youth in
the rejected 'Toilet' of Salome, which was done later, and in
the design for a book-marker (NO. 253) which may have been
done at about the same time. Wispy lines, like the ones stray-
ing in the foreground and the background without any
descriptive function, seem to have been compulsive for
Beardsley at this date: his last and most assertive use of them
being in his design for the front cover of Dowson's *Verses,*
1896 (NO. 457). Parallel wavy lines occur on the screen-like
background in the Japanese manner and bring the whole
composition into line with the Aesthetic productions in
ceramics and lacquer of the 1870s and 1880s. It will be seen
here that Beardsley's contribution to the decline of this
decorative style was to render it grotesque. The well-drawn
flight of birds in the distance expresses a motif that Beardsley
later reduced to a mere arc of V-shapes (NO. 421).

261 J'ai Baisé Ta Bouche Iokanaan. Salome with the head of
John the Baptist. Published in *The Studio,* Vol. I, p. 19, April

1893. Signed with the artist's names and with his emblem. Lettered with title. Pl 272
Indian ink and green water-colour wash, $10\frac{15}{16} \times 5\frac{13}{16}$ inches
Princeton University Library

The green water-colour washes were added after 1893. The drawing in its former black-and-white state featured among others reproduced alongside an article by Joseph Pennell, 'A New Illustrator: Aubrey Beardsley', in the first number of *The Studio*. John Lane's attention having been drawn to this interpretation of a passage in Oscar Wilde's play *Salome*, Beardsley was commissioned by him soon afterwards to illustrate the translation of *Salome* (originally written in French) which Elkin Mathews and Lane published the following year. Later when it came to illustrating the same theme for the book of 1894 (NO. 286), Beardsley improved upon this version and cut out the *Bon-Mots* hair-line flourishes. However, the lilies growing from the pool of blood remained in the later drawing, though they were more tactfully treated. Many of those who opened the first number of *The Studio* must have been sickened by this detail, and it is the outstanding instance of sensationalism in Beardsley's work. At the same time if we dismiss it as purely sensational we should be sharing certain conventions of taste held by the late Victorians, and this would be unreasonable once we see that Beardsley's compulsion to describe such a thought is some rough measure of the strength of the compulsion in him to convert excruciation into a kind of macabre comedy, by way of stylization. There are links between the lilies and the ulcers in NO. 189 and NO. 466, and indeed with everything that is perverse in Beardsley's art. What were the traumatic experiences behind that compulsion? Whatever they were, Beardsley was evidently determined to face the consequences of them, not only in his grotesque drawings, but in his equally grotesque romance *Venus and Tannhäuser*.

262 Of a Neophyte and how the Black Art was revealed unto him by the Fiend Asomuel. Illustration to 'The Black Art', Part II, by James Mew, facing p. 177 of *The Pall Mall Magazine*, Vol. I, June 1893, 8vo. Lettered with title. Pl. 260
From the line-block
Mr W. G. Good, England

The artist invented the name Asomuel, meaning insomnia, for the purpose of this illustration, which was a facetious comment on the article that accompanied it.

263 The Kiss of Judas. Drawing for the plate prefixed to the story 'A Kiss of Judas' by 'X. L.' in *The Pall Mall Magazine*, July 1893, pp. 339–366, 8vo. Signed with the artist's emblem and inscribed with title. Pl. 261
$12\frac{1}{4} \times 8\frac{5}{8}$ inches
Mr R. A. Harari, London

The skilful balance of components in this design can be compared with that of 'A Platonic Lament' (NO. 284) in the illustrations to *Salome*, which however were not published until 1894. There are similar and unusual vertical espaliers in both compositions. They were probably conceived at the same period in 1893, the magazine illustrations being published well ahead of the *Salome* series. About the same time too there must have been drawn the design for the heading of Chapter VI, Book XVII (p. 789 of Vol. II) in *Le Morte Darthur*, which appeared in Part X: in this the forms of the female head and the trees behind

are similar, though less carefully drawn. Indeed quality of the lines in 'The Kiss of Judas' is as high Beardsley ever achieved. The curious brevities, as in simple curve of the woman's arms, and the delicate sugges of shadows in the thickening of the lines describing her are among its many perfections. As to 'The Kiss of Jud '"It's a Moldavian legend"', observed the "great speciali in the story by 'X. L.' (p. 350). '"They say that childre Judas, lineal descendants of the arch traitor, are prow about the world seeking to do harm, and that they kill with a kiss."'
'"Oh how delightful", murmured the Dowager Duchess

264 Design for the frontispiece (The Landslide) to *Pastor S the drama of *Over Aevne* by Bjørnstjerne Bjørnson, transl from the Norwegian by William Wilson, published Longmans, Green and Company, London and New Y October 1893, 8vo. Signed with monogram. Pl. 263
$9\frac{1}{2} \times 6\frac{3}{4}$ inches
Mr F. J. Martin Dent, London

In the monogram and in the Teutonic landscape Beard has imitated Dürer. William Wilson was the pseudony More Adey, one of Beardsley's early London friends; al friend of Robert Ross and Oscar Wilde.

265 Réjane. Profile to left. Signed with the artist's emblem dated in pencil 1893. Pl. 265
Indian ink, red chalk and pencil, $7\frac{5}{8} \times 6\frac{1}{16}$ inches
Mr Ewan Phillips, London

An excursion into the art of rubbed drawing with red ch which Beardsley otherwise did not practise. The resu not technically impressive because he had little experie of how to get the best from this medium. It seems proba that the drawing was meant to be a careful study of Réja profile, made from the life, and that it may have been refer to both for the drawing of Réjane reclining on a divan wh is now in the Metropolitan Museum in New York (see 327) and for the *Yellow Book* drawing (NO. 359). Formerl the collection of Beardsley's friend Frederick H. Evans, present study passed after his death through the salero into a French collection, from which it came to the art mar in 1967.

266 Réjane. Portrait of Madame Réjane, the actress, holdin fan, half-length. Pl. 266
From the line-block

This portrait was published on p. 95 in *A Second Book Fifty Drawings by Aubrey Beardsley*, Smithers, London, 18 where it is stated that it was drawn in 1893 and was hithe unpublished.

267 Design for the frontispiece to large paper copies of *Wonderful History of Virgilius the Sorcerer of Rome*, publish by David Nutt, London, 1893, 8vo. Signed with the artis emblem. Pl. 262
$9 \times 5\frac{1}{2}$ inches
The Art Institute of Chicago

The placing of the figure of the sorcerer, which is comp sated by the movements implied by his gestures, shows

ience of Japanese prints, from which Beardsley learnt
the flat treatment of patterns on garments, as here.

book was issued in January 1894. The drawing was
rred to by the artist in a letter of (?) November 1893, to
ert Ross.

ign for the title-page to *Pagan Papers* by Kenneth
hame, published by Elkin Mathews and John Lane,
don, December 1893, 8vo. Pl. 267
5¼ inches
R. A. Harari, London

book bears the date 1894 on the title-page and at the
of the spine.

pit Vita Nova, c. 1893. Pl. 273
an ink and chinese white over pencil on brown paper,
× 7¹³⁄₁₆ inches
Nicholas Pickard, Kansas City, USA

foetus with the hydrocephalous head might be said to
esent Beardsley's own generation. Chapter-heading II,
k V (p. 157 of Vol. I) in *Le Morte Darthur* incorporates
he design the same title of Dante's prose masterpiece
re Begins a New Life), and was made probably at about
same time as this drawing. The style here has something
he stylized economies of form and tone that signalize the
nouveau designs of such artists as Behrens, dating from
in the 1890s.

drawings on the front cover of Beardsley's copy of the
al score of *Tristan und Isolde, c.* 1893–4. Pl. 268
an ink and chinese white on brown paper, 10¾ × 6¹⁵⁄₁₆
es
ceton University Library

copy of the vocal score is in the Gallatin Collection in
ceton University Library. This is an unusual drawing for
rdsley. The home-made lettering is beautifully worked
e free style of many years later, and the broad treatment
he bisected seed is handled with a looser touch than was
l with him. The strange hybrid clematis-passion flowers,
ch haunt the designs for *Le Morte Darthur,* appear again
very appropriately.

er sides, front and back, of The Playgoers' Club Menu
heir tenth annual dinner, London, 28 January 1894.
69
-block, half-tone and letterpress
ceton University Library

carnival costumes are still influenced by Japanese
ular art, and a Japanese lantern of the kind that attracted
rdsley, according to Gleeson White in his article 'Aubrey
rdsley: In Memoriam' (*The Studio,* May 1898, p. 256)
ars on the back of the menu. The inset photographs
ide one of Carl Hentschel as Honorary Treasurer of the
. This man was head of the firm of process-engravers
ch reproduced most of Beardsley's drawings until he
ked for *The Savoy.* Hentschel's initials, followed by the
rs *sc.* for 'sculpsit', will be found in many of the line-
ks by his firm.

ign for the front cover of *Salome* by Oscar Wilde. Not

used for the edition of *Salome* of 1894 but reproduced as Plate III in *A Portfolio of Aubrey Beardsley's Drawings Illustrating 'Salome' by Oscar Wilde,* published by John Lane, London, N. D. [1907]. Signed in the design with the artist's emblem. Pl. 270
From the half-tone plate
Mr Brian Reade, London

Nothing could be more evocative of the late Aesthetic or *fin de siècle* period than these serpentine peacock feathers growing out of a 'Japonesque' ground. An all-over pattern for the cover was rejected for a simpler design (see NO. 273).

273 Front cover of *Salome.* A tragedy in one act, translated [by Lord Alfred Douglas] from the French of Oscar Wilde, pictured by Aubrey Beardsley and published by Elkin Mathews and John Lane, London; Copeland and Day, Boston, March 1894. Edition de luxe limited to 100 copies for England and bound in green silk with covers and spine stamped in gold, 4to. Pl. 271
Stamped design
Mr R. A. Harari, London

The neat interruption of a tendency to symmetry by the placing of the roses and the inner leaves is characteristic of Beardsley. The diagram roses, with petals something like the scale-shapes he adapted from Whistler's peacock-feathers at 49 Prince's Gate were to become familiar in *art nouveau* decorations in all media.

274– *Salome.* Drawings for illustrations to *Salome,* translated from
83 the French of Oscar Wilde, [by Lord Alfred Douglas], pictured by Aubrey Beardsley, and published by Elkin Mathews and John Lane, London; Copeland and Day, Boston, March 1894, 4to. All signed with the artist's emblem.

274 Title-page. Pl. 274
8¾ × 6½ inches
Grenville L. Winthrop Bequest, Fogg Art Museum, Harvard University, Massachusetts

275 The Woman in the Moon (frontispiece). Pl. 275
8¾ × 6⅛ inches
Grenville L. Winthrop Bequest, Fogg Art Museum, Harvard University, Massachusetts

276 Border for the List of Pictures. Pl. 276
9¼ × 7¾ inches
Grenville L. Winthrop Bequest, Fogg Art Museum, Harvard University, Massachusetts

277 The Peacock Skirt. Drawing for the illustration facing p. 2. Pl. 277
8⅞ × 6¼ inches
Grenville L. Winthrop Bequest, Fogg Art Museum, Harvard University, Massachusetts

278 The Black Cape. Drawing for the illustration facing p. 8. Pl. 278
8¹³⁄₁₆ × 6¼ inches
Princeton University Library

279 The Eyes of Herod. Drawing for the illustration facing p. 32. Pl. 279
8¾ × 6⅞ inches
Grenville L. Winthrop Bequest, Fogg Art Museum, Harvard University, Massachusetts

280 The Stomach Dance. Drawing for the illustration facing p. 40.
Pl. 280
$8\frac{3}{4} \times 6\frac{7}{8}$ inches
Grenville L. Winthrop Bequest, Fogg Art Museum, Harvard University, Massachusetts

281 The Toilet of Salome. Drawing for the illustration facing p. 48. Pl. 281
$8\frac{13}{16} \times 6\frac{5}{16}$ inches
British Museum

282 The Dancer's Reward. Drawing for the illustration facing p. 56. Pl. 282
$8\frac{3}{4} \times 6\frac{1}{4}$ inches
Grenville L. Winthrop Bequest, Fogg Art Museum, Harvard University, Massachusetts

283 The Burial of Salome (cul-de-lampe). Pl. 283
$6\frac{7}{16} \times 6\frac{3}{4}$ inches
Grenville L. Winthrop Bequest, Fogg Art Museum, Harvard University, Massachusetts

These ten drawings were all reproduced by the line-block craftsman, Carl Hentschel, in the 1894 book. In the published title the male organs were deleted. The 'Toilet' was a second version of the subject, in contemporary clothes, replacing the original composition reproduced at NO. 287. The drawings for 'A Platonic Lament', 'Enter Herodias' and 'The Climax' are not available for reproduction, but the line-blocks after them published in 1907 are at NOS. 284, 285 and 286. 'John and Salome' and 'Salome on Settle' (otherwise called 'La Maîtresse d'Orchestre') were not published in the 1894 book but were included in the 1907 portfolio of reproductions on the same scale as the original drawings.

The *Salome* illustrations have had such a great influence on *art nouveau* design, and have remained so well-known since 1894, that comment on them is almost superfluous. In the minds of many people they represent the whole ethos of Beardsley's art, though in fact they date from before the *Yellow Book* period and are strictly the last of his early works. The dramatic force, the sense of abstraction, and the bold elimination of supporting descriptive details were all Beardsley's own and unmatched in the black-and-white medium before, or since. Such features as the crossing of the lines of the skirt in the frontispiece, and a related self-sufficient form in 'The Toilet' (second version); the plethora of roses and the head of rose-hair in the border for the list of pictures; the brilliant adaptation of Whistler's feather-motifs from The Peacock Room and the trailing and arabesque lines of ragged feathers in 'The Peacock Skirt'; the outswung cloak in 'The Stomach Dance'; the white lines in reserve of the almost early-Greek cloak of Salome in 'The Dancer's Reward', and the sensational executioner's arm; the drawing of the powder-box and puff in the cul-de-lampe;—these are all features that have kept their old power to amaze. The quality of the drawn lines, though much praised by favourable critics in the Nineties, and later, seems, in some cases, as in 'The Stomach Dance', to be rather hesitant, and has not the assurance either of *The Yellow Book* drawings or those for *The Rape of the Lock* and for later works. But the conceptions immortalize in fact those strains in the play which the author shared unconsciously with its illustrator. Wilde disliked them possibly because they did just this, and also because they conveyed what Beardsley could seldom repress, an ironical comment on the text. That Wilde was caricatured mildly in the frontispiece, in 'A Platonic Lament', in 'Enter Herodias' and in 'The Eyes of Herod', doubtless annoyed him, but Beardsley had a habit of caricaturing his friends and acquaintances without malice. And the notion that he satirized the play and desp[ised?] Wilde at the date of these drawings cannot be confirme[d] especially as his earlier and gratuitous illustration to 'baisé ta bouche Iokanaan' (which obtained for him [a] commission from Lane to illustrate the 1894 book) sh[ows] that originally he was fascinated by it. Also it should n[ot] be forgotten that he offered Wilde a translation of *Sa[lome]* which was rejected in favour of another one by Lord Al[fred] Douglas. For differing reasons, therefore, the illustrat[ion] caused a rift in the association between Wilde and Beards[ley,] an association which developed otherwise than it might h[ave] done. The effect of Wilde's trial on Beardsley's life and [the] jealous influence of Raffalovich later strengthened [the] alienation from the author whose play contributed in [part] to Beardsley's wide renown.

284 A Platonic Lament. Reproduction of illustration to fac[ing p.] 16 in *Salome,* translated from the French of Oscar W[ilde] [by Lord Alfred Douglas], pictured by Aubrey Beards[ley] and published by Elkin Mathews and John Lane, Lond[on;] Copeland and Day, Boston, 1894. 4to. Signed with [the] artist's emblem. NO. VII in *A Portfolio of Aubrey Beards[ley]* *Drawings illustrating 'Salome' by Oscar Wilde,* published [by] John Lane, London [1907]. Second issue. Pl. 284
From the line-block

Mr Brian Reade, London

The observation and skill required to draw this illustra[tion] were not stupendous. None the less its imagery is remark[able] by virtue of qualities that the technological bias of late n[ine-] teenth- and twentieth-century aesthetic criticism has avoi[ded] and they still need to be referred to as qualities of the Imag[ina-] tion. But to invest imagination of this sort takes cour[age,] the courage of deliberation, which itself becomes a f[ore-] ground to the work of art. The illustration shows the p[age] of Herodias lamenting over the corpse of his friend the Yo[ung] Syrian Captain, who was so infatuated by Salome that [he] killed himself when she discovered her passion for John [the] Baptist. The face of Wilde in the Moon is partly conceale[d by] a narrow cloud in a sky of empty white paper. The clas[h of] near-abstract forms, of topiary tree, of roses on espaliers[, of] leaning youth, and of the body at full length lying crossw[ise] in front of all the rest, has in it the seeds of the invention[s of] Kandinsky, Picasso, Mondrian and many others to co[me] who were to reduce the content of their art to studio ar[range-] ments. This illustration was also seminal at shorter rang[e in] the *art nouveau* of the Glasgow School, and in England, Eur[ope] and the United States.

285 Enter Herodias. Proof of the first state of an illustra[tion] facing p. 24 in *Salome,* translated from the French of O[scar] Wilde [by Lord Alfred Douglas], pictured by Aubrey Bea[rds-] ley, and published by Elkin Mathews and John L[ane,] London; Copeland and Day, Boston, 1894. 4to. Signed w[ith] the artist's emblem. Inscribed in ink:

> 'Alfred Lambart from Aubrey Beardsley.
> Because one figure was undressed
> This little drawing was suppressed
> It was unkind—
> But never mind
> Perhaps it all was for the best.'

m the line-block, $7 \times 5\frac{1}{16}$ inches. Pl. 285
ceton University Library

he second state of this illustration a fig-leaf was shown
on to the male figure in the background: this was the
e printed in the edition of *Salome* published by Mathews
Lane in 1894; and it left part of the meaning of the
stration obscure. For the leaf concealed the point that
youth with the powder-puff, who has removed his mask,
ot excited by Herodias and possibly not by women at all;
ike the infantile monster opposite, whose excitement is
ered by his clothing and whose hydrocephalous expres-
1 is fated to be lustful.

he erotic theme is carried into the pun on the fantastic
:kets, or ancient candlesticks, either side of a creature
ed possibly from a similar one in Rodolphe Bresdin's
ograph 'La Comédie de la Mort', 1854), whose horns
line a female symbol. Meanwhile in the corner, wearing
owl-cap of a mage and holding his prompt copy of the
y, together with the caduceus of a physician, Oscar
lde introduces the scene with the gesture of a showman;
ough his caduceus is also a crutch, because he leans on a
pel of 'curing the senses by means of the soul, and the
l by means of the senses'.

A proof similar to the one above was stated by A. E.
latin to have been inscribed for Frank Harris (*Aubrey
rdsley, Catalogue of Drawings etc.*, 1945, p. 47).

Climax. Reproduction of illustration to face p. 64 in
me, translated from the French of Oscar Wilde [by Lord
red Douglas], pictured by Aubrey Beardsley, and pub-
ed by Elkin Mathews and John Lane, London; Copeland
Day, Boston, 1894. 4to. Signed with the artist's emblem.
XV in *A Portfolio of Aubrey Beardsley,s Drawings Illus-
ing 'Salome' by Oscar Wilde*, published by John Lane,
adon [1907]. Second issue. Pl. 286
m the line-block

Brian Reade, London

s marks a stage in Beardsley's development. The design
ased on that of 'J'ai Baisé Ta Bouche Iokanaan', published
he first number of *The Studio* in April 1893. But the hair-
flourishes in the former drawing have been decisively
ndoned and Beardsley never reverted to this type of
asy (see NO. 261). The lines throughout are firmer, and
curves more rationalized: the cloud-forms at the top left
derived from the short feathers of Whistler's peacocks in
room at 49 Prince's Gate, which Beardsley saw in 1891.
thick, falling blood seems rather to rise upwards, solid
hostile: it helps to link the black ground, which also
ves upward oppressively, with the white area in which
ome kneels. Beardsley's evasions of the left foot and left
d of the princess are characteristic. By such means he
ided what to him was unnecessary in the forcible repre-
tation of an action or a gesture. The lilies growing in the
l of blood symbolize the chastity of John the Baptist.

Toilet of Salome. First version. Intended for illustration
alome, translated from the French of Oscar Wilde [by
d Alfred Douglas] and published by Elkin Mathews and
n Lane, London; Copeland and Day, Boston, 1894. 4to.

Not used. Signed with the artist's emblem. Pl. 287
Indian ink over pencil, $9 \times 6\frac{3}{8}$ inches
Mr Edward James Matthews, New York

This drawing was supplied by Beardsley as one of the illus-
trations to the text of the English translation of *Salome*
published by Elkin Matthews and John Lane in 1894. It was
rejected however on account of the seated youth, and Beards-
ley produced another version of the subject with Salome in
contemporary clothes, which was published in the book (see
NO. 281).

The drawing was given to the present owner by Mr Jim
Barney, before the 1939 War.

288 The Toilet of Salome. Working proof of a line-block made
for illustration to *Salome* by Oscar Wilde, published by Elkin
Mathews and John Lane, London, 1894. 4to. Signed with
the artist's emblem. This version of the subject was replaced
by that at NO. 281. Pl. 288
From the line-block

Mr W. G. Good, England

The drawings illustrating *Salome* contained several erotic
details, some of which were more than Mathews and Lane
could let pass for publication. The bent spine of the youth
sitting on the Moorish stool is intended to convey that in
accordance with Victorian beliefs he has been indulging in
auto-erotism, and he is shown practising this art as he gazes
at the boy with the coffee tray. This was too much for the
publishers, and it is quite likely that the proof was one of
those taken in 1894 and which enabled them to judge and to
discard this block and to require that Beardsley should make
another version of 'The Toilet', in fact the one which was
published in the 1894 volume. The extra black masses show
where the background had not been removed from the
block. Remarkable features of the design are the frail, black
dressing-table in the Aesthetic style of furniture designed by
the architect E. W. Godwin, and the form of Salome in which
all the details that would have gone to complete its definition
in the literal sense, legs, chair, bottom edge of the cloak, are
dispensed with, and there is only a linear evocation of essen-
tials. In *The Early Work of Aubrey Beardsley*, first published
by Lane in 1899, this block was used, but the pubic hair and
turgescent penis of the sitting youth were removed. In Lane's
Portfolio of Aubrey Beardsley's Drawings Illustrating 'Salome',
where all the line-blocks are approximately the same size as
the original drawings, a larger version of this illustration,
unexpurgated, was published.

289 Salome on Settle,. or Maîtresse d'Orchestre. Signed, in the
pleat lines of the upholstery, with the artist's emblem. NO.
XVI in *A Portfolio of Aubrey Beardsley's Drawings Illustrating
'Salome' by Oscar Wilde*, published by John Lane, London
[1907]. Second issue. Pl. 289
From the line-block
Mr Brian Reade, London

This drawing has no reference to any passage in the play,
Salome, and was a larger version of a grotesque on p. 53 of
Bon-Mots of Foote and Hook, London, 1894. The debt to
Japanese print-makers in general should be clear enough,
even to the back-view of a figure, which has a slight element
of novelty. The drawing was not published in the 1894
volume, possibly because the baton could be interpreted as
a dildo; and it first appeared in line-block facsimile as plate
XVI in the *Salome* portfolio of 1907 published by Lane.

290 John and Salome. Signed with the artist's emblem. NO. VIII in *A Portfolio of Aubrey Beardsley's Drawings Illustrating 'Salome' by Oscar Wilde,* published by John Lane, London, [1907]. Second issue. Pl. 290
From the line-block
Mr Brian Reade, London

Although this is one of the most powerful of the *Salome* illustrations it was excluded from the 1894 volume and was first published as Plate VIII in the *Salome* portfolio of 1907.

It is difficult to analyse a drawing in which every detail contributes so forcibly to the subject of tension between the yearning Salome on the right and the resistant John the Baptist on the left—in whom something nevertheless responds to the princess. Here and there the lines in the background run through the figure of John as if his thinness was near to transparency. A bentwood rose-bush with geometrical roses is the prototype of much *art nouveau* decoration. And rising up from the bottom edge of the paper, like apparitions, the figures of John and Salome are distracted by sharp masses of black abstracted from the rational forms of their garments.

291 Music. Headpiece in the periodical *St Paul's,* Vol. I, NO. I, March 1894. Reproduced as NO. 95 in *The Early Work of Aubrey Beardsley,* John Lane, London, 1899. Pl. 292
From the line-block

292 Design for a headpiece in the periodical *St Paul's,* Vol. I, NO. I, March 1894. Signed with the artist's emblem. Pl. 294
$4\frac{3}{4} \times 4\frac{1}{4}$ inches
Graphische Sammlung Albertina, Vienna

The foetus was deleted from the reproduction of this drawing in *St Paul's* and in Plate 96 of *The Early Work of Aubrey Beardsley,* John Lane, 1899.

293 The Man that holds the Watering Pot. Design for a tailpiece in the periodical *St Paul's,* Vol. I, NO. I, March 1894. Signed with the artist's emblem. Pl. 293
$3\frac{5}{8} \times 5$ inches
Graphische Sammlung Albertina, Vienna

This drawing was reproduced at an eccentric angle in Plate 94 of *The Early Work of Aubrey Beardsley,* John Lane, 1899.

294 Pierrot and cat. Headpiece in the periodical *St Paul's,* 20 July 1895. Pl. 291
From the line-block
Mr W. G. Good, England

With Beardsley the dramatic value of the silhouette had priority over descriptive logic: thus the cat has only two legs visible. Like all the four drawings Beardsley made for *St Paul's,* this one was done late in 1893, but not used until eighteen months later than the rest.

295 Design for the front cover and title-page of *Keynotes* by George Egerton (Mrs Chavelita Dunne Bright), published by Elkin Mathews and John Lane, London, and by Roberts Brothers, Boston, December 1893 (Vol. I in the *Keynotes* series). Signed with the artist's emblem. Pl. 295
$9\frac{9}{16} \times 6\frac{1}{4}$ inches
Princeton University Library

The blank panel contained the letterpress of the title etc the title-page the panel is smaller and in the line-block right-hand kite flies outside it.

296 Title-page of *The Dancing Faun,* by Florence Farr, Vol. the *Keynotes* series, published by Elkin Mathews and J Lane, London, and Roberts Brothers, Boston, June 1 Pl. 298
Crown 8vo.
From line-block and letterpress, with title in red
Mr W. G. Good, England

The standard lamp, in a form typical of the Nineties attenuated to the consistency of wire. The high picture of the late Victorians comes in as a black bar. The faun on a daintified Regency sofa wearing the hair and the mon of Whistler, and Whistler's patent shoes, with black b The novel is a light-hearted affair and has nothing to do Whistler; Florence Farr was more interested in Berr Shaw. The layout of the title-page is an expression Beardsley's taste for one-sidedness in design and in respect follows the posters by him. The second and t volumes in the *Keynotes* series had title-pages and front co following the same layouts, with panels on the left. remainder of the series had panels of ornament below titles (see NOS. 298–312 and 315, 316).

297 Title-page of *Poor Folk* translated from the Russian o Dostoievsky by Lena Milman, etc, Vol. III in the *Key* series published by Elkin Mathews and John Lane, Lond and Robert Brothers, Boston, June, 1894. Crown Pl. 299
From the line-block and letterpress
Mr Brian Reade, London

The girl's white silhouette was probably a new versio contemporary clothes of the mediaeval-looking maide the heading of Chapter VI, Book XV (p. 749 of Vol. II *Le Morte Darthur.* Possibly behind both was a remembra of the picture 'Vespertina Quies' by Burne-Jones (18 This panel, with the stately drainpipe and beautifully plar lines and masses, is one of the best of Beardsley's sma designs.

298 Title-page of *A Child of the Age* by Francis Adams, Vo in the *Keynotes* series published by John Lane, London, Roberts Brothers, Boston, November 1894. Crown Pl. 300
From the line-block and letterpress
Mr Brian Reade, London

Francis Adams (1862–1893) spent a number of year Australia working on the staff of *The Sydney Bulletin.* suffered from tuberculosis and became so depressed he committed suicide at Margate just over one year be this mysterious novel was published. Beardsley's desig the bottom panel, like so many of his *Keynotes* designs, near-symmetry, or rather symmetry contradicted by a small details.

299 Design for the front cover and title-page of *The Great Pan and The Inmost Light* by Arthur Machen, Vol. V in *Keynotes* series published by John Lane, London, and

erts Brothers, Boston, December 1894. Crown 8vo.
,01
× 4¹¹⁄₁₆ inches
nceton University Library

inished and unused design for the title-page and front
er of *The Great God Pan and the Inmost Light* by Arthur
chen, Vol. V in the *Keynotes* series published by John Lane,
ndon, and Roberts Brothers, Boston, December 1894.
wn 8vo. On the back is the completed design which was
d (see NO. 299). Inscribed variously in pen and pencil.
302
lian ink over pencil, 8 × 4 inches
nceton University Library

s provides evidence that Beardsley completed his borders
nk before coming to grips with the design within them.
lure in the drawing of the horned head of Pan in this case
y have been one reason for abandoning the design.

sign for the front cover and title-page of *Discords* by
orge Egerton (Mrs Chavelita Dunne Bright), Vol. VI in
Keynotes series published by John Lane, London, and
Robert Brothers, Boston, December 1894. Crown 8vo.
303
× 4¾ inches
nceton University Library

sign for the front cover and title-page of *Grey Roses* by
nry Harland, Vol. X in the *Keynotes* series published by
n Lane, London, and Roberts Brothers, Boston, May
5. Crown 8vo. Pl. 304
× 4½ inches
nceton University Library

lume X of the *Keynotes* series, a group of stories by Harland,
d been advertised as *The Bohemian Girl and Other Stories*.
possible that the change of title to the visual imagery of
y *Roses,* and the better typographical design resulting,
y have been suggested by Beardsley.

le-page of *At the First Corner and Other Stories* by H. B.
rriott Watson, Vol. XI in the *Keynotes* series published by
n Lane, London, and Roberts Brothers, Boston, May
5. Crown 8vo. Pl. 305
m the line-block and letterpress
W. G. Good, England

e motif of the bottom panel is a large double poppy, with
ee seed-pods at three of the corners. There may have been
unconscious memory of Morris's 'Horn Poppy' wall-
er. The plant is treated as if it were a tree or springing
m a very short, thick stem. It looks as though Beardsley
into a habit of drawing the supports of his flowers in this
nner ever since he discovered the formula in his *Morte
rthur* borders.

le-page of *Monochromes* by Ella D'Arcy, Vol. XII in the
notes series published by John Lane, London, and Roberts
others, Boston, June 1895. Crown 8vo. Pl. 306
m the line-block and letterpress
Brian Reade, London

The very lack of geometrical purity in the curves of this long
plant from the corner of Beardsley's imagination is what gives
it a strange effect of vitality.

305 Title-page of *At the Relton Arms* by Evelyn Sharp, Vol.
XIII in the *Keynotes* series published by John Lane, London,
and Roberts Brothers, Boston, June 1895. Crown 8vo.
Pl. 309
From the line-block and letterpress
Mr Brian Reade, London

An ingenious motif of an inn sign bearing the imprint of
John Lane's firm and supported by a symmetrical *art nouveau*
tree.

306 Title-page of *The Girl from the Farm* by Gertrude Dix, Vol.
XIV in the *Keynotes* series, published by John Lane, London,
and Roberts Brothers, Boston, June 1895. Crown 8vo.
Pl. 310
From the line-block and letterpress
Mr W. G. Good, England

The same design was used for the front cover. Occasionally
Beardsley deviated into symmetry, as he did in the title-page
of *The Relton Arms* in the *Keynotes* series (NO. 305). At first
glance he has done so again here: but no; such a principle
seems to have made him uneasy and it will be noticed that of
the two white hemispherical forms near the base-line the
right-hand one has the outline of a nipple, while its counter-
part is without this detail. Meanwhile all but one of the inter-
lacing branches grow across the central feature into their
opposite numbers—a quite irrational concept. The central
feature itself, like the rising cloud of an exploded hydrogen
bomb, is a mystery suggesting all kinds of possible readings.
Beardsley's one fatal weakness, from a strictly intellectual
viewpoint, is disclosed by the addition of his favourite dots,
blown-up like the spots on a bandana handkerchief, and
sprinkled over areas which they detach from the surrounding
space without any purpose except to introduce another
decorative dimension.

307 Design for the front cover and title-page, and key monogram
on the spine and the back cover (and within) of *The Mirror of
Music* by Stanley Mackower, Vol. XV in the *Keynotes* series
published by John Lane, London, and by Roberts Brothers,
Boston, August 1895. Pl. 308
7¹¹⁄₁₆ × 4⁷⁄₁₆ inches
Princeton University Library

The angel with the bass viol is related to a similar figure
designed for the heading of Chapter XXV, Book VIII, p. 334
in *Le Morte Darthur* (1893–4) (NO. 80).

308 Design for the front cover and title-page of *Yellow and White*
by W. Carlton Dawe, Vol. XVI in the *Keynotes* series published
by John Lane, London, and Roberts Brothers, Boston,
August 1895. Crown 8vo. Enclosed in the panel for letter-
press is a design for the key monogram for the spine and
back cover of *The Three Impostors* by Arthur Machen, pub-
lished by Lane and Roberts in November 1895 (Vol. XIX
of the *Keynotes* series). Pl. 314
7¹¹⁄₁₆ × 4⁷⁄₁₆ inches
Princeton University Library

309 Design for the front cover, title-page and key monogram on spine and back cover of *The Mountain Lovers* by Fiona Mac-Leod (pseudonym of William Sharp), Vol. XVII in the *Keynotes* series published by John Lane, London, and Roberts Brothers, Boston, July 1895. Crown 8vo. Pl. 307
$7\frac{5}{8} \times 4\frac{7}{16}$ inches
Princeton University Library

310 Title-page of *Nobody's Fault* by Netta Syrett, Vol. XX in the *Keynotes* series, published by John Lane, London, and Roberts Brothers, Boston, February 1896. Crown 8vo. Pl. 313
From the line-block and letterpress
Mr W. G. Good, England

In the lower panel two of Beardsley's principles of design are reduced to their simplest terms. First, a larger version of the prevailing motif, in this case a flower of dubious botany, stands out in one corner: secondly, all the stems sway on a diagonal twist.

311 Design for the front cover and title-page of *The British Barbarians* by Grant Allen, Vol. XXI in the *Keynotes* series published by John Lane, London, and G. P. Putnam's Sons, New York, November 1895. Crown 8vo. Pl. 315
$8\frac{3}{16} \times 5$ inches
Princeton University Library

312 Design for the front cover and title-page of *Platonic Affections* by John Smith, Vol. XXIII in the *Keynotes* series, published by John Lane, London, and Roberts Brothers, Boston, April 1896. Crown 8vo. Pl. 316
$7\frac{1}{2} \times 4\frac{1}{2}$ inches
Princeton University Library

313 Eight designs for key monograms for volumes in the *Keynotes* series, published by Elkin Mathews and John Lane, London, and Roberts Brothers, Boston, 1893–6. Reproduced in *Early Work*, 1899. Pl. 311
From line-blocks

From left across the monograms are those of Fiona Mac-Leod, Henry Harland, F. Dostoievsky and Lena Milman (together), Evelyn Sharp, George Egerton (Mrs Chavelita Dunne Bright), Gertrude Dix, Grant Allen and Arthur Machen. See also NO. 314.

314 Six designs for key monograms for volumes in the *Keynotes* series, 1894–5; and one design for a key monogram for *The Barbarous Britishers* by Henry Duff Traill, January 1896. Pl. 312
From line-blocks

From left to right on the top row the monograms are those of Ella D'Arcy, Florence Farr, W. Carlton Dawe, Stanley Makower. Below are the monograms of Netta Syrett and Victoria Crosse (pseudonym of Vivian Cory); and one of H. D. Traill, for whose book *The Barbarous Britishers* Beardsley designed a title-page, cover and key monogram (the drawings are reproduced at NO. 316) burlesquing his designs for *The British Barbarians* by Grant Allen (Vol. XXI in the *Keynotes* series). These odd, original, monograms could

scarcely have been conceived except in the age of *art nouve*_ needless to add they flout most academic pieties of g_ design.

315 Title-page of *Young Ofeg's Ditties* by Ola Hansson, transla_ from the Swedish by George Egerton (Mrs Chavelita Du_ Bright), published by John Lane, London, and Rob_ Brothers, Boston, 1895. Crown 8vo. Pl. 317
From the line-block and letterpress
Dr Ian Fletcher, Reading

The same design was used blind-stamped on the dark r_ coloured front cover. The format is in the style of _ *Keynotes* series, but the book was not published in that ser_ Curiosity about life and literature in Scandinavia at this d_ found its champion in the feminist George Egerton, w_ wrote many stories with Scandinavian settings.

In the bottom panel organic logic is sacrificed to Beardsl_ primary inclination towards pattern and arabesque, so t_ the twig in one corner coils into the twig opposite by me_ of a loop like the back of a bentwood chair—that form wh_ seems to have haunted the late nineteenth century (see _ Brian Reade, *Art Nouveau and Alphonse Mucha*, HM_ London, 1967). The eight loose leaves in the middle serv_ break the symmetry but, like the surrounding dots, they _ equally arbitrary.

316 Design for the front cover and title-page and for the _ monogram of *The Barbarous Britishers,* a novel by Henry I_ Traill, published by John Lane, London, 1896. Crown 8_ Signed with a grotesque version of the artist's emb_ Pl. 318
$5\frac{3}{4} \times 3\frac{1}{2}$ inches
Princeton University Library

The maidservant's features caricature Ada Lundberg, _ actress. The design for cover and title is a burlesqu_ Beardsley's design for *The British Barbarians* by Grant A_ published in November, 1895, as Vol. XXI in the *Keyn*_ series (NO. 311).

317 Design for the frontispiece to *Plays* by John Davids_ published by Elkin Mathews and John Lane, London, 1_ 8vo. Signed with the artist's emblem. Pl. 321
Indian ink over pencil, $11\frac{1}{4} \times 7\frac{2}{3}$ inches
Tate Gallery, London

The people represented here are said (see Tate Gallery C_ logue, 4172) to be (from left) Mabel Beardsley, He_ Harland (literary editor of *The Yellow Book*), Oscar Wilde_ Augustus Harris (manager of Covent Garden, Drury L_ and Her Majesty's Theatre), Richard Le Gallienne (man_ letters) and the dancer Adeline Genée (later and still [1_ Dame Genée-Isitt). The figure with the faun's legs and _ does not resemble Harland, and it will be seen that he pa_ conceals the figure of Mabel Beardsley, beside whom_ Oscar Wilde with his legs apparently thonged together. _ innuendo may be that Mabel is interested in Wilde, or_ reverse, but safe from him because his legs are tied toget_ (in other words he has become heterosexually impotent)_ which case it is possible that Beardsley intended the fau_ represent himself. The drawing is mentioned in a lette_ Robert Ross of (?) November 1893, as being an illustrat_ to the fifth and last of the plays in the volume, enti_

aramouch in Naxos: A Pantomime', which had been
tten by Davidson in 1888.

he landscape details are remarkable for their date, being
ost abstractions.

sked pierrot in black. Drawing for the vignette on the
e-page, and in gold on the front cover, of *Plays* by John
vidson, published by Elkin Mathews and John Lane,
ndon, 1894. 8vo. Pl. 319
× 2¾ inches
*nville L. Winthrop Bequest, Fogg Art Museum, Harvard
iversity, Massachusetts*

ew copies of this book had white cloth covers, the rest
ers of plum-coloured cloth.

ster advertising the play *A Comedy of Signs* by John Tod-
ter, preceded by the one-act play *The Land of Heart's
ire* by W. B. Yeats, at the Avenue Theatre, London, 29
rch 1894. Pl. 297
m the colour lithograph, 30 × 20 inches
ctoria and Albert Museum, London

e subtlety of this design lies in its simplicity. The placing
he spots on the abstract curtains, the white line, in reserve,
ming the hair, the languid hand—all combine to produce
armony in four tones, of which two are colours in modi-
contrast.

On this poster Owen Seaman wrote a 48-line poem, *Ars
tera*, which began:

'Mr. Aubrey Beer de Beers,
You're getting quite a high renown;
Your Comedy of Leers, you know,
Is posted all about the town;
This sort of stuff I cannot puff,
As Boston says, it makes me "tired";
Your Japanee-Rossetti girl
Is not a thing to be desired.'

attle of the Bays, London, 1896)

opin Ballade III. Op. 47. Pl. 325
dian ink and ink and water-colour washes, 10⅛ × 9½ inches
onel Mahlon C. Sands, England

e drawing, made early in 1894, appears to be identical with
portrait of the Comtesse d'Armailhacq exhibited at the
yal Society of Portrait Painters in October, 1895. The
ations to an (?) imaginary countess on the the one hand,
d to a ballade of Chopin on the other, seem tenuous. It has
static quality of a bas-relief, and the riding-school pose
the horse is in the manner of equestrian portraits of the
venteenth and eighteenth centuries. The drawing is un-
ual in that Beardsley has used washes to render inter-
ediate tones, a technique he was to develop in less monu-
ental drawings of 1897. This was first reproduced in *The
dio*, May 1898.

ster advertising Singer sewing machines. Reproduction
p. [132] of *The Poster*, Vol. I, October number, 1898.
ned in capitals with the artist's names. Pl. 342
m the half-tone plate
ictoria and Albert Museum, London

The label at the bottom left records that the Polychrome
Printing Company, London, printed this poster in colour
lithography, from Beardsley's design mentioned in a letter
to John Lane, March 1894. It does not seem to have been
used, or used at all widely. The pun on the name Singer
makes the subject of the design, a woman singing to her own
piano accompaniment in the middle of a field, an extension
of the subject of the title-page of *The Yellow Book*, Vol. I,
April 1894, where a woman is shown playing a piano like-
wise in a field (NO. 345). In this design, however, Beardsley
has introduced double outlines everywhere, partly to cope
with the scale, and he has used water-colour washes in the
background and for the pattern on the dress. The lettering
is characteristic. But the general effect is not characteristic,
and has the dreamy bifocal quality of average English *art
nouveau,* and little of the purpose and vitality of Beardsley's
drawings at their best.

322 La Dame aux Camélias. 1894. Published as 'Girl at her Toilet'
in the journal *St Paul's*, 2 April 1894. Later published with
the present title on p. [57] as NO. IV of 'Four Drawings by
Aubrey Beardsley' (Art Index Plate VI) in *The Yellow Book*,
Vol. III, October 1894. On the back is written in pencil
'Yellow Book Immediate/today'. Pl. 323
Indian ink and water-colour, 11 × 7⅛ inches
Tate Gallery, London

NOS. 147 and 1060 in Gallatin's catalogue refer to other repre-
sentations by Beardsley of the heroine of the play by Dumas
fils. Since this drawing was first reproduced with another
title, there seems no need to regard it seriously as Beardsley's
conception of La Dame aux Camélias. Both the early repro-
ductions were line-blocks, but between 1894 and 1897 (see
Tate Gallery Catalogue, 4608) Beardsley added water-colour
washes of pinkish-purple. Apart from the saturation of floor
and wall up to the dado with black shadow, the design is, for
Beardsley, stable and simple, which may be why it has always
been popular.

323 A Caprice. On the right a woman clothed in black with green
trimmings turns toward a beckoning negro dwarf clothed in
red. Behind the dwarf is a view of a town through an arch-
way. *c.* 1894. On the back of the canvas is the painting des-
cribed at NO. 324. Pl. 329
Oil on canvas, 30 × 25 inches
Tate Gallery, London

Of the two paintings on one canvas this was presumably the
first, since the 'Masked Woman' was painted within the area
enclosed by the stretchers. No other paintings in oil by
Beardsley are known to have survived, and these two should
be regarded as experimental. Both are unfinished. The sub-
ject of 'A Caprice' is similar to that of NO. I of 'The Comedy
Ballet of Marionettes', published in *The Yellow Book,* Vol. II,
July 1894 (see NO. 353). William Rothenstein's early paintings
may have given Beardsley the idea of these bold, gloomy
saturated forms; otherwise the general atmosphere is similar
to that of the Venetian artist Longhi. Beardsley's favourite
colours—like black and white—were the complementary
shades of red and green. It is interesting to reflect that here
again, in a field he never exploited, he sought the drama
primarily of direct contrast. For the provenance of this
painting, see NO. 324.

324 A masked woman, half-length, in black, with a white mouse on a table before her. *c.* 1894. Pl. 330
Oil on canvas, 25¾ × 20¼ inches
Tate Gallery, London

This painting is on the back of the canvas supporting the painting 'A Caprice', the only other painting in oil by Beardsley. The canvas was found by Mrs Pugh when she took over the lease of 114 Cambridge Street, Pimlico, London SW1, after the Beardsleys left the house, and it was bought from her by R. A. Walker in 1920. He sold it to the Tate Gallery three years later.

Sickert offered to teach Beardsley oil-painting, but nothing came of it. Neither the 'Masked Woman' nor 'A Caprice' have any particular reference to Sickert's method; rather to the paintings of Longhi. Although Beardsley had only a dormant colour sense, the handling of the flesh shows promise and the possibilities of development. The symbolism of the picture is Freudian, and Beardsley's choice of it is miraculous, considering that Freud's mythology was unknown in England in 1894.

325 The Fat Woman. Inscribed on the back 'A mon ami Will Rothenstein Aubrey Beardsley fec. et don.' Further inscribed over a phallic caricature of a Queen Victoria penny stamp, 'Received by Will Rothenstein'. Pl. 322
Indian ink and wash, 7 × 6⅜ inches
Tate Gallery, London

This was intended as a caricature of Whistler's wife and was published in the journal *To-Day*, 12 May 1894. Whistler was offended. William Rothenstein, who at this period shared a work-room in Pimlico with Beardsley, was given the drawing and later returned it, urging Beardsley to destroy it. It was not destroyed. It is related to the earlier drawing 'Waiting' (see NO. 249) but is less sinister and the composition is more stable. It also has half-tones rendered in indian ink wash.

326 Front wrapper of *The Cambridge A.B.C.*, NO. I, 8 June 1894. Published by Elijah Johnson, Cambridge. 8vo. Signed with the artist's names. Pl. 328
From the line-block and letterpress
Mr W. G. Good, England

While he was an undergraduate at Cambridge Maurice Baring helped to bring out this magazine, and he wrote to Beardsley for a wrapper design. The artist dissuaded him from having a dark red cover and charged him ten guineas for the drawing. The cover was white with the design in black. In it there is a characteristic atmosphere of mystery, and the carnival suit worn by the boy, with its short voluminous legs, heralds the pierrot costumes of later designs. The garden with its fountains has been evolved from the *Morte Darthur* backgrounds, but the balustrade comes perhaps from the memory of Adelaide Crescent in Hove.

327 Rejane [*sic*]. Portrait of Madame Réjane (Gabrielle Charlotte Réju) full-length on a chaise-longue, left profile. Signed with the artist's emblem and inscribed with title. Pl. 332
Indian ink and wash, 13¼ × 8¾ inches
Metropolitan Museum of Art, New York

In this drawing, one of Beardsley's most graceful achievements, he used indian ink wash for intermediate tones, as well as the undiluted medium. He made numerous drawi[ng]s of Madame Réjane of which this is the most elaborate. S[he] acted the role of Catherine in *Madam Sans Gêne* at the Ga[iety] Theatre, on 23 June 1894, her first appearance in Lond[on].

328 Design for the frontispiece to *Baron Verdigris. A Roman[ce] the Reversed Direction,* by Jocelyn Quilp, published by He[nry] and Company, London, July 1894. Signed in brown ink w[ith] the artist's names. Pl. 327
7¾ × 4¾ inches
British Museum

The author's name may have been a pseudonym. The sto[ry] which is pseudo-mediaeval and facetious, is dedicated [to] 'Fin-de-Siècle-ism, the Sensational Novel, and the Conv[en]tional Drawing-Room Ballad'.

329 Design for the invitation card to the opening of the Princ[es] Ladies Golf Club at Mitcham, Surrey, on 16 July 1894. Sign[ed] with the artist's names. Pl. 326
9 × 5½ inches
Mrs R. Hippisley-Coxe, England

This is the most remarkable of Beardsley's silhouette tre[at]ments of women in contemporary clothes, which he exa[g]gerated. The drawing has been well forged (see R. A. Walk[er] *How to Detect Beardsley Forgeries*, Bedford, 1950, p. 11).

330 Page 192 of *The Idler*, September 1894, published by Cha[tto] and Windus, London. 8vo. Headpiece in the shape of [an] inverted L. Signed with the artist's names, and lettered T[he] Idler's Club. Pl. 335
From the line-block and letterpress
Mr W. G. Good, England

A similar design of the same shape on a smaller scale w[as] printed in black on the salmon-coloured front wrapper [of] the periodical. The article by H. E. Abbott was the first o[f a] series on 'How to Court the "Advanced Woman"'.

331 The Idler's Club. Design for a full-page border intended f[or] *The Idler*, 1894, but not used for that periodical. Signed wi[th] the artist's names and inscribed with title. Pl. 334
8⅜ × 6½ inches
Princeton University Library

332 Les Passades. Published in the magazine *To-Day*, Wint[er] Number, 17 November 1894. Pl. 336
From the half-tone plate, 10 × 5 inches
Mr W. G. Good, England

The drawing compares with 'A Night Piece' (NO. 348), whi[ch] is related in subject and composition. The introduction [of] grey indian ink wash in the sky and elsewhere made the u[se] of a half-tone plate necessary, instead of the customary li[ne] block facsimile. Beardsley has carried the positive approa[ch] of Whistler in the 'Nocturnes' to extremes by simply lifti[ng] the shapes of the prostitutes out of a background saturat[ed] with the blackness of night.

e Pseudonym and Autonym Libraries. Poster published
T. Fisher Unwin, London, 1894. Signed with the artist's
mes. Pl. 296
om the colour lithograph, 30 × 20¼ inches
ictoria and Albert Museum, London

ae design here differs in various details from Beardsley's
iginal drawing for the poster (see NO. 334). It may have
en re-drawn by a technical draughtsman on the lithographic
ones for printing the poster in colours. According to
allance the colour scheme was suggested to Beardsley by a
ench poster (Vallance, 77). According to A. E. Gallatin
e poster was coloured by the artist (Gallatin, 789): doubt-
s anyway he directed what colours should be employed.
ae poster was in use for some years after 1894 with varied
terpress; and the design was adapted for a small advertise-
ent slip issued by Unwin, for the cover of *Unwin's Chap Book*
399–1900), and for the front cover of *The Dream and the
siness* by John Oliver Hobbes, published by Unwin in
06.

irl and a Bookshop, 1893. Later used as a design for a
oster advertising The Pseudonym and Autonym Libraries
ablished by T. Fisher Unwin, London, 1894. Pl. 320
dian ink over pencil, 14¼ × 5⅝ inches
hilip H. and A. S. W. Rosenbach Foundation, Philadelphia

ae positive parts of the drawing are all on one side and
wards the top: an excellent example of the disbalance learnt
om Japanese prints. The result is to dramatize the figure
d to suggest motion towards the empty space, as in the
ure of 'Virgilius the Sorcerer' (see NO. 267). In the poster
rtain details were changed and the proportion of the design
ered by the inclusion of more white background, on which
e titles of books appeared (see Pl. 296). The drawing was
hibited in the 1893 winter exhibition of the New English
rt Club.

oster advertising *Children's Books* published by T. Fisher
nwin, London, 1894. Signed with the artist's names and
nblem. Pl. 324
om the colour lithograph, 30 × 20 inches
r Anthony d'Offay, London

uch winged chairs were known as grandfathers' chairs, and
eardsley may have intended to represent a grandmother
tting in an appropriate chair and reading to her grand-
ildren from one of the books advertised in the letterpress
nel. The gown with its leg-of-mutton sleeves is of the
ineties, but the feather is in the mode of the late eighteenth
early nineteenth century. Instead of age and maturity
erefore Beardsley has formulated a disturbing sensuality in
e features of the woman. This was the kind of negligent
ony which repelled so many of his own generation.

aricature of Whistler on a garden seat, pointing to a butter-
, c. 1893–4. Pl. 333
⅟₁₆ × 4⁷⁄₁₆ inches
osenwald Collection, National Gallery of Art, Washington

distorted-looking butterfly was Whistler's emblem, and
such it appeared on numerous etchings and drawing by
m. Here the butterfly has been partly erased. The drawing
as never published in Beardsley's lifetime and was not
idely known until it was reproduced in R. A. Walker's *Some
nknown Drawings by Aubrey Beardsley*, London, 1923. It is
nong the boldest of Beardsley's early drawings. The

balance, or rather disbalance, of what is actually drawn, all in the upper right corner, against the empty foreground, produces a sense of perspective learnt from Japanese art, but here carried to extremes. The seat on which Whistler sits is either meant to be Japanese (like the ones in Japanese prints), or is meant to look like an example of the frail 'Aesthetic' furniture made after the designs of E. W. Godwin which were much influenced by Japanese furniture. Beardsley mentioned this drawing in a letter to Raffalovitch in December 1896, saying it was a 'very malicious caricature of Whistler' that had been hung on the Christmas tree put up by Mabel and himself in 1894.

337 The Murders in the Rue Morgue. The first of four illustrations to *The Works of Edgar Allan Poe*, published by Herbert S. Stone and Company, Chicago, 1894–5. Signed with the artist's emblem. Pl. 337
9⅞ × 6¼ inches
Mr Albert Reese, New York

Four drawings were commissioned from Beardsley for this edition of Poe's works in ten volumes. The line-block plates however accompanied only the Japanese paper issue of ten sets. Stone republished the plates in 1901 (250 copies).

338 The Black Cat. The second of four illustrations to *The Works of Edgar Allan Poe*, published by Herbert S. Stone and Company, Chicago, 1894–5. Pl. 338
9⅞ × 6¼ inches
Mr Albert Reese, New York

See NO. 337. As with the powder-puff in the cul-de-lampe of *Salome*, the white chest of the cat, which is white paper left in reserve, reminds us that Beardsley was not only a master of line and of meaningful black and white shapes, but of the possibilities of indian ink and its limitations.

339 The Fall of the House of Usher. The third of four illustrations to *The Works of Edgar Allan Poe*, published by Herbert S. Stone and Company, Chicago, 1894–5. Pl. 339
9⅞ × 6¼ inches
Mr Albert Reese, New York

See NO. 337. The figure is based upon that of Chopin in an earlier drawing of 1892 in the Japonesque style, subtitled 'Frederic [*sic*] Chopin' (see *The Uncollected Work of Aubrey Beardsley*, John Lane, London, 1925, NO. 13).

340 The Mask of the Red Death. The fourth of four illustrations to *The Works of Edgar Allan Poe*, published by Herbert S. Stone and Company, Chicago, 1894–5. Signed with the artist's emblem. Pl. 340
9⅞ × 6¼ inches
Mr Albert Reese, New York

See NO. 337. This illustration was first reproduced in *The Chap Book*, Chicago, 15 August 1894; and again in the same periodical on 1 April 1898.

341 Design for a poster to advertise *The Yellow Book*, 1894. Signed with the artist's names. Pl. 341
15⅟₁₆ × 10⅞ inches
Princeton University Library

The Yellow Book was conceived on New Year's Day 1894 by

Beardsley and Henry Harland, the novelist, at Harland's house in the Cromwell Road. The first volume came out in April 1894, published by Elkin Mathews and John Lane in London at the Bodley Head, and by Copeland and Day in Boston. The design on the small poster was reduced to a height of $13\frac{5}{8}$ inches and was printed in dark blue from the line-block on yellow paper. In the panel on the right were printed 'Sold Here. The Yellow Book. Contents of Vol. I, April, 1894, etc.'

342 Design for the front cover of the prospectus of *The Yellow Book,* Vol. I, April 1894, published by Elkin Mathews and John Lane, London, and Copeland and Day, Boston. 4to. Signed with the artist's emblem. Pl. 343
$9\frac{1}{2} \times 6\frac{1}{8}$ inches
Victoria and Albert Museum, London

The suggestion contained in the design is that the enterprising young woman who is free to decide what she reads will be interested in just this sort of periodical. *The Yellow Book* was a hard-back quarto with yellow covers and with designs and title etc. in black. The elderly pierrot looking on from the doorway was said to represent Elkin Mathews, the partner of John Lane at the Bodley Head (where *The Yellow Book* was published), who by comparison with Lane was somewhat apprehensive and prudish.

343 Design for the front cover of *The Yellow Book,* Vol. I, April 1894. Published by Elkin Mathews and John Lane, London; Copeland and Day, Boston. 4to. Signed with the artist's emblem. Pl. 344
Indian ink over pencil, $10 \times 8\frac{1}{2}$ inches
Tate Gallery, London

All the cover designs of *The Yellow Book* were printed in black on yellow cloth boards. There lingers in this conception something of the gaiety of Chéret's iconography, particularly when associated with the Quatz' Arts ball of 1893 in Paris. The mephistophelian man gives a sinister note however. What is remarkable is the exaggerated form of the woman's hat cut from the darkness behind—of which it is literally a part—by two bold white curved lines. The balancing of hat, hair and shoulders in this figure inside a rectangle of such a shape, the exceptionally hard, flat, jagged treatment of the gown, differentiated by heavy dots: the dots themselves—vestigial of pointilliste spots or of the spatter on Toulouse-Lautrec's posters—all contribute to a startling design which appears to have in it the seeds of Cubism and of many kinds of abstract art.

344 Decoration on the back covers of Vols. I–V of *The Yellow Book,* published by John Lane, London; Copeland and Day, Boston, 1894–5. 4to. Signed twice with the artist's emblem. Pl. 346
From the line-block

Although Beardsley's contributions to the fifth volume of *The Yellow Book* were withdrawn at the last minute, including the front cover design (see *Catalogue of Aubrey Beardsley Exhibition at the Victoria and Albert Museum,* 1966, NOS. 484,

485), the spine and the back cover were overlooked: the ba cover design had remained the same ever since the fi volume of a year before.

345 Title-page of *The Yellow Book,* Vol. I, April 1894, publish by Elkin Mathews and John Lane, London; Copeland a Day, Boston. 4to. Pl. 345
From the line-block

On learning that there was widespread criticism of t design, Beardsley sent a letter to *The Pall Mall Budget* in wh he recalled that Bomvet described Glück, the composer, accustomed to placing himself in the middle of a field w his piano [*sic*] before him and a bottle of champagne on ea side, and that he wrote in the open air his two 'Iphigeni 'Orpheus' and some other works. 'I tremble to thin Beardsley wrote, 'what critics would say had I introduc those bottles of champagne. And yet we do not call Glüc decadent'. None the less, the composition would have suit the requirements of the Surrealists of the 1930s.

346 L'Éducation Sentimentale. Illustration to the novel of 18 by Gustave Flaubert reproduced on p. 55 in *The Yel Book,* Vol. I, April 1894, published by John Lane, Londo Copeland and Day, Boston. 4to. Pl. 349
From the half-tone plate

The original drawing of the left-hand figure, later covered Beardsley with pink and green water-colour, survives in t Fogg Art Museum, Harvard University (see NO. 347). T differing qualities of cynicism in age and youth are contrast here and subconsciously emphasized by the black and wh contrast in the clothes of the two women. Beardsley's analy of the edges of the features of the older woman comes near forestalling a principle in the art of Wyndham Lewis.

347 Part of the drawing 'L'Education Sentimentale' reproduc in *The Yellow Book,* Vol. I, April 1894 (see NO. 346). Pl. 3 Pen and ink and water-colour, $10\frac{3}{4} \times 3\frac{1}{2}$ inches
Grenville L. Winthrop Bequest, Fogg Art Museum, Harva University, Massachusetts

For some reason, apparently not recorded, Beardsley divid his original drawing into two parts, this part containing t older woman holding the letter. He then added pink ar green water-colour, which entirely changed the character the drawing.

348 A Night Piece. Reproduced in half-tone in *The Yellow Boo* Vol. I, April 1894 (pl. VII in Index), published by Elk Mathews and John Lane, London; Copeland and Da Boston. 4to. Pl. 351
Indian ink and wash, $12\frac{5}{8} \times 6\frac{1}{8}$ inches
Fitzwilliam Museum, Cambridge, England

Sold at Christie, London, 20 December 1901, Lot 71, 'Aubrey Beardsley—in Leicester Square—Black and Whit In fact the wash in the drawing introduced half tones, and t reproduction could not be carried out in line-block. Apa from the disbalance typical of compositions by Beardsl during the *Yellow Book* period, there is the unusual feature a form being raised by a few white lines out of a black bac ground. These lines were made partly by erasure with

e, apparently. The well-poised spaces of white for the
os, head and shoulders, sleeve and instep show Beardsley's
norization of paintings by Whistler; such as, for example,
tersea Bridge'. The half-tone buildings in the background
also in the manner of the 'Nocturnes'.

Patrick Campbell. Reproduced in half-tone on p. [157]
'he Yellow Book, Vol. I, April 1894 (Pl. X in Index), pub-
d by Elkin Mathews and John Lane, London; Cope-
and Day, Boston. 4to. Pl. 347
an ink and wash, $13\frac{1}{16} \times 8\frac{3}{8}$ inches
ional Gallery of Berlin

tter from Beardsley to the actress Mrs Patrick Campbell
ives, written in February or March 1894. In this he thanks
for giving him a sitting (see Catalogue of Aubrey Beardsley
ribition at the Victoria and Albert Museum, 1966, NO. 481).
he time, Mrs Patrick Campbell was playing the part of
la Tanqueray in A.W. Pinero's play The Second Mrs
nqueray at the St James's Theatre, London. In February
4 Oscar Wilde wrote to her asking to present Beardsley
her (see Rupert Hart-Davis, (ed.) Letters of Oscar Wilde,
53). The present drawing was evidently the fruit of this
ounter: it is of course an elegant caricature rather than a
al likeness and it caused indignation when it was pub-
ed in The Yellow Book. The drawing became the property
Oscar Wilde.

ign for the bookplate of John Lumsden Propert. Repro-
ed in The Yellow Book, Vol. I, April 1894 (Pl. XIV in
ex), published by Elkin Mathews and John Lane,
don; Copeland and Day, Boston. 4to. Pl. 350
$\times 4\frac{7}{8}$ inches
R. A. Harari, London

other instance of Beardsley's gift of achieving poise in a
nposition by calculated disbalance. Stabilizing elements
in the curves of the art nouveau style branch, the candle,
in the more important figure of the beseeching pierrot,
o implores attention from the contemptuous and mali-
us-looking female.

ign for the front cover of The Yellow Book, Vol. II, July
4: published by Elkin Mathews and John Lane, London;
oeland and Day, Boston. 4to. Signed with the artist's
olem. Pl. 353
$\times 6\frac{3}{16}$ inches
nceton University Library

e disbalance of the woman's form here is more in line with
ropean conventions than was customary with Beardsley.
thick lips, the soft outlines of her nose and her abundant
r are all features of erotic and 'emancipated' suggestion,
he anti-genteel, anti-Du Maurier style of late Victorian
man. The background is half plain white, and half covered
a wallpaper decorated with large cup-shaped flowers anti-
ating the large floral motifs in art nouveau designs of some
years later. The exaggerated perspective of the bookcase
ruding at an angle, and the drawing of the bowl of flowers
ich is not in perspective, are together characteristic of
rdsley's type of visual wit.

ign for the title-page of The Yellow Book, Vol. II, July
4. Published by Elkin Mathews and John Lane, London;

Copeland and Day, Boston. 4to. Signed with the artist's
emblem. Pl. 352
$3\frac{11}{16} \times 3\frac{5}{8}$ inches
Princeton University Library

There are strange premonitions here of the severer kinds of
abstract art to come: the bands of black which represent the
lawns; the self-sufficient form arrived at by running the girl's
black sash into the patch of lawn behind her, and the odd way
in which the dotted T-form of the junction of paths in the
foreground is crossed by the black-gloved hand and walking-
stick combined. The near-parallel relation between the line
of the stick and the line of the edge of the lawn beyond it to
the right is a typical instance of Beardsley's wit, and once
more reveals his pleasure in kinds of visual experience that
were unexplored by artists at this time.

353 Design for NO. I of 'The Comedy Ballet of Marionettes, as
performed by the troupe of the Theatre-Impossible, posed
in three drawings'. Reproduced on p. 87, Pl. III (in Index) of
The Yellow Book, Vol. II, July 1894. Published by Elkin
Mathews and John Lane, London; Copeland and Day,
Boston. 4to. On the back a slight pencil sketch of a woman.
Pl. 356
$13\frac{3}{8} \times 10\frac{1}{16}$ inches
Princeton University Library

Here the dwarf is shown holding a small box: in The Yellow
Book plate he holds a mask in his right hand with which he
points to the archway in the background. The drawing was
altered in this detail when the design was used as a small
poster for Geraudel's pastilles. Beardsley made use of a
similar composition for his oil painting 'A Caprice' now in
the Tate Gallery (see NO. 323).

The strong disbalance of the black mass of the woman's
garment is countered by the suggestion of her movement to
the left and by the posture of the dwarf who turns inwards
and backwards, and finally by the stabilizing effect of the
distant archway and street at the top left. But as usual with
Beardsley, the off-side black mass is the first, because it is the
most arresting, act in the visual drama. There is a reminis-
cence of the Venetian painter Longhi, more evident still in
the picture 'A Caprice'. But the dramatic elements are Beards-
ley's own. The dwarf invites the woman with her eighteenth-
century clothes to pass with him through the archway to a
world beyond. Being a dwarf he cannot share the life of a
normal woman, but his features are congested with a lust for
vicarious pleasure.

354 The Comedy Ballet of Marionettes, II. Plate IV (in Index)
of The Yellow Book, Vol. II, July 1894. Published by Elkin
Mathews and John Lane, London: Copeland and Day,
Boston. 4to. Pl. 358
From the line-block

The woman in the first design of this group of three (see
NO. 353) is now in clothes of the Nineties and has been
joined by a female in jacket and bloomers who is making
advances to her. The receding chin of the lesbian denotes,
in the phrenological terms of the nineteenth century, ab-
sence of moral fibre equivalent to anti-morality. The dwarf
in the first design is here again, pointing with sarcastic glee
at the situation he has helped to bring about. The quality
of the outlines, apparently, yet not quite, of even width,
speaks for itself.

355 The Comedy Ballet of Marionettes, III. Plate V (in Index) of *The Yellow Book*, Vol. II, July 1894. Published by Elkin Mathews and John Lane, London; Copeland and Day, Boston. 4to. Pl. 357
From the line-block

The heroine of the first two designs in this group of three (see NOS. 353, 354) is here seen wearing the short skirts of a ballet dancer and pointing with a mask held behind her back to her lesbian friend. The lesbian in reply points with an outstretched finger behind her back to the woman. Slightly behind them, on the left, the elderly husband or 'protector' of the young woman, wears the horns of a cuckold and dances clumsily. The dwarf is now the conductor of an orchestra of midgets who are pleased to be the voyeurs of a situation which, like their own condition in the first degree, is abnormal.

356 The Dancer. The central figure cut from the original drawing of 'The Comedy Ballet of Marionettes, III' made for *The Yellow Book*, Vol. II, July 1894 (Pl. V in Index): published by Elkin Mathews and John Lane, London; Copeland and Day, Boston. 4to. Signed with the artist's emblem (added). Pl. 359
$8\frac{1}{8} \times 5\frac{1}{8}$ inches
The Cooper Union Museum, New York

Beardsley's emblem was not used in the design for *The Yellow Book*, and may have been added by another hand when this figure was cut away from the rest of the drawing. It was re-named 'The Black Domino', and later 'The Dancer'. The poise of the figure and the subtle outline of her silhouetted garment are totally stylized; yet they suggest what the dashing lines of the realist draughtsman seldom achieve, the swaying movements of the clothes on the body of the dancer (see also the complete composition at NO. 355).

357 Garçons de Café. Plate IV of 'Six Drawings by Aubrey Beardsley', on p. 93 in *The Yellow Book*, Vol. II, July 1894, published by John Lane, London; Copeland and Day, Boston. 4to. Pl. 354
From the line-block

The drawing for this plate seems to have been lost or destroyed. Originally Beardsley called it 'Les Garçons du Café Royal'. From the heel of the waiter on the left to the end of the sleeve of the waiter on the right there is a continuous black continent absorbing all details within it in the same tone. This saturation effect, combined with the attempt at realism, is a tribute to the woodcut style of Felix Vallotton (1865–1925) who was one of the group known in France as the Nabis. Presumably Beardsley became aware of Vallotton's graphic art when he went to Paris in 1892 and 1893, though the impact could have been made through reproductions in *The Studio* (see Vol. I, NO. 1, 1893) and elsewhere.

358 The Slippers of Cinderella. Plate V of 'Six Drawings by Aubrey Beardsley' on p. 95 in *The Yellow Book*, Vol. II, July 1894, published by Elkin Mathews and John Lane, London; Copeland and Day, Boston. 4to. Pl. 355
From the line-block

The drawing was in ink and first reproduced as shown here. Later the artist coloured it in green and scarlet water-colour.

359 Madame Réjane. Plate VI of 'Six Drawings by Au[brey] Beardsley' on p. 97 of *The Yellow Book*, Vol. II, July 1[894] published by Elkin Mathews and John Lane, London; C[ope]land and Day, Boston. 4to. Pl. 360
From the line-block

The profile of Réjane here is similar to those at NOS. 265 327, but the drawing was probably made in the prev[ious] month when this actress appeared for the first tim[e in] London at the Gaiety Theatre.

360 Design for the front cover of *The Yellow Book*, Vol [II] October 1894. Published by John Lane, London; Cope[land] and Day, Boston. 4to. Pl. 361
$8\frac{1}{16} \times 6\frac{1}{8}$ inches
Princeton University Library

By the date of the publication of this volume, Elkin Math[ews] had ceased, in September 1894, to be a partner with La[ne in] The Bodley Head. The black masses on the right are c[om]pensated by the movement of the figure to the left. [The] fleecy lining of the gown is heavily outlined to conta[in a] self-sufficient white mass, which has an echoing form i[n the] black mass of hair. The weak, pert and narcissistic feat[ures] of the woman are opposed by the looking-glass on [the] dressing-table, which she scrutinizes and which tells [her] nothing because there is no reflection to be seen in it. [All] the bracketed lights on the glass are like London street la[mps] and the flames within are like gas-jets. The insinuation is [that] the woman, although too rich to be a street-walker, [is so] charged with desire to see the love of herself reflected i[n the] eyes of others that she is vulnerable to any bold encount[er in] the streets of London's night life.

361 Title-page of *The Yellow Book*, Vol. III, October 1894, [pub]lished by John Lane, London, and Copeland and [Day,] Boston. 4to. Pl. 362
From the line-block and letterpress

Another example of Beardsley's obsession with bul[ging] pantaloons in harlequin and pierrot costumes. The resu[lt is] a very small leg with the action of a four-footed beast.

362 Portrait of Himself [by Beardsley]. Par Les Dieux Jume[aux] Tous Les Monstres Ne Sont Pas En Afrique. The arti[st is] shown in a bed with enormous curtains. Reproduced o[n p.] [51] as NO. I of 'Four Drawings by Aubrey Beardsley' [(Art] Index Plate III) in *The Yellow Book*, Vol. III, October 1[894,] published by John Lane, London, and Copeland and [Day,] Boston. 4to. Pl. 363
From the line-block

Beardsley has visualized himself in a night-cap more li[ke a] mob-cap, lying alone in a late seventeenth-century bed. [The] designation of himself by implication as a monster w[ith a] rationalization of his early feeling at school, and later, [that] he was markedly different from the other people aro[und] him, and therefore grotesque. By this date, however, he t[ook] a humourous pride in this difference.

363 Lady Gold's Escort. Reproduced on p. [53] as NO. II of 'F[our] Drawings by Aubrey Beardsley' (Art Index, Plate IV[) in] *The Yellow Book*, Vol. III, published by John Lane, Lond[on]

Copeland and Day, Boston, October 1894. 4to. Pl. 364
m the line-block

ing 1894 Beardsley seems to have become attracted to
problem of showing figures in darkness, whether the
kness of night, as in this case, and in 'Les Passades' and
Vight Piece', or the darkness of the auditorium as in 'The
gnerites' (NO. 364). Thus a positive technique was of little
l and he was obliged to leave white lines in reserve, as
, or actually paint them or scratch them out as in 'A
ht Piece' (NO. 348). The original stimulus to this phase of
work was undoubtedly his appreciation of the poetic
lities of Whistler's 'Nocturnes'; only for Beardsley
kness was sinister.

Wagnerites. Drawing reproduced on p. [55] as NO. III
Four Drawings by Aubrey Beardsley' (Art Index Plate
n *The Yellow Book*, Vol. III, October 1894. Published by
n Lane, London; Copeland and Day, Boston. 4to. In-
bed on the back in pencil with a note by Joseph Pennell
*Catalogue of the Aubrey Beardsley Exhibition at the Victoria
Albert Museum*, 1966, NO. 405). Pl. 366
ian ink touched with white, 8⅛ × 7 inches
toria and Albert Museum, London

plate in *The Yellow Book* was reproduced in *Le Courrier
nçais* on 23 December 1894. This is one of the best-known
rdsley's works, because of the bold break-up of the
wded scene into a comparatively few areas of black and
te to represent the darkness of the auditorium. Some of
white lines running into this lower half have been put in
h chinese white, not left in reserve. Paint occurs elsewhere
the whites of the drawing.
he figures of men are indicated in the boxes, but only one
appears in the stalls, presumably a Jew. There is a legend
the woman drawn with a three-quarter profile represents
abeth Browning. The programme on the floor in the
ht bottom corner tells us that the audience is listening to
stan and Isolde, an opera which had an especial attraction
Beardsley. He delights here in the irony of this opera with
theme of idealized love affecting an audience of worldly
l vicious-looking women.

nt cover and spine of *The Yellow Book,* Vol. IV, January
5, published by John Lane, London; Copeland and Day,
ston, 4to. Pl. 365
sign in black on yellow cloth boards
W. G. Good, England

e Mysterious Rose Garden. Drawing for Plate NO. XIV
dex) in *The Yellow Book*, Vol. IV, January 1895, published
John Lane, London; Copeland and Day, Boston. 4to. Pl.

lian ink over pencil, 8¾ × 4¾ inches
enville L. Winthrop Bequest, Fogg Art Museum, Harvard
iversity, U.S.A.

rdsley was busy on this drawing in late 1894, and it
pears there was a former version destroyed at the pencil
tch stage (see NO. 367). Originally he had intended it to be
e first of a series of Biblical illustrations representing
thing more nor less than the Annunciation'. However, he
anged his mind and entitled the drawing for publication
he Mysterious Rose Garden'. As such it acquired a different

significance. The messenger with the winged slippers of
Mercury is whispering a message at dusk to a young girl,
evidently pregnant, wandering in a garden with a background
of symbolic roses on trellises. The import of his message is
left to the imagination. The form of the girl is sufficiently like
that of Beardsley's sister, Mabel, for us to suspect that the
underlying association was with her (compare the left-hand
figure in the frontispiece to *Plays* by John Davidson, 1894.
See NO. 317). The future of the pregnant young woman in
late Victorian society was not easy, and whatever joy the girl
in the 'Mysterious Rose Garden' may have derived from the
news of her condition, would have been offset by the
messenger's warning of her future tribulations as an un-
married mother.

367 Discarded drawing, for 'The Mysterious Rose Garden' as
published in *The Yellow Book*, Vol. IV, January 1895. On
nineteen fragments of paper reassembled. On the back, a
faint scribble and sketch of a nude girl. Pl. 368
Pencil and indian ink, 10 5/16 × 5 13/16 inches
Mr A. J. Ballantine, London

The drawing was re-discovered in 1963, torn into nineteen
fragments held together at the back by lengths of gummed
margins from British postage-stamp issues of *c*. 1881–1902
(See *Catalogue of Aubrey Beardsley Exhibition at the Victoria
and Albert Museum*, 1966, NO. 422). Formerly it had belonged
to John Lane and was sold with others from his collection in
1922.
Pencil sketches by Beardsley are uncommon, as his practice
was to use them as foundations for his finished designs in ink.
Ink border lines, as here, were frequently drawn by him
before proceeding with the inking-in of the design. This
version of 'The Mysterious Rose Garden' (originally con-
ceived as an 'Annunciation') is in reverse of the final version
in the Fogg Museum of Art at Harvard (See NO. 366), and
there are other differences. It would seem this sketch was
torn up (?because of the badly drawn border) and the frag-
ments rescued perhaps without his knowledge.

368 The Repentance of Mrs . . . , Plate XV (Index) in *The Yellow
Book,* Vol. IV, January 1895, published by John Lane,
London; Copeland and Day, Boston. 4to. Pl. 369
From the line-block

The upper part of the kneeling figure of the repentant
adulteress is related to the equivalent part of the figure of St
John in Mantegna's engraving *The Entombment* (Armand-
Durand, NO. 3). Beardsley had memorized the same agonized
profile of St John for the kneeling figure of Mary Magdalen
in 'The Litany of Mary Magdalen' 1891 (see NO. 20). Indeed
the periwigged figure and the dwarf and the cut-away figure
on the right all have their counterparts in the earlier com-
position.

369 Portrait of Winifred Emery. Plate XVI (Index) in *The Yellow
Book,* Vol. IV, January 1895, published by John Lane,
London; Copeland and Day, Boston. 4to. Pl. 370
From the line-block

One of the most delicate of Beardsley's drawings, here
photo-engraved in line-block by Carl Hentschel. What is
unusual is that for once the linear description of the clothes
is precise and without exaggeration.

370 Frontispiece for Juvenal. Two monkeys in livery bearing an elderly person in a sedan chair along a London street. Double-page supplement at the end of *The Yellow Book*, Vol. IV, 1895, published by John Lane, London; Copeland and Day, Boston. 4to. Pl. 371
From the line-block

The last plate by Beardsley to be published in a *Yellow Book*. From Vol. V the plates after his designs were withdrawn before publication. The rest of his illustrations to Juvenal were published by Leonard Smithers (see NOS. 468–70, 483). Here the architecture of the street may have been intended to be Roman, but the buildings are indisputably of eighteenth-century and Regency London as they survived in the Nineties.

371 Design for the prospectus and the front cover of *The Yellow Book*, Vol. V, to be published by John Lane, London, in April 1895, but withdrawn. On the back is a slight pencil sketch of a woman's profile and a two-line border in ink. Pl. 373
$8\frac{1}{8} \times 6\frac{1}{8}$ inches
Brighton Art Gallery, England

This design is similar in some respects to one used for the front covers of the earlier rare-book catalogue issued by Leonard Smithers in 1895 and 1896. It survives in black on yellow cloth on one cover of Vol. V of *The Yellow Book* as originally planned, which forms part of a dummy copy obtained by Sir Edmund Gosse. The published front cover was re-designed by Patten Wilson; the back cover and spine were overlooked, but five plates after Beardsley inside the volume were withdrawn while it was actually in production. This crisis in the history of *The Yellow Book* arose because of Beardsley's dismissal from his post as art editor of the journal at the time of the Wilde scandal (See *Catalogue of Aubrey Beardsley Exhibition at the Victoria and Albert Museum*, 1966, NOS. 425, 426).

372 Atalanta in Calydon. An illustration to the poem by Algernon Charles Swinburne, 1895. Pl. 372
Indian ink and wash, $12 \times 4\frac{3}{8}$ inches
British Museum

The disbalance aids the suggestion of movement to the right, into a black background. Some of the flowers were brushed over with ink wash, thus making the full reproduction of this drawing impossible by line-block. It was to have been published in Volume V of *The Yellow Book* in April 1895, but was withdrawn from the volume as issued, along with three other plates and a title-page after Beardsley, when John Lane dispensed with his services as art editor of the magazine.

373 Portrait of Miss Letty Lind. Reproduced as NO. 84 in *The Early Work of Aubrey Beardsley*, John Lane, London, 1899. Pl. 374
From the half-tone plate

This fine drawing is described in *Early Work* as hitherto unpublished. It represents Letty Lind in the play called 'The Artist's Model' and was among five plates after Beardsley's drawings that were to have been published in Vol. V of *The Yellow Book*, April 1895, but were withdrawn at the last minute when Beardsley's connection with the periodical was terminated at the time of Oscar Wilde's arrest. It was then

that certain pious authors, published by the Bodley Head, conspired to force Lane to abandon the young artist.

374 A Nocturne of Chopin. Pl. 375
Pen, ink and wash, $7\frac{3}{4} \times 7\frac{1}{8}$ inches
Grenville L. Winthrop Bequest, Fogg Art Museum, Harvard University, Massachusetts

First reproduced in *Early Work*, 1899, this drawing is an essay in the technique adopted for some of the *Madomoiselle de Maupin* series, involving varied tones rendered by washes. It was one of the drawings intended for reproduction in the original Volume V of *The Yellow Book*, but withdrawn (see NOS. 372, 373, 394).

375 Design for a poster to advertise *The Yellow Book*, but not used. Signed with the artist's emblem. Pl. 376
$13\frac{5}{8} \times 10\frac{1}{8}$ inches
Princeton University Library

A typical Beardsley poster with a panel for lettering on one side. The alarmingly rising shoulders of the jacket and the jewelled-moth hair ornament (shades of Whistler's butterfly emblem) symbolize the aggressive nature of the New Woman who holds the mannikin pointing to what could have been the announcement of *The Yellow Book*.

376 Design for a front cover of *The Yellow Book*, but not used. Signed with the artist's names. Pl. 378
$7\frac{5}{8} \times 6\frac{1}{8}$ inches
Princeton University Library

The bars in the background representing shelves are noteworthy. Considered as visual formulae they are derived from similar features in Japanese prints. The books which the lady is about to place on her shelves include *The Yellow Book* of course, *Discords* by George Egerton (one of the *Keynotes* series by a New Woman), and Beardsley's own *Story of Venus and Tannhäuser*, first advertised in the Bodley Head list at the back of Volume III of *The Yellow Book* in October 1894, but never in fact to be completed by Beardsley or published by Lane.

377 A title-page ornament. First published in plate NO. 81 of *The Early Work of Aubrey Beardsley*, John Lane, 1899. 4to. Pl. 379
From the line-block

It is not known for what purpose this drawing was made. At the time of its reproduction in *Early Work* it was described as 'hitherto unpublished'. It dates probably from 1895. A nude male figure playing a double-bass was in the same category as a woman playing a piano in a field (NO. 342), except that the actions of this figure in bowing and fingering the strings of the female-shaped instrument are not only eccentric, they are charged with erotic symbolism, by the very fact of his nudity. The original drawing ($6\frac{5}{8} \times 2\frac{1}{8}$ inches) was sold by Christie, London, 19 July 1967.

378 Madame Réjane. Drawing in pen, ink and wash first reproduced on p. 65 in *A Second Book of Fifty Drawings by Aubrey Beardsley*, Leonard Smithers, 1899. Pl. 377
From the half-tone plate

The subject, the conception of the foot and the pen and brush

k suggest that Beardsley was thinking of Constantin Guys
n he made this drawing. As art editor of *The Yellow Book*
nay have arranged for the reproduction of a drawing of
e men by Guys in Plate XII of Vol. V of *The Yellow Book*,
il 1895. His own contributions to Vol. V were removed
re publication, at the time when John Lane was influen-
by a group of Bodley Head authors to drop Beardsley.

cature of Beardsley painted apparently by himself over a
tograph of him (mounted on card) by Frederick Hollyer.
ribed in pen 'Max Beerbohm from Aubrey Beardsley'.
ribed on back in red ink 'Fred^r Hollyer/9 Pembroke
Kensington W'. Pl. 331
er-colour and chinese white over photograph, $4\frac{3}{16} \times 6\frac{7}{16}$
es
Alan Thomas, London

style of the painting imitates the style of Beerbohm's
catures, up to a point. It does not seem as lightly executed
t might have been by Beerbohm himself however, and
ough he had a habit of imitating inscriptions from well-
wn persons for his own amusement, the photograph is
n the same negative by Hollyer from which another
it was made and similarly inscribed, again presumably by
rdsley himself, to William Rothenstein.

ign for a small poster advertising *The Spinster's Scrip* as
piled by Cecil Raynor and published by William Heine-
n, 1895. Signed with the artist's names. Pl. 380
$\times 9\frac{5}{16}$ inches
aceton University Library

. Gallatin, in his catalogue of 1945, maintained that this
ign was never used; but an example of the small poster or
w-card for *The Spinster's Scrip*, with lettering in the panel
the left and 'Sold Here' in capitals at the top left corner
ts in the Print Room of the Victoria and Albert Museum.
book by Rayner was issued in December 1895. A repro-
tion of the design in *Early Work* (1899) includes the
blance of a dog at the end of the leash, which is not in the
inal drawing. The design is remarkable for the arresting
angular silhouette of the standing woman's garment, and
the half-clothed, sphinx-like female leaning on the panel.
space above the second female has been heightened with
nese white to obliterate a discarded feature. In execution
drawing is rougher than was usual in Beardsley's work
his date.

tumn. Design for a calender first published as NO. 91 in
Early Work of Aubrey Beardsley, John Lane, London,
9. Pl. 396
m the line-block
e original drawing ($10\frac{1}{2} \times 5\frac{1}{2}$ inches) was reproduced in
above-mentioned book by permission of William
inemann in 1899, and was described as hitherto un-
lished. It does not seem to have been used for any calen-
. On 12 July 1961 it was sold by Messrs Sotheby for £200
Mrs H. V. Brunner.

itation card for John Lane's 'Sette of Odd Volumes
oke', on 22 February 1895. Pl. 383
m the line-block and letterpress, $4\frac{3}{8} \times 3\frac{1}{4}$ inches
W. G. Good, England

It was characteristic of Beardsley that he should see any
social occasion as an opportunity for the wearing of carnival
costume. The design is unusual amongst his work of this
period in that it is vignetted like some of the earlier *Bon-Mots*
drawings; which is to say, that the forms are not closed up,
the lines being left to end in an undefined space. It is also un-
usual in that the figure has a 'lost' profile and is viewed
three-quarters from the back. Later reproductions of the
design (see *Early Work*, pl. 127) have the letterpress capitals
O and V omitted, together with the initials of Carl Hentschel,
the line-block engraver, while a dotted line is added to the
right-hand end of the sofa.

The design was first reproduced in *The Studio*, September
1895.

383 Drawing for the frontispiece to *A Full and True Account of
the Wonderful Mission of Earl Lavender, which lasted one Night
and one Day* by John Davidson, published by Ward and
Downing, London, 1895. 8vo. Pl. 381
$10\frac{1}{8} \times 6\frac{3}{8}$ inches
*Grenville L. Winthrop Bequest, Fogg Art Museum, Harvard
University, Massachusetts*

John Davidson's peculiar humour, of which *Earl Lavender*
is a good example, is scarcely reflected in Beardsley's delicate
outlines, or in the stilted posture of the woman who holds
up a whip in one hand and her dress in the other, and places
her feet as if in some sort of dance. This is, for all that, one of
the most splendid drawings of the nineteenth, or of any other
century. The delineation of the early Victorian fireplace and
fender is a wonderful transformation of the commonplace
into the grand; and, on second glance, the stilted figure of the
flagellateuse does suggest, without broken or impressionist
lines, the various movements she would make, with a languid,
fin-de-siècle gentility.

384 The Scarlet Pastorale. Illustration on p. 16 in *The London
Year Book*, 1898, and accompanying an article entitled *Aubrey
Beardsley* by W. L., pp. 46–50. Published by the Grosvenor
Press, London. 8vo. Titled 'The Scarlet Pastorale'. Pl. 384
$10\frac{9}{16} \times 7\frac{5}{16}$ inches
*Scofield Thayer Collection, Fogg Art Museum, Harvard Univer-
sity, Massachusetts*

This composition was first published in *The Sketch*, 10 April,
1895; then again in *A Book of Fifty Drawings by Aubrey
Beardsley*, Smithers, London, 1897, p. 35. The first use of
scarlet for the block was in *The London Year Book* of 1898.

The arrested movement of the dancer on the stage is
cleverly aided by a suggestion of the motions that brought
him to the posture he is in. This is done by the gradual
elongation of the lozenges on his harlequin costume to the
left, and by the serpentine alignment of the lozenges along
the front leg to the shoulder on the left. The masqueraders
behind him are not in the same dimension, for they are on the
backcloth and are literally images on the backcloth haunting
the dancer on the stage. The two candlesticks are in another
dimension again, because they are not visibly supported by
anything and are in a different scale from the figures. For
some reason hard to explain the transitions in this design
make it one of the most memorable of Beardsley's works.
If the editor of *The London Year Book* had not been at Brighton
Grammar School with Beardsley it is doubtful whether the

article in memory of the artist, who had just died, would have appeared in such a publication.

385 Front cover of *Sappho*, a memoir with text, selected renderings and a literal translation by Henry Thornton Wharton, published by John Lane, London, and A. C. M'Clurg and Company, Chicago, July 1895. Third edition, and the first with this format. 8vo. Pl. 382
Blue cloth stamped with a design in gold
Mr W. G. Good, England

Beardsley's cover designs are all remarkable for their restraint, for meagre or minimal elegance, in its way another expression of an aesthetic ideal held by such poets as Lionel Johnson and Ernest Dowson, and in the graphic arts by Charles Ricketts.

386 The Mirror of Love. Design for the frontispiece to a book of poems by Mark André Raffalovich, entitled *The Thread and the Path*, published by David Nutt, London, 1895; but not used. Pl. 385
$10\frac{13}{16} \times 6$ inches
Victoria and Albert Museum, London

This drawing was intended to illustrate the line 'Set in a heart as in a frame Love liveth', which was the first line of the first poem in the book. Nutt refused to publish it as a frontispiece, observing that 'whatever you may say the figure is hermaphrodite'. (See *Catalogue of Aubrey Beardsley Exhibition at the Victoria and Albert Museum*, 1966, NO. 555). The candelabrum is a curious conception springing from a form derived from that of a German goblet of the sixteenth century.

387 Venus between Terminal Gods. Design for the frontispiece to Beardsley's romantic novel, *The Story of Venus and Tannhäuser*, advertised to be accompanied by twenty-four illustrations in John Lane's list of 1894, but never completed. Lettered 'Venus'. Pl. 386
Indian ink touched with white, $8\frac{7}{8} \times 7$ inches
Cecil Higgins Art Gallery, Bedford, England

An expurgated version of the incomplete novel was published as *Under the Hill* in *The Savoy*, NOS. 1 and 2, 1896. When this drawing was made in 1895 it was much admired by Lord Leighton, among others (see Haldane Macfall, *Aubrey Beardsley*, London, 1928, p. 69). It is static and frontal: the ideal figure of Venus is flanked by two sinister Terms, a typical Beardsley contrast. The background reverts in style to decorative passages in *Le Morte Darthur*. According to Vallance it reflects the influence of Charles Ricketts or Laurence Housman (R. Ross, *Aubrey Beardsley*, London, 1909; List of Drawings compiled by A. Vallance, p. 95, NO. 101). If Vallance was referring to the background of the title-page in *The End of Elfintown*, which was designed by Housman and published in 1894, then it was more likely that Housman was influenced by Beardsley's early work for *Le Morte Darthur*. Vallance also says the design was intended for 'a version of the Tannhäuser legend to be published by Messrs H. Henry & Co., Ltd.', by which he implies that Henry & Co. as well as the Bodley Head were interested in publishing the novel.

388 Venus. Design for a title-page intended for Beardsley's

romantic novel, *The Story of Venus and Tannhäuser*, but used. Lettered with title. Pl. 388
$4\frac{3}{8} \times 3\frac{1}{8}$ inches
Grenville L. Winthrop Bequest, Fogg Art Museum, Har. University, Massachusetts

This design was first published in *The Studio*, 1898, Vol.

389 Frontispiece to *The Story of Venus and Tannhäuser* Beardsley's unfinished novel, intended to be published John Lane at The Bodley Head, London, in 1895. Sig with the artist's initials and dated 1895 in a roundel. Re duced in plate 92 in *The Early Work of Aubrey Beard* John Lane, London, 1899. Pl. 387
$11\frac{11}{16} \times 7$ inches
Grenville L. Winthrop Bequest, Fogg Art Museum, Har. University, Massachusetts

The exclusion of erotic overtones from this design and astonishing poise bring it close to the work of Anning and they also suggest that Beardsley's story of Venus Tannhäuser was something with serious meanings for beyond, or beside, its lascivious innuendos. Here the cand stick has an exaggerated delicacy of form: the sixteen century German goblet, which struck Beardsley's fancy this date and occurs again in 'The Mirror of Love' (NO. appears just as a student might have drawn it in a muse The fountain and the park seen through the windows tak back once more to *Le Morte Darthur*. The title-page desig alongside this frontispiece is reproduced at Pl. 389.

390 The Story of Venus and Tannhäuser, etc. Designs inten for the frontispiece and title-page of Beardsley's unfinis novel, advertised in *The Yellow Book*, Vol. III, October 18 as on this title-page. Signed with the artist's initials and date 1895 in a roundel in the frontispiece. Reproduced plate 92 of *The Early Work of Aubrey Beardsley*, John La London, 1899. Pl. 389
From the line-block

After the 1895 crisis, when Lane authorized the dismissa Beardsley from *The Yellow Book* staff, there could be no qu tion of *Venus and Tannhäuser* being published by The Bod Head. When the story, in a bowdlerized version, was p lished by Smithers in *The Savoy*, NOS. 1 and 2, these desig were not used.

The architectural frames and the composite capitals linked perhaps with memories of woodcuts in the *Hypnero machia Poliphili* of 1499; and the title-page on the rig crammed with Roman lettering, doubtless follows the p cedent found in the epitaph NO. 108 in Appell's facsimile the *Hypnerotomachia* published in 1889.

391 The Return of Tannhäuser to the Venusberg. Drawing tended to illustrate Beardsley's romantic novel *The Stor Venus and Tannhäuser*, announced with twenty-four full-p illustrations in John Lane's 1894 list, but not comple Signed with monogram. Inscribed on the back with title 'To J. M. Dent my kind friend, & first publisher; fr Aubrey Beardsley. Sept. 1896'. Pl. 390
Indian ink and wash, $5\frac{1}{4} \times 5\frac{3}{16}$ inches
Mr F. J. Martin Dent, London

The first reproductions of this drawing were in reverse, a

Idler, May 1898, and *Later Work,* pl. 74. An earlier wash …ving of the same subject dates from 1891 (see NO. 19). …theme of Tannhäuser's return, in pilgrim's clothes, to the …n of Venus, fascinated Beardsley over the years, and the …ent design is one of the most moving ever to be conceived …im.

…de. Drawing reproduced in colour lithography (red, …n, grey and black) as a supplement to *The Studio,* October …. Titled as above. Pl. 391
…and ink and water-colour, $11\frac{1}{16} \times 7$ inches
…ville L. *Winthrop Bequest, Fogg Art Museum, Harvard* …ersity, *Massachusetts*

…colours used by Beardsley were purple-grey wash in the …kground and grey wash and indian ink for the figure. In …lithograph published in *The Studio* the backcloth is toned …the drawing is hardened, while the colours are bright. …re exists a proof of a colour-lithograph after this drawing, …ribed by A. J. A. Symons as taken before publication in …e 24 of *The Early Work of Aubrey Beardsley,* 1899; in this …e the backcloth is orange, and no green appears. The …e in *Early Work* ended by being the same in colouring as …*Studio* supplement.
…eardsley's interpretation of one of his favourite Wagner-…heroines as a woman of his own period may be compared …n the right-hand woman in 'Café Noir' (NO. 394), who …rs a similar hat, turned up to give the impression of the …ines of an exotic butterfly's wing.

…ssalina returning home. 1895. Illustration to the Sixth …re of Juvenal. On the back a drawing in ink, possibly for …ornamental initial; also a guarantee by Leonard Smithers …d 27 April 1898. Pl. 392
…cil, indian ink and water-colour, 11×7 inches
…e Gallery, *London*

…e pinkish-purple water-colour was added apparently by …rdsley before 1898 and was not part of the original …wing.

…st frontispiece to *An Evil Motherhood* by Walt[er] Ruding, …blished by Elkin Mathews, London, 1896. 8vo. Pl. 393
…n, ink and wash, $6\frac{1}{8} \times 6\frac{1}{4}$ inches
…field Thayer Collection, *Fogg Art Museum, Harvard Univer-*…, *Massachusetts*

…ardsley introduced a grey wash into the drawing which …ant it could only be reproduced by half-tone. This frontis-…ce appeared in six copies only (or twelve, according to …thews himself) of the first issue of the book in November …5. It had formerly been entitled 'Black Coffee' (Café Noir) …l was intended for publication in *The Yellow Book,* Vol. V, …ril 1895, but was withdrawn at the last minute from that …lume along with four other plates and the front cover …er Beardsley's designs when Lane authorized his dismissal …m *The Yellow Book* staff. The drawing was then supplied …the artist to Mathews for Ruding's story, with which it has …connection. Lane objected; and Mathews made Beardsley …sign a fresh frontispiece (see NO. 395) which replaced …ack Coffee' in the rest of the issue. Later issues of the book …d 'Black Coffee' tipped in alongside. It has many familiar …aracteristics of Beardsley's style and is related to 'Waiting'

(see NO. 249) and, in the shape of the right-hand woman's hat, to 'Isolde' (see NO. 392).

395 Second frontispiece to *An Evil Motherhood* by Walt[er] Ruding, published by Elkin Mathews, London, 1896. 8vo. Pl. 394
From the line-block
Mr Brian Reade, London

For the first frontispiece see NO. 394. When Mathews saw the advance copies of the book with the first frontispiece ('Black Coffee') substituted for the portrait of Ruding that had been stipulated, he was, not unreasonably, annoyed: so was Lane, who had commissioned the drawing for Vol. V of *The Yellow Book,* from which it had been withdrawn, along with the front cover design and four other designs within, when Beardsley was dismissed from the art-editorship. But Mathews went to Beardsley's rooms and would not leave until he had seen the present frontispiece (which was more or less a portrait of Ruding) well advanced. Ruding gave Beardsley two or three sittings.

Of all Beardsley's compositions this is perhaps the most evocative of the *fin-de-siècle* drama: the props are the oil-lamp, the antimacassar, the loose-covered armchair, the rug and the fender; the actors are the youth with long hair and pierrot-style slippers and trousers (Beardsley's specific contributions) and the ruthless mother, looking down on her son.

396 Illustration to 'At a Distance', a poem by Justin Huntly M'Carthy (p. 189) on p. 191 of *A London Garland,* an anthology of verse selected by W. E. Henley with pictures by members of the Society of Illustrators, published by Macmillan and Company, London and New York, December 1895. 4to. Pl. 395
From the line-block
Mr W. G. Good, England

On p. 190 was another illustration by W. D. Almond. In *A Second Book of Fifty Drawings by Aubrey Beardsley,* Smithers, London, 1899, Beardsley's illustration in *A London Garland* is reproduced on p. 115 with the title 'A Suggested Reform in Ballet Costume (unfinished drawing)', and is described as 'hitherto unpublished'. The scale there is enlarged and the three-line border on the right re-drawn from the end of the artist's signature. The original drawing included another figure on the left which appears to have been deleted before the block-making stage. Had Beardsley survived into the period of the Ballet Russes he would undoubtedly have been taken up by Diaghilev, who met him once before his death and had a profound admiration for his work.

397 Designs for the front covers and spines of the volumes in the 'Pierrot's Library', a series of novels published by John Lane, London; Henry Altemus, Philadelphia (Vols. I and II) and Rand McNally and Company, Chicago (Vols. III and IV), 1896. Pl. 397
$6\frac{1}{4} \times 4\frac{11}{16}$; $5\frac{9}{16} \times \frac{5}{16}$ inches
Princeton University Library

These designs were used for all the volumes but were stamped in different colours (red, blue, green and brown) on buff cloth for each title.

398 Decoration on back covers of volumes in the 'Pierrot's Library', published by John Lane, London; Henry Altemus, Philadelphia (Vols. I and II); and Rand McNally and Company, Chicago (Vols. III and IV), 1896. 8vo. Design stamped in red, blue, green and brown on buff cloth for each different volume. Reproduced as NO. 138 in *The Early Work of Aubrey Beardsley*, John Lane, London, 1899. Pl. 399
From the line-block

Beardsley had been anticipated in the idea of this motif by Tom Meteyard, who designed the front cover of *Poems from Vagabondia* by Bliss Carmen and Richard Hovey, published by Elkin Mathews and John Lane, London, 1894. In Meteyard's design, which is stamped in black on grey board, there are three faces in the light portion of the Moon, and a dark crescent.

399 Design for the title-pages in the 'Pierrot's Library', a series of novels published by John Lane, London; Henry Altemus, Philadelphia (Vols. I and II) and Rand McNally, Chicago (Vols. III and IV), 1896. Pl. 398
$6\frac{1}{16} \times 4\frac{3}{16}$ inches
Princeton University Library

400 Design for the front end-papers of the volumes in the 'Pierrot's Library', published by John Lane, London; Henry Altemus, Philadelphia (Vols. I and II) and Rand McNally, Chicago (Vols. III and IV), 1896. Signed with the artist's name. Inscribed in pencil near top of tree '1st end paper'. Pl. 400
$6\frac{1}{2} \times 9\frac{3}{16}$ inches
Princeton University Library

The design was printed in olive green.

401 Design for the back end-papers of the volumes in the 'Pierrot's Library', published by John Lane, London; Henry Altemus, Philadelphia (Vols. I and II) and Rand McNally, Chicago (Vols. III and IV), 1896. Signed with the artist's names. Inscribed in pencil behind ruff of right-hand figure '2nd end paper'. Pl. 401
$6\frac{1}{2} \times 9\frac{3}{16}$ inches
Princeton University Library

The design was printed in olive green.

402 Front wrapper of the *Catalogue of Rare Books* offered for sale by Leonard Smithers, Effingham House, Arundel Street, London, NO. 6, 1896. 8vo. Pl. 402
From the line-block and letterpress
Mr W. G. Good, England

The wrappers of the catalogues NOS. 1–4 issued by Smithers bore a design similar to the one for Vol. V of *The Yellow Book*, though different in proportion and details. The wrappers of NOS. 5–7 were printed in black on pink (5), light blue (6) and violet grey (7).

403 Design for the front cover of *The Rape of the Lock*, an heroi-comical poem in five cantos written by Alexander Pope, embroidered with nine drawings by Aubrey Beardsley. Published by Leonard Smithers, London, May 1896. Crown 4to. Signed with intials left and right. Pl. 404
$9\frac{7}{8} \times 6\frac{15}{16}$ inches
Mr R. A. Harari, London

It was at the suggestion of Edmund Gosse that Beard undertook to illustrate this poem. But he seldom illustra anything literally: rather he made graphic comments on text, as he did on *Salome*, which explains the use of the w 'embroidered' on the title-page of *The Rape of the Lock*. cover design is one of the finest ever conceived. The stren and beauty of the drawing in indian ink were somew modified in gold on the covers of the ordinary edition, wh were turquoise-blue, and even more so on those of the editi de-luxe, which were of vellum.

404 The Dream. Drawing for the frontispiece of *The Rape of Lock,* an heroi-comical poem in five cantos written Alexander Pope embroidered with nine drawings by Aub Beardsley. Published by Leonard Smithers, London, N 1896. Crown 4to. Pl. 405
$10 \times 6\frac{3}{4}$ inches
Mr John Hay Whitney, New York

The eclectic confusions of this design gave birth to som the most typical pre-1914 styles of ornament. The deco tions on the bed curtains drawn in Beardsley's stipp manner must have remained in the unconscious of many artist; for here are the posies in baskets, the garlands swags of flat roses, the tassels and the peacocks with spre ing tails which appeared in the medium of dots, just as they here, over many a wallpaper, textile, Christmas card end-paper of the 1900s. These are motifs taken from Louis Seize and Aesthetic periods. As for the clothes of courtier, they are modelled on those of a ballet dancer of first half of the eighteenth century, when the wide-spread *tonnelet* was in vogue. But the *tonnelet* here is enriched w roseate garlands of the 1770s, as popularized by Le Boquet, the costume designer of the Opéra under Louis X The sense of space achieved by lines of slightly differ values is remarkable.

405 The Billet-Doux. The second illustration reproduced headpiece on p. [1] in *The Rape of the Lock* an heroi-com poem in five cantos written by Alexander Pope embroide with nine drawings by Aubrey Beardsley. Published Leonard Smithers, London, May 1896. Crown 4to. Pl.
From the line-block

This illustration has been much admired because it is pre It has the absurd prettiness of a work by some *petit maîtr* the *ancien régime*. In the title-pages of some of the *Keyn* series Beardsley explored decorative symmetry disturb by unruly details. And the style of this illustration r counter to the disintegrative compositions of his for drawings inspired by Japanese art: here the figure is centre with counterbalancing details, and with a ne symmetrical bedhead and wallpaper above. *The Rape of Lock* was a turning point in Beardsley's development: then forward centralized compositions like this became m frequent. The simplification of the hand follows a trenc much decorative drawing of this date, whereby details w taken for granted. But Beardsley's outline treatment o nearly deprives it of meaning.

406 The Toilet. Drawing for the third illustration facing p. 6 *The Rape of the Lock* an heroi-comical poem in five can written by Alexander Pope embroidered with nine drawin

Aubrey Beardsley. Published by Leonard Smithers, ·don, May 1896. Crown 4to. Pl. 406
·6¾ inches
·eland Museum of Art, U.S.A.

·ded dots are used in a stippled effect to suggest varied
·es in the landscape decorations on the screen, on the
·nces of the women, and for the vertical pattern on the
·paper.

Baron's Prayer. Drawing for the fourth illustration
·ng p. 8 in *The Rape of the Lock* an heroi-comical poem in
· cantos written by Alexander Pope embroidered with
· drawings by Aubrey Beardsley. Published by Leonard
·thers, London, May 1896. Crown 4to. Pl. 407
·6¹³⁄₁₆ inches
·ield Thayer Collection, Fogg Art Museum, Harvard Univer-
·, Massachusetts

· design illustrates Pope's lines about the Baron, who

'. . . to *Love* an Altar built,
Of twelve vast *French* Romances, neatly gilt.
There lay three Garters, half a Pair of Gloves,
And all the Trophies of his former Loves.
With tender *Billet-doux* he lights the Pyre,
And breathes three am'rous Sighs to raise the Fire.
Then prostrate falls, and begs with ardent Eyes
Soon to obtain, and long possess the Prize.'

· prize being a lock of Belinda's hair.

· Barge. Fifth illustration facing p. 10 in *The Rape of the*
·k an heroi-comical poem in five cantos written by
·xander Pope embroidered with nine drawings by Aubrey
·rdsley. Published by Leonard Smithers, London, May
·6. Crown 4to. Pl. 408
·m the line-block

Rape of the Lock. Sixth illustration facing p. 20 in *The*
·e of the Lock an heroi-comical poem in five cantos written
·Alexander Pope embroidered with nine drawings by
·rey Beardsley. Published by Leonard Smithers, London,
·· 1896. Crown 4to. Pl. 409
·m the line-block

·noment of suspense is evoked, the moment just before
·Baron cuts off the lock of hair. The sagacious dwarf con-
·ng at the reader and taking a cup of chocolate is the
·est, and almost the central, feature of the composition,
·rony characteristic of Beardsley's art. Everything else is
·cessfully balanced behind him—the clothes (first notice-
· because of their elaborate decorations), the figures, the
·ains (all stipple), the window and the view of the park
·side it. The furniture is scarcely of the eighteenth century:
·ed the chair Belinda sits on is like a Thonet chair with
·kely carvings attached; and, as in other illustrations in
·book, the clothes are more or less appropriate for the man,
·for the women they are taken from fashions of the 1780s.
·pite of anachronisms however the illustration is a record
·Beardsley's skill and taste. In his day this particular
·tery had never been achieved in any medium: nor has it
· achieved since, for the reason that it springs as much
·n limitations as from gifts that can hardly be found in
·bination again.

410 The Cave of Spleen. Drawing for the seventh illustration
facing p. 24 in *The Rape of the Lock* an heroi-comical poem in
five cantos written by Alexander Pope embroidered with
nine drawings by Aubrey Beardsley. Published by Leonard
Smithers, London, May 1896. Crown 4to. Pl. 411
9⅞ × 6⅞ inches
The Boston Museum of Fine Arts, U.S.A.

This strange design, in which some of the creatures appear
to be ornamental motifs coming to life, seems to have had a
considerable influence on Beardsley pasticheurs in the early
twentieth century: for example, Alan Odle, in his earlier
works.

411 The Battle of the Beaux and the Belles. Drawing for the
eighth illustration facing p. 34 in *The Rape of the Lock* an
heroi-comical poem in five cantos written by Alexander Pope
embroidered with nine drawings by Aubrey Beardsley.
Published by Leonard Smithers, London, May 1896. Crown
4to. Pl. 410
9¹⁵⁄₁₆ × 6¾ inches
The Barber Institute of Fine Arts, Birmingham

Beardsley's illustrations to *The Rape of the Lock* were the most
admired of all his works during the years following his death.
The variety of tone and texture suggested by the dots and
the close-laid lines is a marvel of craftsmanship. While the
clothes of the men are more or less appropriate to the date
of the poem, the clothes of the women are based on styles of
the 1780s. The chair is based on rococo designs of the mid-
eighteenth century.

412 The New Star. Drawing for the cul-de-lampe on p. 38 in
The Rape of the Lock an heroi-comical poem in five cantos
by Alexander Pope embroidered with nine drawings by
Aubrey Beardsley. Published by Leonard Smithers, London,
May 1896. Crown 4to. Signed with the artist's intials. Pl. 412
12⅛ × 7⅛ inches
*Grenville L. Winthrop Bequest, Fogg Art Museum, Harvard
University, Massachusetts*

The periwig and tiny cap with vast plumes suggest the
style of the costumes of the famous Carrousel of 1662 held
by Louis XIV in Paris—though there is no written evidence
that Beardsley knew of the engravings that record this event.
The rest of the costume differs little from other gala or
carnival costumes conceived by Beardsley.

413 Front cover of the bijou edition of *The Rape of the Lock* an
heroi-comical poem by Alexander Pope etc., published by
Leonard Smithers, London, 1897. Demy 16mo. Pl. 413
Red cloth stamped with title, and design in gold

The plates of the bijou edition of 1897 were similar to those
of the big edition of 1896, but reduced in scale. Plate 1
repeated in line-block the design of the front cover, without
the lettering. Plate 2 reproduced in line-block a reduced
version of the design for the front cover of the 1896 edition
(NO. 403). Beardsley's original drawing for the present design
was intended for the actual cover of the little red edition.
Writing to Smithers from Paris on 27 April 1897, he enclosed
a slip for the lettering of the title which was arranged as shown
here; and he warned Smithers that there was some chinese
white on the drawing, 'so let it not be touched with india
Rubber'.

414 Design for the front cover of the prospectus of *The Savoy,*
NO. 1, January 1896; edited by Arthur Symons and published
by Leonard Smithers, London. 4to. Signed with the artist's
names in capitals below the design. Reproduced on pink
paper. Pl. 414
$9\frac{3}{8} \times 6\frac{9}{16}$ inches
*Scofield Thayer Collection, Fogg Art Museum, Harvard Univer-
sity, Massachusetts*
According to Bernard Shaw (see Grant Richards, *Author
Hunting,* 2nd ed. 1948, note on pp. 33, 34) Beardsley's other
design for the prospectus, showing a pierrot on the right in
a reversed posture to John Bull (reproduced in *Later* Work,
NO. 107), was objected to by Smithers as too flippant. The
pierrot design was printed, but Beardsley having provided
the Bull design, this too was printed (without his signature)
and distributed in December 1895. When it was too late,
George Moore and other *Savoy* contributors, including Shaw,
told Smithers he must withdraw a prospectus which showed
John Bull with a diminutive erection under his breeches.
Not having any of the prospectuses left, Smithers agreed.

415 Siegfried. Drawing used for the publisher's emblem of
Leonard Smithers, on the back cover of the prospectus of
The Savoy, NO. 1, issued in December 1895; and on the back
cover of *The Savoy,* NOS. 1 and 2. Pl. 417
$3\frac{11}{16} \times 2\frac{13}{16}$ inches
Princeton University Library

The top panel contained the word 'Leonard' and the bottom
panel 'Smithers'. Owen Seaman greeted the appearance of
The Savoy with a 36-line poem entitled 'A New Blue Book',
of which the first stanza ran:

> '"The world's great age begins anew,"
> Cold virtue's weeds are cast;
> Our heads are light, our tales are blue,
> And things are moving fast;
> And no one any longer quarrels
> With anybody else's morals.'

And the fifth:

> 'O cease to know your Bodley pap
> Whence all the spice is spent!
> The splendour of its primal tap
> Was gone when Aubrey went;
> Behold that subtle Sphinx prepare
> Fresh liquors fit to lift your hair.'

(*The Battle of the Bays,* London 1896)

416 The Savoy. Design for the front cover of *The Savoy,* NO. 1,
January 1896. Reproduced on pink boards for that number,
edited by Arthur Symons and published by Leonard
Smithers, London, January 1896. 4to. Signed in ink with the
artist's names and dated 1896; titled in ink 'The Savoy', and
in pencil 'NO. 1 January 1896'. Pl. 415
Indian ink and pencil, $14\frac{5}{8} \times 11$ inches
*Grenville L. Winthrop Bequest, Fogg Art Museum, Harvard
University, Massachusetts*

The design was used also in NO. 2 of *The Savoy,* April 1896.
Proofs were made from a line-block reproducing the design
completed, with the pencilled lettering and numerals inked
in. The putto is shown as if about to urinate on a copy of
The Yellow Book on the ground, Beardsley revealing here
some bitterness over his ejection from the staff of that

magazine eight months before. George Moore having cr
cised this detail, *The Yellow Book* and the genitals of the pu
were deleted for publication.

417 Drawing for the title-page of *The Savoy,* NO. 1, January 18
edited by Arthur Symons and published by Leon
Smithers, London. 4to. Signed with the artist's names
dated 1896. Pl. 416
$14\frac{5}{8} \times 11$ inches
*Grenville L. Winthrop Bequest, Fogg Art Museum, Harv
University, Massachusetts*

This title-page was first used in the first number of *The S*
and again for the second number; also for the gold-stamp
design on the front covers of the publisher's cases of vio
cloth as provided for binding the eight numbers of
periodical in three volumes; and also for the gold-stamp
designs on the de luxe front covers of vellum.

418 John Bull in a cloak, holding with his right hand a quill a
a draughtsman's pencil and pointing with his left ha
toward the word Contents in Gothic lettering which w
added on the printed page. Design for p. 7 preceding
page with the contents list in *The Savoy,* NO. 1, January 18
edited by Arthur Symons and published by Leon
Smithers, London. 4to. Pl. 418
$9\frac{1}{16} \times 7$ inches
*Scofield Thayer Collection, Fogg Art Museum, Harvard Uni
sity, Massachusetts*
The figure here was a non-provocative re-statement of
figure of Bull as formerly drawn for the second prospec
of *The Savoy.*

419 The Three Musicians. Intended illustration to the poem
Beardsley thus entitled on p. 65 of *The Savoy,* NO. 1, Janu
1896, edited by Arthur Symons and published by Leon
Smithers, London. 4to. Not used. Pl. 419
From the line-block

This design was considered provocative and was replaced
the one reproduced at Pl. 420. It was first published in
Book of Fifty Drawings by Aubrey Beardsley, Smithers, Lond
1897, p. 167.

420 The Three Musicians. Illustration to the poem (p. 65)
Beardsley thus entitled on p. 64 of *The Savoy,* NO. 1, Janu
1896, edited by Arthur Symons and published by Leon
Smithers, London. 4to. Pl. 420
From the line-block

This design replaced the one at NO. 419. The actress, Sop
Menter, was, according to Beardsley in a letter to his sis
the heroine of the poem.

421 The Bathers. Illustration to the article 'Dieppe: 1895'
Arthur Symons on p. 87 of *The Savoy,* NO. 1, January 1
edited by Arthur Symons and published by Leonard Smith
London. 4to. Pl. 422
From the line-block

In the summer of 1895 Beardsley and Symons had b
staying in Dieppe, and the illustrated article was one of

ults of their encounters. While Symons enjoyed seeing
men bathing on the beach, Beardsley seldom went out of
ors and paid very little attention to the sea. The result is
moonscape with the familiar arc of flying birds in the sky
suggest the open air. Even more strange is the central
ure with her high shoulders, flat breasts, long sixteenth-
tury waist and exaggerated pelvis. This is intended to be
actress Cléo de Mérode, who is referred to in the article
wearing a gold chain over her bathing dress—though in
her respects the drawing scarcely corresponds with the
cription by Symons. Cléo de Mérode died in 1966.

oska. Illustration to 'Dieppe: 1895' by Arthur Symons on
1 of *The Savoy*, NO. 1, January 1896, edited by Arthur
mons and published by Leonard Smithers, London. 4to.
421
om the line-block

ne dance has begun: it is the Moska, with its funny
rthm, its double stamp of the heels'. This passage in the
icle 'Dieppe: 1895' by Arthur Symons refers to a dance
he *Bals des Enfants* in the Casino at Dieppe, which occur-
l on certain afternoons and fascinated Beardsley. It is
ssible that such a fan would have been suspended on a
bon, but Beardsley has not indicated this and the position
he hand is the only weakness in an otherwise remarkable
wing.

e Abbé. Drawing for illustration to *Under the Hill* by
brey Beardsley, reproduced on p. 157 in *The Savoy*, NO. 1,
nuary 1896; edited by Arthur Symons and published by
onard Smithers, London. 4to. Pl. 423
× 6⅞ inches
R. A. Harari, London

der the Hill was the original title of Beardsley's unfinished
vel which was to have been published by John Lane as
e *Story of Venus and Tannhäuser*. The spavin-legged dandy
ginally represented the 'Abbé Aubrey' as the hero of the
ry: the Abbé Aubrey however was changed to the 'Abbé
nfreluche', in *Under the Hill* as published in *The Savoy*, and
the 'Chevalier Tannhäuser' in the version of *The Story of*
nus and Tannhäuser published by Leonard Smithers in
7. The drawing illustrates a passage at the beginning of
der the Hill on p. 156 of *The Savoy*, NO. 1. 'The place where
stood waved drowsily with strange flowers, heavy with
fume, dripping with odours. Gloomy and nameless weeds
to be found in Mentzelius. Huge moths, so richly winged
y must have banqueted upon tapestries and royal stuffs,
pt on the pillars that flanked either side of the gateway,
l the eyes of all the moths remained open and were burn-
, and bursting with a mesh of veins'.

e Toilet. Illustration to *Under the Hill* by Aubrey Beards-
, Chapter II, reproduced on p. 161 of *The Savoy*, NO. 1,
nuary 1896, edited by Arthur Symons and published by
onard Smithers, London. 4to. Pl. 424
om the line-block

is illustration was later called 'The Toilet of Helen', under
ich name the Venus of the original story appears in *Under*
Hill. The seated figure on the right represents 'Mrs
rsuple', the fat manicure and fardeuse.

Pl. 424 has been made from one of the prints of 1896 in which parts of the reproduction were defective, giving broken lines, patches of white etc. in the floor and the figures of the two dwarfs. Later reproductions were made from the same line-block print of 1896, and exaggerated these defects.

425 The Fruit Bearers. Drawing for illustration to *Under the Hill* by Aubrey Beardsley, Chapter III, reproduced on p. 167 of *The Savoy*, NO. 1, January 1896; edited by Arthur Symons and published by Leonard Smithers, London. 4to. Pl. 425
9¾ × 6⅞ inches
Scofield Thayer Collection, Fogg Art Museum, Harvard University, Massachusetts

426 A Large Christmas Card. The Virgin and Child on a card loosely inserted at the end of *The Savoy*, NO. 1, January 1896; edited by Arthur Symons and published by Leonard Smithers, London. 4to. Signed with the artist's names. Pl. 429
From the line-block

Beardsley himself had a low opinion of this design for a Christmas card.

427 Choosing the New Hat. Front cover of *The Savoy*, NO. 2, April 1896, edited by Arthur Symons and published by Leonard Smithers, London, 4to. Pl. 427
From the line-block

The cover was of pink boards with the design in black. The same design was printed on white paper as a plate at the end of the volume, p. 201. Beardsley's very personal ideas of tall Roman capitals, with the unbalanced S, the high-barred A and the small Y, which appeared first on the front cover of NO. 1 of *The Savoy*, were retained for NOS. 2–7. The background of the composition has been evolved from looking at French prints of the 1780s, whether by Moreau, Eisen or St Aubin scarcely matters. The clothes of the women are strictly of the late nineteenth century, but survive well in a Louis Seize atmosphere. The page, or hatter's apprentice, is a creature of the 1780s, but also the last-but-one manifestation of the foetal obsession of 1893 to occur in Beardsley's work; *not* an infant, he wrote to Smithers, 'but an unstrangled abortion'. The name of the hat-shop 'Elise', in slanted facsimile handwriting, and the date 19..., are memories of the dying nineteenth century carried over to a dream of the living present, which for Beardsley at that date was in the last years of the *ancien régime* of the previous century.

428 A Footnote. Illustration on p. 185 preceding the instalment of *Under the Hill* in *The Savoy*, NO. 2, April 1896; edited by Arthur Symons and published by Leonard Smithers, London. 4to. Pl. 428
From the line-block

This self-portrait by Beardsley was reproduced in gold on the scarlet front cover of *The Second Book of Fifty Drawings by Aubrey Beardsley*, Smithers, London, 1899, but with Pan's torso and the cord deleted. It is a vital point to comprehend that the artist saw himself as tethered to the pagan god Pan, and he emphasizes this affinity by exaggerating the faun-like ears. Also it must be noted that this is the only representation of Beardsley's legs that we have: if they were really like

this, then the spavin-shaped Abbé (who was originally the 'Abbé Aubrey', NO. 423), the knock-kneed Siegfried (NO. 164) and similar figures in his work as a whole can be understood as partly self-identified.

429 The Ascension of Saint Rose of Lima. Illustration to a passage in *Under the Hill* by Aubrey Beardsley (Chapter IV) on p. 189 in *The Savoy*, NO. 2, April 1896; edited by Arthur Symons and published by Leonard Smithers, London. 4to. Pl. 426
From the line-block

The aesthetic and baroque elements in later Roman Catholic legends began to appeal to Beardsley, especially in 1896 when his friendship with André Raffalovich and John Gray, both homosexuals converted to Catholicism, became more necessary to him. This illustration and its treatment are leading in a direction later explored in literary terms by Ronald Firbank, in such novels as *The Flower Beneath the Foot* (1923).

430 The Third Tableau of Das Rheingold. Drawing reproduced on p. 193 in *The Savoy*, NO. 2, April 1896; edited by Arthur Symons and published by Leonard Smithers, London. 4to. Pl. 430
$10 \times 6\frac{7}{8}$ inches
Museum of Art, Rhode Island School of Design, U.S.A.

The figures represent Wotan, Loge and Fafner in Wagner's operatic cycle The Ring, and the drawing is one of a group by Beardsley illustrating subjects in *Das Rheingold* (see NOS. 438, 446, 447, 448, 449).

431 The Driving of Cupid from the Garden. Design for the panel below the title on the front wrapper of *The Savoy*, NO. 3, July 1896; edited by Arthur Symons and published by Leonard Smithers, London. 4to. Signed in capitals 'Aubrey Beardsley Etc.' Pl. 431
$9\frac{3}{4} \times 7\frac{3}{8}$ inches
National Gallery of South Australia, Adelaide

The design was printed in black, with title in red, on light blue paper for the wrapper, and in black on white paper for the first page of the volume.

The old man in the odd cap is making advances to the young woman. Cupid, muffled in a cloak, is hastening away from them.

432 Puck on Pegasus. Drawing for decoration on the title-pages of *The Savoy*, NOS. 3–8; edited by Arthur Symons and published by Leonard Smithers, London, 1896. 4to. Signed with the artist's initials. Pl. 432
$9 \times 6\frac{7}{8}$ inches
Scofield Thayer Collection, Fogg Art Museum, Harvard University, Massachusetts

A small version of the Puck emblem was used for the imprint on many of the books published by Smithers.

433 The Coiffing. Reproduction in *The Savoy*, NO. 3, July 1896, p. [90]; edited by Arthur Symons and published by Leonard Smithers, London. 4to. Illustration to Beardsley's own poem

'The Ballad of a Barber' on p. [91]. Signed with the artist['s] names. Pl. 434
From the line-block

To understand this composition in the sense that Beards[ley] intended, it should be necessary to read the poem it illustrat[es]. It is sufficient to say that the capable, brilliant barber, w[ith] his ornate hair framing a sly, domed, constipated, feminin[e] face set on the form of a female, and wearing a symbo[lic] apron tied with a sash at the back, is so ravished by the pre[tty] little princess of thirteen whose hair he has been tending t[hat] he destroys her, and then tiptoes out of the room on point[ed] feet. Soon afterwards he is hanged.

The drawing is in the same line of development as t[he] second frontispiece to *An Evil Motherhood* (NO. 395) wh[ich] itself links up iconographically with the outline engravin[gs] of Henry Moses and other Neo-Classic artists of the Regen[cy]. The varying strengths of line help to give depth, or an illusi[on] of space, to the composition. The orderly flight of bir[ds] outside the window is contrasted with the dangerou[sly] placed *art nouveau* vase on the edge of the Victorian table w[ith] its attenuated and abruptly-curved cabriole leg. For all t[he] richness of the background, the whole effect is suggesti[ve] not of a palace but of a late Victorian house in the subur[bs], which makes the illustration all the more alarming, becau[se] the barber's act becomes furtive and commonplace. From [a] technical standpoint this must count as one of Beardsle[y's] finest drawings: and yet, looking back upon it now, it see[ms] to betray and not to illustrate his poem.

434 Cul-de-lampe illustrating Beardsley's poem 'The Ballad o[f a] Barber' on p. [93] in *The Savoy*, NO. 3, July 1896; edited [by] Arthur Symons and published by Leonard Smithe[rs,] London. 4to. Signed with the artist's initials. Pl. 436
From the line-block

A reminder that Beardsley's craft was linked to the silhoue[tte] tradition of the eighteenth and nineteenth centuries. H[ow] far he had studied pictorial silhouettes, if at all, is not kno[wn]. A silhouette caricature of himself was published in *A B[ook] of Fifty Drawings by Aubrey Beardsley*, Leonard Smithe[rs,] London, 1897. His maternal grandmother, Susan Lam[b,] had been a skilled silhouettist; but there is no evidence t[hat] Beardsley was inspired by, or even saw, her portraits in t[his] medium.

435 Design for the panel below the title on the front wrapp[er] of *The Savoy*, NO. 4, August 1896, edited by Arthur Sym[ons] and published by Leonard Smithers, London. 4to. Sig[ned] with the artist's names. Pl. 433
$9\frac{3}{8} \times 7$ inches
Mr John Hay Whitney, New York

The design was printed in black with title in red on light b[lue] paper for the wrapper, and on white paper for the first p[age] of the volume. The heaped grapes, symbolizing August, [are] comparable with the heaped fruit on a much more orn[ate] stand, approached by a woman in similar fashion, in Bear[ds]ley's drawing called 'Autumn' made for a calendar (see [NO.] 381). The figure and stand on *The Savoy* wrapper are the ot[her] way round, however. And the figure's relation to the curt[ain] is comparable with the relation of figure and curtain in [the] poster for the Avenue Theatre (NO. 319). But the design [of] the poster is more successful. Here the curtain simply ta[kes] up half the panel and is perfunctorily drawn. The seque[nce]

the three forms is ineffective: the heavy stand, the white
t transparent figure and the transparent but seemingly
aque curtain do not succeed as a witty composition, but
ey leave the impression that Beardsley's former mastery
disbalance was beginning to desert him. This in fact was
e case, as many of his latest works indicate.

ont wrapper of *The Savoy*, NO. 5, September 1896; edited
Arthur Symons and published by Leonard Smithers,
ondon. 4to. Signed in capitals at left bottom 'Giulio
oriani'. Pl. 438
om the line-block and letterpress

he signature was a joke. The original drawing for this
ver was done at Boscombe, Bournemouth, when Beards-
was seriously ill. The backgrounds of certain pictures by
atteau, and even by Claude, are distantly echoed in the
mosphere of the lake, with its dark banks and overgrown
rms. There are affinities here with 'The Mysterious Rose
arden' (NO. 366), though the drawing is by comparison
rfunctory. As on all the wrappers from NO. 3 to NO. 7, the
le was printed in red, the rest being printed in black; the
per was light blue.

he Woman in White. Plate reproducing a sketch in white
toned paper on p. 53 of *The Savoy*, NO. 5, September 1896;
ited by Arthur Symons and published by Leonard
nithers, London. 4to. Signed with the artist's names.
437
om the half-tone plate

he drawing evokes the title of Wilkie Collins's famous
vel, but was not necessarily an illustration connected with
In fact it was based, though it is not known exactly
hen, on a drawing reproduced as a vignette in *Bon-Mots* of
mb and Jerrold, 1893, p. 48; and again in *Bon-Mots* of
ote and Hook, 1894, p. 17, as the left half of a composite
adpiece.

he Fourth Tableau of Das Rheingold. Drawing for the
ont wrapper of *The Savoy*, NO. 6, October 1896; edited by
rthur Symons and published by Leonard Smithers, London.
. Signed with initials. Inscribed in pencil in top panel
ierce' within an oval flourish. Pl. 440
× 8⅝ inches
r R. A. Harari, London

or the 'Third Tableau' see NO. 430. Together with a design
r a frontispiece, and drawings of 'Flosshilde', 'Alberich',
d 'Erda', this formed part of a series illustrating 'Das
eingold' which Beardsley never completed. The figures
re represent Wotan and Loge in Wagner's operatic cycle.
he composition is one of the most boldly disbalanced of all
ardsley's inventions; and the flame-shaped hair on the
ad, chest and navel of Loge, harmonizing with his draper-
, has no precedent in European art, except in the hair of the
derly Lacedemonian ambassador in plate 8 of *The Lysistrata*
896), which however grows in clusters downwards.

he Death of Pierrot. Illustration on p. 33 in *The Savoy*, NO. 6,
ctober 1896; edited by Arthur Symons and published by
onard Smithers, London. 4to. Signed with the artist's
mes. Pl. 435

From line-block proof on Japanese vellum, 8 × 5⅜ inches
Mr W. G. Good, England

A text printed (on p. 32) opposite this illustration reads: 'As
the dawn broke, Pierrot fell into his last sleep. Then upon
tip-toe, silently up the stair, noiselessly into the room, came
the comedians Arlecchino, Pantaleone, il Dottore, and
Columbina, who with much love carried away upon their
shoulders, the white frocked clown of Bergamo; whither we
know not.' The brilliance of the composition and the ren-
dering of different textures and patterns are among Beards-
ley's triumphs. Identifying himself in some degree, like so
many men of the Nineties, with the character of Pierrot in
the old Commedia dell'Arte, Beardsley was haunted by the
irony of his own inevitable death.

440 First page of *The Savoy*, NO. 7, November 1896; edited by
Arthur Symons and published by Leonard Smithers, London.
4to. Same design on front wrapper of light blue paper with
title in red. Pl. 439
From the line-block

The headdress of the Pedant, like a bandage, and even his
profile, take us back to the man with a foetus in the *Bon-Mots*
of Smith and Sheridan, p. 26 (NO. 172). He wears a smock and
cravat like an artist of the old guard. The youth who suffers
from his pedantry has the bald forehead and the cap of
Watteau's pierrots: characteristically the pattern on his
jacket has a life apart from the form of the garment, even
though a few lines representing folds break the continuity;
and the effect beside the grass, stylized in a Japanese manner,
is almost that of a painting by Braque, in terms of black and
white only.

441 Ave Atque Vale. Illustration to the translation by Aubrey
Beardsley of Carmen CI by Catullus. Reproduced on p. 53 in
The Savoy, NO. 7, November 1896; edited by Arthur Symons
and published by Leonard Smithers, London. 4to. Signed
with the artist's names and initials. Inscribed in pencil on the
back 'Keep the white dots as small as possible AB'. And
inscribed also in pencil in another hand 'No reduction,
Satur morn Smithers'. Pl. 441
6¾ × 4¼ inches
Mr John Hay Whitney, New York

It was because Beardsley was such a master of design, in the
sense that he knew how to make the most of black against
white, that this drawing is so rivetting. For example, nobody
questions the solidity of the youth's torso, which is defined
by the very minimum of detail, a naval and a nipple (placed
slightly too far to the right so as to give a broad-chested
effect, and also the effect of an arrested movement of the
youth to his right); yet the body of the torso is as white as
the white background. The abscence of the trees behind the
head would have impoverished the design. As usual the
heavy disbalance is redeemed, in this case by the upflung arm
breaking the white ground on the left. There is a single
weakness, and that a typical one: the thumb is too small.

Only the initials AB appeared in the line-block in *The
Savoy*, NO. 7. It must be admitted that the poem and the draw-
ing which illustrates it had a fatal relevance to Beardsley's
own short life, then nearing its end: 'Hail and Farewell'.

442 First page of *The Savoy*, NO. 8, December 1896, edited by

Arthur Symons and published by Leonard Smithers, London, 4to. Signed with the artist's initials and lettered with title. Same design, all in black, on front wrapper of light blue paper. See also NO. 453. Pl. 442
From the line-block

The figure was probably intended for one of the Ali Baba series (see NOS. 458, 459).

443 Mrs Pinchwife: From Wycherley's *Country Wife*. Reproduction on p. 31 in *The Savoy*, NO. 8, December 1896, edited by Arthur Symons and published by Leonard Smithers, London. 4to. Signed with the artist's initials and lettered with title. Pl. 443
From the line-block

Floating on the tide of sexual ambivalence released by Gautier in *Mademoiselle de Maupin*, Beardsley, who illustrated that book (see NOS. 487–492), was attracted to any manifestation of transvestism, whether by males in female clothes, or by females in male clothes, as here. Male impersonation had been a recognized feature of theatrical entertainment, especially pantomime, since the eighteenth century in England and was not considered burlesque. Female impersonation by males, although going back to *Twelfth Night*, had become by the nineteenth century largely an excuse for the soothing of unconscious ambivalence by laughter.

444 A Repetition of 'Tristan und Isolde'. Drawing reproduced on p. [11] in *The Savoy*, NO. 8, December 1896; edited by Arthur Symons and published by Leonard Smithers, London. 4to. Signed with initials. Pl. 444
$7\frac{1}{4} \times 6\frac{3}{8}$ inches
Mr R. A. Harari, London

445 Don Juan, Sganarelle, and the Beggar. From Molière's *Don Juan*. Illustration reproduced on p. 29 of *The Savoy*, NO. 8, December 1896; edited by Arthur Symons and published by Leonard Smithers, London. 4to. Pl. 445
$8 \times 4\frac{3}{4}$ inches
Scofield Thayer Collection, Fogg Art Museum, Harvard University, Massachusetts

The postures of Sganarelle leaning on his cane, and of Don Juan with his extended arm were undoubtedly suggested by the two chief figures on the left of Watteau's painting 'The Italian Comedians', after which an engraving was made in the eighteenth century. Beardsley has given his own type of Pierrot head, itself inspired by Watteau's pierrots, to the figure of Don Juan.

446 Frontispiece to The Comedy of the Rheingold. Reproduction on p. 43 in *The Savoy*, NO. 8, December 1896; edited by Arthur Symons and published by Leonard Smithers, London. 4to. Signed 'By Aubrey Beardsley' in capitals after the bottom line of the title as above, and dated 1897 in Roman numerals. Pl. 450
From the line-block.

'The Comedy of the Rhinegold' was a publication never achieved. It was to have included Beardsley's 'Third Tableau' (*Savoy*, NO. 2) and 'Fourth Tableau' (*Savoy*, NO. 6), and 'Flosshilde', 'Erda' and 'Alberich', these last three and the frontispiece being published in *The Savoy*, NO. 8. The use of

waves and strands of female hair as symbolic and decorati formulae was by now well established by *art nouveau* artis among others by Mucha in Paris. Beardsley's treatment of is in terms of the close-laid lines he used so frequently; b when he illustrated *Le Morte Darthur* his rendering of ha however fetichist, was much more abstract, and in that se more prophetic (see NO. 105).

447 Flosshilde. The second in a series of four illustrations i tended for 'The Comedy of the Rhinegold' (never co pleted), reproduced on p. 45 in *The Savoy*, NO. 8, Deceml 1896; edited by Arthur Symons and published by Leona Smithers, London. 4to. Inscribed in pencil on the ba 'Flosshilde Same size Smithers'. Stamped with collecto mark. Pl. 446
$2\frac{1}{2} \times 3\frac{1}{2}$ inches
Mr John Hay Whitney, New York

In the same last volume of *The Savoy* also appeared t 'Frontispiece to The Comedy of the Rhinegold' (NO. 44 'Erda' (NO. 449), and 'Alberich' (NO. 448). The survival the Japanese-Burne-Jones formula for land in the mid distance is notable in the waves of the hair of Flosshil The drawing has all of Beardsley's wing-movement co positional style, but the dots of the scarf are, for him, rou and uneven. Contemporary German interest in Beardsley proved by the reproduction on a small scale of this illu tration, from the *Savoy* plate, on the penultimate page *Jugend*, NO. 5, 29 January 1898. Flosshilde was one of t daughters of the Rhine who guarded its gold in 'Das Rhe gold', the first of the four music dramas in *Der Ring Nibelungen* (1869).

448 Alberich. The third in a series of four illustrations intend for 'The Comedy of the Rheingold' (never completed) produced on p. 47 in *The Savoy*, NO. 8, December 1896; edi by Arthur Symons and published by Leonard Smithers. 4 Pl. 451
Scofield Thayer Collection, Fogg Art Museum, Harvard Univ sity, Massachusetts

The drawing for this illustration belonged at one time Herbert J. Pollitt, a friend of Beardsley, and of Wilde, a who later took up the study of Black Magic with Aleis Crowley. The Nibelung, Alberich, is depicted here as a s of Caliban, a *Bon-Mots* monster more realistically conceiv In 'Das Rheingold', the first of the four music dramas for ing Wagner's *Der Ring des Nibelungen*, Alberich is the malev lent character who renounces Love to acquire the Rhine g by theft.

449 Erda. The fourth in a series of four illustrations intended f 'The Comedy of the Rheingold' (never completed) rep duced on p. 49 in *The Savoy*, NO. 8, December 1896; edited Arthur Symons and published by Leonard Smithers, Lond 4to. Inscribed with title. Pl. 447
$5\frac{7}{16} \times 3\frac{1}{2}$ inches
The British Museum

The pouches under the eyes, the tired mouth, the volumino breasts and the hair which envelops her, all contribute Beardsley's idea of the goddess of wisdom and mother of t Valkyrs in Wagner's music drama *Der Ring des Nibelung* But the artist is working in the vein of Baudelaire and Ro

which Woman was the instrument of Evil, presumably
:hout conscious effort. The breasts are diagrammatic and
ggest once again that there was a limit to Beardsley's
ling for the secondary sexual characteristics. Erda's rolling
r is in the movement, since hair fetishism was recurrent
m the days of Rossetti, both in English and continental
; but it is somewhat confused with the landscape, perhaps
:ause it illustrates the passage in 'Das Rheingold' in which
: emerges from a rocky cleft.

lix Mendelssohn-Bartholdy. The composer with his head
l bow-tied cravat on a larger scale than the rest, sitting
:. chair to right, holding a large quill. Drawing reproduced
p. 63 of *The Savoy* NO. 8, December 1896; edited by Arthur
nons and published by Leonard Smithers, London. 4to.
,ned with the artist's initials and titled as above. Pl. 448
× 4 1/16 inches
nville L. *Winthrop Bequest, Fogg Art Museum, Harvard
versity, Massachusetts*

unt Valmont. Illustration to *Les Liaisons Dangereuses* by
oderlos de Laclos, on p. 71 of *The Savoy*, NO. 8, December
)6; edited by Arthur Symons and published by Leonard
.ithers, London. 4to. Pl. 452
om the line-block

ly Beardsley would have thought of representing the
rotal character of this novel, naked apparently, under a
ak. The aggressive-looking hand expresses a similar im-
ience to the snapping toes on the feet of 'The Impatient
ulterer' (not reproduced). The peculiar thick-featured
e will be found again in 'The Impatient Adulterer' and
venal Scourging Woman' (NO. 468) and seems to have
resented for Beardsley a symbol of masculine violence
l virility.

in Arcadia Ego. Drawing reproduced on p. 89 in *The
roy*, NO. 8, December 1896; edited by Arthur Symons and
blished by Leonard Smithers, London. 4to. Signed with
tials. Pl. 449
× 5 7/8 inches
inceton University Library

e middle-aged dandy with button-boots and waxed
rustache approaches on tip-toe the mysterious monument
one who, like himself, had once lived in Arcady. There is a
rlesque reference to the Virgilian inscription on the
nb in Poussin's picture 'Les Bergers d'Arcadie' in the
uvre; and moreover to Leonard Smithers's shop which
this date had been moved to the Royal Arcade, London.

e *Savoy* complete in three volumes, price one guinea nett.
onard Smithers, Royal Arcade, W. A small poster or
ow-card with the design of Beardsley's front wrapper of
e *Savoy*, NO. 8, December 1896. Signed with intials in left
ttom corner. Pl. 453
lour lithograph, 9 5/16 × 6 7/8 inches
Anthony d'Offay, London

is show-card advertises the set of three volumes bound in
ilet cloth containing all eight numbers of *The Savoy*.
Beardsley's growing desire to embellish his black-and-
ite designs with colours is shown in the way this litho-

graph was produced. On 23 October 1896 he wrote to
Smithers asking for two or three pulls from the line-block
used for the wrapper of *The Savoy*, NO. 8. These were to be 'on
water-colourable paper, it will be better not to paint on the
original [drawing]'. Then on 1 November he wrote: 'Here is
the posterette. Do not be troubled about the unevenness of
colour (not intentional). Lithographer must not of course
attempt to reproduce brush marks which are inevitable. The
green is *emerald green* & a little black the red, *pure vermilion* the
yellow chrome orange the grey simple black and white
mixture.'

The chief additions to the *Savoy* cover design (which was
all black) were the thick vertical and horizontal bars of black.
The backgrounds to those in the top and bottom panels were
green and the outlines of the tops of the letters of the word
'Savoy' were of the same colour. The backgrounds of the
central panel and the border and the shoes, were red; and the
ankles and pink jacket were achieved by grained 'tints' of
this colour. The grey hat was obtained by a grained 'tint' of
black.

454 Pencil sketch in pencil and ink of a young girl. On the back
of the drawing 'A Footnote', Beardsley's self-portrait re-
produced in *The Savoy*, NO. 2, April 1896 (see NO. 428).
Reproduced as Pl. 7 in *Early Work*, 1899.
From the half-tone plate
It was Beardsley's habit to begin his work with a baroque
scribble of pencil lines which suggested a great deal, later to
be fused into the beautifully poised pattern of outlines he
placed over them. Such a technique demands concentration
and firmness of touch in quite unusual degrees.

455 Apollo pursuing Daphne. Unfinished drawing. Pl. 455
Indian ink and pencil, size unknown
Present owner unknown

The incomplete left leg ends in a pencil sketch of the left
ankle and foot. The rest of the drawing is in ink, apparently.
Once it belonged to Herbert J. Pollitt, who bought several
drawings from Beardsley, including the bookplate design at
NO. 471 and 'The Impatient Adulterer'. It was exhibited at the
Galeries Shirleys, Paris, in February 1907, and was NO. 13 in
a catalogue of this exhibition, which contained a brief fore-
word by Pollitt. 'Ali Baba', 'Erda' and the bookplate design,
all in Pollitt's collection, were shown at this exhibition and
were marked as not for sale; the Apollo drawing however
was afterwards the property of Count Robert de Montes-
quiou-Fezansac, the poet and social paladin who died in 1921
(information from Mr W. G. Good, based on entries in an
unpublished catalogue by R. A. Walker in his possession).
Together with the 'Children Decorating a Terminal God',
which Beardsley presented in 1892 to Puvis de Chavannes,
the drawing is among the few works by Beardsley known to
have been in French hands. Incomplete as it is, this design is
one of his most successful achievements in pure outline, and
dates probably from 1896. The figure of Daphne is missing,
but a nipple of one of her breasts and part of a laurel tree
remain beside Apollo's outstretched hand.

The drawing was first reproduced in R. A. Walker's *Some
Unknown Drawings of Aubrey Beardsley*, London, 1923, NO. 29.

456 Design for the front cover of *The Life and Times of Madame
Du Barry* by R. B. Douglas, published by Leonard Smithers,

London, 1896. Signed with initials, right and left. Pl. 456
$9\frac{9}{16} \times 6\frac{1}{16}$ inches
Princeton University Library

The design was stamped in gold, without the surrounding lines, on the violet book cover. The form of the canopy is to be found in French stage designs of the eighteenth century.

457 Design for the front cover of *Verses* by Ernest Dowson, published by Leonard Smithers, London, 1896. Signed with initials. Pl. 457
$7\frac{3}{8} \times 5\frac{3}{8}$ inches
Mrs Hippisley-Coxe, England

The curves of this exceptionally economic design, which is near to nothing, may be said to reflect, in Beardsley's idiosyncratic style, a current *art nouveau* form. The design was stamped in gold on parchment board.

458 Ali Baba. Drawing for the front cover design of *The Forty Thieves*, a projected publication never undertaken. Signed with initials and titled as above. Pl. 458
$9\frac{7}{16} \times 7\frac{13}{16}$ inches
Grenville L. Winthrop Bequest, Fogg Art Museum, Harvard University, Massachusetts

The drawing was reproduced in *A Second Book of Fifty Drawings,* Smithers, London, 1899, pl. 41.

It combines something of the old *Yellow Book* dramatic contrast between black and white forms and, in the seemingly coruscating jewels, something of the tense detail of *The Rape of the Lock* series. The lettering of the title is remarkable in being as near as Beardsley ever got to true Roman lettering: compare the title of the cover of *The Savoy*, NO. 1, which has a more period look.

459 Ali Baba in the Wood. Illustration intended for a projected version of *The Forty Thieves*. First published in *A Book of Fifty Drawings by Aubrey Beardsley,* Smithers, London, 1897, p. 147. Pl. 459
$9\frac{5}{16} \times 6\frac{15}{16}$ inches
Scofield Thayer Collection, Fogg Art Museum, Harvard University, Massachusetts

The crowded leaves of the thicket are suggested, or rather symbolized, by white dots of varying sizes and at calculated distances from each other on a black background, in which close-laid lines represent the trunks of the trees. All the whites in this drawing are left in reserve, not applied on the black background—an amazing technical feat.

460–66 Drawings for *The Lysistrata of Aristophanes* Now First Wholly Translated into English and illustrated with eight full-page drawings by Aubrey Beardsley, and published by Leonard Smithers for private distribution, London, 1896. All signed with the artist's names, except for the fifth which is unsigned. The first titled 'Lysistrata'.
Indian ink with traces of pencil, each $10\frac{1}{4} \times 7$ inches
In private possession, London

The eight drawings by Beardsley for *The Lysistrata* (translated by Samuel Smith and published in a limited edition by Smithers) were made at the Spread Eagle Hotel, Epsom, in the summer of 1896. Seven of the eight drawings are reproduced here: the other one, which belonged at one time to

Herbert Horne and was destroyed in a fire, is represented a reproduction from the collotype facsimile made of it fo portfolio of reproductions after the whole series in the 1920

460 Lysistrata shielding her Coynte. Drawing for the front piece. Pl. 460

461 The Toilet of Lampito. Drawing for the illustration faci p. 4. Pl. 461

462 Lysistrata Haranguing the Athenian Women. Drawing f the illustration facing p. 12. Pl. 462

463 Lysistrata Defending the Acropolis. Drawing for the ill tration facing p. 30. Pl. 463

464 Cinesias Entreating Myrrhina to Coition. Drawing for t illustration facing p. 44. Pl. 464

465 The Examination of the Herald. Drawing for the illustrati facing p. 46. Pl. 465

466 The Lacedaemonian Ambassadors. Drawing for the illust tion facing p. 50. Pl. 466

Beardsley had studied Greek vase painting in 1894 at t British Museum, and the Lysistrata drawings reflect som thing of the Greek vase spirit, including the bawdiness, wit out perhaps much of the spontaneity of Greek draughtsma ship. The absence of backgrounds, as in the *Salome* illustr tions, makes the designs of closed outlines and bold dots a rare decorated blacks, all the more dramatic. The mo elegant of the series are 'The Toilet of Lampito' and 'Cinesi Entreating Myrrhina to Coition': the boldest are the fir which was reproduced as a frontispiece; 'Lysistrata Haran uing the Athenian Women', where the heroine of the play seen urging a band of Athenian women to give up sexu relations with their husbands—and the frustration of the women is inspiring, in one case, a lesbian gesture; and 'T Lacedaemonian Ambassadors' which has startling and a surd qualities. The tallest and youngest of the ambassado has a heaped-up head of hair like the 'hermaphrodite' figu in 'The Mirror of Love' (see NO. 386), and like so many of t young males in the *Morte Darthur* illustrations. The phallus are abnormally large to symbolize frustration and anticip tion. But the morbid defect of this drawing lies not in t sizes of the phalluses, which are referred to in the text of t play at this point, but in the comic-cartoon rays which m symbolize an inflamed ulcer on the dwarf—the inferen being that this undersized person reaches oversize in o respect, not to be outdone, by manipulations in the mann of accomplished Japanese courtesans. This was perha Beardsley's reference to the representations of that subject the erotic prints by Utamaro which William Rothenstein h given him—unless, of course, the detail is intended for hairy mole. But on the unconscious level the large phall referred to a castration complex in the artist, and to ea anxieties about differences of sex, to be found at first in *Morte Darthur,* alongside the breast-boles and anal fruit, a other anomalies. Oddly enough the footgear of the elder man is designed in the mediaeval vein of *Le Morte Darthu* that of the tall youth in a style of late seventeenth-centu pastiche, which seems to have followed the eighteent century pastiche of *The Rape of the Lock*.

It is difficult to believe that the decorated black stockin in 'The Toilet of Lampito' and 'Lysistrata Defending t

...cropolis' were not, in fact, stylized and dramatized memor-
ations of those similar stockings in prints by Félicien Rops
—'Pornokrates' and 'Les Cousines de la Colonelle', for
...xample—although Robert Ross denied that Beardsley knew
...nything about this Belgian interpreter of Woman as the
...nstrument of Evil (R. Ross, *Aubrey Beardsley*, London, 1909,
...40). Yet Beardsley mentioned Rops in a letter of December
...896 to Smithers.

...Two Athenian Women in Distress. Reproduction of the
...rawing for the illustration facing p. 34 in *The Lysistrata of
...Aristophanes* Now First Wholly Translated into English and
...llustrated with eight full-page drawings by Aubrey Beards-
...ey. Printed privately by Leonard Smithers, London 1896.
...to. Signed with the artist's names. Pl. 467
...rom a collotype
...ictoria and Albert Museum, London

...ee NOS. 460–466. Beardsley's fifth drawing for *The Lysistrata*
...vas never in the possession of Herbert Pollitt but belonged
...o Herbert Horne. The rest of Horne's series of *Lysistrata*
...rawings were copies, but all were subsequently destroyed
...n a fire. Before the fire a set of collotypes, reproducing the
...even Pollitt drawings and the one Horne original, was
...ssued by Philip Sainsbury, on paper water-marked AB. This
...et was not dated but appeared about 1925. The original
...rawing for 'Two Athenian Women in Distress' was of
...ourse reproduced by line-block in the book issued by
...mithers in 1896. The later collotype plate however was a
...loser reproduction of the drawing and has been used here
...nstead of the contemporary line-block for that reason.

The subjects of this illustration are in fact less erotic than
...night, at first glance, have been supposed. They refer to
...ysistrata's complaints that she cannot keep the women
...way from their husbands. 'I found . . . another one slipping
...own by the pulley; . . . and another one I dragged off a
...parrow by the hair yesterday just as she was ready to fly
...own to the house of Orsilochus (A well-known pander.
...ranslator's note).' The passage occurs on p. 36 of the book
...rinted by Smithers in 1896.

...uvenal Scourging Woman. Illustration to the Sixth Satire
...f Juvenal, 1896. Signed with the artist's names and dated.
...l. 468
...³⁄₈ × 6³⁄₄ inches
...rinceton University Library

...his was one of the drawings published by Leonard Smithers
...n *An Issue of Five Drawings Illustrative of Juvenal and Lucian*,
...ondon, 1906.

Stylistically it belongs to the same group as 'The Lysis-
...rata' illustrations: strong outlines, no massed blacks, no
...ackgrounds. Beardsley's ambivalent approach to women is
...evealed in the treatment, let alone choice, of the subject. For
...is conception of the reversal of roles in flagellation see the
...rontispiece to *Earl Lavender* (NO. 383).

...athyllus in the Swan Dance. Illustration to the Sixth Satire
...f Juvenal. Entitled 'Bathyllus'. Pl. 469
...¹⁄₈ × 5³⁄₄ inches
...r R. A. Harari, London

...A companion drawing to this was called 'Bathyllus Postur-
...ng' (NO. 470). Both were published by Leonard Smithers in

An Issue of Five Drawings Illustrative of Juvenal and Lucian,
London, 1906. There is a brief reference early in the Sixth
Satire to an effeminate young man, Bathyllus, acting the part
of Leda in a ballet.

470 Bathyllus Posturing. Illustration to the Sixth Satire of
Juvenal. From *An Issue of Five Drawings Illustrative of Juvenal
and Lucian*, published by Leonard Smithers, London, 1906.
Pl. 470
From the line-block
Victoria and Albert Museum, London

Smithers published smaller versions of the three Juvenal
designs in Pompeian-red line-blocks, in 1903, at 'The Jesus
Press'.

471 Design intended for the bookplate of the artist; not used by
Beardsley but by Herbert J. Pollitt. Signed with the artist's
initials. Pl. 471
6⁷⁄₈ × 4⁵⁄₈ inches
*Scofield Thayer Collection, Fogg Art Museum, Harvard Univer-
sity, Massachusetts*

In the Gallatin Collection at the Princeton University Lib-
rary is a proof of the bookplate embodying this design, and
Roman lettering in the space at the top spelling the name of
Pollitt. This man, Herbert Charles Pollitt (1871–1942), who
took the name of Jerome, came to know Beardsley late in the
artist's life, and formed a collection of his drawings including
'The Impatient Adulterer', intended as a Juvenal illustra-
tion, but too amusingly nasty for publication, and not one
of Beardsley's best works. The proof of the bookplate is
inscribed in pencil, 'This could be better A.B.'. Whether by
that Beardsley meant the design, or the quality of the line-
block, it is difficult to see how the result could in fact have
been better. The fully-fashioned nude woman gratified a
singular impulse of Beardsley's own, and the misshapen
punchinello, bald and neurotic in appearance, with a peascod
stomach falling over his sash and both covering and reveal-
ing an erection, looks prudishly away from the woman's
delta which promises a pleasure not for the likes of him. The
position of the knot on his sash is very strange, and has a
similar effect to that of the rose on the figure of the saint in
the 'Ascension of Saint Rose of Lima' (NO. 429). That such
an arresting vision should happen to be drawn with obvious
conviction is a sadly ironical comment when considered in
the light of Beardsley's personal history.

472 Self-portrait by Beardsley. Half-length, profile to the left, in
outline. Pl. 472
From the line-block

First published in Percival Pollard's *Posters in Miniature*, New
York, 1896. The coat is Regency in cut, the frilled shirt an
imaginary garment.

473 Design for the front cover of *A Book of Fifty Drawings by
Aubrey Beardsley*, with an iconography by Aymer Vallance,
published by Leonard Smithers, London, 1897. 4to. Signed
with the artist's names and initials. Pl. 473
8¹⁄₈ × 6³⁄₄ inches
*Scofield Thayer Collection, Fogg Art Museum, Harvard Univer-
sity, Massachusetts*

On the front cover was added in capitals at bottom left of the right-hand panel, 'London Leonard Smithers Royal Arcade. W 1897'. In September 1896 Smithers had moved his bookselling premises from Effingham House, Arundel Street, Strand, London, to 4 and 5 Royal Arcade, Bond Street, which address appeared on the title-page of the book. The design for the cover appears to have been made by Beardsley about this time, in September 1896. 'The Death of Pierrot', which was published in NO. 6 of *The Savoy,* and the present drawing were the last to bear Beardsley's full names as his signature.

The empty panel on the left, linked by a flying bird to the pictorial panel on the right, is a witty feature typical of Beardsley, who could always transform a fashionable lay-out by introducing some unexpected element of design.

474 Title-page of *The Parade,* an Illustrated Gift Book for Boys and Girls, 1897, published by H. Henry and Company Ltd., 93 St Martin's Lane, London, 1897. 4to. Pl. 474
From the line-block and letterpress

The lettering is in golden brown. Beardsley designed the black decorative branch only. This has its antecedents in *Le Morte Darthur,* but the hairpin bends and whiplash curves are no longer related to natural forms, and the floral lamp with tasselled cords, which grows out of the bottom twig, is even more capricious.

475 Frontispiece to *A Book of Bargains* by Vincent O'Sullivan, published by Leonard Smithers, London, 1896. 8vo. Signed with initials. Pl. 475
From the line-block
Dr Ian Fletcher Reading, England

The frontispiece illustrates 'The Business of Madame Jahn', one of a collection of macabre short stories by O'Sullivan. The figure represents an apparition, cleverly suggested from the shoulders downwards by dotted outlines and contrasted with the hard actuality of the boldly outlined desk.

476 Design for the front cover of Ernest Dowson's *The Pierrot of the Minute,* a dramatic phantasy in one act, published by Leonard Smithers, London, March 1897. Pl. 476
$8 \times 3\frac{3}{8}$ inches
Rosenwald Collection, Library of Congress, Washington

The covers of the edition of 300 copies were bound in green cloth: those of the edition de luxe printed on Japanese vellum were bound in vellum. The design by Beardsley was stamped in gold on the front covers of both editions.

477 Drawing for the frontispiece to Ernest Dowson's *The Pierrot of the Minute,* a dramatic phantasy in one act, published by Leonard Smithers, London, March 1897. Signed with initials. Pl. 477
$8\frac{1}{2} \times 4\frac{5}{8}$ inches
Rosenwald Collection, Library of Congress, Washington

The scene, with the trellis, lilies, stylized roses, tall trees and Eros on a pedestal, is supposed to be in the garden of the Palace of Versailles, and is a translation into Beardsley's medium of a type of scene painted by Watteau. The figure of Pierrot, which has a noticeably helpless posture and a dazed expression, was clearly linked reminiscently with one of Watteau's pierrots, probably 'Gilles' in the Louvre.

478 Drawings for a headpiece and the initial letter P (on o. sheet) in Ernest Dowson's *The Pierrot of the Minute,* a dramat phantasy in one act, published by Leonard Smithe London, March 1897. Pl. 478
$5\frac{1}{4} \times 3\frac{3}{4}$ inches
Rosenwald Collection, Library of Congress, Washington

479 Design for the cul-de-lampe in Ernest Dowson's *The Pierr of the Minute,* a dramatic phantasy in one act, published Leonard Smithers, London, March 1897. Pl. 479
$5\frac{5}{8} \times 3\frac{5}{8}$ inches
Rosenwald Collection, Library of Congress, Washington

The garden background with the urn is in the manner Watteau. Beardsley's gift of design is revealed once more the white disbalanced figure of Pierrot moving out of th picture. His head, divided by a bald line from his hat, mig be said to derive in that feature alone from one of Watteau pierrots; but the embittered expression is Beardsley's com ment on the character of the Pierrot in what he called 'foolish playlet'. The shells, stylized roses, garlands and ri bons surrounding the vignette in dots (simulating a eighteenth-century pin-prick picture—though the artist ma not have known of such things) inspired illustrators i Russia, Germany and England, whose eighteenth-centur pastiches in this manner came into vogue following th decline of *art nouveau* decorative styles in the 1900s.

480 Head of Balzac. Design for the decoration stamped in blac on the front covers of *Scenes of Parisian Life* from *La Coméd Humaine* by Honoré de Balzac in eleven volumes, and pul lished by Leonard Smithers in scarlet cloth, London, 8v Pl. 480
$3\frac{7}{8} \times 2\frac{3}{4}$ inches
The British Museum

A design remarkable for its near-symmetry. The spines the two series were decorated with the mask reproduced NO. 481 which however was stamped in gold.

481 Design for a mask to be stamped in gold on the spines *Scenes of Parisian Life* from *La Comédie Humaine* by Honoré Balzac in eleven volumes published by Leonard Smither London, 1897, 8vo. Pl. 481
$2\frac{5}{8} \times 1\frac{7}{8}$ inches
Mr R. A. Harari, London

In a letter to Smithers dated 9 February 1897, Beardsle wrote, alluding to this drawing, '. . . Let me know if the whi lines should be *firmer.* I didn't like to make them too hard

482 Atalanta in Calydon (with the hound). The figure of Atalan is represented on the right and prancing in front of her is hound clothed in a decorated overcoat with a coronet at th bottom of the flap near his left hind-quarters. Pl. 482
From the line-block

This drawing was reproduced in *A Book of Fifty Drawings Aubrey Beardsley,* Smithers, 1897, p. 151, and in *The Idle* March 1897. It has also been known as 'Diane'. Beardsley former mastery of disbalance was exercised again at a perio when he was less inclined to it. Atalanta's hair is unique being represented entirely by the graded dots usually use for other purposes. For an earlier version of the subjec see NO. 372.

essalina returning from the bath. Illustration to the *Sixth
tire of Juvenal*. Titled 'Messalina'. Pl. 483
× 5⅝ inches
R. A. Harari, London

he gross power of Messalina is conveyed by stouter and
avier lines than were used by Beardsley in any drawing
nce the design for the cover of *The Yellow Book*, Vol. 1, 1894.
his illustration was published on p. 191 of *A Second Book of
fty Drawings by Aubrey Beardsley*, Smithers, London, 1899,
here it is stated that it was drawn in 1897 and hitherto
npublished.

Dame aux Camélias. Water-colour and pencil sketch
ade in 1897 on the fly-leaf of a copy of the book presented
Beardsley by the author, Alexandre Dumas *fils*, in 1895.
gned with the artist's initials. Pl. 484
om the half-tone plate

he sketch was first reproduced in *A Second Book of Fifty
rawings by Aubrey Beardsley*, Smithers, London, 1897. While
aying at Dieppe in the late summer of 1895, Beardsley and
rthur Symons went on a pilgrimage to Puy, where Dumas
s was living in the house of his father, the author of *The
hree Musketeers*. By 1897, when Beardsley made the drawing
the front fly-leaf of the book Dumas had given him, he
d assimilated for the purpose something of the loose,
atery touch of the painter Charles Conder.

ont cover of *The Houses of Sin* by Vincent O'Sullivan, pub-
hed by Leonard Smithers, London (400 copies), 1897. 8vo.
gned with the artist's initials. Pl. 485
rchment board stamped with the design in gold
R. A. Harari, London

he same design was repeated on the back cover. Of all his
ook covers this must be considered one of Beardsley's most
ring and most successful. De-centred according to the
dvanced principles of the period, the amazing growth on
e column surpasses most of his abstractions born out of an
terest in the Rococo. It is tempting to believe that the
inged pig-face, which is also the face of a woman, was a
miniscence, much transformed, and on a different psycho-
gical plane, of the pig leading a blindfold woman in the
ching 'Le Femme au Cochon' ('Pornokrates') by Félicien
ops, especially as flying cherubs in the manner of Watteau's
erubs in 'The Embarcation for Cythera' precede the
oman. This famous etching was published first in 1887 and
en, in reverse, in 1896. The journal *La Plume* published a
mposium of essays on Rops in 1896: Beardsley must
rely have been aware of the works of this artist (see NOS.
0–66).

ont cover of Vol. I of *The Souvenirs of Léonard, Hairdresser
Queen Marie-Antoinette*, now first rendered into English
ith a preface and annotations by A. Teixeira de Mattos,
rivately printed by Leonard Smithers, London, August
897. Two volumes, 8vo. Pl. 486
esign stamped in gold on violet cloth boards
W. G. Good, England

nother instance of severity and purity of design in book
vers. Compare NOS. 385, 457.

487 Mademoiselle de Maupin. Drawing for the frontispiece to
the series *Six Drawings Illustrating Théophile Gautier's Romance
Mademoiselle de Maupin by Aubrey Beardsley*, reproduced by
Houssod, Valadon and Company in photogravure in 50 sets
and published by Leonard Smithers and Co [*sic*], London,
1898. Signed with the artist's initials beneath the design.
Pl. 487
Pen, ink and green and pink watercolour, 6 × 3⅞ inches
*Grenville L. Winthrop Bequest, Fogg Art Museum, Harvard
University, Massachusetts*

One of the least satisfactory of Beardsley's drawings, this
was separately published in colour on white satin (10 copies)
and on Japanese vellum (15 copies) by Smithers. Gautier's
famous book was first published in 1835.

488 D'Albert. The second in the series of *Six Drawings Illustrating
Théophile Gautier's Romance Mademoiselle de Maupin by Aubrey
Beardsley*, published by Leonard Smithers and Co. [*sic*],
London, 1898. Signed with the artist's initials. Pl. 488
From the photogravure
Mrs Pierre Matisse, New York

Beardsley's drawing of the faces of his 'ideal' characters at
the end of his life is quite unlike anything else in the history
of art; nor could his imitators ever succeed in copying it.

489 D'Albert in Search of His Ideals. Drawing reproduced as the
third in the series *Six Drawings Illustrating Théophile Gautier's
Romance Mademoiselle de Maupin by Aubrey Beardsley*, pub-
lished by Leonard Smithers and Co. [*sic*], London, 1898.
Signed with the artist's initials. Pl. 489
Pen, ink and wash, 7⅞ × 6⅝ inches
*Grenville L. Winthrop Bequest, Fogg Art Museum, Harvard
University, Massachusetts*

Beardsley's leaning toward caricature, which was his means
of expression as a boy, developed into a subtle sense of irony.
But here everything is exaggerated, and there seems to be an
insistent reversion to facile curves in the form and the clothes
of D'Albert.

490 The Lady at the Dressing Table. The fourth in the series of
*Six Drawings Illustrating Théophile Gautier's Romance Mademoi-
selle de Maupin by Aubrey Beardsley*, published by Leonard
Smithers and Co. [*sic*], London, 1898. Signed with the
artist's initials. Pl. 490
From the photogravure, 9¼ × 7½ inches
Mrs Pierre Matisse, New York

The original drawing was in indian ink and wash. Pictorially
this is one of Beardsley's masterpieces. The differing em-
phases on all parts of the composition are carefully propor-
tioned. In *Yellow Book* days his perspectives were often con-
tradictory: here there are contradictions in perspective which
are more plausible, less abrupt. For instance, the conflicting
vanishing points, that of the figures and the tipped up table
and that of the architectural background, conjure a sense of
space, a sense that was later insisted upon, with turbulent
stylization, by the followers of Cézanne. The composition is
in the spirit, but not in the manner, of the Venetian painter
Longhi, with whose pictures in general there is a much
stronger affinity in Beardsley's painting 'A Caprice' (NO. 329).

491 The Lady with the Rose. The fifth in the series of *Six Draw-ings Illustrating Théophile Gautier's Romance Mademoiselle de Maupin by Aubrey Beardsley*, published by Leonard Smithers and Co. [*sic*], London, 1898. Signed with the artist's initials. Pl. 491
Pen, ink and wash, $7\frac{3}{4} \times 6\frac{7}{16}$ inches
Scofield Thayer Collection, Fogg Art Museum, Harvard University, Massachusetts

The strange conical hat was either an invention of the artist's, or more likely a memorization of certain hats on Chinoiserie male figures. In many of his drawings after *The Rape of the Lock* the quilling of cloth, rendered by stippled lines, appeared more and more, either in curtains or in garments: here it is the main feature of the lady's overskirt. By this date the nearly plebeian, nearly *putassière*, faces of his earlier women have become transformed, as in this illustration, into faces in which over-large eyes and lips seem to stress a uterine drive that responds to any kind of romantic sensuality, without the stimuli of gain, of greed or of aggression. The striped wall-decoration reflects the artist's own taste: one of the rooms at 114 Cambridge Street was decorated similarly; and the revived vogue for 1780 stripes can be said to have been abetted by Beardsley, and to be found at the centre of that mixture of Louis Seize and Robert Adam pastiche which grew apace in the 1900s.

492 The Lady with the Monkey. Drawing for reproduction in photogravure of the last plate in the series *Six Drawings Illustrating Théophile Gautier's Romance Mademoiselle de Maupin by Aubrey Beardsley*, published by Leonard Smithers and Co. [*sic*], London, 1898. Signed with the artist's initials. Pl. 492
Pen, ink and wash, $7\frac{7}{8} \times 6\frac{5}{8}$ inches
Mr R. A. Harari, London

This is the most elaborate example of Beardsley's technique in this manner with washes of ink interpreting the intermediate tones. It was intended as an illustration to *Volpone*, but was transferred to the group illustrating *Mademoiselle de Maupin*. The miniature monkey was perhaps an unconscious *revenant* of the foetuses of 1893, in more plausible terms.

493 Design for the book-plate of the poetess Olive Custance, afterwards Lady Alfred Douglas. Lettered 'Ex Libris Olive Custance' and signed with initials. Pl. 493
Pen, ink and wash, $3\frac{11}{16} \times 5\frac{3}{8}$ inches
National Gallery of South Australia, Adelaide

The drawing is executed in a technique whereby intermediate tones were introduced by ink wash. It belongs to the group which includes 'Arbuscula' and the illustrations to *Mademoiselle de Maupin*.

494 Arbuscula. Drawing for illustration facing p. 38 in *A History of Dancing From the Earliest Ages to our own Times*, from the French of Gaston Vuillier, published by William Heinemann, London, 1898. 4to. Signed with the artist's initials. On the back of the paper, in Beardsley's hand, is a pencil inscription: 'Dont *rub (pencilling)*'. Some pen and indian-ink scribbles are cancelled by brush strokes. Pl. 494
Indian ink, wash and pencil, $5\frac{1}{4} \times 3\frac{15}{16}$ inches
Mrs P. J. Mayer, London

Arbuscula was the name of a dancer during the earlier

Roman Empire. The table has been drawn mainly with pencil. Since the artist had used pencil-shading as well ink wash in order to render the intermediate tones in t drawing, the reproduction in the 1898 book was in phot gravure. The photogravure was reproduced in green p. 75 of *Under the Hill* by Aubrey Beardsley, published John Lane, London and New York, 1904. It had been rep duced in green in the portfolio of extra plates supplied w the de-luxe edition of the book.

495 Design for the front cover of *Ben Jonson his Volpone: or T Foxe*, with a critical essay on the author by Vincent O'Sul van and an eulogy of the artist by Robert Ross, published Leonard Smithers and Co. [*sic*], London, 1898. 4to. Sign with initials and dated 'Paris 1898'. Pl. 495
$10\frac{15}{16} \times 8\frac{3}{16}$ inches
Scofield Thayer Collection, Fogg Art Museum, Harvard Univ sity, Massachusetts

The design was stamped in gold on the turquoise blue clo front covers of the edition of 1000 copies on art paper, a in gold on the vellum front covers of the edition on Japane paper of 100 copies.

496 Volpone Adoring his Treasure. Drawing for the front piece to *Ben Jonson his Volpone: or The Foxe*, with a criti essay on the author by Vincent O'Sullivan and an eulogy the artist by Robert Ross, published by Leonard Smith and Co. [*sic*], London 1898. 4to. Signed with initials. Pl. 4
$11\frac{1}{2} \times 8$ inches
Princeton University Library

This drawing was intended for the prospectus of the boo The frontispiece, five initial letters and front cover desi for *Volpone* together constituted Beardsley's last underta ing, not completed at the time of his death on 16 March 18 They were published with the text later in the year by Leona Smithers in an edition of 100 copies on Japanese vellum, a 1000 copies on art paper bound in turquoise-blue cloth wi the cover design stamped in gold. The prints, and partic larly the frontispiece, came out sharper on the art paper th on the Japanese vellum. In the frontispiece Beardsley stro to recapture the qualities of a seventeenth-century engravin The result is one of the most exalted achievements of pe manship in the history of art.

497 Design for the initial V on p. 19 of *Ben Jonson his Volpone: The Foxe*, published by Leonard Smithers and Co [*si* London, 1898. 4to. Pl. 497
Pen, ink and pencil, $4\frac{11}{16} \times 6\frac{5}{8}$ inches
Grenville L. Winthrop Bequest, Fogg Art Museum, Harva University, Massachusetts

Following up his past successes in overloading one side o composition and redeeming this effect by an intuitive visu event on the 'empty' side, Beardsley here links the upp half of a composite column, the soffit of an architrave and decorative swag and a pendant. He has used a pencil solidify all this with soft shading. Cancelling the whole co position, yet ranged on the outer edge of the architra comes a Roman V outlined in ink. In the search for tangib effects the artist has failed in structural logic and produc for once an incoherent design. This and the succeedi drawings for initials in *Volpone* had to be reproduced half-tone because of the soft shading in pencil.

esign for the initial V on p. 21 of *Ben Jonson his Volpone: or he Foxe,* published by Leonard Smithers and Co [*sic*], ondon, 1898. 4to. Pl. 498
en, ink and pencil, $7 \times 6\frac{5}{16}$ inches
renville L. Winthrop Bequest, Fogg Art Museum, Harvard niversity, Massachusetts

eardsley has now abandoned his gift of dramatizing out-nes and silhouettes in an attempt to dramatize the values of ghlighting. The stability of the composition is emphasized y the elephant itself, and tradition by the use of this familiar nage with its basket-shaped urn full of fruits—which in the egency would have been a 'castle' or howdah. The drawing as a thick, ponderous force.

esign for the initial S on pp. 55 and 116 of *Ben Jonson his olpone: or The Foxe,* published by Leonard Smithers and o [*sic*], London, 1898. 4to. Pl. 499
en, ink and pencil, $6\frac{15}{16} \times 6\frac{1}{4}$ inches
renville L. Winthrop Bequest, Fogg Art Museum, Harvard niversity, Massachusetts

his is probably the most successful of the *Volpone* initials ecause the *sfumato* is not overdone. Perhaps the letter S ispired the artist to recapture his old sense of design in omplex curves. These curves are integral to the form of the gressive bird, which is a monster out of his old *Bon-Mots* eriod, turning the corner of Beardsley's mixed feelings of umour and fear. The rectangular contrast of a rusticated aroque building and the pencil-shading symbolizing the xture of old stone form an admirable contrast to the bird's iovement.

ketch for a variant of the initial S in *Ben Jonson his Volpone: The Foxe,* published by Leonard Smithers and Co [*sic*], ondon, 1898 (p. 55). With a slight sketch of a satyr below. l. 500

Pencil on a sheet of ruled paper, $7\frac{1}{2} \times 4\frac{1}{8}$ inches
Princeton University Library

The final design for the initial S was of a totally different character. However, pencil drawings by Beardsley are rare.

501 Design for the initial M on p. 83 of *Ben Jonson his Volpone: or The Foxe,* published by Leonard Smithers and Co [*sic*], London, 1898. 4to. Pl. 501
Pen, ink and pencil, $7\frac{1}{16} \times 6\frac{1}{16}$ inches
Grenville L. Winthrop Bequest, Fogg Art Museum, Harvard University, Massachusetts

·It is hard not to suspect a decline of vitality behind the comparatively limp draughtsmanship of this drawing. Beardsley's former obsession with breasts seems to be gratified by a desperate realism. The pencil-shaded mother and child have the air of an ill-cleaned *tenebroso* picture of the seventeenth century. None the less he was struggling to acquire a sculpturesque sense of feeling in the round: it was as if approaching death brought an unconscious wish to assert the reality, the solidity, of his concepts, bringing also a promise of new developments, in anticipation of the rough art of the early twentieth century.

502 Design for the initial V on p. 147 of *Ben Jonson his Volpone: or The Foxe,* published by Leonard Smithers and Co [*sic*], London, 1898. 4to. Pl. 502
Pen, ink and pencil, $6\frac{15}{16} \times 6\frac{1}{4}$ inches
Grenville L. Winthrop Bequest, Fogg Art Museum, Harvard University, Massachusetts

The best part of this design is the letter V which casts into the *sfumato* background of rubbed pencil the very stable and centralized term of the great god Pan. The congested expression of this god is neither very sinister nor very amusing. Romantic trees constitute a new element in Beardsley's art, unfortunately never to be developed.

Index